Psychoanalysis a

New Interventions in Art History

Series editor: Dana Arnold, *University of Southampton*

New Interventions in Art History is a series of textbook mini-companions – published in connection with the Association of Art Historians – that aims to provide innovative approaches to, and new perspectives on, the study of art history. Each volume focuses on a specific area of the discipline of art history – here used in the broadest sense to include painting, sculpture, architecture, graphic arts, and film – and aims to identify the key factors that have shaped the artistic phenomenon under scrutiny. Particular attention is paid to the social and political context and the historiography of the artistic cultures or movements under review. In this way, the essays that comprise each volume cohere around the central theme while providing insights into the broader problematics of a given historical moment.

Psychoanalysis and the Image

Transdisciplinary Perspectives

Griselda Pollock

Blackwell
Publishing

© 2006 by Blackwell Publishing Ltd
except for editorial material and organization © 2006 by Griselda Pollock

BLACKWELL PUBLISHING
350 Main Street, Malden, MA 02148-5020, USA
9600 Garsington Road, Oxford OX4 2DQ, UK
550 Swanston Street, Carlton, Victoria 3053, Australia

The right of Griselda Pollock to be identified as the Author of the Editorial Material in this Work has been asserted in accordance with the UK Copyright, Designs, and Patents Act 1988.

First published 2006 by Blackwell Publishing Ltd

1 2006

Library of Congress Cataloging-in-Publication Data

Pollock, Griselda.
 Psychoanalysis and the image : transdisciplinary perspectives / Griselda Pollock.
 p. cm. — (New interventions in art history)
 Includes bibliographical references and index.
 ISBN-13: 978-1-4051-3460-6 (hardcover : alk. paper)
 ISBN-10: 1-4051-3460-7 (hardcover : alk. paper)
 ISBN-13: 978-1-4051-3461-3 (pbk. : alk. paper)
 ISBN-10: 1-4051-3461-5 (pbk. : alk. paper) 1. Psychoanalysis and art. 2. Art, Modern—20th century.
I. Title. II. Series.

N72.P74P65 2006
701′.15—dc22

 2005037433

A catalogue record for this title is available from the British Library.

Set in 10.5/13pt Minion
by SPI Publisher Services, Pondicherry, India
Printed and bound in Singapore
by Fabulous Printers Pte Ltd.

The publisher's policy is to use permanent paper from mills that operate a sustainable forestry policy, and which has been manufactured from pulp processed using acid-free and elementary chlorine-free practices. Furthermore, the publisher ensures that the text paper and cover board used have met acceptable environmental accreditation standards.

For further information on
Blackwell Publishing, visit our website:
www.blackwellpublishing.com

Contents

Figures

Notes on Contributors

Mieke Bal is Dutch Royal Academy of Sciences Research Professor and Professor of Theory of Literature at the University of Amsterdam and founding director of the Amsterdam School for Cultural Analysis, Theory and Interpretation (ASCA) at the University of Amsterdam. Her most recent publications include *Travelling Concepts in the Humanities* (2002) and *Quoting Caravaggio: Contemporary Art, Preposterous History* (1999). Among her many other books are *Narratology: An Introduction to the Theory of Narrative* (2nd edition, 1997), *The Mottled Screen: Reading Proust Visually* (1997), *Double Exposures: The Subject of Cultural Analysis* (1996), and *Reading 'Rembrandt': Beyond the Word–Image Opposition* (1991 [1994]). She also edited a programmatic volume, *The Practice of Cultural Analysis: Exposing Interdisciplinary Interpretation*, published by Stanford University Press in 1999, which gives a good idea of the nature and practice of cultural analysis. The breadth of Mieke Bal's research contributions is also acknowledged by *Looking In: the Art of Viewing*, essay and afterword by Mieke Bal, with a commentary by Norman Bryson. Her areas of interest include literary theory, semiotics, visual art, cultural studies, postcolonial theory, feminist theory, French, the Hebrew Bible, the seventeenth century, and contemporary culture.

Karyn Ball is an Assistant Professor in the Department of English at the University of Alberta in Edmonton. She edited a special issue of *Cultural Critique* on "Trauma and its Cultural After-effects" (Fall 2000). Her article "Unspeakable Differences, Obscene Pleasures: The Holocaust as an Object of Desire" appeared in the 2003 *Women in German Yearbook*, and an essay entitled "Global High Culture in the Era of Neo-Liberalism: The Case of Documenta 11" has been published in *Research in Political Economy* (vol. 21, 2004). Current projects include *Traumatizing Theory*, an edited collection of essays that explore the conditions and limits of psychoanalysis as a theory of

culture and society, a special issue of *parallax* devoted to the concept of "visceral reason," which concerns the adrenalized affective leftovers of histories of persecution, and a book entitled *The Entropics of Discourse: Climates of Loss in Contemporary Criticism* which will focus on the vicissitudes of politicized agendas in recent critical philosophy, cultural studies, and literary studies.

Adriana Cerne is a PhD doctoral candidate at the University of Leeds, researching feminist counter-cinema films and filmmaking from the 1970s to the early 1980s. Her work engages with art and its objects in an interdisciplinary way, which includes feminist theory, psychoanalysis, literary theory, and cultural analysis. She has written widely on subjects as diverse as hagiography and hysteria. She is currently researching seventeenth-century Dutch genre paintings and the tradition, and relation, of the epistolary to literature and the polemics of women's filmmaking, in order to explore the concept of the 'everyday' as an aesthetic encounter. She teaches Visual Culture and Theory at The London College of Communication. She has been published in the *Journal of European Studies* (June/Sept 2002).

Young-Paik Chun is Assistant Professor in the Department of Art History & Theory at the University of Hong Ik (Seoul, Korea). She has been published in the journal *Art History* (June 2002) and the book *Generations and Geographies in the Visual Arts* (1996). Her Korean publications include "Art History and Psychoanalysis: Julia Kristeva's Semiotic Reading of Painting," "A Psychoanalytic Reading of Cézanne's Large Bathers," "British Formalist Criticism and the Modernist Art of Bloomsbury," "Art History in an Expanded Field: Rosalind Krauss's Theoretical Development in the Discourse of Art History," and "Urban Space and British Art in the 20th Century: Art and Spatial Politics in London Since the Postwar Period." She has also translated several books: G. Pollock, *Avant Garde Gambits 1888–1893: Gender and the Colour of Art History* (2001), H. Foster, *The Compulsive Beauty* (forthcoming), and R. Krauss, *Bachelors* (forthcoming).

Bracha L. Ettinger is currently Research Professor of Psychoanalysis and Aesthetics at AHRC Centre for Cultural Analysis, Theory and History and at Bezalel Academy of Art in Jerusalem. Her paintings have been exhibited extensively in museums of contemporary art including Pompidou Centre, Paris (1996), Israel Museum (1996), Stedelijk, Amsterdam (1997), Villa Medici, Rome (1999), with solo exhibitions at The Russian Museum, St Petersburg (1993), Museum of Modern Art, Oxford (1993), and The

Drawing Centre, New York (2001); a large retrospective was curated by Paul van den Broek at the Palais des Beaux Arts, Brussels: *Bracha Ettinger Art Working 1985–1999* (2000). She has developed a distinctive contribution to post-Lacanian psychoanalytical theory with her concepts of Matrix and Metramorphosis which have been published in a series of papers and books since 1992 (e.g. "Matrix and Metramorphosis," *Differences* 4:3, 1992; *The Matrixial Gaze*, 1994). She has published conversations with Levinas, Jabès, and Boltanski. A collection of her *écrits*, *Regard et Espace-de-Bord Matrixiels*, appeared in French in 2000, and in English in 2005 (as *Matrixial Borderspace*). A second volume on psychoanalysis and aesthetics, edited by Griselda Pollock and Anna Johnson, is scheduled to appear in 2006. A special issue of *Theory, Culture and Society* (21:1, 2004) focused on her work, including essays by Judith Butler and J.-F. Lyotard.

Izumi Nakajima is a doctoral candidate at the Graduate School of Language and Society at the Hitotsubashi University. She has worked extensively on Yayoi Kusama and women artists in postwar Japan. She studied Art History in Japan and did an MA in Feminism and the Visual Arts at the University of Leeds in 2003. She has written on contemporary art, and her research concerns the experience of expatriate Japanese women artists, cultural production in conditions of migrancy, and in relation to sexuality and gender.

Griselda Pollock is Professor of Social and Critical Histories of Art and Director of the Centre for Cultural Analysis, Theory and History at the University of Leeds, working in/on Social History of Art, Cultural Studies, Feminist Studies in the Visual Arts, and Modern Jewish Studies. A series of strategic interventions into Art History and Cultural Theory, starting from *Old Mistresses: Women, Art and Ideology* (with Roszika Parker, 1981), through *Vision and Difference* (1988, reissued in 2004) to *Generations and Geographies in the Visual Arts: Feminist Perspectives* (1996) and *Differencing the Canon: Feminist Desire and the Writing of Art's Histories* (1999), have systematically challenged dominant phallocentric and Eurocentric models of art and cultural history while actively providing new methods for international and postcolonial feminist studies in the theory, practice, and analysis of the visual arts that breach the divisions between theory, practice, and history. She is currently working on trauma and cultural memory in a trilogy of books including a study of Charlotte Salomon called *Theatre of Memory*, and postmodern engagements with psychoanalysis and aesthetics in a book titled *Encounters in the Virtual Feminist Museum* (further information is on the website www.leeds.ac.uk/cath/pollock).

Series Editor's Preface

New Interventions in Art History was established to provide a forum for innovative approaches to and perspectives on the study of Art History in all its complexities. The series seeks to expand the boundaries of Art History through cross-disciplinary investigations of thematic and historical issues that are germane to our understanding of the visual. This collection of original writings more than adequately fulfills this brief by presenting a series of psychoanalytical speculations about the image, gaze, and scene of desire by a group of well-known authors in the field. It also provides a stimulating mix of Western and non-Western scholars, bringing new and fresh perspectives to an audience that wants the latest in research in this area of academic inquiry.

Psychoanalysis and the Image: Transdisciplinary Perspectives explores the ambiguous space between psychoanalysis and the image through a series of closely read studies of specific texts (painted, written, filmed, installed) ranging from the actual to the imaginary. The chapters combine to offer a transdisciplinary investigation where questions of history, theory, and analysis are at play. In this way the volume opens up questions of psychoanalysis, feminism, and cultural memory to lively and rigorous scrutiny which it is hoped will be a prompt for future research and debate. *Psychoanalysis and the Image* makes a very strong and welcome contribution to the *New Interventions in Art History* series.

Dana Arnold
London, 2005

Preface

I once wrote that unsolved difficulties reside in the "and" that appears so innocently to conjoin two concepts. In presenting a volume that shamelessly opens the ambiguous space between psychoanalysis *and* the image, we want to invite the reader to join in a series of closely read studies of specific texts – some painted, some written, some filmed, some installed, some imagined – that explore both psychoanalysis as we can read it through image-work, and image-work as we can decipher it through psychoanalytical concepts that were never theorized independently of the subject's formation within the image – the imaginary and its varied *mise-en-scène*. Starting with a reading of a photographs of the space in which classic Freudian psychoanalysis was generated amidst a private museum of archaeological artefacts and images testifying to cultural memory and memories of other cultures, this book explores a range of different dimensions of the image in psychic life and psychoanalytical terms in reading images.

Reminding us of the significance of psychoanalysis in theorizing sexual difference, Mieke Bal tackles the relations of art, sexuality, and dreaming through a reading of Chrisopher Bollas and the work of Katherine Gilje and Joseph Grigely. Artist Bracha Ettinger theorizes with and from Marguerite Duras's novel *The Ravishing of Lol V. Stein* to propose a radical post-Lacanian feminist scenario for the formation or failure of feminine desire – rephrasing Freud's infamous question "What does a woman want?" with its implied subclause, 'from a man' to read "What does a woman want – to become a woman – from a woman?" For many, the ethnic and geopolitical specificity of psychoanalysis' genesis in late-nineteenth-century Vienna brands its discourse as so culturally specific to be limited in its relevance to the internationally expanded constituency of scholars and of artists we might be inclined to study.

Three chapters in this collection explore psychoanalytical possibilities in the reading of art made under differentiated psycho-linguistic and geo-political positions. Young-Paik Chun engages with the paradoxes of Cézanne's melancholia and the affecting inhumanness of his portraits. Izumi Nakajima deploys social and historical readings of American and Japanese abstraction to the case of Japanese painter Yayoi Kusama to re-read her work as a negotiation of the dual patriarchies she endured as a postwar Japanese daughter. This movement or displacement from home as mother, language, and place also invites a psychoanalytical reading of the postcolonial textuality of Theresa Hak Kyung Cha by Karyn Ball.

A final text by Adriana Cerne resumes the underlying thematic of the daughter's place in the historical formations of psychoanalysis and feminism through a creative journey precipitated by the final seven minutes of Chantal Akerman's epistolatory film, *News from Home*, that brings the book back to the "scene" of "Dora's" fascinated two hours before Raphael's *Madonna* in Dresden, which is the point of departure for Bracha Ettinger's theorization of a feminine dimension to image and gazing that she names *fascinance* in counterpoint to Lacan's deadly *fascinum*.

This book aims to demonstrate the continuing vitality of psychoanalytical speculations about the image, gaze, and scene of desire.[1] We equally insist on the intrinsic rapport, the poetic covenant between the image and psychoanalysis in the moment of reading. Our method is close reading, never losing the specificity of making nor the particularity of historical location. We aim to conjugate history, theory, and analysis in a transdisciplinary perspective.

Note

1 An extended version of this preface, elaborating these key concepts, is available on line and to download at www.leeds.ac.uk/cath/publications.

1

The Image in Psychoanalysis and the Archaeological Metaphor

Griselda Pollock

Seeing Psychoanalysis

In May 1938, a young Viennese photographer, Edmund Engelman, was commissioned to take pictures in Sigmund Freud's apartment at Berggasse 19, Vienna.[1] Shot secretly under surveillance by the Gestapo on the eve of the aging doctor's flight from the country, Engelman's photographs not only document the space in which Freud worked and his family lived. They *picture* the space of psychoanalysis, documenting the genesis of psychoanalysis in the perplexing presence of so many images.

The photographs of Freud's consulting room captures the *mise-en-scène* of Freud's psychoanalytical practice in 1938 (Figure 1.1). Rather than a medical space, we encounter a private, domestic sitting room only a little unusual in the population of so much art on walls, surfaces, and even the couch itself. Indeed, the consulting room and connected study look like the private museum of an avid and learned collector of antiquities. Walls, surfaces, and cabinets are filled to overflowing with antique objects, casts, and prints. Max Pollack's striking portrait of Freud (cover) at his desk presents not the quietly absorbed scholar at work, but a man almost transfixed by the incoming gaze of the antique statuettes that circle the space in which he will inscribe his reflections on human, psychic life. An earlier photograph pictures Freud seated in front of a cast of Michelangelo's *Dying Slave* and other souvenirs of his cultural tourism that are

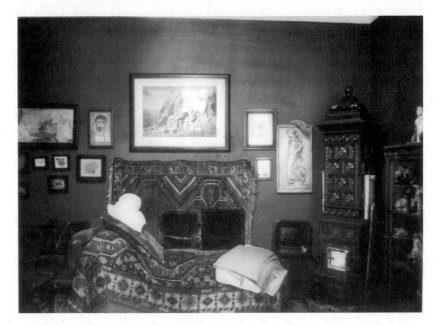

Figure 1.1 Edmund Engelman, *Berggasse 19*, view of the consulting room, 1938. Reproduced courtesy of Todd Engelman and Freud Museum, London.

markers of his personal and professional fascination with sculpted, drawn, and painted images (Figure 1.2). So to the question, "Why psychoanalysis and the image?," we might reply that psychoanalysis emerged in the active presence and enigma of the image.

Now Vienna's Freud Museum, the Berggasse 19's empty shell houses only photographic replicas of the contents of a complex interior scheme of images, books and artifacts in which Freud's passions and his professional and vacation journeys through art, archaeology, anthropology, and psychology were visually charted in a rebus of images.[2] Today, we can visit a reconstruction of the contents of that Viennese space in the home of the exiled doctor at 20 Maresfield Gardens, London where the ensemble functions as the historical installation within the Freud Museum – itself an archaeological display of the founding history of psychoanalysis itself.[3]

Many scholars have contemplated the significance of the archaeological image in Freud's thought. In 1951, Bernfeld analysed aspects of Freud's traumatic childhood losses in relation to the fantasies about death and incipient eroticism that overdetermined his fascination with the

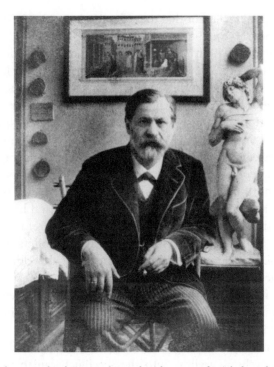

Figure 1.2 Photograph of Sigmund Freud with a cast of Michelangelo's *Dying Slave*, photograph, *c*.1905. Reproduced courtesy of Freud Museum, London.

resurrected past signified by the recovery of artifacts of ancient civilizations that defied death and disappearance.[4] In 1989 Lynn Gamwell and Richard Wells organized an exhibition and published an accompanying volume, *Sigmund Freud and his Art*, which included articles on "the archaeological metaphor."[5] My concern here is neither with the archaeology of psychoanalysis itself nor with the meaning of the metaphor for Freud's own psyche. The reference to archaeology demonstrates, I suggest, a profound engagement with both the function of the image in the structure of memory and the structure of mnemonic images in the formation of the subject.

The archaeological metaphor opens onto the study of the image in the visual and literary arts, and finally onto the creative/poetic process viewed through the prism of psychoanalytical investigations into the patterns of human subjectivity conceived as an "archaeological" structure: a palimpsest of time and meaning, history, memory, and oblivion. It is by means of

the archaeological metaphor that the reductive use of psycho-biography of the artist/producer can be avoided in favor of attention to the relay between structures within cultural representation and socio-historically formed structures of sexed subjectivity.[6] The engagement with psychoanalytical theory in current studies in the visual arts differs, therefore, from Bernfeld's and other Freudian scholars' interest in particular psychologies or personal histories. In this volume, the studies of the psychoanalytically conceptualized image through the prism of its theorization of varied psychic processes and subjective positions will not be iconographic, teasing out a hidden, neurotic content. It is, following Freud, addressed to structural questions of psychic processes, such as the dream, the primal scene, melancholia, and difference, how we know of them, and how they inflect and inscribe themselves in creative practices in literature, art, and cinema.

We seek to understand processes of fascination, sublimation, delusion, pleasure, desire, anxiety, and, above all, creativity as well as looking at/ reading images – be these sculptural, two-dimensional, dreamt, spoken, or written. The image in psychoanalysis is more than visual representation, even if imaginary visualization is in a privileged but challenging relation to the psychic formation and role of the image. *Imago* – the Latin term – feeds into general psychoanalytical concepts of the parental Others who haunt each psyche as well as into the specific Lacanian theory of the Imaginary and the mirror phase. Freud himself thought his project through the metaphor of scenes: the primal scene, the sight of castration, and the scene of the dream. The image is a holding place of meaning, already structured by psychological processes, servicing them as the carrier of affects, phantasies, and displaced meanings. The image can be imaginary. It can inhabit an object, a thing, a picture created visually or in literature. It is never pure, purely visual, or even perceptual. *Imago* was the title of the psychoanalytical journal founded by Freud in 1912 as a journal of applied psychoanalysis, opening onto anthropology, archaeology, literature, and aesthetics.[7] Journeying around the consulting room as it is revealed to us by Engelman's camera in 1938, I will work, in the rest of this introduction, towards a close reading of one of the artifacts, a bas-relief of a walking woman whose presence at the end of the couch hinges this space to Freud's early writings on the aesthetic/poetic process in a text considered to be the "turning point in Freud's attitude towards art."[8]

Engelman's photographs (Figure 1.1) make visible the acoustic space of Freud's scientific fieldwork at the intersection of the speaking subject and the mute object, historical relic or, as I shall suggest, the bearer of cultural

memory. The photographs offer insight into the range of transcultural visualities that lined this modernist, analytic theater. If we were to compare Freud's workspace with, for instance, that of the French poet Apollinaire around 1915, we might find a similar dependence on other cultures that confirm Freud's symptomatic place in the history of European Modernisms, and hence histories of the image and alterity in modernist cultures.

Culturally and personally determined choices of furniture and fittings created the material environment for a mental journey in which the present of the reclining analysand is suspended, and then fractured, by the surfacing of buried memories or mnemic fragments from childhood that are no longer accessible in full to the adult consciousness that they, none the less, overdetermine. Freud's analytical theater, full of objects and casts, stand for the shattered, incomplete and repressed histories, no longer available in their original unity or vitality. Instead, each item is marked by both oblivion and anamnesis, exemplifying in material form the shards of memory and fantasies that analytical sessions will conjure up in the transferential presence/present of the analyst with whose partnership, some hermeneutic sense of these discontinuous fragments may be rewoven into a tissue of shifting, subjective meaning.

In that space of induced reverie and daydream, the adult is invited to fall back into an active relationship with what Freud considered the subject's infantile "prehistory" and to excavate his/her subjectivity in its sedimented layers that are also interleaved temporal strata, resurfacing across the immediate plane of language and the "speaking," fantasizing body. A cavalcade of verbally induced memory images is invited to pass before the analysand's mental eye and the analyst's listening ear in order to offer each piece as an element of the puzzle of human subjectivity that psychoanalysis aims to explore through clinical observation and metapsychological theorization.

Although contemporaneous with Proust's autobiographical reflections on childhood and time, and coeval with the major philosopher of time and memory, Henri Bergson, the Freudian model suggested by this image-filled space is radically different.[9] It is more tragic and obscured than the Proustian recovery of voluntary and involuntary memory. The terms prehistory, sedimented layers, and temporal strata evoke what has been frequently noted as "the archaeological metaphor" that is deeply embedded in Freudian psychoanalysis.[10] For Freud, however, memory was never, as for Proust, a recoverable world of sensation laced with emotion. It is

already a mnemic trace that functions psychically rather than synaesthesically, whose substance is marked only by a psychic representative – a coded displacement or translation. A memory image structures for the subject the remnant of unfinished emotional business that hinges the subject and human culture forever between an incomplete past and a never fully experienced present. This suggests, therefore, that subjectivity can only be grasped chrono-topologically and in a profound relation between what is absent(ed) – the lost moment of formative sensation and emotion – and what is imaged/imagined as its trace in the psychic representational systems generated in response to the initial welter of impressions and intensities.[11] The representational act of art is both a further staging and what Sarah Kofman defines as an originary repetition.

George Dimock has argued that furnishings, pictures, and objects signify as an unconscious or dream text of the collector, Sigmund Freud.[12] They invite a reading of Freud's mind that is also the Freudian psyche: split between consciousness and unconsciousness, between what is imagined and what is absent, but traced in the charged image that holds before the psychic "eye" the relay of repressed affects and meanings that it is the job of psychoanalysis to retrace anamnesically. The subject is arrested by images that serve as a rebus-like representation of thoughts and affects that cannot be directly known but must be deciphered, just as was the hieroglyphic language of the Egyptians by Champollion in 1822. Never purely personal, although singular to their author in visual articulation, the space-text of the consulting room requires a structural analysis that may produce an understanding of the patterns of relations, substitutions, and relays in which the image plays such a part in psychoanalysis. These reflections take us to the heart of both the Freudian paradox of a subject formed in memory and of modernity itself defined by the partner it created: the ancient, archaic, or foundational past.

So, we might ask: Why did the modern, atheist neuro-psychologist, promoting his new science in a medical practice, live intellectually and affectively in a world populated by such fragmentary image-bearers of its antithesis, namely, mytho-poetical, cultic, and religious thinking? Why so much pagan art in the place of modern science? Not for Freud Gauguin's Oceania or Picassso's Africa. Rather, the pagan cultures of the ancient world – Egypt, China, Greece, India, Etruria, and Rome – spoke to and of his desire and his childhood dreams framed in a still potent Jewish heritage within a Germano-Christian culture.[13] Psychoanalysis emerges, therefore, in a musealized space, reflecting back to us the modernist

consciousness that needs, invests in, and mis-remembers the many pasts and prehistories the museum holds in its keeping before the gaze of the present through images it has recovered and redisplayed.

The luminously simple modernist architecture and décor of the suburban house in Maresfield Gardens locates the famous couch covered with the rich colors of a Persian carpet directly beneath a print of André Brouillet's painting of *Leçon du Mardi, Salpêtrière* in which the nneteenth-century neurologist Jean-Martin Charcot lectures to an assembled medical, and all-male, audience while his assistant holds the fainting body of a woman patient in mute, hysterical collapse echoed across the room by the enlarged image of an anguished arching hysterical female body (Figure 1.3). In the Vienna setting, however, this print hung on the wall opposite Freud's chair, in *his* line of vision, and next to a print of the Roman Forum that had strong links with a memory of Freud's father, Jacob Freud. Both acknowledge and resist filial descent. "Un visuel," as Freud described Charcot in 1893, a man of "an artistically gifted temperament," who allowed himself to be absorbed by a long observation of visual appearances

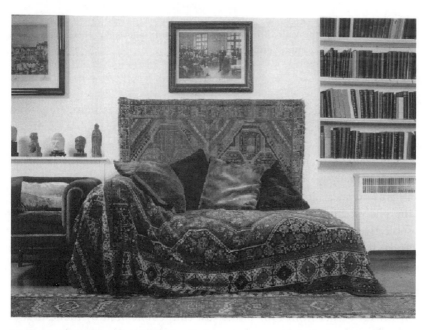

Figure 1.3 Photograph of Freud's Consulting Room, 20 Maresfield Gardens, London. Reproduced courtesy of Freud Museum, London.

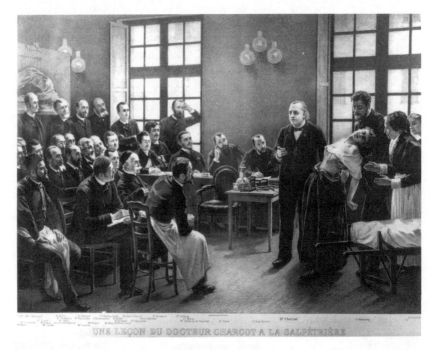

UNE LEÇON DU DOCTEUR CHARCOT A LA SALPÊTRIÈRE

Figure 1.4 Print after André Brouillet, *Leçon du Mardi, Salpêtrière*, 1888. Reproduced courtesy of Freud Museum, London.

until their superficial chaos yielded intelligible order, is represented in a medical setting, lecturing in the presence of his "possessed" but silent and mentally absented object of medical demonstration.[14]

Charcot's gendered scenario is structurally opposed to the scene of Freudian analysis over which it appears to preside (Figure 1.4). Berggasse 19 is as private as it is dialogic: we note the chair at the head of the sofa for the analyst himself, represented in his absence by a place in a trans-subjective structural exchange Freud would theorize as transference. There is no image of Freud at work with an analysand. Indeed, it would make no sense to represent the process of psychoanalysis by an imaging of the doctor at work.

In the original Viennese setting, above the couch hung a colour gouache by Ernst Koerner from 1907 of the vast cliff temple built by Rameses II at Abu Simnel, massively signifying both a fascination with the past of human civilizations and with the Egyptian cult of death against which

the sculpted images stands as both attempted defeat and monumental embodiment.[15] The London setting places the couch within an acoustic space framed by Freud's library on the right, and elements of his considerable collection of antiquities on the left. The former obviously represents Freud's scholarly profession. Freud was a multidisciplinary scholar, reading widely in contemporary archaeology, anthropology, and, significantly, art history. Collecting antiquities was a passion that began in December 1896, two months after his father's death, a coincidence that has not passed without inevitable, psychoanalytical comment.[16] If, as Jan Assman argues, Jewish monotheism's repudiation of the graven image is a cultural inversion of Egypt's monumental culture and its sculpturally encoded cult of eternal life after death, such a powerful invocation of the opposing cultural imaginary – so recently disinterred by modern archaeology – marks Freud's modernity and inscribes psychoanalysis as the analytics that seek to see beyond cult to the human longings and anxieties such systems encrypted so powerfully in cultural form that the counter-memory of Judaism proscribed their solace.[17]

In reading this array of images as an art installation that can itself be deciphered just like a dream text, Freud's dream, George Dimock cites Freud's early invocation of the archaeological metaphor in his "Aetiology of Hysteria" of 1896:

> Imagine that an explorer comes in his travels to a region of which but little is known and there his interest is aroused by ruins...He may content himself with inspecting what lies there on the surface and with questioning the people who live nearby, ..., about what tradition tells of the history and meaning of these monumental remains, and taking notes of their statements – and then go on his way. But he may act differently; he may have come equipped with picks, shovels and spades, and may press the inhabitants into his service and arm them with these tools, make an onslaught on the ruins, clear away the rubbish, and, starting from the visible remains, may bring to light what is buried.[18]

By such a method the archaeologist may uncover enough remains, tablets, inscriptions, an alphabet, and a language sufficient to produce "undreamed of information" about the events of the past "to commemorate which these monuments were built."[19] The past may leave a fractured, indecipherable trace. Deep excavations and collection of remembered stories allow some reconstruction of what these remains, themselves already signifying yet baffling images, *commemorate*. This is the ambiguous term at the heart of

Freud's later theory of fetishism which attempts to disavow unbearable knowledge while simultaneously placing at its traumatic site a memorial marker, the fetish. What is excavated may, however, be understood as the lost culture's mnemonic: inviting speculation about those elements, ideas, or beliefs within a culture significant enough to call forth or necessitate a cultural form for their remembrance, and to initiate a cultural practice that is the basis of the secondary and non-derivative, non-mimetic, but poetic world of representation.

Yet this invocation of the buried past is not at all straightforward. In "Notes Upon a Case of Obsessional Neuroses (The Rat Man)" of 1909, Freud reported, in an almost conversational manner, an exchange between himself and his patient:

> I then made some short observations upon the *psychological differences between the conscious and unconscious*, and upon the fact that everything conscious was subject to a process of wearing-away, while what was unconscious was relatively unchangeable; and I illustrated my remarks by pointing to the antiques standing about in my room. They were, in fact, I said, only objects found in a tomb, and their burial had been their preservation: the destruction of Pompeii was only beginning now that it had been dug up. – Was there any guarantee, he next enquired, of what one's attitude would be towards what was discovered?... No, I said, it followed from the nature of the circumstances that in every case the affect would be overcome – for the most part during the process of the work itself.[20]

Freud makes an important distinction: "Every effort was made to preserve Pompeii, whereas people were anxious to be rid of tormenting ideas like his." Here the association proves paradoxical. The formative phases and events of human childhood, archaic memories, and feelings are preserved, like artifacts in the tombs of ancient civilizations, but by the mechanism of repression. Repression at once erases and encrypts traumatic memories. They are *buried* and thus preserved like relics in the unconscious which is, as Derrida has helped us to recognize, the Freudian archive.[21] Analysis is not only excavation; it is at the same time something more shocking: exhumation. In this double form, analysis does not, however, aim at merely re-archiving relics in the psychic museum.

Analysis exposes the preserved past to the present, to the dynamic transformation called "working through," which, more than the mere effect of time, erosion, and atmospheric change, wills release from and

transformation of a past that, unconsciously, haunts the subject, torments him/her from the tomb/archive of the unconscious. In the case of ex-humed artifacts, however, people aim for perpetual conservation for which we have created the museum and its new cult priests, ourselves the art historians. So we might ask: is the museum a transparent tomb – keeping the past in tact but preserved from time – or is it a culture's amnesiac memory bank upon which we should constantly work in order better to understand ourselves?

The analyst seeks to bring about change in the analysand, relieving him/her of anxieties and phobias generated in childhood that deprive him of the effects of time. The debate about psychoanalytic theory as a structural resource in studying art's histories and the discipline, art history itself hinges on this distinction between commemoration and analysis, between fetishistic preservation and an open, historically vital working [on] through. The latter, like psychoanalysis, appears to the conservers within art history as scandalous because it desacralizes the past, resisting idealiz-ing fantasies of heroes and myths of greatness in favor of a deeper understanding yielded through analysis of the structures and processes of art works and cultural forms that produce knowledge of human sub-jectivities in all their complexity.

There is a further danger here. If mapped simply onto this model, exhumed civilizations may suggest that the past is merely the infantile prehistory of the present. The visitor to the museum appears to confront from a safe distance, via chronological display, traces of human prehistory that veils the ideological twinning of Modernity with its invented other, Primitivism – which is further distanced from the Western self through cultural and geographical othering. The active childhood formations of all humans are disowned as the permanent, backward condition of racialized others. Psychoanalysis risks this deformation of its own insights through inevitable ideological entanglement with its historical moment. As im-portantly, it also works against this racialized twinning of modern-adult/primitive-child because of its radical retheorization of the subject as overdetermined by the matrices of archaic, infantile and childhood for-mations that are neither primitive nor surpassable.[22]

Non-teleological, psychoanalysis is a tragic legend of our capture by intensities and traumas that happen too soon for us to know, articulate, or redefine them. Instead these pre-verbal events groove the tracks of our subjective formations, creating the reserve of emotional and affective

forces that will plot out the adult as displaced repetition. Thus, the psychoanalytical study of the prehistory of individuals or what we might call ancient human cultures is always a study of the self, not the other, of the pre-shaped present not the superseded past that can be projected out and away to be conserved museally.

If the ideologically defensive position of the modernist's false consciousness of progress and advance were not challenged by the human subject's perpetual working through of his/her own formation, we would be unable to confront the neuroses and phobias that are active in our own age. Hence the monitory importance I attach to the co-presence of analysis and antiquities in Freud's working environment. Freud too, while listening, was "un visuel," allowing himself, however, to be interrogated and challenged in his modernist will for scientific mastery as he searched these encoded emblems of human subjectivity and culture for a warning against the arrogance of modernist teleology: that what they confronted was in any way superseded. For Freud, the archaic and the infantile are not the same as the socio-evolutionary concept of the primitive. They fall not into historical time but into archaeological, hence coeval space. They are representations or inscriptions in visual mnemonics of what is perpetual, if always distorted by repression, in the human subject, its constitutive foundations and overdeterminations, as it came to be theorized, in their transcultural presence, as psychoanalysis. Hence this multi-faceted human past is not something out of which the adult person grows. That the opposite is the case is the message of Freud's work in that consulting room, itself a monument to the productive relay both between past and present and between the known and the enigmatic via the mediation of the questioning image: the gaze that returns to us from the world's culturally encoded pasts.

The problems of the archaeological metaphor, therefore, for societies and for individuals – or the tensions between them – are revealed in the moment of its enunciation. I want to plot out some of the varied uses of different archaeological metaphors used by Freud in his researches into the role of the psychologically archaic in relation to his ideal concept of adult psychological self-management. As a result of such investigations, we can catch both the trace of nineteenth-century evolutionary progressivism still at work in Freud's thought, and, more radically, the very terms of its undermining. I want, therefore, to distinguish three, historically framed images of what Donald Kuspit called "the mighty metaphor" of archaeology in psychoanalysis.[23]

Pompeii

Pompeii represents recovery of an almost complete classical city preserved in its everyday complexity by the freak of its ashen burial after the eruption of Vesuvius in 79 CE. Discovered by Domenico Fontana in the late sixteenth century, and identified as the Roman city of Pompeii in 1763, the ruins were only systematically excavated by Italian archaeologist Giuseppe Fiorelli (1823–1896) after 1860. Interpretations made possible by his careful documentation and casting were published in 1900 by Augustus Mau in his *Pompeii in Leben und Kunst*. Pompeii as revealed by Fiorelli and Mau's modern research becomes a model for Freud's proposition that human psyches forget nothing and the entirety of our infantile period is repressed beneath the somewhat more solid barrier of the impenetrable unconscious.

Troy

When Freud was born, Troy was still the stuff of schoolboy storybooks. The recovery of a possible site for a real historical Troy entered popular knowledge through German amateur archaeologist Heinrich Schliemann's widely reported excavations at Hisarluk in Asia Minor in the 1870s. Schliemann (1822–1890) not only claimed to have found what he mistakenly took for the Bronze Age civilization of the Homeric epic, and later the culture of Mycenae in the Greek Peloponnese, both of which discoveries pushed back the time-line of Western history. Schliemann's digs also brought to light eight further strata, indicating even older civilizations preceding what had been up to that date not even prehistory but the world of myth and legend. Schliemann's much more rigorous and professional collaborator Wilhelm Dörpfeld applied the new techniques of stratigraphy to the Trojan sites and this method was illustrated in Schliemann's popular publications in a suggestively evocative manner of the section drawing.[24]

Knowledge of prehistory was radically extended by a physical record of superimposed, layered deposits of persistent occupations of a single site. For psychoanalysis, therefore, the Troy metaphor is a much more dialectical metaphor of sedimentation and stratification of the accumulating layers of the past. A single site, like a single human subject, is the composite of all its own history, each period laid down stratum by stratum, once the site of life and energy, which is then superseded by

that which occupies that same space, incorporating into different usage and meaning some relics of the past: an altar becomes a door lintel, for instance. Nothing is forgotten, but the elements are changed dynamically by their uses in the multiple levels. What appears on the surface, as the conscious adult, is merely the tip of a deep shaft that can be excavated analytically, layer by layer.

We can see this method demonstrated in the textual structure Freud created for the writing up in 1914 of the analysis of the "Wolf Man."[25] Freud moves back, layer by layer, to show how a hypothetical primal scene occurred at a moment when the subject had too underdeveloped a psyche to process what it, none the less, traumatically registered. Subsequent stages of psychic, linguistic, and physiological development retrospectively catch up these garnered mnemic traces, reshaping them with meanings dependent upon further maturation, fantasy, and language acquisition. Thus the human subject is imagined in a time-reversing relay binding its prehistory, pre-language and pre-Oedipal processes, to the retrospective structuration of the later Symbolic by means of which we gain access to these deep strata that can never, like Pompeii, be excavated in their untransformed originality. The strata are mutually determining. Yet by working through the layers that collectively build up to form the present terrain, elements of significance, can be disinterred to propose interpretations of these lost ages.

Psychoanalysis hypothesizes, therefore, that subjectivity is formed through constant accretion and reframing, just as a long-occupied single site might yield its layers, each one shaped by and reshaping its own foundations. Using this new archaeological terminology, Freud wrote to Fliess in 1896:

> I am working on the assumption that that our psychical mechanism has come into being by a process of stratification: the material present in the form of memory traces being subjected from time to time to a *re-arrange-ment* in accordance with fresh circumstances, to a *retranscription*. Thus what is essentially new about my theory is the thesis that memory is present not once but several times over, that it is laid down in various kinds of indications.[26]

From this derives his key concept *Nachträglichkeit* – translated into English as "deferred action" and to French as "après coup."[27] This concept is central to contemporary critical feminist studies in the histories of art

which resist progressive narratives and heroic modernist teleology. *Nachträglichkeit* enables us to think in non-reductive or essentialist terms about the deep and many layered structurations of subjectivity that overdetermine the activity of artistic representation as non-originary "repetition."[28]

Knossos

The third model is provided by the Cretan site of a civilization even older than the militaristic cultures of Troy and Mycenae: Knossos. Knossos as a metaphor emerges later in Freud's writings, its appearance corresponding to the publication of Sir Arthur Evans's excavations after 1900 and to the advance in his own thinking. Schliemann had suspected that there was another culture to be discovered on Crete, and had unsuccessfully applied for permission to dig to the Ottoman authorities who controlled the island. In 1899 Arthur Evans, curator at the Ashmolean Museum in Oxford, purchased the tract of land on which the vast complex of Knossos was to be uncovered. Filled with mythic stories from a classical education, Evans identified the many-storied and painted buildings he found with the labyrinth of Greek legend. He named "Minoan" after King Minos the cultural remains he not only found but radically reconstructed. At Knossos 3,000 clay tablets were unearthed bearing a script named Linear B which was famously deciphered in the middle of the twentieth century by Michael Ventris. Evans's key publications were *Scripta Minoa* (1909) and *The Palace of Minoa* (1921–1936). These are key dates in major shifts in Freud's thinking, notably about femininity and sexuality.

The Knossos metaphor provides something radically different from the other two metaphors. It is a model of cultural rupture and loss, wherein excavation reveals a formerly unknown and utterly different civilization screened behind what appeared, up to that point, to have been the earliest foundations of the present. Following Evans's revelation/reconstruction of "Minoan" culture (a title that itself inscribes Evans's own desires based on legendary stories of childhood), Freud was obliged to acknowledge a subject violently forced from one functional model of psychic life into another, just as what appeared to be a gynocentric, Minoan culture was violently overthrown by the warriors of Mycene. It was this model of violent superimposition that has specific implications for Freud's theories of the Oedipal trauma in general, but specifically of femininity as the veiled remnant of an earlier, mother-centered, pre-Oedipal psychic order,

from which the girl-child has violently to be wrenched.[29] In 1931, Freud famously wrote his essay on "Female Sexuality" where we find: "Our insight into this early pre-Oedipus phase in girls comes to us as a surprise, like the discovery in another field, of the Minoan-Mycenaean civilizations behind the civilization of Greece."[30]

I want to argue, therefore, that it is only by keeping distinct these different, and culturally generated, metaphors of the buried past, pre-served relics, and ruptured memory that we can appreciate what the archaeological metaphors enabled Freud to think both about individual subjectivities and about the history of cultures. Equally, we may use psychoanalysis to reflect upon what archaeologists and hence art histor-ians as a sub-type of that genre desire to find, ignore, or project in their researches into these varied forms of the recovered past. For this we must return to Pompeii, Freud's favorite metaphor that actually functions in his work to deal with key dimensions of subjectivity and of cultural memory: death and eroticism. It will also be the stage for his first contributions to a psychoanalytical theory of the image.

As Freud sat in his analyst's chair, what did he see? Not only another cabinet cluttered with his antique collection of pots and Egyptian statu-ettes, but the print of Charcot's Tuesday Lectures. Fascinated by this picture, Freud's daughter Mathilde asked her father what was wrong with the fainting woman. Freud replied: "Too tightly laced."[31] This para-doxical reply – the image reveals a décolleté – disavows and acknowledges Freud's major hypothesis about the repressive control specifically of female sexuality in the etiology of the disturbance that afflicted women rendered mute by the dominant ideologies of sexual difference in Western Mod-ernity. If Freud grasped intuitively through the objects left by older civilizations that death was a defining anxiety and desired return to inanimate stasis, he also tracked the life force, the energy that would seek pleasure and thus leave a trace of life through sexuality and procre-ation: libido. "Too tightly laced" takes its metaphor from contemporary fashion which encased in metal and whalebone a female body that was both stimulated and suppressed by such constriction, a body both interred in clothing and fetishistically eroticized by it. Given that Brouillet's image itself shows off a woman's body being made the image in a state of unlaced decolletage for a gaze underlined as masculine by the representation of an all-male audience within the picture who sit under a huge representation of the orgasmic "arch of hysteria," Freud's comment encodes the conflict between the social and the erotic, staged across the body of woman as

image of conflicting masculine desires. Was Freud's purpose to dehyster-icize women by unlacing – hence exposing – their fetishistically sexualized bodies or by freeing their tongues to speak their own desires? Against stasis or confinement, is the figure of psychoanalysis the image of movement?

This question leads us to the curious juxtaposition at the foot of the couch, within the view of the dreaming, regressing analysand (Figure 1.5) where a photograph of a painting, *Oedipus and the Sphinx* by Jean-Dominique Ingres painted in 1808, hanging in the Louvre where Freud would have seen it in during his study years with Charcot in Paris

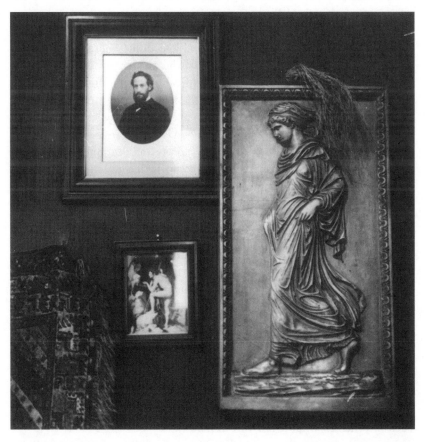

Figure 1.5 Edmund Engelman, *Berggasse 19*, view of the end of the couch showing *Gradiva* and Ingres's *Oedipus and the Sphinx*. Reproduced courtesy of Todd Engelman and Freud Museum, London.

in 1885–6 is hung beside a copy of a bas-relief of a classical female figure, walking or, rather, tripping along.

Being almost too predictable an image for the infamous Oedipus Complex, Ingres's painting condenses the many layers of the legend into a single image. If Freud slowly discerned, resisting as it appeared before him, through analysis, the potency of infantile desire addressed above all but not exclusively to the Mother, with concomitant desire for the father and hostility to both parents as rivals for the child's bisexual "desires," how could images so blatantly reveal the repressed traces of infantile sexuality and its repression? What do images remember for us – in ways that appear to be within the realms of education and knowledge, but are lined with the affects of our repressed formations?

As George Dimock has pointed out, Freud's project was to transform into a tragic narrative of forever incomplete desire the single moment condensed in Ingres's painting: namely the posing of a riddle whose answer plots a development – not a stratification. The Sphinx's question – what starts in the morning on all fours, then walks in the afternoon on two and ends in the evening on three? – is an allegory of the ages of the human being. As a painting, this image does not visualize progression from the childish to the adult and its decline into old age and decrepitude. It images in one moment the layers of subjectivity in which no stage is lost, but rather becomes the substrata of the next, recurring in uncanny hallucination for which art finds measured forms.

Ingres's painting centers itself on the idealized nudity of the Apollonian man. Oedipus' pose suggests reflection and thought. The edges of the painting, the world in which this self is framed, is fringed by the darkness of a lack of self-knowledge, a darkness over which presides a monstrous hybrid, a semi-human, female figure only partially separated from the animalistic, inhuman world, like the Pan and the Centaur in the Pompeiian fragments that hung around Freud as he sat in his working chair. Those who fail to answer the enigma the Sphinx knows, the riddle this breasted, thus maternal "she" poses to the middle term Man, fresh from the unknowing yet destined murder of his own father, are eaten, consumed, re-incorporated: reversing the separation that is birth, reversing the child's milky cannibalism at her breast. In this death, woman takes back into herself what is born from her.

To stay that reclamation, the Son-Man – Oedipus – must see only his own self-delusion in the mirror of maternal feminine difference, even while Ingres brilliantly manages to convey through his figure of Oedipus

simultaneously a human who crouches, leans upon his spears and yet seems a standing figure. Behind him in the counter-pictorial scheme of a flowing curve of hyperbolic drapery, and the broken outline of a citation of a famous pose of energy from Pollaiuolo's *Hercules Slaying the Hydra*, a man embodies anxiety and dread. He wishes to flee this menacing place for the safety of the man-made, geometric architecture of the city as the institutional antithesis of the uncanny evocation of our earliest dwelling signified by the natural formation of a cave. But let us pause at the lower left, beyond the signature and date, painted above the sun-dried skeleton and skull, as *memento mori*, where a single horrific, still-fleshy foot rises from the darkness, detached from the unseen corpse. A recent victim, we assume. The sole of this foot, this fragment, neither dried nor bony, so recently living yet already unnaturally pale, calls to the large image that Freud placed on the above to its right: the cast of a bas-relief he encountered in the Vatican Museum on a visit there in September 1907. Sigmund Freud reported in a letter to his wife written in Rome that he had come across a "dear, familiar face." It was not a real acquaintance who was thus affectionately described, but this sculpted bas-relief, high on the wall, in which another bare-soled foot will claim our attention (Figure 1.6). The sculpted relief of a running/walking woman should cause us to pause. Despite its lack of *apparent* mythic framing, it may tell us more about the role of the image in psychoanalysis and art history.

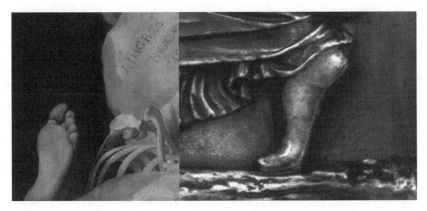

Figure 1.6 Griselda Pollock, Montage of a detail from Ingres's *Oedipus and the Sphinx* (Paris, Musée du Louvre) and the foot of *Gradiva*.

This relief was familiar to Freud as a real object that had inspired a fictional delusion, in a short story written by the minor German writer Wilhelm Jensen in his novella, *Gradiva*, published in 1903. The novella inspired Freud's first sustained engagement with a literary text: a collaboration of analyst and an imaginative fiction about archaeology and an archaeologist fixated on an image of a woman that bursts the bounds of both to present us with the puzzle of the image in relation to memory and memory-loss: repression.

Art: Dream and Delusion

Jensen's novella features a young German archaeologist, Norbert Hanold, who becomes deluded. He is trapped neurotically with the dead in order to avoid the living, and becomes preoccupied with his new science of the past in order to evade eroticism, fixating upon a woman of marble and stone in order to escape the inadmissible attraction to living flesh. Norbert Hanold, enamored from adolescence by the emerging science of archaeology, encounters this fragment of a relief and becomes obsessively fascinated by the woman's movement. He builds a fantasy around it, imagining that it shows not a Roman but a Hellenistic girl, living possibly in Pompeii at the time of its destruction. Intrigued above all by her gait, he tries to observe young women on the streets of his own town to see if such is woman's natural stride, only to be laughed at and derided for looking under women's skirts like a demented fetishist. Dreaming that this girl was alive in Pompeii on the day of its destruction in 79 CE and imagining himself, Norbert, as a witness, he is unnerved badly when he thinks he sees this ancient girl in the street of his German hometown. He becomes restless and, on impulse, travels to Italy, ending up, inevitably in Pompeii. There, in the mid-day sun, he thinks he is meeting the revenant of the girl in the bas-relief about whom he has fantasized so intensely. Speaking to her in Greek and then Latin, he does not register fully the significance of the fact that she replies in German.

At this point in the novella, the reader is unclear whether she is reading a ghost story. Soon, it is made clear through the author's change of convention that the girl is a living German contemporary who already knows Norbert well. It transpires that she was his childhood companion. She gradually fell in love with him as they grew up while he swerved away from erotic involvement into archaeology and amnesia. Through gentle

wordplay, the young woman slowly cures Norbert of his delusion and they finally meet as desiring adults, allowing the flow of erotic and affectionate connection. Freud comments on the final simile of the novella: of the "childhood friend *dug out of the ruins*," where,

> ... the author has presented us with the key to the symbolism of which the hero's delusion made use in disguising his repressed memory. There is, in fact, no better analogy for repression, by which something is preserved, than burial of the sort to which Pompeii fell victim and from which it could emerge once more through the work of spades. Thus it was that the young archeologist was obliged in his phantasy to transport to Pompeii the original of the relief which reminded him of the object of his youthful love. The author [Jensen] was well justified, indeed, in lingering over the valuable simplicity which his delicate sense had perceived between a particular mental process in the individual and an isolated historical event in the history of mankind.[32]

The hinge of the novella and Freud's psychoanalytical demonstration occasioned by it is an image of a foot rising almost perpendicularly from the pavement as the young woman walks, gently holding up her flowing skirts. This might well bring to mind something more obviously Freudian: fetishism. No doubt it is endowed with that quality of inherited and displaced association with female sexuality and with its necessary phallicization as a defense, behind which stands the forbidden body of the phallic and then castrated phantasy of the mother.

But it is also the condensed and displaced image of a word that gave the sculpture a name, and the novella a title: *Gradiva*. Even here there is a vital link with art and archaeology via psychoanalysis. For the making of an image is connected with an invisible thought, endowed with emotional or affective intensity, not with the transcription of a visible world. For Freud, the mental apparatus transforms memory traces into what he calls thing-presentations, closer to perceptual modes which are later joined by word-presentations that allow the memory trace endowed with affective association to rise to the level of thought and consciousness. Dreams are particularly significant because they operate across these two modes, often translating thoughts barred from consciousness, censored or repressed by conflicting forces, into images that are imaginatively experienced as sensory: heat, thirst, sight and so forth. The powerful drive in Western Christian art to develop representational technologies that can transport us through the great narrative paintings of the Renaissance and academic tradition that was

inherited by narrative cinema in the twentieth century could be analytically explored as being driven less by content than by the displacement of barred meaning onto synesthetic effects which need to be analytically decoded rather than considered either mimetically or iconographically. Enveloped in color, sound, and compelling recreations of palpable bodies and places, the viewing subject of art or cinema recognizes the apparently visual memories of dream images rather than the likeness of the material world.

Although it appears that we regress to archaic modes, it is more a matter of translation or circumvention based on the always present effects of the unconscious. Thus a word in a dream is a rebus, itself an image of a thought that may need to be untangled down a series of overdetermined signifying chains. Just so is the word *Gradiva*, which seems on the surface to describe the lively gait of a sculpted Roman maiden, while, in fact, it is veiled allusion to a person known to the archaeologist around whom once arose premature erotic feelings that are now barred from consciousness.

Meaning a light or a sprightly gait, *Gradiva* is the Latin version of the surname of the young woman, known to the hero archaeologist Norbert Hanold, but obliterated from his conscious memory. Her name is Zoë Bertgang. Bertgang is the German word for a sprightly gait. Zoë, however, means life in Greek, and thus down this chain of signifiers she is linked with Eve, *Havvah*, named in the Bible as "the mother of all living things," the moment of conscience and moral choice in the Hebrew Bible and the proscribed source of sin in the later, misogynist Christian interpretation/ mis-remembering of that same text. Against the death drive, Zoë stands for life and for sexual possibility in a chain that encodes both the ancient respect and the Christianocentric horror of the sexual woman. Yet, in the novella, the unrecognized memory trace of this living neighbor of the archaeologist is transposed onto a metal sculpture of a woman that the archaeologist, enflamed like Schliemann by his fantasies about the buried and recovered city of Pompeii, transposes to an ashen funerary grave. Life is translated, frozen into its opposite, death.

Hanold even has a dream in which he encounters this spritely gaited young woman in 79 CE on the day of the dreadful eruption. She moves to a temple bench, lies down, gradually turns pale and petrifies as the ash descends and buries her. When, as a result of the agitation persisting in waking from this dream, young Norbert goes to Pompeii and "by chance" encounters his German neighbor Zoë Bertgang, his delusion leads him to imagine that he is encountering the ghost of she who died in his dream, although the dream – as Freud decodes it – has clearly told him that this

woman he desires is living in the same time/town as he. Thus Hanold asks the apparition on the bench to assume the pose he witnessed in the dream, only to be rudely repelled as the living young woman recognizes instantly what the posture he invites her adopt as a remembered pose actually signifies in a more mundane erotic sense.

Freud's essay on Jensen's story holds much that is valuable and important for our thinking about Freud, archaeology, and cultural histories of the image. Indeed, in her study of Freud's esthetics, Sarah Kofman calls it the pivotal work of Freud's aesthetic theory.[33] "The Gradiva essay is the narrative account of a riddle which figures in miniature the riddle constituted by the work of art as such."[34] Whereas Freud modestly declares that he simply wants to interpret a few dreams scattered throughout the text, what he in fact does is inquire into the nature of poetic production itself. Kofman sees Freud staging and moving through a double session in his study of the novella, almost as a reflection of his own intellectual journey. Firstly, Freud the passionate collector of antiquities is, like Norbert Hanold, a professional man fascinated by the art of the past that seems to call to him, promising what it does not, however, disclose. Therein arises delusion that traps us in unacknowledged childhood fantasies that are indirectly resurrected via their echo in the art work that fascinates us. The relic is a memory-bearer of its own culture, but is also animated as the screen for our own uncognized memories.

Freud first uses the short story to suggest that the poet or author – Jensen in this particular case – has insights into those very same mental processes that the young discipline of psychoanalysis was only just beginning to name in the formal realm of psychological science. Freud admiringly demonstrates how the dreams imagined by Jensen conform to the patterns of condensation and displacement which Freud himself had, just three years earlier, identified in *The Interpretation of Dreams* (1900), the major work that he wrote following the death of his father and the beginnings of his collecting in which he provides a psychoanalytical theory of the image. Freud also finds Jensen adroit in showing the pattern of a delusion. But then Freud identifies two moments of poetic license on the author's part. They are needed for the novella's plot to work. Freud uses them to turn the tables on the author himself.

After the first stage, Freud writes:

> We – author and analyst – probably draw from the same sources and work upon the same object, each of us by another method. And the agreement of

our results seems to guarantee that we have both worked correctly. Our – that is the psychoanalyst's – procedure consists in the conscious observation of abnormal mental procedures in other people so as to be able to solicit and announce their laws. The author no doubt proceeds differently. He directs his attention to the unconscious in his own mind, he listens to its possible developments and lends them artistic expression instead of suppressing them by conscious criticism. Thus he experiences from himself what we learn from others – laws which the activities of the conscious must obey.[35]

This neat alliance between author and analyst breaks down: for the author is not really a self-analyst. Rather Freud comes to show that the art work is more like a symptom or its subject laid out on its text as couch. In following what he names the endopsychic surface of mental life and actions – rather like Charcot "le visuel" – the author, Jensen, catches the correct contours and patterns of psychic formations in his description of his characters. He does not, however, fully understand what else is being said by his own *writing*. In one sense, the analyst Freud parallels the author because both reveal a certain kind of truth beyond appearances that Jensen achieves by his novella about a delusion. Yet Freud shows how the author is unaware of the unconscious forces that haunt his own writing: these require the analyst proper, who applies what Kofman names a structural method. Freud reads and then compares a range of works of Jensen so that he can identify the recurrence of motifs across several works. These include such motifs as dead girls and apparitions in the mid-day sun. By giving aesthetic form to the author's unconscious and invested past, such originary repetition – for only in their having appeared in writing do these psychic elements become memory – opens a displaced pathway into representation for otherwise repressed childhood fantasies. But this is not a reductive interpretation of the relations between materials from the author's psychic life and the text.

Replication does not mean the projection of pre-existing fantasies or the translation or expression of a previous text, even though Freud uses terms which could lead one to believe that he remains a prisoner of the traditional logic of the sign. The only existing text is the text of the work, which is one with the text of life; it is through the text of the work that life is structured as a text and that phantasies can be structured; that is organized in such a way that they can be read as such and such a fantasy. The work is not the double of the author understood as a reflection of a being or of a

pre-existing life; *it is an originary double, a replica which is necessary precisely because the text of life is lacunary,* and because the ego does not exist prior to what it produces, as a presence full of meaning whose products would be merely second and secondary representations. The work is a "supplement", an originary substitute. (my italics)[36]

Thus, the author ceases to be father of his own text with knowledge of others' conditions. He is revealed to be more like the analysand on the couch, offering up his artistic text like a dream itself to be deciphered from its complex articulation, for the first time, of displaced fragments that, buried in the unconscious, determine from elsewhere the shape, rhythm, pattern, and interests of any story/image. "It is because childhood impressions have never been lived in the full possession of their significance that there is repetition. It is because the originary text is absent that there is an echo, the second text, which is thus originary in its secondness."[37]

Kofman concludes that Freud's theory of art appears close to Plato: the poet is unaware of what s/he is saying. In fact, she considers Freud is more akin to Aristotle's contention that there is a truth revealed in illusion:

All that is needed to possess the truth is to convert poetic language, the language of disguise, into metapsychological language...Myth is the childhood of philosophy for Aristotle, just as for Freud, art is the childhood of psychoanalysis. Art occupies an intermediate position between the pleasure principle and the reality principle and reconciles them to one another.[38]

Art is not reducible to the psycho-biography of the author; without the art, there would be no knowing of what the particular psychic prism might be. In so far as psychoanalysis provides a means of understanding these structures of subjectivity, it also makes clear there is no "outside," even for itself and its practitioners.

In the novella, there is, however, an analyst-figure who forms a third, and more remarkable, double for Freud. She is the woman: Zoë Bertgang herself.[39] He names her a physician and notes that she, like an analyst, performs three critical tasks. She raises buried unconscious thoughts to the surface: an archaeologist herself. She furthermore makes the explanation – interpretation – coincide with the cure. Thus she animates language with the power to defrost the frozen, deadened past. She thus awakens feelings, restoring affect and desire. Thus Zoë is an archaeologist with a difference. That difference is her acknowledgement of the circle of hermeneutics, precisely what psychoanalysis offers.

In the end, psychoanalysis does not provide a haven of science of detailing the formal contents of human consciousness, let alone an iconography of the unconscious. It offers a provisional, still troubled and faulty method for working with human subjectivity that it poses as a complex interweaving of corporeal, imaginary, and symbolic registers; as a rebus composed in a process across what we can only call temporal space that produces an accretion of every element in different levels that oscillate between repressed memory and anamnesis. Thus the comparability of the historicity of the human individual as socio-psychic subject to the history of human civilization is not a simple analogy. It is a composite one in which the several metaphors of archaeological excavation of sedimented ruins and fragments vie with the anthropological search for the rules by which human cultures make meaning and create/are created by signifying systems. Psychoanalysis lends its hermeneutics to any study of culture. All three related disciplines, archaeology, anthropology, and art history, see something of importance in those products of individuals in society which are the external endopsychic forms of this socio-psychic fabric we call human. Art history, however, bears more of an affinity with the delusional structure described in *Gradiva* and analyzed by Freud's reading of the novel. In its institutionalized forms, canonical Art History wants to remain adamantly ignorant of the cultural, gendered, racializing story it is telling without analytical self-consciousness of either repression or displacement. Psychoanalysis brings us, often unwillingly, to a difficult self-awareness that is the basis of criticality.

In Freud's reading of the novella, Gradiva, the dead, lost object, revenant screens but is then replaced by the intellectually acute and empathetic Zoë, a feminine figure of a dis-illusioned knowledge necessary to release Norbert back into a living rapport with both life and knowledge. At the end of the story, when the lovers are reconciled and engaged, Norbert asks her one last time to trip across the paving stones of Pompeii, revealing that famous gait. Clearly meant ironically, it serves as a warning of the fixation with the image that leads to fetishism against which even the living intelligence of women investigators cannot stand. Forgetting and remembering are deeply political and the lesson of Freud is that we are made by what we repress. We move on only when we are prepared to confront the overdetermination of all knowledge by its structuring repressions. Psychoanalysis does not offer a means of interpreting the image, but shows how the image interprets the complexities of subjectivity to us.

Notes

1 Edmund Engelman, *Berggasse 19: Sigmund Freud's Home and Offices, Vienna 1938* (New York: Basic Books, 1976).

2 Harald Leupold-Löwenthal et al., *Wien IX, Berggasse 19: Sigmund Freud Museum* (Vienna: Verlag Christian Brandstätter, 1994).

3 The Freud Museum, *20 Maresfield Gardens: A Guide to the Freud Museum* (London: Serpent's Tail, 1998).

4 Suzanne Cassirer Bernfeld, "Freud and Archaeology," *American Imago*, vol. 8, no. 2 (1951), 1107–1128.

5 Lynn Gamwell and Richard Wells (eds.), *Sigmund Freud and his Art: His Personal Collection of Antiquities* (New York: Harry N. Abrams in conjunction with London: Freud Museum, 1989); Donald Kuspit, "A Mighty Metaphor: The Analogy of Archaeology and Psychoanalysis," in Lynn Gamwell and Richard Wells (eds.), *Sigmund Freud and his Art: His Personal Collection of Antiquities*, pp. 133–51; Donald Spence, *The Freudian Metaphor: Towards Paradigm Change in Psychoanalysis* (New York: Norton, 1987).

6 Laura Mulvey, "Visual Pleasure in the Narrative Cinema," *Screen*, vol. 16, no. 3, (1975), 6.

7 Closed down in 1937, the journal was refounded as *American Imago* by Hans Sachs in the United States.

8 Sarah Kofman, *The Childhood of Art: An Interpretation of Freud's Aesthetics*, trans. Winifred Woodhull (New York: Columbia University Press, 1988), p. 198.

9 Henri Bergson, *Matter and Memory*, trans. N.M. Paul and W.S. Palmer (New York: Zone Books, 1991).

10 See also Sandra Bowdler, "Freud and Archaeology," *Anthropological Forum*, vol. 7 (1996), 419–38; Richard H. Armstrong, "The Archaeology of Freud's Archaeology: Recent Work in the History of Psychoanalysis," *The International Reivew of Modernism*, 1999, vol. 3, no. 1 (1999), 16–20.

11 As Laplanche and Pontalis point out, Freud never fully expounded his own specific, psychoanalytical concept of memory despite the centrality of such a problem of amnesia and anamnesis to its analytical practice. Yet they insist that the key term of his thinking on memory, the "Mnemic Trace" be taken seriously because memory traces do not form a single unity, but rather "are deposited in different systems," work in chains and relays, and "are only reactivated once they have been cathected," hence charged psychically by subsequent events, emotions and situations. J. Laplanche and J.B. Pontalis, *The Language of Psychoanalysis* (London: Karnac Books, 1988), p. 247.

12 George Dimock, "The Pictures over Freud's Couch," *The Point of Theory; Practices of Cultural Analysis*, ed. Mieke Bal and Inge Boer (Amsterdam: Amsterdam University Press, 1994), pp. 239–50.

13 The specific significance of and repression of Egyptian mythology and its
 material remnants in the formulation of psychoanalysis despite its omnipres-
 ence within the analytical theater is analysed by Joan Raphael-Leff, "If
 Oedipus was an Egyptian: Freud and Egyptology," *International Review of
 Psychoanalysis*, vol. 17 (1990), 309–35.

14 Sigmund Freud, "Charcot" [1893], trans. Joan Riviere, *Sigmund Freud: Col-
 lected Papers*, Volume I (London: The Hogarth Press, 1924), p. 10.

15 The invention of this method belongs in fact to Berthe Pappenheim
 whose treatment by Freud's mentor and colleague Josef Breuer in 1880–81
 laid the foundations for what would become psychoanalysis. She it was who
 conceived of "the talking cure" and it was her self-induced hypnotic states,
 what she called her "private theater," that led Breuer to adumstrate a new
 kind of psychological therapy based on recovered memories. See Sigmund
 Freud and Josef Breuer, "Anna 'O'," *Studies in Hysteria, 1893–95*, Penguin
 Freud Library, vol. 3 (London: Penguin Books, 1991), pp. 73–102; "private
 theater," p. 74; "talking cure," p. 85. See also Lisa Appignanesi and
 John Forrester, *Freud's Women* (London: Weidenfeld and Nicolson, 1992),
 pp. 72–91.

16 Bernfeld, "Freud and Archaeology," 127; Gamwell and Wells, *Sigmund Freud
 and his Art*, pp. 23–4. His first mention occurs in a letter to Wilhelm Fliess,
 December 6, 1896: "I have decorated my study with plaster copies of Flor-
 entine statues."

17 Jan Assmann, *Moses the Egyptian: The Memory of Egypt in Western Mono-
 theism* (Cambridge, MA: Harvard University Press, 1997)

18 Sigmund Freud, "Aetiology of Hysteria" [1896], Sigmund Freud, *Collected
 Papers*, vol. 1, trans. Joan Riviere (London: The Hogarth Press, 1924),
 pp. 184–5.

19 Ibid., 185. There follows the Latin phrase, *Saxa loquuntur!*, which is the
 subject of an interesting debate between Jacques Derrida (*Archive Fever*,
 trans. Eric Prenowitz [Chicago: University of Chicago Press, 1995]) and
 Yosef Hayim Yerushalmi (*Freud's Moses: Judaism Terminable and Interminable*
 [New Haven and London: Yale University Press, 1991]).

20 Sigmund Freud, "Notes upon a Case of Obsessional Neurosis" [The "Rat
 Man", 1909], Penguin Freud Library, vol. 9, *Case Histories II* (London:
 Penguin Books, 1979), p. 57.

21 Jacques Derrida, *Archive Fever: A Freudian Impression*, trans. Eric Prenowitz
 (Chicago: University of Chicago Press, 1996).

22 See *Freud and Philosophy: An Essay on Interpretation*. Paul Ricoeur reads
 Freud's work as a theory of the human subject and specifies both the
 centrality of the idea of archaeology to the Freudian subject and the dialectic
 between the archaeological – the sense of determination by the deepest
 layers – and the teleological, see pp. 419–94.

23 Donald Kuspit, "A Mighty Metaphor: The Analogy of Archaeology and Psychoanalysis," in *Sigmund Freud and his Art: His Personal Collection of antiquities*, ed. Lynn Gamwell and Richard Wells (New York: Harry N. Abrams, 1989), pp. 133–53.

24 In the Standard Edition the translation of a passage in "The Aetiology of Hysteria" refers specifically to a stratified ruin site (SE, vol. 3, 198).

25 Sigmund Freud, "The History of an Infantile Neurosis [1914; 1918]," in *Case Histories II*, 233–367.

26 Sigmund Freud, *The Complete Letters of Sigmund Freud to Wilhelm Fliess 1887–1904*, ed. Jeffrey Masson (Cambridge, MA: The Belknap Press at Harvard University Press, 1985), p. 207.

27 A letter to Fliess of November 14, 1897, uses the term; Freud, *Complete Letters*, p. 280.

28 I owe this concept to the work of Sarah Kofman, *The Childhood of Art: An Interpretation of Freud's Aesthetics*, trans. Winifred Woodhull (New York: Columbia University Press, 1988).

29 Key texts such as "The Dissolution of the Oedipus Complex" [1924] and "Some Psychical Consequences of the Anatomical Distinction between the Sexes" [1925] date from the mid-1920s and "Female Sexuality" from 1931.

30 Sigmund Freud, "Female Sexuality," *On Sexuality*, Penguin Freud Library, vol. 7 (London: Penguin Books, 1977), p. 372.

31 Cited in Engelman, *Berggasse*, p. 62.

32 Sigmund Freud, "Delusions and Dreams in Jensen's *Gradiva*" [1907/1907], in Sigmund Freud, *Art and Literature*, vol. 14, Penguin Freud Library (London: Penguin Books, 1990), p. 65. See also Peter L. Rudnytsky, "Freud's Pompeian Fantasy," in *Reading Freud's Reading*, ed. Sander L. Gilman et al. (New York: New York University Press, 1994), pp. 211–231.

33 Sarah Kofman, *The Childhood of Art: An Interpretation of Freud's Aesthetics*.

34 Ibid., p. 178.

35 Freud, "Delusions and Dreams," pp. 114–15.

36 Kofman, *The Childhood of Art*, p. 187.

37 Ibid., p. 189.

38 Ibid., p. 198.

39 On Zoë-Gradiva as analyst, see Mary Bergstein, "Gradiva Medica: Freud's Model Female Analyst as Lizard-Slayer," *American Imago*, vol. 60, no. 3 (2003), 285–301.

2

Dreaming Art

Mieke Bal

I often find that although I am working on an idea without knowing exactly what it is I think, I am engaged in thinking an idea struggling to have me think it.

<div align="right">Christopher Bollas[1]</div>

Bill Viola's video installation *The Sleep of Reason* (1988) shows a TV monitor on a chest against the far wall of a room in which the viewer is invited to stand. Flanking it are a vase of flowers, a cosy bedside lamp, and an alarm clock. The set-up has connotations of a bedroom without a bed, or, alternatively – perhaps simultaneously – an altar, but without the religious paraphernalia.

On the monitor the viewer sees the head of a sleeping man. Immobile, mostly. Watching him sleep makes the viewer feel uneasy. As the uninvited witness to sleep's vulnerability and its similarity to death, the viewer seems to gain more control than is warranted over the man's most private world. A further uneasiness comes from the temporal expansion: watching a sleeping head on a pillow is no big thrill. Hence, the double uneasiness prevents the kind of self-righteousness that, in resistance to voyeurism, comes so dangerously close to puritanism. Here, the viewer feels badly on both counts – for her or his own transgression and for the sleeper's boring hold over her.

As the stillness of the image begins to exhaust the viewer, suddenly, a loud noise interrupts it. The light goes off and the monitor goes black. Flashes of gigantic and frightening images appear on all the walls of the room: roaring seawater, a fluttering white owl, gigantic crawling ants. But only very briefly. Then the room returns to stillness, to the sleeper on the screen.

Clearly, the images represent dream images, nightmares, flashes of a frightening nightlife. They are frightening even though we cannot really see what they are and, hence, why they scare us. They are very short, but every bit as frustrating as the lengthy periods of still sleep. The viewer is denied the opportunity of grasping the images, of making sense of them. They are noisy, overwhelmingly so, visually and aurally. And since they are projected onto the walls surrounding the viewer, the latter is pulled inside them, as if being imprisoned in someone else's dream.

To be inside someone else's dream: could that not be a definition of the experience of art? Perhaps this simple idea can help make sense of the vexed combination "psychoanalysis and art."[2] In this chapter I will first look at psychoanalytic theory for help, then return to Viola's video to juxtapose it with another installation, before addressing the "yes, but..." objections that can be – and often are – offered, especially from a feminist perspective. Far from agreeing with these political objections, I will argue that psychoanalysis is indispensable, and that denying its relevance to the art of women, especially women from non-white traditions, is both condescending and discriminatory. I will also argue, however, that more is to be gained if the psychoanalysis-and-art theory is taken with a grain of salt – or humor – than when it is "applied" earnestly.

Inside the Other's Dream

In the chapter "At the other's play: to dream" of his book *The Shadow of the Object*, psychoanalyst Christopher Bollas, a theorist close to object-relations theory, begins his discussion of dreams with a critical comment on Freud's view as expressed in *The Interpretation of Dreams*. He summarizes Freud's view as follows:

> ...the dream is an emblematic arrangement of veils articulated by the unconscious, and the task of psychoanalysis is to read the discourse of the dream by translating its iconographic utterance into the word.[3]

Bollas then goes on to offer an alternative to it. His criticism of Freud is that despite its emphasis on the visual *Darstellbarkeit* of dream thoughts, it privileges the word. Bollas' criticism further suggests why visual art and the people who study it are resistant to such an activity of translation: reducing visual art to its iconographic elements and then

translating these into words is less than helpful to understanding visual art better.

Bollas uses the phrase "iconographic *utterance*," which already defines visual dream images as linguistic performance. A double reduction takes place here: the visual utterance is reduced to iconographic signs, and these are in turn translated *into words*. If the visual image is already an utterance, then Freud's method involves stopping the performative process to which that concept refers in order to reduce the visual material to discreet signs representing a thematic content. This first reduction of performance to theme is more decisive than the second, which is only the secondary act of giving the theme a label.

It should, however, be pointed out that the quoted account is also an adequate rendering of the practice of iconography, that stock-in-trade of traditional art history.[4] Iconography, too, requires the first reduction, and then entails the second as its practical consequence. The visual utterance is reduced to its iconographic components, which, now discreet rather than dense, can be considered – and will be translated into – words.[5] As a result what follows in my appropriation of Bollas' analysis should be taken not primarily as a revision of Freud (Bollas' context) or a dismissal of the use of psychoanalysis for the study of art, but as an attempt to point out the similarity between psychoanalysis and a dominant practice in art history so as to allow Bollas' revision of the one to benefit the other. My discussion of psychoanalysis-and-art is also to be taken as a statement about the relations between disciplines in that fashionable but elusive venture known as *interdisciplinarity.*

Bollas' alternative view offers a helpful, clear account of how dreams can also, and more adequately, be construed: not as what they are not yet standing for, but rather as what they are and do. This is also my preference for an approach to art.

> I regard the dream as a *fiction* constructed by a *unique aesthetic*: the *transformation* of the *subject* into his *thought*, specifically, the placing of the self *into* an allegory of desire and dread that is *fashioned* by the ego. (emphasis added)[6]

If we tentatively transpose this vision to the experience of art, the elements of fiction and a unique aesthetic will not only not encounter much resistance; they will also constitute precisely the core argument against the use of psychoanalysis for understanding art. The key question is

whether it is possible to accept the remainder of the statement. Accepting that art is like a dream requires that we accept a number of other ideas as well. First, the idea that the subject – say, the maker of the work of art – is, through the aesthetic, transformed into his or her thought. Second, it suggests that the self is not the director of the play thus staged but a character (most likely, but not necessarily, the hero) in the representation.

The first assumption says that the fiction that is the work of art is a transformation of subjectivity into thought in the same way a dream is. This idea – that subjectivity is transformed but not eliminated, and that thought, not just form or fun, is the result – is important to a feminist conception of art. Feminism's greatest contribution to cultural life as a whole, and to academic work in particular, is primarily as thought. What makes a work of art relevant for feminism is if it offers *thought* that is relevant.

The idea of thought does not imply that art-as-thought steers away from visuality. I have argued many times that images have conceptual content, that they "think" in a visual way, rather than just illustrate pre-established, non-visual thought.[7] In comparison with the image-as-dream idea, thoughts are even more emphatically shielded from a linguistic construction since they are supposedly unconscious, unarticulated in language. Even at this very elementary level, I think it is heuristically useful provisionally to accept the equation.

The second element in this assumption is that the thought is that of the artist-dreamer. It is probably commonplace for art historians to think this, since to attribute whatever we see in the image to the maker's intention is usually taken as valid, so much so that arguing against it remains even today an exceedingly difficult task.[8] Yet it is precisely to work against this assumption that psychoanalytic premises can be brought in. If the maker is the shaper and purveyor of the thoughts that the image visually embodies, on the one hand, then psychoanalysis has taught us to stop short of attributing the relation between maker and thought to conscious will (which is a definition of intention), on the other. The *transformation* of subjectivity into thought in fact disassociates the maker's intention from the result, even if the former is somehow still involved in the latter. "How" is precisely the question addressed by psychoanalysis-and-art.

A first consequence of this analysis of "the transformation of the subject into his thought" phrase would be, then, that the maker is "present," involved, in the thought the image has become, yet "absent" as its master. This foreshadowed consequence – of the maker's presence – could be

recognized in Leonardo's enigmatic statement that all painters paint themselves,[9] that all art is to some extent self-representational, just as literature is always somewhat autobiographical. I tend to be willing to accept this view for much of Western post-Renaissance art, even if I am a radical anti-intentionalist, and even if this view begs several questions. It fails, for example, to argue why art-as-self-representation would be relevant given the ubiquitous presence of the "self" in art that the view presumes. It also begs the question raised by Bollas' view of *what* the aesthetic does to transform the subject into thought, that is both hers and not hers to master. A reverse view, therefore, deserves attention. This view would say not that something of the maker resides within the image, but that the maker has only partial mastery over the result. In a discipline where the maker is indicated by the word "master," this is a crucially important revision.[10]

Bollas, who uses theater terminology, articulates the nature of the aesthetic involved, by insisting that the ego, not the subject, "directs" the play. The validity as well as implications of the art work/dream equation depends on this split *within* the individuality of the maker. In other words, it depends on whether we can accept that, on the one hand, the maker's thought is in the image, and on the other, that she does not wholly master it – either the thought itself or the transformation that produced it. Conversely, though, we must also accept that persons are not whole. The ego is defined as somehow "other" to the subject, out of the latter's grasp:

> the unconscious organizing processes determined by a mental structure that evolves from the inherited disposition of the infant and the dialectic between this intrinsic character of the child and the logic of the parental care system.[11]

Attributing part of the ego's organizing processes to "the logic of the parental care system" without dismissing "inherited disposition" is the right way to put, analogously, the artistic ego at the intersection of the inherited disposition that we call talent, and the cultural environment, whose logic, like parental care, may do a good or less good job, but which, in any case, always does a specific and fraught one in nurturing that disposition. In contrast, the subject, the "I" who experiences the dream, is defined as "self-reflective consciousness" and appears long after the ego in the life of the person. But, in this case, it is the subject who "has" the

dream, who undergoes its feeling and mood, and who "sees" the images. It is also the subject who makes the image – dreams it up, so to speak.

Bollas' alternative view further implies that the "mood" of the representation is sketched in by desire and dread. These features perhaps make "desire and dread" quite attractive as an alternative to "beauty." But, "the placing of the self into an allegory of desire and dread that is fashioned by the ego," according to the passage quoted earlier, points to the bond between two aspects that together sever the anthropomorphic psyche from the work of art. The first aspect is the splitting of the subject that the exteriorization of an artist's dearest ambition into an object that is not her necessarily entails. The second aspect is the fictional nature of the resulting image.

Bollas' use of the language of theater makes sense of the theatrical flavor of Viola's video, in which the chest with the monitor on it and the household banalities invoke a setting of private life, whereas the altar-like quality of the same objects intersect that setting, with a generalizing one of prescribed, ritual behavior. The stage set, in its stillness, sets the stage for the entrance of innumerable unknown individuals into the private theater of dreams. In this way, Viola's video helps make the language of theatre more than just metaphorically relevant.

The sequence of the sleeper in a lit room, the interruption by noise, darkness, and violent images and the return to the calm of sleep posits the split subjectivity of the dreamer according to Bollas. The metonymic relationship between sleeper and dream image is obvious, but the disappearance of the light and sleeper during the brief dream sequences severs that tie, as if to emphasize the transformation of subjectivity into thought. Hence, the sleeper is not only the subject of the dreams, metonymically bound to them, and the non-subject of them, with the viewer standing in as an understudy to take over the role assigned to the subject by the dream's director (here, one assumes, not the sleeper's ego but that of the maker of the art work). The sleeper is also shaped, like the dreamer's ego, by individual disposition – this particular art work – as well as by the logic of cultural framing.

The viewer is not the sleeper, but stands on the stage where the dream images make their disturbing appearance. The viewer, of course, does not actually have those dreams, nor do we know if the sleeper does. The brief flickering of the images results in the mood of the images, the visual coloring of the stage, which remains on the viewer's mental retina after

their disappearance. It is as the subject in whom the mood of the dream coheres and sticks that the viewer takes over the role of the disappeared sleeper. It is in the way the setting manages the subject as an object undergoing the violence causing these moods, that the subjectivity of the maker is transformed into dramatized thought – split and wilfully given over – to be shared by the viewers.

After standing there for a while and being imbued by the other's dreams and contaminated by his moods, something changes. After one of the dream flashes, a different sleeper appears on the screen. This time it is a woman. She is as unnoticeable as the man. So, nothing has changed. Or has it? The most disturbing moment in the entire sequence is the reoccurrence of the same dream images that we already saw when the man was the sleeper but this time "emanating from" a different sleeper. What we assumed to be the most private part of a person's inner world is here not only given over to public sharing but also distributed among different "actors." The arbitrariness of this change almost breaks the spell of the fiction.

Until, that is, the idea of arbitrariness colludes with the metonymic process experienced within each viewer because of the lingering effect of the flashes. The irresistible metonymic relation of the sleeper to dream images which the viewer has assumed was already disrupted by the screen black-outs. But "replacing" rather than "disappearing" the sleeper makes it impossible to completely break the metonymic process. Of the residual images that have come to inhabit the viewer, a lingering framing tenaciously remains. As a result of this after-image, a woman dreaming up a gigantic owl fluttering its wings in our face cannot be felt as being quite identical to a man dreaming the same owl. Nor can the piercing bird's eye that threatens and thrills, repulses and allures, be considered stable in those effects or gender-neutral. Cultural history has etched gendered connotations related to desire and fear too strongly in our memory for that to happen.

This lingering shift in framing that makes the association between a bird and a male versus a female sleeper so utterly different – specifically, in terms of desire and fear – strengthens the validity of the heuristic image/dream equation.[12] Retrospectively, the changing of the individual sleeper into one of another gender adds some weight to the relevance of Bollas' "placing of the self into an allegory of desire and dread" specification.

Psychoanalysis, indeed, generalizes the motivation of dreams from desire or dread. Art does not, nor does the Viola video. But what art,

and specifically this video as theoretical object, does do is *use* the psycho-analytic generalization. It appropriates it as a culturally available idea to connect the unconscious images of the dream to images of a work that *posits*, as its own thought, that there is something about the experience of art that links it in important ways to the experience of dreaming – in gendered terms and specificity.

That the terms of desire and dread do, in effect, contribute dynamics, intensity, and gender difference to aesthetics makes them a viable alternative to the notion of beauty, as well as a more concrete version of the sublime – although only paradigmatically since they are too limited to generalize. The gender-boundedness of the shift in framing, however slight, further qualifies the notion – staged by the blackout of the monitor – that the dreamer is the *object of staging*.

This shift, I contend, is of major importance. It demonstrates how attention to gender can change the very foundations of looking. The viewer, already sharing in the images of which the dreamer was not the subject but an object, also gets to share the director's part. The ego, already in place when the subjects come into being and shaped by many factors at once, is the director of the dream, the dramaturge who interprets the script. This agency is now shared by the viewer, whereby the process that puts the most private thoughts on public display is advanced and the viewer becomes more deeply engaged in that process.

What happens at this stage is best described in terms of narrative. The specific slant, the coloring, the perspective a narrator casts on the events recounted, is best articulated through the concept of *focalization*.[13] This concept refers to, and makes analyzable, the relation between the agent of representation and the object represented. At the moment when the viewer of Viola's work senses an uneasiness about the gender-change of the sleeper, it is not just the gender identity of the subject of the dream that changes, but also, and more importantly, the viewer's relation to the *process* of the dream – of being in it and not mastering it, of not being unified.

Focalization, here, is foregrounded in the projection that each viewer in her own gendered body casts onto the sequences of dream images and the sleeper. The viewer actively projects a partial restoration of the metonymic link between the images and the sleeper. The viewer, that is, intervenes in the agency thus far ascribed to the ego. She or he projects focalization, by coloring the relation between the focalizer (the subject who sees) and the focalized (the subject seen), and by determining the intensity of that bond.

When this happens, the viewer becomes a co-agent not only of "acting" but also of staging. The disappearance of the sleeper from the screen now acquires another meaning: the viewer takes his or her place. But, given the changing gender, any viewer is bound to experience a specific relation to sexual difference as the key to this promotion from puppet to director. This sexualization of viewing the video is simultaneously connected to the ego of the "director" – which is older than her subjectivity and shaped by culture.

This meta-discursive change has another consequence. The dream images remain disturbingly overwhelming: they are too short, too big, and too loud not to frighten. Not only are they literally close-ups, overly large, and closing in on the viewer from all sides. They also move violently across the screens before settling down – ever so briefly, as crawling ants, flapping wings, a piercing bird's eye – to torture and tantalize us with the encompassing gaze that frames us, but that, perhaps, we can also master. Most characteristically, as we can now see, these images are out of control. With the sleeper gone and the viewer burdened with a part in directing them, it becomes evident that no one can control these specters.

What changes when the sleeper is a woman? Everything. This allegory of the equation between art and dream is a useful reminder that the decision to consider gender not only changes gender itself. As the history and impact of feminist thought has amply proved, it also changes the structure – the logic – of culture. It is perhaps a testimony to both the success and tragedy of feminism that its ramifications are so decisive that many feel it has outgrown its identity as a recognizable movement. This is true if we consider that the attention to identity and otherness has had such important consequences in recognizing the need for attention to other kinds of identities and othernesses.

The theatricalization of dreams that Bollas proposes points out that the issues that change with feminism have earthquake-like proportions:

> The dream text is a primordial fiction. What Freud discovered and then neglected was the notion of the dream space as a night theatre involving the subject in a vivid re-acquaintance with the Other. He did acknowledge that a person is capable of being profoundly affected by the dream... but he did not fully recognize that the fundamental contribution of the dream to human sensibility was its offering a place for this interplay of self and Other.[14]

The word "interplay" is no longer a case of metaphorical wish-fulfilment. Understood through Viola's visual theorizing, it is a key word that points out why art is important in enabling the experience of something that the ideology separating private from public and personal from collective has made virtually impossible. Without in the least wishing to assign credit, I think it matters that this is a major feminist tenet, although perhaps a barely visible one because it has been recast here within a mainstream idea.

Inside the Other's Pants

Does this help us, specifically, to understand art made by women? Crossing gender lines is one way of acknowledging and "working through" the inhibited interest in the other (gender), which Viola's concretization of this process suggests, and thus of turning into a gender issue what Bollas' theoretical propositions articulated otherwise, without a specific focus on gender. Crossing that line once again, I would now like to argue, through another art work – this time one made by a woman projecting her phantasies onto a man – that psychoanalysis cannot be "applied" to art, but only "brought to bear" on it, and this, only if it too can afford to be put at risk.

The work, *The Musicians, restored*, by Kathleen Gilje (Figure 2.1), comprises three items. One is the painting itself, presented as a "lost original" of Caravaggio's *Musicians*. It is the only item hung in the gallery space, whose walls are painted in a subdued green. It is cordoned off by a metal railing, as valuable works often are in museums. The second item is a simulated "study" installed at the back of the gallery, where visitors are normally not allowed and where normally there would only be office space. The desk in the study is cluttered with the paraphernalia of art-historical research: books, slides, a carousel, a light box, yellow post-its on open books, Xeroxes, announcements and notes, and postcards on a bulletin board. Upon closer examination, the desk is riveting in its detailed account of what any art historian would recognize as her own practice. The object the scholar is studying is Caravaggio's *Musicians*. On the bulletin board is a photograph of an X-ray of the under-painting of *The Musicians, restored* (Figure 2.2).

The third item is a brochure called *Caravaggio's Musicians*, written by Joseph Grigely, DPhil., University of Michigan, Ann Arbor, who also designed the desk.[15] It could be a brochure of the kind that any major

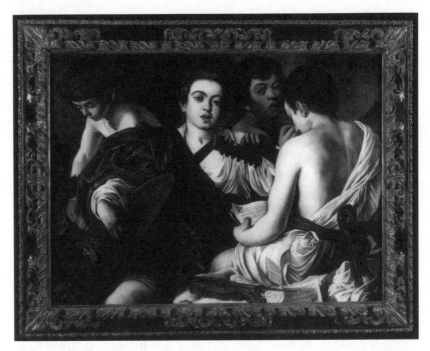

Figure 2.1 Kathleen Gilje, *The Musicians, restored.* 1996, oil on canvas, $34\frac{5}{8} \times 47\frac{1}{16}$ in. Private collection. Reproduced courtesy of Bravin Post Lee Gallery, New York. Photo Theo Coulombe.

museum produces to accompany small exhibitions – for example, when a famous painting has been restored or when two paintings by one artist on the same subject are brought together. It looks like such a publication and also reads like one. It comes as close to the product of art history as the desk does to actual art-historical practice, and the "restored" painting to Caravaggio's famous early work of the same name from 1595–6, in the Metropolitan Museum of Art in New York.

The installation is a collaboration between Gilje, a former restorer who took up painting, and Grigely, a conceptual artist. It is a merciless parody of art-historical, psychoanalytic, and museal conventions, and ridicules any attempt to restore original meaning on the basis of scattered pieces of evidence. It is also an acknowledgment of the powerful, perhaps inevitable, temptation to project fantasies onto works of art, and – in its painstaking detailing of all elements of that process – a homage to the power of art to entice us to do just that.

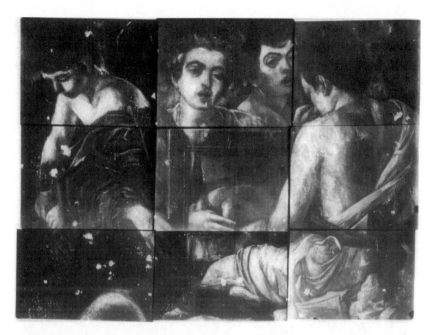

Figure 2.2 Photograph of X-ray of under-painting of *The Musicians, restored*. Detail. Private collection. Courtesy of Bravin Post Lee Gallery, New York. Photo Theo Coulombe.

Gilje's painter's experience as a restorer pays off. In her "restoration" of *The Musicians*, she used the same pigments as Caravaggio, staying as close to his technique as present knowledge allows, painting the work, as she says, almost mathematically.[16] Since Caravaggio, whenever he copied his own work, tended to alternate slightly between cooler and warmer tones, she painted her "restored" version in somewhat cooler tones than the Metropolitan version, thus skilfully disguising the inevitable difference between copy and original through the fictional choice of the artist.

Her active intervention in making the copy involved the production of an under-painting that only X-rays could reveal. Grigely's brochure elaborately explains how the *pentimenti* – or compositional revisions – that led the painter to change the "definitive" version that he allegedly painted over the first draft, provides evidence that the "restored" copy is the original version and the Metropolitan one, the second, autographic copy. The brochure explains the existence of the second copy of *The Musicians*

Figure 2.3 Detail of Figure 2.2.

through a story about the Roman prelate Cardinal Del Monte, who commissioned and later owned it. Under raking light, the under-painting accidentally shows through ever so slightly, because the lead white used for the flesh tones in the under-painting absorbed the fatter lake used as a somewhat transparent pigment in the over-painting. This effect was unintended, but is subsequently brilliantly exploited in the brochure.[17]

The under-painting shows a somewhat different scene of the musicians as they prepare for their concert. Instead of holding a sheet of music, the boy we see from behind, with his typically fleshy, bare shoulder, is holding an erect penis, as the rectangular mirror on his lap reveals (Figure 2.3). This detail is the one that, due to a chemical reaction in the drawing process, happens to show through when the over-painting is seen under raking light (Figure 2.4). The brochure speculates that it was this that impelled Del Monte to commission another copy of the work, because he judged that a public showing of the over-painted version was rather risky.

Figure 2.4 Detail from the Brochure "Caravaggio's *Musicians*," by Joseph Grigely. Published in conjunction with the exhibition "Recovering Lost Fictions: Caravaggio's *Musicians*," a collaboration between Kathleen Gilje and Joseph Grigely, MIT List Visual Arts Center, Oct. 9–Dec. 28, 1997. Reproduced courtesy of Bravin Post Lee Gallery, New York.

This scene in the under-painting is the punchline of Gilje's work. It is its interdiscursive allusion to psychoanalysis with its imagery of layers and depth, hidden, repressed desires and the need to work these through. As such, it is also a critical commentary on the idea of "applying" that theory to art. The X-ray of the under-painting is discretely displayed only in the art historian's office, whereas the "restored" painting is alone in the pristine gallery room. According to the brochure, this scene "explains" a feature of Caravaggio's painting – that "the composition is, as scholars have frequently noted, awkward and forced, as if Caravaggio had used individual models (or even one model) to 'collage' the scene piecemeal." The remark is duly followed by a note with a reference, for the brochure is amply documented with art-historical sources. Hence, we recognize our own colleagues and teachers amongst the characters of this fictional work. The reasoning parodied here is easy enough to recognize: the scholar posits a feature "awkward" because it is not up to standards, yet enigmatic because the work is by a great artist. It is this positing of enigma that informs and propels both art-historical research and psychoanalytical interpretation.

The joke comprises several obvious elements, one of which is the need to acknowledge homosexuality in the canon. In Caravaggio's case, this is hardly a novelty. Many contemporary artists produce the kind of work of which Gilje's piece is an example: critical jokes on old masters. The

remarkable performance of her piece, which makes it stand out as an artwork-equals-dream, is the combination of incredibly detailed attention to both the visual and the material object and the equally perfected parody of scholarship. It is, in fact, much more than just a joke; the discrepancy between effort and result would be pathetic if the only result were a joke, no matter how good its punchline.

Three questions emerge, an investigation of which should help define the exact nature of the performance of this work. What does the joke mean with regard to the "restored" painting, to the work of a woman artist today? What does this elaborate work have to say about psychoanalysis-and-art? And what does it, in that respect specifically, have to say about the original Caravaggio? Let me re-phrase these questions: how does this work enable us – feminist art historians – to read it "with" psychoanalysis; how does it "think" psychoanalysis; and how does it "do" art history?

The installation proposes that we see psychoanalysis through the same model as informs art-historical connoisseurship and the kind of detection fictional accounts which we enjoy reading, a model that typically belongs to the nineteenth century.[18] This model of clues, or, in semiotic terms, indexical abduction, is seductive because it allows for creative interpretation, while at the same time requiring solid, existentially based "evidence."[19] The interest a woman artist shows in male homosexuality can be seen as a strong case for Bollas' conception of the dream. The *interplay* between self and other is given literal embodiment here.

Grigely's brochure exquisitely exploits the painting's joke when it responds to the vast body of current scholarship that sees the composition as a weakness of the painter. In a hilarious, increasing double discourse that stays tongue-in-cheek, Grigely writes that

> ... we may also interpret this as a sign of Caravaggio's initial decision to enhance the tactile effect of the composition. The figures touch each other, and in their awkwardness reflect the social awkwardness of the event itself. The tightness of the figures is thus a prelude to their eventual release from containment ... [20]

The brochure ends by stating that the viewer, in particular the art historian, participates in the creation of the fiction that emerges when one fact overrules and effaces another fact. *The* meticulous scholarly *mise-en-scène* in the "study" does this, and thus contributes to what the brochure's last sentence offers as a definition of art:

For this reason the Caravaggio canon, like that of Rembrandt, can never be complete. Therein lies the mystery, and in the mystery lies the art.[21]

What is most troubling about this concluding sentence is that, in the light of the detailed "analysis" of the case, it cannot be dismissed as merely a metaphysical definition of art. "Mystery" here is loaded with epistemological meaning. Instead of metaphysical flight, the word now indicates limitations.

That epistemological meaning concerns a homosexual encounter seen in a mirror and then made invisible. In terms of Bollas' and Viola's respective theories of dreams, the analysis so far is too thematic. The art work – Gilje and Grigely's – offers thought, presumably extended by the artists but not mastered by their subjectivities. A woman painter, a man conceptual artist, and a theme that rings true, both as "applied" psychoanalysis of the kind art historians such as Howard Hibbard or Herwarth Röttgen might put forward and as a meta-theoretical theme concerning intersubjectivity, as demonstrated by Viola's shift to a woman sleeper.[22] The word "mystery" puts the thought out for the viewer/reader to process further.

The answer to the first of the three questions this work raises – how does it enable us, feminist art historians, to read it "with" psychoanalysis, as a woman's work – is, then, two-fold. On the one hand, it pokes fun at any such attempts by demonstrating that any psychoanalytic interpretation that, on all of its many levels, "sees" metonymic links between maker and image is really a projection: here, the desire to see Caravaggio as gay leads one to project the collective masturbation scene as a "logical" metonym for homosexuality. This projection yields a fiction that erases "facts" – the "awkwardness," whereas the "facts" displaced by that projection are in turn unveiled as fictions resulting from projections – of classical ideals of spatial composition. The somewhat vulgar expression "inside the other's pants" is meant to draw attention to the need to step down from haughty standards to get access to, and bodily engage with, the other, who is insistently present in dreams and images alike.

On the other hand, the complexity of this "argument" is, in and of itself, evidence of what it also argues at a meta-theoretical level. The image-as-dream shifts agency away from the maker, whose "ego" relinquishes her mastery over the image for the pleasure of attracting the viewer to join not only the partying subject in the picture but also the "director" who wills the gay theme into existence-transformed-into-this-thought. The joke works

that way: either we "get it" and merrily participate in the interplay with the other, or we resist it and can only fall back onto the caricature of the art historian who believes in her own fictions. At a deeper level, therefore, the work imposes its own nature of image-as-dream, directed by an "ego" that moves across genders and sexual orientations, thus offering the possibility of doing so as a definition of art. "Mystery" may be exactly the right word for this, provided we take it seriously in its reference to fiction and detection, two ways of managing epistemic limitations. The word thus prepares the ground in this meta-artistic statement, for the second question, for which it already harbors an answer.

Inside the Other's Theory

The second question – "How does the work "think" psychoanalysis?" – can also only be double-edged. At the primary, most obvious, level, it says what many people say: psychoanalysis is like art history, a chain of projections that produces fictions and reduces visual performance to theme-bound words. Although this is the most superficial reply, it remains important that the work *also* says this, so that the two disciplines, recognizing their similarity, can collaborate to remedy the shortcomings of this view.

But, in accordance with Bollas' revision of Freud's theory of dreams, the "thought" of this work is the esthetically transformed subjectivity of the dreamer, who, as we have already seen, is not the maker but only her "ego," that part of her that is a composite of herself and her environment. The dramatization of this subjectivity, which turns it into the object of dramaturgical revision and staging, is specifically visible in two "details" of the X-ray photograph. The hand-held penis is not "really" held, for the thumb is placed so that it falls just short of holding it and the other fingers don't show any "grip." Second, the whole masturbation scene is only revealed through a mirror. The split between directing ego and directed subject is given further dramatic expression through the fragmentation of the image that this mirror brings about and that is cleverly repeated by the fragmentation of the X-ray photograph itself into panels. And, as if this isn't enough to drive the point home, the division of the X-ray cuts through the face of the boy in the background, commonly taken to be a self-portrait, once more splitting the directing from the directed part of "Caravaggio."

For the viewer, this double splitting recasts not only her own gender identity but also the whole structure of gender. On stage, there is no fixed place, no culturally carved, comfortable, niche to identify with, lay down in. For women, straight or gay, any identification with the subject has to be indirect. For straight men, the image offers the unsettling suggestion that even this most standard of positions is not stable. For gay men, the image is tantalizing but also troubling since it is doubly fragmented – nothing but a near-erased trace, hidden. Hence, the only place left is to side with the "ego" who staged the scene. Whatever comfort that position offers, it is predicated upon the split of ego and subject that can only be pleasurable if one accepts to participate in the "interplay of self and Other."

This is, perhaps, the place where feminism has led us to most fruitfully today: the opening up not just of gender identity and sexuality but of the very notion of subjectivity itself. Getting inside the other's pants is the interactive variant of getting inside the other's dream. As such, it can be seen as an even more radical step than the one Viola allowed. Except, of course, that painting and pants are not quite the same thing, so that the X-rayed under-painting not so much "enhances the tactile effect of the composition" as qualifies this effect as a fiction, a fiction that is helpful, pleasurable, and comprehensive as long as it is endorsed as fiction.

Feminism has fed off psychoanalysis (and vice versa) to accomplish this insight, but it could not endorse the theory wholesale. Before answering the third question this work raises – "How does it 'do' art history?" – I wish to recall some of the reasons why psychoanalysis-and-art is so problematic. This work also demonstrates an aspect of psychoanalysis-and-art that has far-reaching methodological consequences: it demonstrates that for a productive encounter between the discourses of art history and psychoanalysis, it is crucial we give up any subordination of the one to the other as "theory" to "practice." It is for this reason that I have alleged the works of Bollas, Viola, and Gilje/Grigely as three instances of thought interrelated in their theoretical positions, even if no contact has been made between them by their authors. Instead, the contact among the thoughts can be accounted for in terms of the "logic of parental care" that the common culture provides. The distinction between theory and practice is as tenacious and damaging in its tendency to become oppositional and hierarchical as the one between private and public, upon which psychoanalysis-and-art is contingent, or between male and female, so intimately linked to both parties of our combination.

The only way the combination can be productively mobilized, then, is through a form of integration that respects difference without opposition and hierarchy. In fact, as these three works suggest, getting into the other's dream in the sense that "getting into the other's pants" becomes an open, if fictional, possibility, is only possible if we are willing, according to the same complex model of subject-splitting and shifting identification, to get into the other's theory – with the same bravura and the same benefits.

This is not as obvious as it seems. In art history, psychoanalysis is itself an "other," a different discourse, with different assumptions, goals, and methods (although these are not so different after all), and a different status. Since Karl Popper denounced the circularity of the argument, resistance to the use of psychoanalysis can no longer simply be explained away as evidence of its relevance.[23] Nor can feminist arguments against the white-male-straight bias that has characterized the theory from its inception be dismissed, although much work has been done since that beginning that makes the argument in its generality increasingly difficult to sustain as a dismissal.[24]

Numerous problems continue to hamper the productive integration of the two fields. First, it is not so obvious what the object of analysis is when we bring this theory to bear on images or other cultural objects: is it the artist? the theme represented? the figures? the facture of the image? the audience perhaps? the family history of these subjects? their fantasies? Psychoanalysis theorizes a process and functions through dialog, while an image is an inert object that cannot speak back. My argument has thus far largely been an attempt to prepare the ground for answering this fundamental question. But for that answer to become possible, psychoanalysis needs revision precisely where art history also needs it: in the practice of doubly reductive iconographic reading, in the assumption that the individual subject stands at the origin (art history) and center (psychoanalysis) of the interpretation, and in the assumptions of fixity (art history) and normativity (psychoanalysis) of gender positions.

A second problem is the unsatisfactory state of the surplus meaning one expects any theory to help articulate. This problem is related to the tendency – again, widespread in both disciplines – of confusing origin with articulation. What is the point, one might ask, with respect to a more complex understanding of its meaning for the viewer, its effect, of saying that an image reflects an Oedipus complex, uterus envy; or, in a more women-oriented view, an imaginary, maternal rage; or, in a less gender-specific orientation, the mirror stage, fetishism, or a death wish? In other

words, what is the benefit of applying to an image a thematic label that fails to fully articulate, that refers to an origin not at all bound up with the theme, and that does not necessarily help us to understand its dynamic any better?

An answer to this problem has been suggested by the multiplicity of the Caravaggio fiction. Although I have tossed in one or two concepts – image-equals-dream, focalization – I have avoided summarizing the analysis thematically. Any attempt to do so would irredeemably reduce the visual works to something they are not. In contrast, suspending labels has helped me account for at least a portion of their visual import. Articulating their *thought* in its metonymic relationship to the maker, as well as the fragility of that relationship, was possible without recourse to the notion of intention.

There is the third, historical, problem that operates in two directions. When history is taken into account, it becomes practically impossible – in an age where everyone knows about the theory – to assume the unconscious status of psychoanalytic thematic presences. This is one reason why labeling is a futile endeavor. The Gilje/Grigely installation is just one of many art works that poke fun at psychoanalysis and its favourite themes. Many other contemporary art works also do this. Surrealist art was already too aware of psychoanalysis to allow that theory's "application" in its interpretation. In such cases, we need to know the theory to get the point of the work. But any interpretation of the point articulates only the overt meanings, none of which is unconscious. Hence, the domain of interpretation is semantics or thematics, not psychoanalysis. I hope to have shown that this is only half the truth, because the development of any new insights is possible provided this problem is taken into account. Moreover, Viola's video suggests a theoretical possibility that the Gilje/Grigely work successfully exploits. The historical position of works in a post-Freudian era makes it impossible to claim unconscious status for any psychoanalytic thematics. But I have argued that this is just as well, for thematic interpretation has always been unsatisfactory and reductive. Instead, post-Freudian art can be brought to bear on an open-ended psychoanalytic theory whenever this theory is brought to bear on art.

The other direction in which the historical problem works is the alleged anachronism of psychoanalytically informed interpretations of older art. It is easy to dismiss these two sides of the same coin by plotting one against the other. For, if both objections are valid, there are few areas where the theory can plausibly be used. I believe the anachronism argument is

untenable precisely because the post-Freudian argument is, in principle, valid. But, as we have seen, the latter can be made productive by complicating the relationship between the two fields, and this complication retrospectively complicates the notion of history itself.

Years ago, I was led to reply to this charge of anachronism. I came up with eight answers, which I will refrain from repeating here.[25] But the one I consider most important concerns the consequences of not allowing psychoanalysis to bear on art. One consequence is that this would deprive art of the one theory that, for better or worse, has gender at its core. Even if we do not like the way psychoanalysis has theorized femininity, masculinity, homosexuality, and – not to be forgotten – race and cultural difference,[26] these things were brought onto the agenda of cultural thought long before feminism made the dent it has. Who do we think we are, today, to assume that none of these issues were culturally active at other times, even if the discourse in which they were played out was not Freudian and the cultural habits that shaped the egos of the agents of those times were different from ours? To deny historical or cultural others the possession of an unconscious, a subjectivity not entirely overlapping with an ego, and a complex agency to make works in which those aspects of their person play themselves out, is to deny those things that define the human being as cultural agent. The burden of articulating the historically specific ways once culturally available for this "interplay between self and other" weighs on us, not on the past. But the difficulty of doing so is surely not a reason to deny *de facto* the complexities of subjectivity in texts that are temporally "other."

The latter argument is also valid for combating the objection which maintains that psychoanalysis is totally irrelevant for communities with more urgent social issues to contend with. In a sense, this argument is one and the same, for time is not simply the linear development on which we project the superiority of the present. It can also be a distancing device.[27] Keeping what seems different at arm's-length is one way of denying the coevalness between the products of art that exist today, whether they were made now or then, here or there.

I was happy to encounter an argument along the same lines brought forward by Claudia Tate in *Psychoanalysis and Black Novels: Desire and the Protocols of Race.*[28] Against the argument that a materialist analysis is much more urgent than a psychoanalytic one, Tate points out that this demand reduces black agency to a political activist one, thus denying the artistic products of black subjects their full richness, in an unwittingly

condescending or conceding limitation that is not imposed on white artistic production. Enriching the potential of stepping inside the other's theory, she also works simultaneously on the two levels of furthering literary insights through psychoanalytic ones and *vice versa:* "Psychoanalysis, I believe, can help us to not only analyze black textuality but also effectively explain important aspects of the deep psychological foundations of the destructive attitudes and behaviours of racism."[29]

The important surplus here is – hopefully – obvious. Tate goes two steps further. Not content with the mutually illuminating effect of the one discourse on the other, she also claims a meta-theoretical gain congenial with the one I have outlined above, when she writes:

> Ascertaining how this process [of analyzing the traces of emotional meaning] works in black textuality can, I believe, provide a model for understanding how individuals transform the material circumstances of cultural experience into personal emotional and cognitive meaning.[30]

This program seems to me to be a good companion to Bollas' psychoanalytic project of articulating the "night theater" staged by the ego.

Tate's second step beyond the integration of the two discourses concerns another frequently alleged problem of psychoanalysis, namely its roots. Do we really want to squeeze out what we can from a theory made by, and through, and largely for white middle-class men in Western Europe? Who needs a theory that revels in the hostile and fearful projections of such men, that sketches women as phallic, bossy mothers or shadow figures, whose sole *raison d'être* is to love and thereby support the personal growth of their beloved sons into just such hostile, projecting men?

Tate answers this objection head-on but makes it more specific, so that she is able to connect sympathetically to the cause whose consequences she rejects:

> Rather than simply denounce psychoanalysis [. . .], I try to understand its own compensatory defences by questioning the cultural effects of its Jewish origins in anti-Semitic Austria at the turn of the twentieth century. Such origins have produced a psychoanalytic practice that silences its own ideological history by presuming the culturally neutral family as its object of investigation. This displacement is important because it designates the family as primarily responsible for the tragic fates of real individuals who, for example are like Bigger Thomas of Richard Wright's *Native Son* (1940) or Pecola Breedlove of Toni Morrison's *Bluest Eye* (1970).[31]

I quote this passage at length because it seems extraordinarily important to realize that the centrality of the family in psychoanalytic theory can be more adequately undermined if it is first adequately understood, not as the opposite of culture, as in the private/public opposition, but as a cultural peculiarity. It seems fitting that the contextualization of psychoanalysis in its own time and place and the context of racist hostility within which it was developed should both be understood through a defensive reaction to that centrality within another context specified by race and the need to fight racism.

Tate's triple endeavor is: to endow black textuality with its full complexity, including both the representation of social protest and "the rhetorical performance of unconscious desire";[32] to understand racism better through psychoanalysis; and, to understand psychoanalysis better through an understanding of racism. Her endeavor demonstrates that if feminist cultural analysis is to benefit from the conjunction of the two discourses, the bothersome objections to psychoanalysis should be neither accepted nor ignored, but rather addressed and worked through.

Inside the Other's Thought

Gilje's painstaking effort to *copy* Caravaggio's painting, which she qualified as "almost mathematical," can serve here as an emblem of the detailed, sympathizing, *heteropathic* attention to the other: a scene that the intentional, (self-)conscious subject Kathleen Gilje would be unlikely to identify with but whose presence in *her* dream she wishes to emphasize. She endorses the subservient role of the mechanical copyist but creates that role herself. The goal is to produce a work of art that, emphatically, does *not* "demonstrate" psychoanalysis as an "application" of that theory, as a site for its labels, an articulation of its stories of origin, and a collage of its iconographic signs-equals-words – although, equally, these three impossible "applications" would be signified in the work, just enough so that the academic debate could be represented in its entirety.

For Gilje is not the master of the dream. As a subject she acts in it, together with the viewers, but she also participates in its staging. The act of copying, instead of creating, an "original" art work whose unconscious Oedipal "influences" are there for the art historian to trace, is simultaneously a disenchanted and honoring act of heteropathic identification. In

other words, it is an active gift of love. A gift to Caravaggio, a historical, sexual, gender-wise other; and a gift to the history of art. For, as I will argue below, the manner in which Gilje's split-off thought espouses a Caravaggio that is split off in *his* work, is, for all the disavowing irony and outrageous parody, a psychoanalytically informed art-historical performance.

What does it mean to give an active gift of love to art history from the side of psychoanalysis and vice versa? In other words, what kind of *attention* does psychoanalysis have to offer a field so deeply entrenched in close scrutiny of overly-venerated works of art? Impossible as it is to do justice to the irreducible riches of psychoanalytic attention, let me briefly evoke three of its tenets as they bleed into art-historical attention. These aspects of the kind of attention psychoanalysis has promoted have serious consequences for the study of works of art made by women artists, especially those who remain – not because of gender alone – a bit aloof in mainstream culture.

Gaps R Us. In the wake of phenomenological philosophy, theories of reception have, for a long time, proposed the fundamental incompleteness of any representation. No text can ever give their readers all the information they expect, hope for, or require. Texts are full of holes, gaps, *Leerstellen.*[33] In spite of the differences between texts and visual art, basically the same can be claimed for images.[34] But such gaps, although often concretely pointed out by critics as if they had textual existence, are generated by the reader's own presuppositions. It is only from the vantage point of one's own preoccupations that the anxiety informing such questions – like those that lead to the hypothesis of gaps – comes about.[35]

Reception aesthetics posed the principle of the incompleteness of texts, a thesis also inherent in semiotic theory.[36] But psychoanalysis urged theorists to *place* the gaps more specifically. This question resonates with the problem I raised earlier, of the *object* to be analyzed in psychoanalytic criticism. What psychoanalysis contributes to the notion of gaps is not only the acceptance of the limits of what we can posit to be "there" in the image, but also the accountability of the one pointing out such gaps. In the mock brochure, Grigely offers a nice example of the positing of a gap – routinely called "awkwardness" in art history – as a site of projection. It is emphatically the twentieth-century art historian who is hooked on something that is, in itself, iconographically, "there" but also only noticeable, peculiar, if one holds certain standards to it.

This attention to gaps, including their location, opens up the interpretation of artworks to a dynamic vision of art as process in which the viewer who "sees" the gap is part of what is being analyzed. The situation Gilje's under-painting places the viewer in, then, is one in which the gap disappears as soon as the viewer accepts the under-painted scene as "normal," whereas resistance to this solution – refusal to play one's part in the other's dream – throws the viewer back into a gap which, now that an "explanation" for it has been offered, is no longer "there" but only in oneself. This confronts viewers and critics with their defensive distantiation from anything that seems strange to them, from anything belonging to the other.

Fitting In Misfits. Related to this attention to gaps and their subjective origin is the acceptance of whatever does not seem to fit an image's coherence. Trained in the post-romantic classical tradition, most art historians – and most artists for that matter – remain confined to a mode of looking that makes sense of the image as a whole. Thus, they have unlearned looking at images, and instead escape into the world of iconographic detection. If some detail eludes the whole as assumed by the viewer, then it will be either an iconographic allusion, in the best of cases, or an awkwardness, a mistake, a left-over from a previous draft, or a later addition.

The under-painting of Gilje's *Musicians* is more than a joke because it eludes even the parody written to match its punchline. While filling in the gap of the art historian's judgment of "awkwardness," the comment quoted earlier – "the figures touch each other" – emphatically fails to match the X-ray. I mentioned earlier the uncertainty of the relation between the hand and the penis, but the question – to touch or not to touch – that is supposed to solve the gap's enigma remains emphatically, forcefully open, through the interposition of the mirror. The only thing the most prominent boy is touching is the frame of the mirror, with his half-invisible hand that bears no relation to any of the bodies present. The hand, which presumably touches the penis but fails to do so convincingly, belongs to the owner of that member so that the facial expression on which the commentator projected "eventual release from containment" bears no relation to the hand that seems to float between one fiction and the other. Whereas there is nothing psychoanalytic about this particular misfit, the picture draws attention, through its deceptively simplistic thematics, to the provenance of what could be called a "theory of misfits."

Slow-down. Perhaps the most precious aspect of psychoanalytic attention is its indifference to objective time. Whereas psychoanalysis as a

therapeutic practice is almost obsessively preoccupied with the analysand's past, looking to work through irretrievably lost memories to come to terms with present dis-ease by reconnecting past and present, the analytic process itself suspends and then thickens worldly time. Silences – the analysand's gaps – are left to linger; meticulous attention to one dream fragment or parapraxis can take weeks of sessions. The time of analysis can feel fast or exasperatingly slow, but it is always palpable. In a world so riddled with speed and visual overload, the slow-down inherent in psychoanalysis is especially important for the study of visual culture.

The suspension of calculable time in order to bring time itself to consciousness holds an invaluable lesson for art history. I would like to conclude by looking at one way of dealing with this slow-down, as a way of bringing this patient omnivorous attention that knows no limits in what it deems worth stopping for, to bear on the question of feminism and art history. I mean to stop the hasty escape to a fictional past and endorse the historical positioning of the art-historical gaze in the present that creates that past. Gilje and Grigely have demonstrated the productivity of such a reversal, which I have elsewhere called *preposterous history*.[37]

Beyond the thematics of homosexuality and their undeniable importance ("inside the other's pants"), beyond the theoretical contribution to the theory of the subject and the consequences of looking through gender at what splitting the sleeper from the dream's director can mean ("inside the other's dream"), Gilje and Grigely's work recasts Caravaggio's *Musicians* from a dead historical object qualified as "awkward," to a live presence that reframes that judgment as the contemporary historian's gap. Looking from the X-ray to the art work in the Met and back again, we get a sense of what art as process can do.[38]

There are four boys in the "restored" *Musicians,* one – the figure of Amor – who does not participate in the interplay. But if, as Gilje suggests, the boy who most directly confronts us is "really" busy with the (penis of) the boy whose back is turned to us, one might wonder whether he is "touching" him, as the brochure suggests, or whether he is looking at the mirror image of the penis. Subsequently, one might wonder whether asking these questions is already the same as participating in what the painting is doing. The art-historical act Gilje has performed has a self-critical component that is driven home when we realize neither act is possible. The boy seen frontally can neither touch nor see the penis. The mirror becomes an important screen that stands between the viewer and the "truth" of the painting. But the same boy also mirrors – looks

like – the one behind him, who mirrors the "masturbating" one through the pose of his body but rhymes with the one seen frontally through his gaze and open mouth. Whatever the boy represented frontally is doing with the boy whose back is turned to us, the artist's self-representation is also doing with the viewer.

The mirror stands between the two boys. As the screen in which identity is shaped in mis-representation, as Lacan has it, the mirror provides a visual sense of self. Given the homosexual scene, in one sense it does not matter whether the boy seen frontally participates in the jubilatory moment. But, in the context of the tight group depicted in this image, the mirror also evokes the self-relation, a relationship not with another as same but with the self-same as other, as in narcissism.[39] What makes the tightness of the group troubling and uncomfortable, then, is not the painting's awkwardness, but the imposition of its mirroring effect and the need to choose one of these possibilities, a possibility based on sameness shared with the other. For, if the mirror stands between the two boys and the Caravaggio figure looks so much like the boy seen from the front, then his partner in the interplay can only be the viewer.

The gap now, as brought in by Gilje, is the need of the painter's represented self – the subject as directed there, as object, in the dream – to get a partner for his interplay. Not only is he, as is generally acknowledged, an alluring figure, seducing the viewer to join the party. He is specifically seducing the viewer into an interplay of sameness that is other than the official gaze of art history.

What the boys are "really" doing there – partying, making music, or having sex, together or alone – is, of course, totally irrelevant, as long as we don't whisk away the open invitation extended by what was, before Gilje, an "awkwardness." What Gilje has done by expanding and tightening the importance of gender for the split subjectivity of the dream/image-equals-image-equals-dream, is to change this painting forever. This is how she performs art history "with" psychoanalysis. It is fitting, then, that Amor, the traditional "clue" for a thematic psychoanalytically inclined reading, is not really involved in this interplay.

Notes

1 Christopher Bollas, *The Shadow of the Object: Psychoanalysis of the Unthought Known* (New York: Columbia University Press, 1987), p. 10.

2 The problematic conjunction "and" must be maintained to avoid a subordination of one discourse to the other. See Shoshana Felman, "To Open the Question," *Yale French Studies: Literature and Psychoanalysis. The Question of Reading: Otherwise* (special issue), vol. 55/56 (1977), 5–10.

3 Bollas, *The Shadow of the Object*, p. 64.

4 Most commonly known through the introduction to Erwin Panofsky *Meaning in the Visual Arts* (Harmondsworth: Penguin, 1955). For a critical and historical study that offers a much more complex image than the practice of iconography suggests, see Michael Ann Holly, *Panofsky and the Foundations of Art History* (Ithaca and London: Cornell University Press, 1984).

5 For the distinction "discreet" versus "dense" as a rendering of the ontological difference between word and image, see Nelson Goodman, *Languages of Art: An Approach to a Theory of Symbols* (Indianapolis: Hackett, 1976). For a critique, see W.J.T. Mitchell, *Iconology: Image, Text, Ideology* (Chicago: University of Chicago Press, 1986).

6 Bollas, *The Shadow of the Object*, p. 64.

7 See my *Reading "Rembrandt": Beyond the Word-Image Opposition* (New York: Cambridge University Press, 1991), and my *Quoting Caravaggio: Contemporary Art, Preposterous History* (Chicago: University of Chicago Press, 1999).

8 On this topic, see my article "Abandoning Authority: Svetlana Alpers and Pictorial Subjectivity," in Celeste Brusati, Mark Meadow and Walter Melion (eds), *Taking Pictures Seriously* (in press).

9 See Robert Zwijnenberg *The Writings and Drawings of Leonardo da Vinci: Order and Chaos in Modern Thought* (Cambridge: Cambridge University Press, 1998).

10 The oddity of that word has been famously undercut by Rozsika Parker and Griselda Pollock, *Old Mistresses:Women, Art and Ideology* (London: Pandora Press, 1981; revised edition, 1995).

11 Bollas, *The Shadow of the Object*, p. 285.

12 In both psychoanalysis and iconography, birds are often assumed to "stand for" male desire, or for male desire projected onto women by male critics. They are also assumed to represent fear, and they often occur in nightmares. These two assumptions combined would make male desire the object of female dread. Sigmund Freud, *The Interpretation of Dreams*, vol. V, pp. 533–621, in *Standard Edition of the Complete Works of Sigmund Freud*, ed. James Strachey (London: Hogarth Press, 1900); Eddy de Jong and Ger Luijten, *Mirror of Everyday Life: Genre Prints in the Netherlands 1550–1700*, trans. Michael Hoyle (Amsterdam: Rijksmuseum, 1997).

13 See my *Narratology: Introduction to the Theory of Narrative*, fully revised and expanded edition (Toronto: University of Toronto Press, 1997), pp. 142–60.

14 Bollas, *The Shadow of the Object*, p. 68.

15 Joseph Grigely, "Caravaggio's Musicians," published in conjunction with the exhibition *Recovering Lost Fictions: Caravaggio's Musicians*, a collaboration between Kathleen Gilje and Joseph Grigely (Cambridge: MIT List Visual Arts Center, 1997).

16 Kathleen Gilje, personal communication, April 1, 1998.

17 Grigely, "Caravaggio's Musicians," p. 8.

18 Carlo Ginzburg, "Morelli, Freud, and Sherlock Holmes: Clues and Scientific Method," *History Workshop*, no. 9 (1980), 5–36.

19 On abduction, see Jan C.A. van der Lubbe and Aart J.A. van Zoest, "Subtypes of Inference and their Relevance for Artificial Intelligence," in *Semiotics Around the World: Synthesis in Diversity*, Proceedings of the Fifth Congress of the International Association for Semiotic Studies, eds Irmengard Rauch and Gerald F. Carr (Berlin/New York: Mouton de Gruyter, 1997), pp. 805–08.

20 Grigely, "Caravaggio's Musicians," p. 3.

21 Ibid., p. 11.

22 Howard Hibbard, *Caravaggio* (New York: Harper & Row, 1974 and 1983); "Riflessioni sul rapporto tra la personalità del Caravaggio e la sua opera," in Herwarth Röttgen, *Il Caravaggio. Ricerche e interpretazioni* (Rome: Bulzoni edizione), pp. 145–240.

23 Karl Popper, *The Logic of Scientific Discovery* (New York: Harper and Row, 1968).

24 See, among many others, a book particularly relevant for a psychoanalytic theory of vision and firmly anchored in feminist thought, Kaja Silverman, *The Threshold of the Visible World* (New York: Routledge, 1996).

25 Mieke Bal *On Story-Telling: Essays in Narratology* (Sonoma, CA: Polebridge Press, 1991), pp. 240–1.

26 See, among others, Marianna Torgovnick, *Gone Primitive: Savage Intellectuals, Modern Lives* (Chicago: University of Chicago Press, 1990).

27 See Johannes Fabian, *Time and the Other: How Anthropology Makes Its Object* (New York: Columbia University Press, 1983).

28 Claudia Tate, *Psychoanalysis and Black Novels: Desire and the Protocols of Race* (New York and Oxford: Oxford University Press, 1998).

29 Ibid., p. 16.

30 Ibid., p. 17.

31 Ibid., p. 16.

32 Ibid., p. 20.

33 Most famously, Wolfgang Iser, *The Act of Reading: A Theory of Aesthetic Response* (Baltimore: Johns Hopkins University Press, 1978).

34 See Wolfgang Kemp (ed.), *Der Betrachter ist im bild: Kunstwissenschaft und Rezeptionsasthetik* (Köln: Dumont Buch Verlag, 1985).

35 I have argued on this basis with Menakhem Perry and Meir Sternberg in "The King Through Ironic Eyes: the Narrator's Devices in the Biblical Story of

David and Bathsheba and Two Excursuses on the Theory of the Narrative Text," *Ha-Sifrut*, 1968, pp. 263–92 (in Hebrew; also in Sternberg, *The Poetics of Biblical Narrative: Ideological Literature and the Drama of Reading* [Bloomington: Indiana University Press, 1985]). See my *Lethal Love: Literary Feminist Readings of Biblical Love Stories* (Bloomington: Indiana University Press, 1987), chapter 1.

36 Most famously, Umberto Eco, *The Open Work* (Cambridge, MA: Harvard University Press, 1989, orig. 1962).

37 See Mieke Bal, *Quoting Caravaggio.*

38 For a recent and thorough historical study of the painting in its relation to its patron Cardinal Del Monte, see Creighton E. Gilbert, *Caravaggio and His Two Cardinals* (University Park, PA: Pennsylvania State University Press, 1995), especially chapter 9.

39 See chapter 8 of my *Quoting Caravaggio* for an analysis of narcissism in Caravaggio's *Narcissus.*

3

Fascinance and the Girl-to-m/Other Matrixial Feminine Difference

Bracha L. Ettinger

I

Remember Freud's Dora? Dora went alone through Dresden's galleries, and "stopped in front of the pictures that appealed to her. She remained two hours in front of the Sistine Madonna, rapt in silent admiration. When I [Freud] asked her what had pleased her so much about the picture she could find no clear answer to make. At last she said: 'The Madonna'."[1] Dora didn't know what she wanted from the Madonna, but Freud wove for her from interpretation to interpretation the knowledge of what she as a woman-girl wanted: she wanted the man, according to him, she wanted Mr K., and under him veiled by repression she wanted her father, and beyond him hidden in suppressed transference she wanted another father-figure, Freud himself. But Dora, precisely around this Madonna's case, stopped the analytical process. Apparently, she did not know what she wanted, but she did know what she did not want.

In "What is a picture?"[2] Jacques Lacan presents the gaze as *fascinum*. *Fascinum* is the unconscious element in the image that stops and freezes life. The gaze inside an image has such an arresting power because, as an unconscious *objet a*, it is a product of castration:

> What is that thrust, that time of arrest of the movement? It is simply the fascinatory effect, in that it is a question of dispossessing the evil eye of the gaze, in order to ward it off. The evil eye is the *fascinum*, it is that which has the effect of arresting movement and, literally, of killing life. At the moment

the subject stops, suspending his gesture, he is mortified. The anti-life, anti-movement function of this terminal point is the *fascinum*, and it is precisely one of the dimensions in which the power of the gaze is exercised directly. The moment of seeing can intervene here only as a suture, a conjunction of the imaginary and the symbolic, and it is taken up again in a dialectic ... which is concluded in the *fascinum* ... In the scopic field ... The subject is strictly speaking determined by the very separation that determines the break of the *a*, that is to say, the fascinatory element introduced by the gaze.[3]

The matrixial sphere offers other possibilities for the gaze.[4] A matrixial borderlinking is transformational. I call the transformational subjectivizing potentiality of a matrixial link (gaze or voice): *fascinance. Fascinance* is an aesthetic affect that operates in the prolongation and delaying of the time of encounter-event and allows a working-through of matrixial differentiating-in-jointness and copoiesis. *Fascinance* can take place only if borderlinking within a real, traumatic or phantasmatic encounter-event meets compassionate hospitality. *Fascinance* might turn into *fascinum* when castration, separation, weaning, or split abruptly intervenes.

Dora constituted contemplative relations of fascination with the Madonna since this image served for her the function of *fascinance*. Dora created the moment of looking at the Madonna's painting as a matrixial encounter-event by her unconscious urge to produce transformation in the traces of imprints of earlier moments of encounter that had failed. The daughter solicits *fascinance* within the girl-mother relations. We have in psychoanalysis a long tradition of ignorance concerning the woman-to-woman, non-Oedipal relations. Even in Ogden's description of a feminine transitional relation,[5] the woman-mother contains the father within her in relating to the girl: the transitional femininity is Oedipal. Kristeva too reads the girl-mother relations through the prism of the Phallus and the Oedipus complex.[6]

If Oedipal sexual difference is the key to feminine sexual difference, the question *what does a woman want?* is quickly turned into the question *what does a woman want from a man?* It is not sustained long enough at the level of *what does a woman want from a woman?* Dora's case is one of Freud's most glorious failures. Freud corrected himself *a posteriori*, claiming that Dora was not in love with a man but with a woman – with Frau. K. After such a courageous correction, it is not easy to proclaim that, again, Freud did not grasp what Dora wanted. Yet such is the case. Dora's fascination with Frau K., like Dora's admiration of the Madonna,

were not expressions of homosexual desire. Dora did not desire Frau K. sexually. She desired to be caught in a move of fascination that belongs to femininity, a move composed of a fascination of a girl toward a woman-mother figure, who is fascinated too by the daughter-girl and who allows her sufficient proximity to sustain the illusion of inclusion in her mature elusive femininity – a femininity which is not directed at the girl but outside and away from her. Yet the girl desires to be included inside it for instants of eternity whereby she participates in advance, and by proxy, in a world not yet fit for her own immature sexuality.

Dora could not experience this move with her own mother; her mother was a rejected figure. She could not complete such a move with her aunt or with Frau K. Her aunt had died and Frau K. had betrayed her. So, she leaned on what cannot betray or die: an object of art that corresponds to the internal subjective-object of her phantasm. More than *looking at* the Madonna, Dora was caught in the illusion that art images "know" how to create, namely, that the gaze is reciprocal. Therefore, it was the Madonna who was looking at Dora and was fascinated by her. Such was this moment of matrixial *fascinance* where a few feminine figures met: a mother and a virgin, a woman and a girl.

In a matrixial encounter, the private subjectivity of the individual is momentarily unbounded. The psyche momentarily melts, and its psychic threads are interwoven with threads emanating from objects, images, and other subjects. In a matrixial encounter with an image, a transformation occurs. To get a feeling of the arresting (*fascinum*) and transformational (*fascinance*) potentiality of an image I will offer, as an addition to the Dora case, a reading of the novel, *The Ravishing of Lol V. Stein* by Marguerite Duras.[7] In that novel, an extraordinarily potent *fascinance* is staged but is arrested in midstream. Lol's own mother knocked it out when she bursts in upon the scene. Lol looked and looked, but she was torn away from the image too soon. An instance of differentiation on the long path of transformation from girlhood to womanhood was arrested. Lol's passion was fixated into a permanent desire to turn the catastrophic resulting *fascinum* into *fascinance* again and to release its transforming potentiality to complete the subjectivizing move. From then on, she repeatedly seeks a similar image/scene that holds a similar fascinating-fascinated gaze. The image of the couple for Lol (and in the couple, primarily the image of the woman), and the image of the Madonna for Dora are crossed by the same form of unconscious longing.

An encounter between the different m/Other figures and Dora who, fascinated by them, wished for them to be fascinated by her, had been taking

place at this level of dispersed, partial, and interwoven subjectivity where psychic elements diffused from one unconscious to the other create a shareable unconscious field. Gazing at the Madonna completed a mental move that the earlier, missed encounters had not accomplished. In a similar way, Lol was bathing in *fascinance*, sharing the offering of a transforming fascinating-fascinated gaze, before it prematurely turned into *fascinum*. In order to become a woman, she had to somehow complete the move that left her eternally in a position of a girl along the woman-to-woman differential string. Even when she became a woman, a wife, and a mother, she remained a girl along the feminine-matrixial differential axis, unable to close the gap between these two poles: the girl's and the woman's. A matrixial encounter whose transformational potentiality had failed, captured in an image of a scene, and the endless attempts to reconstruct a similar scene-image in order to break the *fascinum* – such is the "case" of Lol Stein, this enigmatic figure of Marguerite Duras's novel.

II

In the case of Dora, at first Freud thought that Dora sexually desired a man. He set off in the wrong direction. Later, he thought that Dora sexually desired a woman. Already this shift gives Freud's other interpretations a very different weight. Although it is more difficult to demonstrate, he was also mistaken in this second conclusion. His argument was based on the Oedipal triangle, whereas the kind of love that Dora carried towards Frau K., and indeed a kind of love it is, cannot qualify as sexual desire. It is a replication of the cry of the baby for the fascinating-fascinated gaze of the m/Other found and lost in the archaic relationships.[8] In my view, Dora does not identify with the Other-man, with the man's desire for a woman (which for her would be a homosexual desire), nor with the Other-woman's desire for a man (a heterosexual desire toward Herr K. or toward her father). Not yet. Nor is she even exploring the enigma of the woman as a desired *object* for the man, neither as a lost or missing nor as a present object – the cause of the man's (or the father's) desire. For Dora, there is something that is even more urgent, something that comes before Oedipus (from a developmental viewpoint) and that remains beside Oedipus (from a structural viewpoint).

This is the riddle of the desirability-in-itself that emanates from the Other-woman, whether woman-mother figure (her aunt, Frau K.) or a

mixture of girl-mother figure (the Madonna), desirability that joins mental traces of the desirability of the archaic m/Other with whom the girl once dwelled in an ancient *time-space of encounter*. This is the enigma of the closeness and distance, resemblance in difference of the girl from the blinding and stupefying ravishing *Woman-m/Other-in-encounter*, considered archaic in that both herself and the encounter belong to the remarkable matrixial time-out-of-time and matrixial border-space, and in that the *Woman-m/Other with-in the encounter* is neither present nor lost, neither assimilated nor rejected by the emerging self. Furthermore, it is archaic in that she-with-in-the-encounter still and always gives signs, in the case of Lol as in the case of Dora, via rare apparitions of fascinating scenes in reality, through that which appears as a reincarnation of a fascinated subjective-object in fascinating Thing-Encounter, but in the now and via new fascinated faces that are facing and encountering someone else. Each Encounter-Event takes place at the heart of some kind of primal scene where the I encounters a non-I in her encounters with other non-I(s) just as in the originary human primal scene. This, and not the Oedipal scenario, is the theater of Lol's drama. This is the image she tries to see. She is not ready yet to love the man. She wants to gaze at the scene and be a part of it, as a pure gaze upon pure eye, by the transgressive force of fascination that will include her.

> Lol, rooted to the spot, had watched.
> Her gaze was diffused over the entire surface of her eyes.
> ...Lol changed. She watched and waited for what would come next.
> Lol had watched them...She seemed to love them.
> ...and together – with Lol – all three of them had aged years and years, grown centuries older.
> For a long time they had stared at each other in silence, not knowing what to do, how to emerge from the night.
> ...dawn arrives with incredible cruelty and separates her from the couple...forever, forever. Each day Lol goes ahead with the task of reconstructing that moment.
> She was born to witness it.
> "What did you want?"
> "I wanted to see them."
> She wants to see, and to have me witness with her.
> I ask again: "What is it you wanted?"
> "To see them."
> She can spend the rest of her life here looking.

If the image is sustained long enough, and the gesture of the scene is completed, the distance between the Girl and the Woman will fade out, Girl and Woman will become sisters in the feminine. Lol cannot enter the Oedipal triangle. This is because she is obsessed with the enigma of the primal scene, out of which she has emerged into being, and out of which she is still and is always trying to emerge into becoming-with-an-other. She is obsessed with it because her desire to be a fascinating subject for another fascinating maternal-woman subject is unfulfilled.

In Lol's case, as in Dora's, the girl's need to be included in the gaze of fascinance of mature femininity exceeds the desire toward the man. It exceeds it because it precedes it, and because it is not yet processed. The desire toward a man is kept waiting in suspense, and the girl asks about her femininity by proxy by way of another woman-m/Other. Lol, Duras tells us, lurked for the gaze. "Lol, rooted to the spot, had watched" and asked herself the questions every girl asks in front of a fatal woman-m/Other: "What had she experienced that other women had missed? By what mysterious path had she arrived" at her femininity? Lol phantasmatically joined this woman-m/Other during her encounter with a man-lover, and in her jointness she began to transform herself, and she was fascinated:

> Lol changed. She watched and waited for what would come next [...] If she herself had been the agent not only of its advent but of what would come of it, Lol could not have been more fascinated by it.

Lol sees her body as if emerging from the body of the m/Other and replacing it in the making of love to a man, she wants her own girl-body to fade for the other woman-body and she silently cries out her need to become this other woman so that even the womb of God surrenders.

The girl beneath the woman that Lol, like Dora, is, desires to get in contact and make alliances – in the Real that extends between trauma and phantasy – with a Woman, a figure of femininity that dwells beneath a fatal woman-m/Other figure. But this fatal Woman becomes inaccessible, hidden behind the phantasy of the phallic mother (All-mother) and behind the reality of a rejection or a split. In the novel, there is no rejection from the scene by the Lover [or the lover-beneath-the-father-figure] nor by the other woman who symbolizes for her a Woman-m/Other. The Man and the Woman do not exclude Lol's gaze. The night contains the three of them. "The man scanned the room for some sign of eternity. Lol Stein's

smile, then, was one such sign." It was, in fact, her own mother who cut the gaze, and Lol reacted to this violence with violence: "The screen which her mother formed between them and her... With a powerful shove of her hand, she knocked her mother down." Under this sudden break of the *fascinance*, the girl that Lol was could not actualize her potentiality to be transformed into a woman by inclusion in the matrixial moment that was in the process of changing all partners of the encounter. "She was, it seems, transported in the presence of this change [...] Lol was watching him, watching him change [...] Lol changed..." But she was prematurely outcast from the moment of transformation. Still waiting in suspense to live by proxy the mutual fascination, her change became a frozen fixation. She, therefore, remains an eternal child captured in a repetitive primal scene out of which she cannot emerge for lack of absorption in a gaze of *fascinance*. She was trapped by *fascinum*.

Think of Dora's admiration for Frau K., for her aunt, for the Madonna. Dora nourishes the idea of being silently recognized by fascination by these women-Mothers, and it is the image of Madonna, an art image, who finally returns her gaze. The girl desires to enter the realm of this fatal femininity, but to accomplish this entrance she needs not an identification with the woman-mother but an *inclusion in trans-subjectivity by a compassionate, generous hospitality* that would emanate from the fatal woman-m/Other figure.

A similar transgression is also the effect of artistic images. Sometimes, this transgressive hospitality is precisely what the psychoanalyst offers. This was, however, not the case of Freud with Dora. This was indeed the case of Jack Hold with Lol (Hold who occupies, in fact, the place of the author, who is, metaphorically, Marguerite Duras herself). To Dora, Freud was a phallic mother in transference, and a failing phallic father too. The phallic mother is a screen that blurs the woman-beneath-the-mother so longed for by the girl. Can a girl discern any desirability in herself if she cannot designate any desirability at all in her own mother or in another woman, thus establishing the desirability of her own archaic m/Other as fascinance for herself, not for a man? Can a girl become a woman without being co-affected in an encounter of fascination with a m/Other? Without looking for her share, for a sharing in a gaze that radiates from a phantasmatic entity composed of a couple captured in a passionate encounter of which she is the result, and thus subjectivizing herself as the future and potentiality of such an encounter? Can a girl become a woman if she

cannot receive admiring recognition of her femininity from another woman-Mother? Can a girl become a woman without aspiring to participate in the missing gaze that will arise from the encounter, will turn around the couple and herself and look back at the couple from her future self, a gaze that will envelop her and subjectivize her as a potentially ravishing being, closing the gap between a Girl and a Woman in the establishing of the necessary woman-to-woman difference?

Such a gaze that is an aerial of the psyche that streams from another partner or from several partners and returns to all the partners of the encounter is *a matrixial gaze.* It diffuses matrixial affects. To begin with, it is a measure of difference in the field of affects, not in the field of perceptions, but it infiltrates the field of perception and shapes the images upon its specific paths of desire. The screen of this gaze is a matrixial screen of phantasm. As an image it penetrates the gestures of co-eventing and co-emergence in the Real – in the Real of Encounter-Event.[9]

I am not talking about Oedipal or negative Oedipal drives nor of transitive Oedipal wishes in Ogden's terms. I am describing a trans-subjective psychic position that infiltrates these later psychic positions. I suggest that long before and also beside, after, and beyond Oedipus, the girl is not jealous of the mother because the father desires the mother instead of herself. This will arrive later. The girl is jealous because she recognizes the difference between a girl and a woman-m/Other. The girl needs to find ways, and many times she fails again and again to find them, for sharing in the secrets of femininity with a m/Other whose fascination she must catch in/for their shareable space. She looks for a Woman-Mother figure whom she might adore and whose secrets she would be able to share on condition that such a m/Other would open herself to allow such a sharing and accommodate her gaze. She looks for proofs of the desirability of this figure by images and symbols. Any rejection or betrayal of and by such a figure feels catastrophic for the girl who is trying to become a woman. Dora, for a period before her disappointment, bathed in the gaze of fascinance. She had found proofs of this desirability and a certain sharing in it in the person of Frau K. She had also found proofs of it and a phantasmatic sharing in it in the image of the Madonna. This type of sharing is possible only by way of matrixial weaving and metra-morphosing[10] whereby change and transformation occur. The analytical relationships echo this mode of psychic transformation and also transform by/with-in it.

When the matrixial sphere, this unconscious borderspace of the several, is foreclosed and such sharing with several others is impossible, the psychoanalytical working-through and counter-transference must open such a sharing and make it possible, by forming a matrixial alliance in the transferential relationships and co-emerging with the analysand. Here, new creations rather than replications can occur, depending on the psychoanalyst's awareness of this dimension and his/her surrendering to matrixial femininity. Here, "feminine" does not design the opposite of the masculine in a feminine/masculine dichotomy. Feminine is to be understood, matrixially, as a differential potentiality before and beyond this [phallic] dichotomy. New creations depend also on the psychoanalyst's availability and responseability, no less than on the patient's capacity for working-through in the transferential relationship.[11]

Will Lol Stein survive the repetition of the image that unfolds in front of her eyes, of that scene, a repetition of an earlier traumatic encounter? Once again, her languishing eyes melt inside the erotic antennae that arise from her matrixial psyche when an archaic real and now also phantasmatic image belonging to a liminal time-space of a primal scene bumps into the Real again within a new ravaging encounter. That which Lol finds ravishing at the same time as it ravages her, is the blind desirability within the fatal-woman-Other-mother, (pronounced phonetically in French, "femme," i.e. woman: *ffAm* [*femme-fatale-Autre-mère*]): the being of the ravishing m/Other-Thing-Event in-itself as becoming with-in encounter; this Woman-beneath-the-mother, always almost lost and longed-for and almost always not-yet found again, both outside (in reality) and inside the self (in phantasm), who shines through another woman who is relating to a man to whom the subject intimately relates as well. A *femme-fatale*, who is always also a mother-figure (like Anne-Marie for Lol and like Frau K. for Dora), is captured by a gaze which is not a gaze, which in fact is an affective swerve, a non-gaze of the subject in the duration of relating to an intimate other, a Lover. A ravishing m/Other-Event-Encounter appears in front of the subject who is, herself, co-emerging with her and is in the process of becoming a woman, as if *it* is materialized in reality by an encounter between a woman and an-other (the Lover, a man in these cases, but who is not necessarily a male subject in my view) – an encounter in which the subject could have found a site for herself in order to continue this process in a satisfactory manner, but out of which *the subject is prematurely evacuated*. The premature evacuation creates an unconscious move in which the subject is repetitively rejected: a repetitive

phantasmatic scene of rejection from a matrixial femininity. She, Lol, will remain forever waiting for the "end" of the encounter, for the encounter not to be abruptly cut, for the right moment to emerge from it after having dwelled inside it long enough, after being recognized as a partner in the encounter.

An encounter that had "pushed out" the subject too early from its parameters of time, place, and scene, is doomed to be relived. In repetition it is relived, performed, or phantasized, leaving the girl once more (Dora, and here Lol) mesmerized and breathless, astonished and languishing, not for the woman, not for the man, but for the blinding, puzzling, and slippery *encounter.* She wants the encounter-event to take its full time and space and to complete its course so that it will include her and so that she will differentiate herself inside it and from it to become both a separate subject *and* a partial subject in a matrixial borderspace. But the almost-missed yet never-ending encounter aborts the girl and sets her on the routes of wandering and repetitive exiles. It subjectivizes her as an orphan to the matrixial sphere, from now on and once again and perpetually. Orphan of this fatal encounter and of the world, a detached strand in a plait that should have been composed of at least nine strands, as we shall show later on.

In an event that will later become traumatic again, what Lol confronts is the enigma of the encounter between a fatale-woman-m/Other and an other: the Lover. She confronts the enigma of the effect of a fatal-woman-m/Other when she is affecting her own self – a woman-child longing to become a Woman-beneath-the-Girl that she is. Being affected by her is a subjectivizing event. This woman-m/Other is emphatically sensed by proxy by the girl as a ravishing subject – not as a ravishing or desired *object.* This process should not be confused with the process of identification with a woman, because the unconscious move here operates on a *level of partial subjectivity* that transgresses the individual boundaries and where activity and passivity, subject and object, and psychic past and future are transgressed and re-transgressed.

An encounter-event is once and again exposing itself to Lol's gaze, as an offering to the affective "eyes" or antennae of her psyche. This encounter-event echoes not an Oedipal triangle, but a primal scene, a scene of change and exchange that will affect all its actual and potential participants. This type of encounter-event might expose itself suddenly, at any moment, in different ways, to any human being. It exposes itself to any human being embodied as female, as the enigma that surrounds the difference between

herself as a subject and herself with-in trans-subjectivity, between her self and any significant other woman, and, to begin with, between herself and any significant other woman-mother, starting from the difference of the female subject and the subject's archaic Other-mother-with-in-encounter. We are talking here about an originary difference of the feminine that is opened inside the field of the feminine-beyond-the-phallus. (I will not discuss here the ways this difference enters and alters the psyche of a male child, but the reader is invited to think about this question.)

III

The sexual difference of any human being (female or male) is staged with and against a female m/Other-woman figure. Even where the maternal post-natal figure is male, the prenatal maternal figure is always female, and the imprints of the contact with this female figure will infiltrate any maternal figure, be it the same or another person. The first corporeal-psychic connection between I and non-I occurs inside the maternal womb where every I is in linkage with the female invisible corporeality and is borderlinking to the m/Other's psychic environment. From then on, the self-difference and the sexual difference of any human being embodied as female (Girl) is defined with and in reference to another woman (the m/Other) first, and at a later stage also to several other women who can hold the site – time-and-space – of the Woman-beneath-the-m/Other, who remains forever enveloped inside the figure of the archaic m/Other that dwelt in resonance with the I within the primary relational field of encounter. In the post-natal life, this relational field is thought of not in terms of inter-subjective relationships of the Girl-with-the-Woman-m/Other but firstly in terms of trans-subjectivity. The I is first in prenatal and later on in post-natal trans-subjective co-existence and co-emergence with the non-I. Thus, long before but also beside and even after Oedipus, *a feminine sexual difference* is marked by the matrixial co-emergence, i.e.: by *the difference of the female child from another female – a woman-m/Other figure – and not from men, boys or the father –* a difference opened in jointness and inside resemblance. In other words, *the enigma of feminine sexual difference is posed from the start between female subjects and between the woman-beneath-the-mother and the woman-beneath-the-girl in non-Oedipal pre-transitional trans-subjective psychic interweaving.* The feminine-matrixial woman-to-woman difference comes before the forma-

tion of separate subjects, whole objects, and personal identity; this differ-ence is not a question of gender identification. Though this enigmatic difference has to be dealt with in terms of the primary impressions at the earliest psychic phase and position which is prenatal, it is further shaped in post-natal development. Later on it will also shape gender identification. However, its parameters are molded by and patterned upon the matrixial potentiality. A trans-subjective pre-subject is shaped in terms of *pre-birth transgressive becoming-together with prematernal subjectivity.* When the matrixial bonding between the one (I) and the other (non-I) emerges in the primary encounter, as well as when it emerges during life in intimate encounters, then though it forms the space of the two or the several *it is not symbiotic.* When the matrixial bonding emerges in the space of the three or the several that are linked *in bonds of one to one,* it is not an Oedipal triangle. The matrixial encounter is a potential intimate bonding between several I(s) and non-I(s), where *each time the focus is upon specific I and non-I,* or upon a singular co-emergence that enables both an assembling and an exchange of psychic imprints, psychic transformation, and a process of growing differentiation in the course of further distinc-tion and separation-in-proximity.

The archaic Woman-m/Other (non-I) and the infant-Girl-daughter(I) coemerge and differentiate in primordial encounter. A later series of en-counters is registered along the same net of mental connective strings. There, the enigma that arises from the impact of the archaic m/Other as a fatal woman, as a non-cognized subjectivizing, ravishing, and shining presence that arrives toward a pre-subject who comes-into-being-with "her-It," opens up a sexual difference, not in relation to a lacking *object-mother* or *Thing* but in the relating to a *dawning and vanishing link with the m/Other* who is a subjectivizing transformative agency in her position of a subject-in-resonance-with and in co-affection with the I. In terms of the image, the transformational fascination with the *fascinance* arising from the maternal image precedes the freezing fascination with the *fasci-num* of this image. The passion and compassion of the woman-m/Other operate on the edges of a psychic common cloth that is always and forever shareable, where yet the I is not "the same" as the non-I. Inside this cloth the becoming subject co-emerges with and differentiates itself without fusion with the m/Other-Woman or rejection from the m/Other-Woman. Such is the case for males and females, but the case of females has a multiple charge, because difference is less evident in their relative corpor-eal sameness. Yet *each woman-female-girl differs in her sexuality from*

another woman firstly – the mature woman-m/Other – and then, also, from men. This difference originates with-in an encounter in the matrixial sphere where all participants are involved in processes of transmitting and receiving, attuning and reattuning, exchanging of traces and transform-ation. Thus, a subject does not only look with desire for an absent object (*objet a*), as Lacan would have it, or for a gaze that is forever castrated and castrating. Rather, from a matrixial angle, she looks with a longing desire for *the affective looking-for* and *after* herself revealed *in* the m/Other; the becoming-subject looks for a matrixial erotic binding and connecting, for reproduction and co-production of moments of fascinance. With fascin-ation and awe the girl looks for signals and signs of links during moments of vanishing of links (*link a*) of cross-connectedness, when certain vibrat-ing frequencies flicker and the m/Other's pulsating being is turned else-where and away from the girl – when she is fascinated by something or someone else. At the level of the image, this kind of longing for binding-in-difference in fascinance can be healed only by vibrations of admiration inside future transgressive moments that evoke cross-connectedness via an image. By cross-connectedness I design the human capacity to capture and give meaning to the cross-scripting of unconscious mind-waves and affect-ive traces emanating from the other. Between a girl and a m/Other this happens in asymmetric mutuality during continuous trans-subjective encounter-eventing. This matrixial longing for binding-in-difference is erotic, it is the labor of Eros, but this Eros of compassion, longing, and adoration is not sexual in the Oedipal sense, and between females it does not stand for a homosexual or lesbian desire. It is a necessary pre-condition for moving from a Girl position to becoming a Woman.

It is now time to emphasize the difference between "woman" as a desired object, "woman" as a desiring subject, and this subjectivizing ravishing and fascinating potentiality of a Woman-m/Other that is created or rediscovered in co-presence and co-emergence and whose psychic waves, vibrations, and grains are redistributed, for an instant or for eternity, in trans-subjectivity, in time-spaces of encounter-event where the individual limits of all the subjects that participate in the encounter-event open up so that each of them becomes a partial-subject of the same encounter. Such a time-space is a psychic "point" along the same vibrating string, shared for an instant that is an eternity in terms of its unconscious impact. An image can carry a transformative potentiality for a subject when the subject enters into relations of fascination with its site (or time-space) of fascinance.

IV

I turn now to Lol Stein, the heroine of Marguerite Duras's novel, in order to state that a Woman as a desiring subject can contribute to the becoming-girl's subjectivity if an actual woman-m/Other who carries the potentiality for being a subjectivizing ravishing Woman-m/Other for a girl in the process of becoming-a-woman, opens herself up in compassionate hospitality to that girl by/with-in matrixial Eros. In this process, the girl is initiated to the matrixial difference as a feminine-difference. The matrixial-feminine difference is inscribed in the tension and the passage along such psychic unconscious erotic strings when traces emanating from the same vibration along the frequency emitted by the woman are exchanged between the different but now co-subjectivizing agencies of the Woman-beneath-the-Girl, the Girl-beneath-the-Woman, the m/Other-beneath-the-Woman and the Woman-beneath-the-Mother, all these different positions of Girl and Woman-m/Other present and trans-relating in crossed relations in a web of strings between the individuals who participate in the encounter. The transgression of subjective borderlines between the individuals creates momentarily not a single separated subject (a Girl) vis-à-vis another subject (a Woman, a Mother) or even a third subject (a Man), but an aggregated subjectivity or what I call *subjectivity-of-the-several in encounter-event* that, in a blissful Real or in a traumatic and phantasmatic way, opens a path for cross-inscription. In the case of Lol Stein, such matrixial subjectivity opened momentarily to include Lol, the Girl in a particular woman-beneath-the-girl position, in a relationship of fascinance with a desired man desiring an-other woman. "Man" here stands for the Lover, both M. Richardson and J. Hold in Duras's novel, likewise it stands for the father-figures in Freud's Dora and for Vronski in Tolstoy's saga. "An-other woman" stands here for a position of woman-beneath-the-mother: Anne-Marie, and likewise Anna Karenina and Frau K. – all these remarkable adorable mature woman-m/Other figures caught in a desiring relationship with a desiring "man" under the gaze of the fascinated girl.

In the novel, these relationships take place, in fact, twice – once in a spontaneous way and then repeatedly. Lol invents again and again the same scene, with different persons in the same positions. There is in the scene a fascinating image she wants to see again and again. An image of a man who, in front of the desiring and fascinated gaze of Lol, the Girl or the woman-beneath-the-girl, is desiring a m/Other figure who is also a

fascinated-fascinating fatal woman in a position of "woman-beneath-the-m/Other" for the Girl. The alliances that mark the becoming-subject-girl are those that take place between herself, as a becoming-woman-beneath-the-girl, and the other woman, this woman-beneath-the-m/Other who carries and echoes, for the girl, her own archaic m/Other in a primordial encounter of a primal scene while she also represents a desiring and desired woman-mother figure. The new image of encounter replicates the earlier encounter-event. Even though there are three figures there – a Girl, a Woman-m/Other and a Man – the scene is matrixial and not Oedipal. It has a very powerful transformational potentiality. *The earlier encounter-event replicates the enigma of* the primal scene *out of which the subject-girl is phantasmatically about to emerge, again and again, as rejected and out of place.* I want to stress that it is not a repetition of the Oedipus complex in which the subject-girl as a subject of identity is already embedded on another level.

In *The Ravishing of Lol V. Stein*, Marguerite Duras unfolds the fragility of this moment of becoming-subjectivized in the matrixial sphere. Will the subject be transformed with-in this moment or will its becoming coagulate and the transformation it offers be arrested? Duras directs our affect-laden eyes toward the traumatic coagulation of a moment of such an opening of such a matrixial feminine difference. Lol, her subject, will pay the full price for the procrastination of this moment's duration. Her becoming in this instant, and the traumatic encounter-event itself, are one and the same entity. In a similar way,

> ...this crisis and Lol were one and the same, and always had been.
>
> Michael Richardson...scanned the room for some sign of eternity. Lol Stein's smile, then, was one such sign, but he failed to see. For a long time they had stared at each other in silence, not knowing what to do, how to emerge from the night.

I am interested in this subjectivizing ravishing that runs through relations between human females who are in the processes of differentiating themselves and of working out their matrixial sexual difference in a relationship between the Woman-beneath-the-Girl, the Girl-beneath-the-woman, the m/Other-beneath-the-Woman and the Woman-beneath-the-Mother, in a fatal encounter with a woman-in-relating to another man who, for the differentiating becoming-subject, hides behind her ravishing veils the Woman-beneath-the-archaic-m/Other in an encounter-event on the level

of the Real. Such a subjectivizing potentiality should, in my view, also be released by the transferential and counter-transferential relationships in the course of psychoanalysis. I was inspired in my reading of Duras's *Lol Stein* by Lacan's treatment of the structure of the primal scene in his 1966–67 seminar.[12] I have already proposed elsewhere a matrixial interpretation for this seminar[13] and I will now propose a possible development of the later Lacanian notion of the plait found in Lacan's late seminars (1973–75),[14] moving the concept of RSI [R(eal)-S(ymbolic)-I(maginary)] braid from the field of the phallic, separate subject to the matrixial trans-subjective sphere where strands of RSI from different subjects can weave a common cloth.

V

In the Oedipal triangle, three subjects are *already there*. But in the primal scene one cannot yet speak of three identifiable subjects, even if the primal scene is detected during psychoanalysis via the subject's phantasmatic reconstruction of the relationship between her parents before her arrival in the world. The primal scene is of primordial importance because it exposes the parental sexual relationship out of which a baby can be conceived, and, more precisely, out of which she, the subject, can literally accept *her own potentiality for being conceivable*. Here, a becoming-subject and the Other-mother perceived as having a sexual relation with her own partner – Lover and potential father – are woven together and are bound to one another forever through *the very process of subjectivization* of the future becoming-subject. A past relation *will* become or *will* function as a primal scene for a subject only if such *potentiality* becomes actual and its consequences embodied in her potential self.

With Lacan, we know that both the feminine non-phallic or supplementary jouissance and the sexual relation of the primal scene are irretrievably missing for the subject, due to the cut or split from the entity of a Woman-Other-Thing. Lacan believes that *this* Thing cannot be apprehended subjectively. Anything that might be apprehended would be imaginary only. The cut from the union with the m/Other is described by Lacan in terms of a tear in a "cloth" or "bubble" that stands for symbiosis and fusion.[15] From the primal scene and from the union with the m/Other, the *I* can only move forward as the product which is forever cleft from any union in flesh and in the Real. The law of desire and the

prohibition against incest ensure that this split occurs for every subject that encounters the Symbolic. With his use of the Moebius strip, however, or the development of the "a-sphere of *not-All*" Lacan sets up, alongside the law of desire conditioned by Oedipus, another – strangely troubling and uncanny – function, one which throws light on the primal scene. With this function we might manage to establish a certain differentiation inside the symbiotic "bubble." While the schism relates to castration both in the Oedipal sense (where the gaze, the *objet a*, is lost and separated from me) as well as in the sense of a separation from the texture of the cloth (where the gaze is lost and also separated from the Other), another law also arises alongside the schism. Through this law "the subject is suspended in the place of the Other, characterized by this . . . slice-of-reality, which is . . . also perhaps all the reality to which we have access" through the archaic mother and in relation to her union with the father during the primal scene, and whose loss does not only involve the object, but also, I believe, a link, the link between the becoming-subject and the Other-mother-woman in encounter. Thus, to better understand the function of the primal scene once it is separated from the Oedipal function, and even though it may be partly regulated by a similar mechanism of cutting so that an act of castration is always doubled retroactively, I suggest that one must always also take into account "the profound disparity between feminine jouissance and masculine jouissance" in terms of the difference between the primal scene and the Oedipus complex.

The implications of this difference will be viewed with regard to the death drive and to the impossibility of avoiding incestuous relations with the m/Other in the phase of pregnancy. This impossibility creates a sexual difference at the heart of the maternal. There is a difference at the level of the "knowledge of the Real" opened in the traumatic and phantasmatic links between boy-borderlinked-to-m/Other and girl-borderlinked-to-m/Other. The difference does not begin in each being, but in the clusters and the borderlinks. The trans-subjectivity that inscribes the links will distribute traces primarily impressed upon it in different ways, where the corpo-reality will play a role.

In Duras's novel, behind an apparent intersubjectivity related to the Oedipal scene, lie three subjects who can address a triple cross-subjectivity to each other through the primal scene's *non-law of passion*. Here, the *non-gaze*, a metaphorical figure raised by Lacan and repeated by J.A. Miller following Marguerite Duras herself, should in my view be considered as a link and not as an object, a *link a* more than an *objet a*. Here lies hidden,

always in the process of vanishing, a link involving the blind spot of the Event-Encounter wrapped in its own time and space which are, for the Oedipal triangle, non-time and no-place. The Event-Encounter, no longer qualified as a Thing, that is actively given to be affected by the "passions of the *a*," is ravishing.

> had this non-gaze of hers swept over him as it took in the ballroom...her gaze was diffused over the entire surface of her eyes, and was hard to meet.

It is the details of the scene described by Duras that enable the reference to a primal scene rather than to an Oedipal scene. The scene is an unexpected encounter, one that is outside of real time and outside of the reality of a place. It is an unbelievable, unexpected scene of passion, that is traumatic and traumatizing, and that produces a stupefied becoming-subject outside language, in front of the non-gaze of a woman-mother in relationship with her own lover. Partial subjectivities: a not-yet-barred subject (Lol) relating-without-relating and borderlinked to vanishing-and-mesmerizing objects of desire, are enacting and affecting one another in a non-symmetric yet reciprocal way. Duras points to this invisible reciprocity by putting them all in the same relations to a particular time-out-of-time:

> all three of them had aged years and years, grown centuries older, that kind of age which lies lurking, within the insane.

When the metaphor of the cloth is taken for a matrixial interweaving, inside the same relations to a time-out-of-time and place-out-of-place, the three partial-subjectivities of the same matrixial fabric are both united and distinguished. Unconscious threads of time and space differentiate between them and hold them together. The threads do not belong to the one or to the other; they traverse them all and link them, while all three participants are necessary for the scene to hold together. Two partners alone are not enough to create a primal scene; a transgression of the individual boundaries, a transgression of incestuous constitution, underlines the scene.

When we speak of the cloth of the primal scene in terms other than fusion and total symbiosis, a "feminine incest" in terms of a traumatic encounter in the Real whose paradigmatic matrix is the encounter inside the maternal womb appears and reveals to us that there is a basic human condition where

transgression of borderlines is certain. Such a transgression inscribes its marks in the psychic sphere of the "bubble," in the trans-subjective dimension. Unlike Lacan, I propose that we see in the mother–child common "cloth" transgression and not fusion, braiding and not melting. Braiding takes place already then and there. While such an incest cannot be measured against, and is not even comparable to, sexually perverted or genital-phallic incest, this incest that circumvents the phallic law is a primordial psychic field of transgressions between several participants who render and temporarily loosen their Oedipal borderlines, thus creating crossings between their traumas and jouissances, phantasms, and even desires, and enabling the trans-scripting of traces of the links in an assembly of the several (in "severality") outside of linear Oedipal time. It is marked by an evanescent matrixial relation, not a union, not symbiosis, but a plaiting in a field of partial and differential trans-subjectivity and crossed subjectivity. In my view it is Lacan himself, almost ten years later, who "invites" such an interpretation of his "cloth," against his own symbiotic proposal, when he says: "when the thread/rope shows, it's because the weaving is no longer camouflaged by what we call the cloth . . . The link between castration and the incest prohibition is what I call 'my' sexual relation." "There is no sexual relation, except for in neighboring generations, in other words, between parents and children. And it's with the sexual relation that I decorate the prohibition of incest." This means that the supplementary sexual relation, which is feminine, enigmatic, and "impossible," passes through some kind of incest between neighboring generations. And for women, who are potentially maternal, it would be impossible to avoid this incestuous condition, be it in trauma or in phantasm. How can any woman traverse an incestuous transgression so strongly foreclosed from culture without becoming psychotic? Lol could easily become psychotic. So can we.

In order to further present the problematic we are facing here, I am going to interpret the late Lacan under the prism of a specific psychic sphere I have named matrixial. This is a trans-subjective sphere based on the phantasmatic and traumatic links between each future subject and its future mother, between the not-yet-born baby and its becoming-mother. This trans-subjective sphere, no less than the singular consciousness "belonging" to each emerging separate subject, underlies the field of intersubjective relationships.

Indelible psychic traces of contact with the inside of the body of a woman are inscribed as links and not as objects, like trails of encounter-events in the Real with pain and jouissance that contain their dynamic gestures, inscribed

in several subjects. These trails reveal their meaning in the thoughts and phantasies of at least two participants of an encounter, when each one can get to know oneself and the other and give birth to meaning for oneself and for the other only in joining within metramorphosis and creating a shared scene in an encounter where the perceived frontiers between subjects dissolve and their limits are crossed and transformed into thresholds. Transgressive, contingent borderlinks then emerge together with the borderspace of encounter itself, as its constituting strings. Here, transgression itself appears as a feminine sexual difference marked by the partial loss of relations to the archaic m/Other and by the vanishing of some borderlinks with her. Such a loss and such a link involve individuals of either *the same* or *different* corpo-reality – same or different from the woman's, *in a connecting with* a woman. Thus, the matrixial difference opens not between a man and woman, but between a woman–woman link and a man–woman link inside a web of multiple linking. Every woman, as once a girl, carries an originary woman–woman path of links where transgression and difference from another woman-m/Other are operative. These transgressive metramorphoses are creative instances that engrave what seems to be the same traces of each Event-Encounter in several subjects *differently.* Subjectivity-as-encounter emerges, where the Other-mother is never an absolute Other, absolutely separate, and where the first difference for a woman (a female child) is from another woman (a female grown-up). The matrixial position, however, reveals that this relative non-separation does not entail a melancholic state for feminine subjects. We move into a sphere where desire is a borderlink based on a vanishing and fading, but never disappearing link, where the object of desire is not an object but rather a process of partial loss of relations in transformation and a loosening and dispersal of links between few partners. The foundation of desire is in the matrixial liaison between I and non-I, to begin with, between oneself and one's mother. It should be emphasized again that the "cloth" composed of fetus-and-mother in the womb does not refer to a lost symbiotic paradise (as Lacan presents it, from a phallic perspective) but rather, and from a matrixial perspective, to an already-differentiation with-in/between "feminine" subjectivizing elements where female–female or male–female links are unavoidable. *The impossibility,* for every human being, *of not-sharing* in such an incestuous-maternal transgressivity in female–female or male–female links, and moreover, *the having already-shared* an incestuous-maternal transgressive borderspace, as either a male or a female, demands its price. The price is the potential risk of psychotic regression and fragmentation.

The matrixial transgression, however, also creates its beauty and weaves its ethical meaning. The cloth of trans-subjectivity is not only regressive; it has sublimatory outlets. The matrixial sphere strives for sublimation no less than the phallic arena: the sublimation of the Thing-Encounter and the Thing-Event, and underneath them both, of the Event-Encounter and of the processes of metramorphosis.

To establish a borderlink while differentiating oneself from the other is a pathway to the Other that transgresses individual limits. To move from a Girl position (*f-f*: femme-fille, woman-beneath-the-girl and girl-beneath-the-woman, a daughter position) to a Woman position (a *ffAm*: *femme-fatale-Autre/mère*, femme-fatale-Other/mother, Woman-beneath-the-Mother and m/Other-beneath-the-Woman, whether one is mother or not) one must pass through these kinds of matrixial relations-without-relating which form and might also traumatically dissolve trans-subjectivity, which are subjectivizing and differentiating. Such relations allow momentary participation in a partial and shared subjectivity in adulthood. I will describe now the trans-subjective transgression by a shift in the notion of the individual's unconscious braid (found in the late Lacan) that I transform to apply for the plaiting of several individuals.

I agree strongly with E. Laurent and J.A. Miller that, in relation to Lol Stein, it is essential to speak of a being-three/triple-being.[16] It is not enough, however, to raise this triple-being (patterned upon Oedipal tri-angulation) to the sublime or sacred trinity, nor to reduce it to the personal Oedipal trinity, where Lol would be either a psychotic or a hysterical figure. Beside and behind these trinities, one must open and explore the work of the primal scene through the figure of the Matrix and open the RSI personal unconscious plaiting beyond the personal, so that the RSI plaits will account for several fields of personal unconscious interweaving.

In a rare and enigmatic development of the notion of the plait, Lacan moves from three strands of RSI (Real–Symbolic–Imaginary) as "personal subjective supports" of each individual, to six or eight strands in a schema that he draws on the board, in which a few strands of RSI emerge from different moments in one person's life. Different moments thus emerge and intermingle in a plait of six or more strands. I go further to suggest that such strands, emerging from different people in close proximity, can be crossed and plaited together so that a plait of six or nine strands can represent an interweaving of a shared psychic space. Thus, we can describe an RSI plait as a crossed inter-subjective support that creates a

trans-subjective sphere. Let us suggest that RSI strands emerging from different individuals get plaited during one and the same event. Let us imagine Lacan's three positions belonging to different moments in the same person as attributed to different individuals. Thus, instead of a subjective position evolving in time, we receive a momentary trans-subjective web of three positions: (1) The position of a Girl-beneath-a-Woman and a Woman-beneath-a-Girl: Lol and also Tatiana in identification with Lol (a sister, girl figure) in Lol's mind. (2) The position of a m/Other-beneath-the-Woman and a Woman-beneath-the-m/Other: Anne-Marie and also Tatiana in identification with Anne-Marie (the Woman) in Lol's mind. (3) The position of a Father-beneath-the-Man, a Man-beneath-the-Father, the Lover in sexual relation to a ravishing woman-m/Other or fatal woman: Mr Hold and also Michael Richardson.

We have here three plaits intermingled in matrixial trans-subjectivity. But first, we must ask: what is the original Lacanian subjective (non-matrixial) plait?

VI

In *Les non-dupes errent*,[17] Lacan asks "What is a plait?" The context of the question is, undoubtedly, feminine difference. In his last theory, Lacan initially, and as usual, describes the three RSI dimensions: the *R*(eal), the *S*(ymbolic) and the *I*(maginary) subjective supports, as personal, i.e.: individual. These subjective supports are linked to each other by a knot, which sometimes becomes a knitted and woven plait, made up of three strands, in which the strands of the Real are linked to the strands of the Imaginary and the Symbolic. This kind of plaiting introduces a certain kind of knowledge based on the Real "which can be read by unraveling it," as opposed to knowledge supplied by language. We know that for Lacan, the Real, the Symbolic and the Imaginary are totally separate; they need an arbitrary function to hold them together. Where the *phallic law* and *the Name of the Father* served to link these three domains in the early theory, it is the *sinthôme* that does the job in the late theory. The linking, the relating, the rapport between them is otherwise impossible. Had it been possible, the feminine-beyond-the-phallus "impossible relation" would have made its appearance. If, however, the bodily traces of jouissance and trauma (in the Real), their representation (in the Imaginary) and their meaning (in the Symbolic) are interlaced around and within each psychic event as a plait,

rather than being held together by a fourth notion, we may conceive of knowledge of the Real that marks the Symbolic through its particular way of sense-making in a way no less weighty than the way knowledge treasured in the Symbolic gives meaning to the Real by signification and concepts.

Exceptionally, strands sometimes multiply in a plait, suggesting different moments in time. But, as I say, one can there envisage an intertwining into a plait of different RSI strands coming from several individuals. Although on December 18, 1973[18] Lacan drew a plait of three, in his seminar of May 13, 1975[19] he announced that he would stop at six strands (two times *RSI*) even though he could go on to nine. When, later on, a fourth element (the *sinthôme*) was joined to the three separate supports RSI not simply to hold them together but as a fourth strand, Lacan again moved from the knot to the plait to describe an even wider texture, and on the board[20] he presented an enigmatic plait in which the four elements were already joined twice: an eight-strand plait. I propose to move from the plaits intertwined from six or nine RSI strands, or from eight strands composed from RSI *plus sinthôme* strands as plaits of the same individual to plaits composed of strands arriving from several individuals, so that a shareable psychic sphere appears. If the individual plaits already present a transgressive feminine-psychotic picture: the blurring of the intrapsychic borders between the Real, the Imaginary, and the Symbolic of the same individual, the transgressivity of such interweaving on a trans-subjective level is entirely inconceivable for Lacan.

In *Les non-dupes errant*, Lacan moves from the knot to the plait to demonstrate something of the impossibility of the feminine:

> The woman does not exist ... but a woman can occur, when there is a knot, or rather a plait ... she ties up a plait ... she manages to achieve sexual union. Only this union is the union of one with two, or of each one with another, of these three strands. The sexual union, if I may say, is internal to her (its) spinning. And it is there that she plays her role, by showing what it is for her to succeed in being three. In other words the Imaginary, the Symbolic and the Real are only distinguished by being three parts, and just that ... without the subject finding him or herself. It's through this tripleness – which a woman may sometimes obtain by failing it, in other words, which satisfies her as achieving ... within herself the sexual union – it's through this that man gains some commonsense, through the idea that a knot has a use ... The knotting of the plait gives us ... the Real before the order ... the one that makes three along with the Imaginary and the Symbolic ... The Real itself is made up of three, namely, jouissance, the body

and death, in as much as they are knotted, that is only, of course, by the unverifiable impasse of sex...There is knowledge in the Real, which functions without us being able to know how the connection is made in what we are used to seeing happen.[21]

With the idea of a plait, Lacan speaks about non-conscious knowledge of a kind that does not lead to phantasm, but instead takes us beyond: to the pure Real in its traumatic occurrences: jouissance, body and death. These three, strictly individual, speak themselves by their manifestation and connection. With the matrixial borderspace, we are conceiving of a sphere where the traces of these occurrences in the I are inscribed in the non-I, where the phantasmatic inheritance of the I emerge from the trauma of the non-I and give birth to a knowledge of the non-I in the I.

If we imagine a plaiting of RSI elements coming from three individuals in such a matrixial, almost-impossible linking, the strands of the Real-Symbolic-Imaginary are interlaced in the plait not only in an intra-subjective fabric or cloth but also in a cross-subjective fabric. If the knot and the "lapsus of the knot" remain within the limits of the individual, linking, or failing to link his or her three subjective dimensions, then, on the other hand, a plaiting of six or nine, in difference from a knot or a plait of three or four, can represent either different events of the same individual, or the connection between several individuals upon the same event. If, then, a "woman" in the matrixial sense is whoever exhibits the intersections of knots or a multiplied plait, that is: a trans-individual fabric, then, such a "woman" is not a radical Other, but instead a limit-Other, a border-Other, a transgression, a more-than-one and less-than-whole (*pas-toute*) who cannot be approached by a universal, but who can, still, be encountered by following her threads in the weft and the warp of the fabric and along the plaited strands. In other words, if knots provide an enigmatic explanation of the failure to inscribe feminine desire in the Lacanian paradigm that remains, always and inevitably, phallic, then by plaiting and by the inscription of the traces of limit-liaisons of the I in the non-I, from the matrixial angle, a meaning would be liberated/created/invented/ revealed or unveiled in each inter-lacing of strands, on condition that it is possible to read between the threads of a six- or nine-part plait that are hidden beneath a triple-being united in a psychic fabric, in a cloth made up of nine strands. In other words, beyond the Oedipal triangle there hides a texture of several threads that forms trans-subjectivity on the partial level.

In the RSI knotted individually, the cutting of a strand would lead to the detachment of the other two, and, thus, to psychosis. In an RSI plaiting-of-several with at least six strands, on the other hand, one or even two strands can be cut without the fabric falling apart. Plaiting, which is temporary by definition, manages to hold despite its extreme fragility, in instances where the Borromeen knot, which is a more solid and durable structure, cracks. With the plait where the subject-"woman" is knitted with her "archaic" m/Others, we therefore see the possibility of holding together a temporarily assembled subjectivity for a while, even when one strand is torn. The plait may be fragile, but it manages without falling apart when apparitions of the Real in the form of the archaic m/Other disturb reality for a while. With a knot, for the subject-"man" who is clearly separated from his "archaic" m/Others, when apparitions of the Real in the form of the archaic m/Other disturb reality, psychosis would surely appear.

In Lol, we see a person in search of a temporary sharing of this type of plaited subjectivity. What caused her pain was not that the encounter of a m/Other with her own lover took place. Rather, it was that the matrixial encounter was too short for her to complete her own transformation and become a woman. She was expelled from the encounter where she did not exist alone but was included in co-emergence. In her own oblivion she took part in a mature femininity and was also its witness, waiting for a gaze and gazing in fascination in a mature woman-m/Other in an instant with a flavor of eternity in a time out of time, an eternal moment that is going to be searched for again and again and again. She did not suffer; she wanted to see the gaze. There is no Oedipal triangle, the man in the picture is not on his own an object of love. Rather, he belongs "to a perspective which she is in the process of constructing with impressive obstinacy."

> She can spend the rest of her life here looking, stupidly seeing again what cannot be seen again [...]
> Lol dreams of another time when the same thing that is going to happen would happen differently. In another way. A thousand times. Everywhere. Elsewhere. Among others, thousands of others who, like ourselves, dream of this time, necessarily [...]
> Lol was looking. Behind her, I was trying to accord my look so closely to hers that, with every passing second, I began to remember her memories.

Look at this man. Like a psychoanalyst who agrees for a moment to dwell in the matrixial time-space his analysand is looking for, he includes her in compassionate hospitality. He creates for Lol the film to offer for her

lusting gaze. He creates the time. He creates the picture. He creates the human trans-subjectivity the like of which was lost to her in the past, in which she wanted to be co-re-born as a woman in relations of fascination. He created the conditions to find the lost gaze embedded in the acceptance of a ravishing woman to include another woman in her ravishing space. Only if the moment will last long enough and the girl will be nourished by the gaze, she would, perhaps, continue on her own path of femininity. Psychosis can be suspended and perhaps avoided if a plait-of-several can hold longer and open itself to include her for a while, for the time she needs in order to accomplish a process of differentiation and individuation out of a primal scene. From such a plaiting, under some conditions, she could still come out as only neurotic. We recall Duras's perfectly apt formulation to describe this suspension out of madness, this existence on the edges: "Lol is ready for the asylum, but she is not mad."

VII

The matrixial gaze of *fascinance* is an affective vibration: not an *objet a* but a *link a*. By the gaze of *fascinance* the Girl and the Woman-m/Other do not "see" one another but are joining in a metramorphic string and are transformed by one another. A matrixial gaze enables a glimpse at the forever out-of-time-and-space. By it, the forever-future and the archaic past join in the now of co-eventing in the Real, between trauma and phantasm and transform the old scar or mark. A new glimpse at older zones of inscription of a similar eventing in the Real, zones that are, in principle, blocked from access in the phallic arena of the post-Oedipal subject, is enabled. In a matrixial sharing, the other's most intimate but hidden unconscious zones are accessed to the subject in a parallel shared Real beyond the perceivable here and now.

> For a long time they had stared at each other in silence, not knowing what to do, how to emerge from the night...I move Lol away from me so that I can see her eyes. I see them: a transparency is looking at me. Again, I cannot see...The transparency has gone through me, I can still see it, blurred now, it has moved on toward something else that is less clear, something endless, it will move on toward something endless, it will move on toward something else, some endless thing I will never know.

With Michael and Anne-Marie, Lol was not in despair over losing her lover. Lol felt a strange happiness in a limit-shareability in a matrixial scene she needed to be a part of, longer and longer. She needed the repetition of this scene later on, once more, again and again, in order to emerge from a matrixial plait as a woman who is no longer a girl. With Hold and Tatiana, Lol tried to create and watch without seeing, with her non-gaze, a scene of passion in which she can feel, as in a primal scene, included on condition of being partly excluded from it; included as a potential consequence whose being, paradoxically, preceded the scene. Her question is not: to be or not to be. It is not: to have or not to have. Her question is how to both become *and* not be, how to have by losing, how to come later as the one who was there from before, how to be the result of a scene she must initiate as a subject in order to become its resulting lost object. She cannot enter these positions by a cut from the m/Other, nor can she remain fused with her in a cloth. She must differentiate herself in and by matrixial affects inside a plait that will include her to compose this specific matrixial alliance.

In the scene of differentiation that is not separation, the Lover's role *resembles* the father in an Oedipal role, but it is not the same role at all. The Woman-beneath-the-Girl needs the Lover *to be in love with the m/Other-Woman* and confirm the desirability of the Woman for himself and for the Girl. He is not loved by the girl; not yet, or not anymore, or not at this moment. For the Girl, the Lover must be unable to live without an m/Other-Woman; her coming into being depends on this. The coming-into-being in womanhood of the Girl depends on the unconditional ravishing of the m/Other-Woman as such, and on her own both inclusion and exclusion from a scene that will give birth to her differentiated woman-self. If the m/Other-Woman will not be ravishing in a matrixial event in a matrixial space and time suspended out of each participant's personal history, but included in their shareable trans-subjectivity as traces of the memory of one another for one another, or if the repetition of such an event of encounter is doomed to fail again and again, if it stops before the time needed for the accomplishment of the process of interweaving and differentiation, it loses its healing potentiality. For the desirability of the m/Other-Woman to be established, where the Girl would be able to share her ravishing with her while disappearing from the primal fabric, the Lover must prefer the m/Other-beneath-the-woman to the Woman-beneath-the-Girl. Not being able to love the m/Other-Woman when making love to her is the Lover's only crime in the eyes of the primal

scene revived by the erotic antennae of the girl. And this is, precisely, why the repetition of the primal scene – with Hold in the position of the Lover and Tatiana in the position of the m/Other-Woman – that was orchestrated by Lol, failed. Because Hold loves Lol, and not Tatiana. Because for the scene to succeed, once and for all, Hold had to love Tatiana: this was Lol's desire. The desire of Hold for Lol ruined it all. Once again, and from another angle, the primal scene became traumatic.

In the first scene, during the Dance, the Lover (Michael Richardson) was fascinated by a m/Other-Woman (Anne-Marie Stretter) who failed to include Lol's fascination for her in the scene. Here, Lol was prematurely excluded. In the second scene, endlessly repeated, Hold failed to be fascinated by a m/Other-Woman (Tatiana). Here, therefore, Lol was not excluded enough from the scene, because she was the object of the Lover's fascination and she could therefore not absorb without perceiving a scene where fascination and desirability are played *without* her being their object. Lol looks for a perspective in which a Lover is fascinated by a Woman and not by a Girl, while the Woman includes the girl in her ravishing perspective. Her birth as a woman is rooted in these inclusions and exclusions within the same matrix. Thus, each scene wounded the emerging matrixial fabric from another angle.

"He was younger than she was"... "I wanted to see them"... "What is it you wanted?"... "To see them"... There are two of us now, beholding Tatiana naked beneath her dark hair... "Please, I beg you, implore you, don't leave her"... That moment when Lol was completely forgotten, that extended flash, in the unvarying time of her watchful wait, Lol wanted that moment to be, without harboring the slightest hope of perceiving it. It was... We must have been there... all three of us, an hour since she had seen us appear in turn in the frame of the window, that mirror which reflected nothing and before which she must have shivered with delight to feel as excluded as she wished to be... "You cannot bear to be without her, can you?" I see that a dream is almost realized. Flesh is being rent, is bleeding, is awakening. She is trying to listen to some inner commotion, fails to, is overwhelmed by the realization, however incomplete, of her desire... She loves, loves the man who must love Tatiana. No one. No one loves Tatiana in me. I belong to a perspective which she is in the process of constructing with impressive obstinacy... JB is under the impression he saved me from the depth of despair... I've never told him it was something else... That from the moment that woman walked into the room, I ceased to love my fiancé ... They took me with them. When I woke up, they were gone... I forgot

Tatiana Karl, I admit having committed that crime... "Yes but you were supposed to fall in love with her too"...She used to think that it was possible for there to be a time which filled and emptied alternately, which filled and emptied, and then was ready to be used again, always, to be used and reused, she still believes it, she will always believe it, she will never be cured... "This year, this summer, you came too late". "I could not get here at the right time. It's because I started to love you too late"...Tatiana is there, so that I can forget Lol Stein in her...Lol, close beside me, moves even closer, closer to Tatiana... "I don't love you and yet I do"...Now there was no longer any difference between her and Tatiana...

During an encounter with-in the matrixial-feminine event that is conceived in a plaiting-of-several, at least in a being-of-three, traces of the immemorial can be stirred up and reinvested. If the feminine differentiating agency does not only weave the Real, the Symbolic and the Imaginary so that no definitive frontier separating them can be established, if it also weaves the RSI of several individuals, then in the plaiting, no personal identity can work-through its sole destiny in relation to the question of whether to live or not live as a body-psyche awakened in the bodily Real that is still submerged in the impossible sexual relation of the primal scene. This scene is none other than phantasmatically incestuous by nature, but of this incest, built upon an originary incest that is not-yet prohibited because it is necessary for bringing someone into life, and that at any moment is relived as between not-yet-life *and* life, the encounter of not-being with becoming and non-desire with desiring takes place.

"I don't love you and yet I do. You know what I mean." I ask: "Why don't you kill yourself? Why haven't you already killed yourself?" "No, you are wrong, that's not it at all"...Lol was looking. Behind her, I was trying to accord my look so closely to hers that, with every passing second, I began to remember her memories...One trace remains, one. A single, indelible trace, at first we know not where. What? You don't know where? No trace, none, all has been buried, and Lol with it...

A matrixial difference based on the weaving of links, rather than on essence or negation, thus opens up, between one woman and her others, between one woman and another. Thus, reconsideration of the primal scene through the plait sheds light on sexual difference as a question that women-girls do not address to man nor in "The Name of the Father," not yet, in any case, but to an Encounter-Event-Thing beneath another

woman-mother-Other, to a subject envisaged as similar-but-not-the-same, from whom one differentiates-in-the-union and through whom it is possible to open a distance only in proximity, in shareability, in a plaiting of a transgressive being-of-three.

VIII

Lol tries to cross and share a process of subjectivization in an event of encounter, marked by the actively blinding ravishing, before-as-besides of any identification either with *the being desired as an object* or with *the being desiring as a subject*. This occurs by participating in a momentarily opened and shared subjectivity, whose matrixial *objet a*, like the becoming-subject who is found "between the center and nothing" in a matrixial borderspace, is a *link a*. It links presence and absence and non-living (not-yet born) and hardly-living. Through the participation in the event of encounter, a matrixial woman–woman difference struggles to open up, a difference that has nothing to do with Oedipal man/woman difference, but which accompanies and subtends it. This difference is neither Oedipal nor anti-Oedipal, nor even pre-Oedipal, because its origin lies elsewhere, in an already crossed subjectivity. The difference opens while living the transition and circulating in the link between the primal scene and the Oedipus complex, and it leans on a potentiality for redistributing traces of memory between different participants of the encounter. The matrixial event is momentary. It vacillates. It is evanescent in the loss of the borderlinks; and the unraveling of each matrixial plait is always on the horizon of its creation.

The fatal ravishing, neither conscious nor unconscious, but non-conscious, does not try to see, or to see itself, or to be seen. This is where Duras's expression concerning the non-gaze of this fatal woman, Anne-Marie Stretter, is critical. If the gaze is conceived as an "incommensurable" measure of object loss at the heart of the process of coming-into-being of the subject, then I consider the non-gaze, as its reverse, as responsible for the relative loss in the borderlinks during the tying up of limit-links with the trauma of the Other. This is how, in transgression in a trans-subjective plaiting, remembering the memory of the other and even for the other, whose subjectivity is suspended, becomes possible. Recognized only in/with and by an other in the momentary, phantasmatic and traumatic encounter, the ravishing is the non-gaze par excellence. Blind and stupefying, the ravishing-ravager non-gaze operates by reconnecting a woman-girl who

finds herself in the position of becoming-subject initially with the death drive, unless a fatal woman who is her subjective support takes on the fragile position with her, by opening her borders and interlacing her RSI strands so that she too becomes a partial subject, including the girl "inside" her bodily imaginary which is a carrier of life drives. When we move from the field of phallic loss, through castration, of the object-Other-mother/woman-m/Other- and its trace as *objet (a)*, towards relations-without-relating with-in the woman-m/Other-Thing as *link a*, we see the difficulty of thinking through the links, as well as their failures, outside of plaiting itself. It is only by crossing the non-gaze in a trans-subjective and cross-subjective opening, and in participating in a plaiting that includes it, that an assembly-that-joins-in-separating allows a girl in turn to become a woman. I therefore differentiate between a phase of non-identificatory sexual differentiation linked to the primal scene, which hides under a plaited being-of-three, and which the formula of hysteria overlaid on Oedipus veils, erases, and foils.

To summarize: even if the three triangular scenes in which Lol involves herself – or is implicated – are Oedipal, it is not an Oedipal triangle that operates here in terms of the active desire of the man (father) for a woman (mother) seen by the child (constituted in terms of the male child's narcissism by Freud). Instead we have a plaiting from the perspective of feminine desirability that operates as an active, rather than a passive, pole, as one that is subjectivizing, not objectivizing. The ravishing of the non-gaze is formative, and it enables us to conceive of feminine difference firstly on the Woman–Woman axis along the movements between the Woman-beneath-the-Girl, the Girl-beneath-the-Woman, the m/Other-beneath-the-Woman and the Woman-beneath-the-Mother, starting from the links between the female child and the archaic Woman-m/Other, subtending and neighboring the Woman-Man axis, and thus constituting the hidden weft of the Oedipal being-of-three.

An important detail: it is Lol's mother who prevents, in the first scene (the dance floor), a new pathway to an other Woman-Other-mother from proceeding to its "end" by introducing the ravaging in the same place where the ravishing had just been born, by stopping the process of weaving and plaiting prematurely. For Lol is not perverted at that moment; she is in the process of becoming a subject-woman-girl in a difference with and from another woman-mother. It is this process that is cut in a traumatic manner by the still premature presence/absence alternative, instigated by her own mother in the first scene, and then differently by the man in a sexual encounter (Hold with Tatiana) in the last scene. Without passing

through an encounter with the Other as Woman-m/Other-Encounter that might occur by remaining in a partial dimension at the risk, of course, of fragmentation and dispersion, Lol cannot come into being in the place reserved either for a desiring subject or for a desired object without the risk of devastating madness. In the second scene (the series of meetings between Tatiana and Hold that she tries to watch from the field), she is not yet a "normal" woman or a "hysterical" woman. Nor is she psychotic yet. In the third scene, however, when she is rushed toward an imaginary triangulation that is essentially Oedipal (Lol alone with Hold), while she is still trying to link up with a primary encounter-event relating to a primal scene, she does go mad.

Contrary to an Oedipal situation, a man-father-lover as an identified subject, who is the imaginary support of the Name of the Father, cannot conclude this affair in the place of a ravishing Woman-in-Encounter, in place of the "impossible" Encounter-Event itself where the ravishing of the Woman and the differentiating inside a feminine field might occur. The first scene "prepares" for psychosis only as a possibility. The second scene holds this possibility in suspense. Here, repetition in difference, as in psychoanalytical matrixial transferential relationships, can make all the difference for further psychic development. In a new plaiting with-in the Real, outside of regular time and place, that which failed in the first attempt is given a second chance. Lol reaches for an original therapy: she tries to move forward in the place where the first scene stopped too early for her. She wants to move forward otherwise. Through her own, overly concrete means she works to give herself a primal scene through the scenario of herself-with-Tatiana-with-Hold, with a new plaiting-of-three that would include her, phantasmatically and traumatically, in order to work-through this scenario of working-out a woman–woman difference that is sought out again. She tries to draw the strands of the RSI of this new crossed-subjectivity. She is plaiting her own RSI strands in an encounter. Only after the success of this type of plaiting could she have opened up to the man–woman difference so as to become "normal" or neurotic.

The second scene is a time outside of time and a place outside of place, because it is the prolongation of the primal scene in a plaiting of severality, under the cover of an Oedipal scene that seems perverted, but which is not so in fact, for Oedipus is *not yet there*. From the second scene she could perhaps still get herself out without psychosis, for she is not yet psychotic. She becomes psychotic during the third scene because she has been rushed toward the Oedipus complex too quickly, without having achieved a

departure from the primal scene through the difference in the winding in the feminine plaiting between the Woman-beneath-the-Girl, the Girl-beneath-the-Woman, the m/Other-beneath-the-Woman, and the Woman-beneath-the-Mother, leaning on the links between herself as a female child and her archaic Woman-m/Other:

> She can spend the rest of her life here looking, stupidly seeing again what cannot be seen again... I accept... the end which has still to be invented, the end I do not yet know, that no one has invented: the endless end, the endless beginning of Lol Stein... Lol dreams of another time when the same thing that is going to happen would happen differently. In another way. A thousand times. Everywhere. Elsewhere. Among others, thousands of others who, like ourselves, necessarily dream of this time.

Notes

This chapter is the extended and revised version of "Plaiting a Being-in-Severality and the Primal Scene," a lecture presented at J.A. Miller's seminar on June 7, 2000, originally published *in Almanac of Psychoanalysis*, no. 3, 2003, 91–112. This essay develops three new concepts: the matrixial trans-individual braid; the woman-to-woman matrixial feminine difference; and *fascinance* as a feminine shift of Lacan's concept of *fascinum*.

1 Sigmund Freud, "Fragments of an Analysis of a Case of Hysteria" [1905 (1901)], *The Standard Edition of the Complete Psychological Works of Sigmund Freud*, vol. VII (London: Hogarth Press, 1953), pp. 15–112 (p. 96).
2 Jacques Lacan (1964), *The Four Fundamental Concepts of Psycho-analysis*, trans. A. Sheridan (New York: Norton, 1981), pp. 105–19.
3 Ibid., p. 115.
4 Bracha L. Ettinger, *The Matrixial Gaze* (Leeds: Feminist Arts and Histories Network Press, University of Leeds, 1995).
5 Thomas H. Ogden, *The Primitive Edge of Experience* (New York: Jason Aronson, 2003).
6 Julia Kristeva, "Experiencing the Phallus as Extraneous, or Women's Twofold Oedipus Complex," *parallax*, vol. 8 (1998), 29–39.
7 Marguerite Duras, *The Ravishing of Lol V. Stein*, trans. Richard Seaver (New York: Grove Press, 1966). All the quotes are from this edition unless otherwise noted.
8 Sigmund Freud, "Fragments of an Analysis of a Case of Hysteria," *Standard Edition*, vol. VII. I have commented on this case in my essay (in Hebrew) "On the Matrix, on Feminine Sexuality and One or Two Things about Dora," *Sihot-Dialogue*, vol. VII, no. 3 (1993), 175–83.

9 See Bracha L. Ettinger, "The With-In-Visible Screen," in C. de Zegher (ed.), *Inside the Visible* (Boston, MA: MIT Press, 1996), and "Art as the Transport-Station of Trauma," in *Artworking* (Ghent-Amsterdam: Ludion, 2000).

10 See Bracha L. Ettinger, *The Matrixial Gaze*; reprinted in C. de Zegher and B. Massumi (eds), *Bracha Lichtenberg Ettinger: Eurydice Series. Drawing Papers*, no. 24 (New York: The Drawing Center, 2001).

11 For more on the question of the practice of psychoanalysis see "'Working-Through': A conversation between Bracha Lichtenberg Ettinger and Craigie Horsfield," in *Drawing Papers*, no. 24. See also Bracha L. Ettinger, "Trans-subjective Transferential Borderspace," in Brian Massumi (ed.), *A Shock to Thought* (London and New York: Routledge, 2002).

12 Jacques Lacan, *La logique du fantasme*. Unpublished seminar, 1966–67.

13 In "Wit(h)nessing Trauma and the Matrixial Gaze," *parallax 21*, vol. 7, no. 4 (London: Routledge, 2001). Previously printed in P. Vandenbroeck and B. Vanderlinden (eds), *The Fascinating Face of Flanders* (Antwerp: Stad Antwerpen, 1998).

14 Jacques Lacan, *Les non-dupes errent*, Unpublished seminar, 1973–1974; Lacan, *RSI*, Unpublished seminar, 1974–1975; Jacques Lacan, *Le sinthôme*, Unpublished seminar, 1975–1976.

15 I analyzed the "bubble," the cloth, or the fabric of the baby–mother union and the primal scene in: "Wit(h)nessing Trauma," op. cit. (n. 13).

16 I refer to few discussions in the frame of the course of J.A. Miller in May and June 2000, Paris-VIII, The University and the Freudian Field, Paris, 2000.

17 Lacan, *Les non-dupes errent*.

18 Ibid.

19 Lacan, *RSI*.

20 Lacan, *Le sinthôme*, December 9, 1975.

21 Lacan, *Les non-dupes errent*.

Melancholia and Cézanne's Portraits: Faces beyond the Mirror

Young-Paik Chun

If the artist projects his own nature into a portrait, that nature may be one indifferent to personality, it may itself be a personality that seeks to free itself from the difficulty of communication with others by creating a solitary expressive domain where it is master.

Meyer Schapiro[1]

Introduction

Some portraits by Paul Cézanne have struck art historians as having an "inhuman" effect. It is as if Cézanne lowered mankind to the level of inanimate things. Of the *Portrait of Victor Chocquet* (1877; Figure 4.1) Schapiro writes, "the texture of the pigment is more pronounced than the texture of the represented objects, and the painted pattern is clearer than the structure of things."[2] The physiognomic features of Chocquet are extremely simplified. The geometric construction is reinforced by the exaggerated patterns of the wall, and the carpet which is brought forward by bright colors unifying the whole surface. Relaxing in an armchair in his dining room with his hands interlocked and one leg crossed over the other, Chocquet appears to settle completely into this meticulous composition of color, as pieces of a puzzle fit into a whole design.

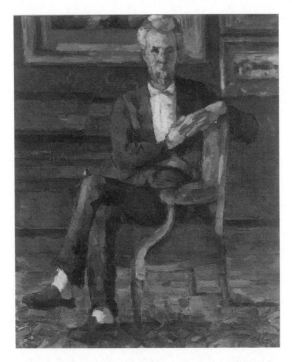

Figure 4.1 Paul Cézanne, *Portrait of Victor Chocquet.* V.373, 1877. 46 × 38 cm. Reproduced courtesy of Columbus Museum of Art, Ohio: Museum Purchase, Howard Fund.

In *Madame Cézanne in a Yellow Chair* (1893–5; Figure 4.2), Hortense Fiquet, the painter's wife, wearing a crimson dress with a shawl collar, is shown in three-quarter view, sitting in a high-backed chair of patterned yellow fabric. Its simplicity enforced by its thin paint surface, the body, supported by the yellow chair, slants radically to the left, a movement that is balanced by the vertical line of her upright head and the horizontal red band crossing behind her. As if to prevent her from toppling over, Hortense Fiquet's glance is alert and straight, accentuated by the reduced form of her head. She is depicted with her hands held together, adopting an erect and still pose in the chair that appears to hover in between standing and lying. The sense of distance and indifference seems to reach the highest degree. Hortense Fiquet looks extremely cold and aloof, not only because of the absolute inexpressiveness of her countenance, but also because of the metallic light reflected on her face. In facing his wife who

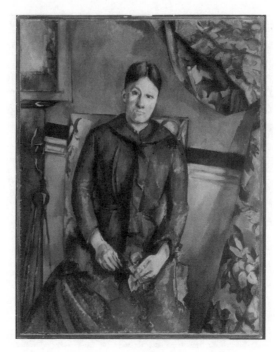

Figure 4.2 Paul Cézanne, *Madame Cézanne in a Yellow Chair.* V.570, 1893–5. 116.5 × 89.5 cm. Reproduced courtesy of The Metropolitan Museum of Art, New York.

had also been his mistress for 16 years since 1870, and having every reason to be considered his object of erotic cathexis, Cézanne's obstinate control over emotional revelation does not seem to have slackened, as Hortense Fiquet's small and thin lips are firmly closed in this portrait.

Portrait of Joachim Gasquet (1896; Figure 4.3) depicts Joachim Gasquet in half-length, wearing a dark gray suit and leaning against a window-like plane with its frame in a radically unfinished state. Gasquet's body leans to the left across the painting, a diagonal sustained by the line constituted by his nose and the join of his waistcoat and counterbalanced by the line of his shoulders, receding to the inner space of the painting. Gasquet's curled hair corresponds with the circular patterns in topaz behind him to his right, which press down on his shoulders. Strikingly, Gasquet's eyes are not even; while his penetrating right eye reaches out to the viewer, the left one, much lower than the right one, fades out in a vague incompleteness. The visible spaces of bare canvas appearing through the thin coat of paint suggests that Cézanne spent little time on this portrait of Gasquet,

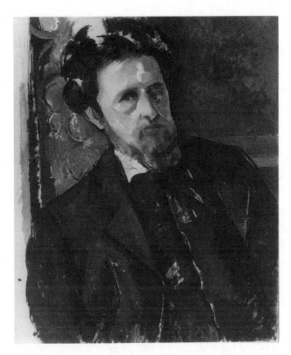

Figure 4.3 Paul Cézanne, *Portrait of Joachim Gasquet.* V.694, 1896. 65.5 × 54.4 cm. Reproduced courtesy of Národní Galerie, Prague.

capturing his sitter only as a sketch. Gasquet himself, however, recalls: "I sat no more than five or six times. [...] Much later I learned that he had devoted about sixty sessions to it."[3]

As the model of this portrait, Gasquet felt that the artist "took [his] inner being by surprise" and represented it in this portrait. Despite such an "inhuman" treatment of the figure – the distortion of eyes and the incompleteness of the left parts of the configuration – there is, nonetheless, a certain affect which is profound and deeply moving. Why did Cézanne have to have, as Gasquet appreciates, "the apparent harshness which conceals the humane tenderness of his most beautiful canvases"?[4]

Portrait of Ambroise Vollard (1899; Paris, Musée du Petit Palais) is the portrait of the art collector who gained public recognition for Cézanne's work. This painting is an example of the artist's idiosyncratic request for the model at the sitting – to "remain still like an apple." After an agonizing 115 sessions, the artist left this portrait apparently unfinished. Cézanne depicted Vollard with one leg crossed over the other and the hands,

holding a journal, folded in his lap. While Vollard's upright body constitutes the distinct vertical axis in this painting, the bottom of the studio window delineates the horizontal axis, which intercepts the figure at his neck. As is so often the case, the latter is on a different level at the left and right. To Vollard's upper right, behind him, one is led to a distant view outside through the window, where there are geometrical forms of chimneys and roofs, among which two oval shapes in dark gray are reminiscent of Vollard's head. In a deep and compact structure of color, this representation of Vollard retains a somber and calm mood, characteristic of Cézanne's portraits of the 1890s.[5]

The aloofness and emptiness in Vollard's face in this painting reaches its apogee among Cézanne's portraits. Reff writes of the face as "singularly inexpressive." It is separated from the hair and beard by the strong contoured definition. "It is almost literally a mask and says little about Vollard's colourful and crafty personality."[6] It appears that Cézanne omitted individual characteristics of Vollard in this "general" portrait,[7] and intensified something that touches upon an essence of Vollard's subjectivity, slowly emerging on this portrait's thick and dense surface.

Vollard's eyes are the most conspicuous feature in this portrait. It is not because the eyes are highlighted by the painter's sophisticated skill or light effect; on the contrary, their attraction comes from the fact that they are "badly treated." It is even difficult to see where the pupils are. Although it is true that Cézanne often neglected a detailed description of the sitter's eyes, one can find no other sitter's eyes which are less realized than those of Vollard in this portrait. Badt offers an explanation for "empty-eyed" Vollard: he was "blind from too much light."[8] In contrast to Badt's reasoning, the light looks far from strong in this portrait. It comes from behind Vollard, through the window, softly brightening the background and falling onto the sitter's forehead, shoulder, and along the line of his right arm, finally culminating in his square fist. Light is subsumed in every part of this painting, and glows in its internalized state. Vollard's sightless eyes and lifeless glance appear to highlight his isolation in the world. The void of Vollard's eyes only corresponds to the eye sockets of the skulls, which Cézanne painted around this time (*Pyramid of Skulls*, 1898–1900; V.753; Private Collection). As if they were holes in the texture of the visible and known, Vollard's eyes appear blank, implying an immeasurable depth of texture, which is invisible on the surface of the painting. His gaze seems intractable, appearing to look nowhere and at the same time to look everywhere.

Reading Cézanne's portraits from a psychoanalytic perspective is not an easy task. Firstly, in general terms, as Schapiro notes, "a portrait, besides being an image of an individual, is also a painting with its special problems of composition and colour." Secondly, in the context of art criticism, Cézanne's portraits have been perceived in contradictory ways, especially regarding the quality of non-expressiveness, around which interpretations are varied and inconsistent. Despite the cold façade of Cézanne's representation, some critics such as Schapiro have spotted certain traits through which Cézanne reveals his desire for the human being; the traits, in Schapiro's words, that "surmounts the influence of the still life and the landscape."[9] I would like to search for a theoretical trajectory in order to apprehend this paradox of Cézanne's portraits, where the two opposed affects of the absence of expression and highly intense desire merge.

Furthermore, the reading I propose of Cézanne's painting in terms of melancholia encounters the challenge of identifying the *structure* of "Cézanne's" representation as distinct from the artist, Paul Cézanne. It seems obvious that Cézanne was a depressive person. In the history of western art, there are few artists whose level of depression was as profound as Cézanne's. It is well known that Cézanne exhibited an extreme disgust toward human beings and an almost pathological fear of physical contact. Above all, he had a notoriously uneasy relationship with women, keeping them at a distance. His somber mood was so resilient that even the great success of his one-man show in 1895 did not bolster his self-esteem. Cézanne's despair, moodiness, and even melancholy are familiar terms in any biography of Cézanne, where he is often described as an unpleasant individual. When, however, we see an undeniable beauty in the low-keyed tones of sadness in Cézanne's painting, we are naturally drawn to wonder if his despair retains a trait too fundamental and too identifiable to be diagnosed merely as a person's peculiar psychological distress.

Although it is treacherous to draw an absolute line between an artist's individuality and his work, Cézanne's own melancholy is not my concern in this project. The art or process of representation may surpass an artist's limited personality, emerging from pictorial structures in which unexpected outcomes can result, moving beyond the artist's original plan for the composition of form and color in painting. This project, therefore, attempts to read *Cézanne's portraits* through recent psychoanalytic theories of melancholia. I shall not only read the symptomatic structure of melancholia represented in Cézanne's painting. I want to present the

activity of his painting as a constant tension between indulging melancholia and withstanding it.

I Mask-like Expressions in Cézanne's Portraits

In *Black Sun*, Julia Kristeva analyses the sadness in the discourse of the depressed as a shield against madness:

> [...] As for the discourse of the depressed, it is the "normal" surface of a psychotic risk: the sadness that overwhelms us, the retardation that paralyzes us are also a shield – sometimes the last one – against madness.[10]

In melancholia, according to Kristeva, the separation from the mother – which is necessary for the subject's entry into language – is not accomplished. As an "unsuccessful separation from the mother" and an "unsuccessful emergence of primary narcissism," melancholia is dominated by sadness.[11] The melancholic's sadness seems to be a psychic rupture through which we see the internal structure of melancholia, whose object relations are rather peculiar. Kristeva states: "for such narcissistic depressed persons, sadness is really the sole object; more precisely it is a substitute object they become attached to, an object they tame and cherish for lack of another."[12]

Let me propose that a peculiar, yet specific sadness emanating from his forms and colors pervades Cézanne's works. Perhaps such sadness might lie not in his paintings themselves, but rather in the process of our perceiving them. Inadequately described by any existing words, the affect of such sadness in its precarious identity would be best expressed in terms of detachment, as some art critics, such as Fritz Novotny, have already done. It seems, nonetheless, that in order to trace the structural aspect of the disposition of detachment emerging through Cézanne's paintings, we need, as a starting point, to approach it in terms of a representation of sorrow.

Strictly speaking, sadness, including the sense of unhappiness which most people perceive in the paintings of Cézanne's mature period, would not signify what Cézanne might have sought to elicit through his representation. Perhaps it could be one of the affects that he wanted to erase from his painting or from the way in which he looked at things. Otherwise, how can we explain the mask-like expression of the figures in

Cézanne's portraits, which provokes a sense of loss and void? By extension, how should we perceive his landscapes, which appear as if they were kept behind a thin yet impermeable screen?

The quality of non-expressiveness and indifference in Cézanne's portraits, so predominant in the viewer's perception of these images, has attracted both attention and perplexity since the earliest analysis of Cézanne's painting. The mask-like expression (or non-expression of the mask-like faces) of the people portrayed by Cézanne has been articulated in various ways by many art critics, most emphatically by Novotny.

Novotny identifies a crucial characteristic of Cézanne's paintings, which, I would argue, shares a psychical structure with melancholia: "the lack of 'mood' or 'atmosphere' " ("*Stimmung*" in German).[13] Novotny asserts that "aloofness from life" or "aloofness from mankind" is what gives Cézanne's painting "a cold, rigid, almost repugnant character, and renders their comprehension difficult for many people." He highlights this aloofness most evidently in Cézanne's representation of people, saying that "in Cézanne's pictures the human figure often has an almost puppet-like rigidity, while the countenances show an emptiness of expression bordering almost on the mask."[14]

One may grasp Cézanne's intention in such a fundamental detachment, through his radical gesture of rejecting the viewer's sympathetic gaze when one tries to relate to the puzzling images in his portraits: the sitter in a stiff – almost frozen – pose in a geometrical composition in the *Portrait of Gustave Geffroy* (1895; V.692; Musée d'Orsay, Paris); the monk-like rigidity and obstinate resistance of the *Old Woman with a Rosary* (1895–6; V.702; The National Gallery, London); the unfinished, yet sharp and sensitive face of Joachim Gasquet (1896; Figure 4.3); the strikingly blank eyes of Ambroise Vollard (1899), and Madame Cézanne's doll-like head, weightless body, and the complete muteness of her face in the *Portrait of Madame Cézanne* (1888–90; V.529; Museum of Fine Arts, Houston) and the *Madame Cézanne in a Yellow Chair* (1893–5; Figure 4.2).

The novelist D.H. Lawrence's reading of Cézanne's painting written in 1929 provides an insightful literary interpretation of the artist's visual language. He maintains that there is a necessary distinction at the level of the outward appearance of an object: the distinction between *cliché* and what he names *appleyness* in a metaphorical sense. In the case of figure paintings, the physical *cliché* is equivalent to "so-called humanness, the personality, the 'likeness'," which, according to Lawrence, "we know all about and find boring beyond endurance," whereas the *appleyness* of an

object is, he explains, something that can be perceived only by intuitive apperception or instinctive awareness of the object.[15]

Such apperception of the *appleyness* refers to an essential physicality that, in Lawrence's view, captures the object from all around, even penetrates its interior. Cézanne's painting, according to him, aims to capture the *appleyness* of an object and to exclude its *cliché*. Thus we can assume that the *appleyness* that Lawrence glimpses in Cézanne's painting requires the artistic eye, capable of seeing through an object to the point of the revelation of its hidden aspects, its quintessence and thus its difference from its objecthood in both literal and psychoanalytic terms.

One can grasp the meaning of Lawrence's notion of *cliché* and *appleyness* in many of the paintings I have discussed. In these portraits, all the hindrance of *cliché*, such as the unnecessary description of surroundings, reference to the social status of the person, or description of personality, are eradicated in the configuration of the figures, whose anonymous forms are then revitalized by the lively and dense colors applied by the painter. Such portraits confirm that once Cézanne had evacuated all ordinary and banal associations, his laconic visual language has been endowed with forceful directness and condensed meaning.

Cézanne's *Portrait of Joachim Gasquet* (Figure 4.3) offers a more direct example of Lawrence's reading. In fact, one cannot find a more convincing reading than Lawrence's as an explanation of Gasquet's radically unfinished face, those bare parts, which nonetheless ironically appear to contribute to an essential configuration of this sensitive poet. These schisms and cracks in Cézanne's representation of Gasquet are captured by Lawrence when he accounts for Cézanne's "final method of avoiding the cliché": "just leaving gaps through which it fell into nothingness."[16]

Despite all the uncolored gaps, dispersed throughout Gasquet's face, hair, and collar, I find it difficult to describe this painting as flimsy, since it extracts what could be regarded as the essential structure of the sitter. When we focus on Gasquet's face, we see the way in which the color patches and blank parts cooperate in the face, and then contribute to the construction of the overall image of the face. As a face without cliché, in Lawrence's words, the basic structure of Gasquet's face is constituted by the minimal brushstrokes of patches of apricot, vermilion, crimson, and sage green color. The untouched spaces of Gasquet's face become scattered holes through which we can push through the cliché in our perception of this figure in order to reach a pure seeing. Through these gaps, any form of our emotional investment slips out of this painting. Only Gasquet himself,

now free of the cliché, is left on the surface in the minimal sense that his existence is on the threshold between being and non-being. As precarious as he looks between the coverage of color patches and the blank emptiness behind it, Cézanne's Gasquet resides on the edge of his appearance.

The viewer is afraid of losing Gasquet's face; the face in which the undefined bare parts tend to cancel his being on the one hand, while the texture of the color structure holds it tenaciously like a skeleton on the other. In Cézanne's portrait, Gasquet is suspended between the two contradictory forces in the apparatus of perception. Cézanne's project was to capture the sharp borderline state of the sitter as such.

We may have to look at Gasquet's face while bearing in mind Ambroise Vollard's recollection. After noting that Cézanne loved to paint portraits, Vollard records that "he would say that 'the goal of all art is the human face.' "[17] What did Cézanne seek to achieve in the far less defined, almost neglected face of Gasquet? The full degree of concentration and intensity, at least, reaches a climax in his right eye, whose pair is radically deformed and dislocated, thereby increasing the distinctive effect of the right one. I do not know of any other portrait in which the sitter's glance looking out at the viewer is more direct. The possible exception of his first self-portrait (c.1861–2; V.18; Private Collection), which, we know, may correspond to this unbearable confrontation issuing from Gasquet's penetrating glance. The Gasquet portrait retains an optical force almost strong enough to reverse the sitter's position of "being seen" to the one who "sees."

Gasquet himself points out that one of Cézanne's "usual procedures," especially with regard to his portraits, was "to work after the sitter had left."[18] Gasquet's own memory of Cézanne's distinctive way of portraying people as such, can be read as revealing the artist's stubborn intention not to be deluded by the apparent physical appearance of the sitter. What did Cézanne aim for in this sketch-like representation by devoting about sixty sessions even while the sitter was absent? The poet recalls:

He [Cézanne] wanted to catch the life, the facial mannerisms, the actual feeling of words being spoken, and I don't doubt that he used to guide me into an expansive mood in order to *take my inner being by surprise* in one of those passionate outbursts during a discussion [...]. (original emphasis)[19]

Despite Gasquet's impression that the artist took his inner state of mind, (if we define state of mind as conventional portraits do), Cézanne's portrait of the poet offers no hint of the so-called "inner being." It is

treated too summarily to represent Gasquet's physiognomic character-istics, and his oblique pose is not assumed to be idiosyncratic. Nor does it provide an image faithfully remaining on the surface. The unfinished, radically broken surface, not being a unitary plane, holds this loosely constructed but intense representation of the sitter's very private self – Gasquet's image when he is alone rather than with others.

As difficult as it may seem, Cézanne's portrait functions on the border be-tween sharply capturing an essential part of a sitter, and not turning it into a cliché of his (or her) tedious emotional expression. The enigma is this: through these aloof images of people, Cézanne succeeds in reaching a pro-found psychic condition to the extent that Gasquet feels "his inner being taken by the artist." What is intriguing is the unlikely relation between the façade of indifference and coldness featured in people's faces and the emergence of an archaic affect, between the impression of immobility and withdrawal of the people and the expression of a deep secret from their intimate lives. We have Gasquet's testimony of feeling that something intensely intimate was touched on in Cézanne's painting, a painting that otherwise looks the antithesis of a conventional, romantic portrait wherein the sitter's soul is believed to be mirrored. In Cézanne's portrait of Gasquet, what perplexes is a pictorial effect on the surface of the painting that holds an affect that is not the expressiveness of the human countenance.

I propose that the unfamiliar affect in Cézanne's portraits can be fairly accounted for in relation to psychic processes characteristic of melancho-lia. This maintains his painting on the edge of being in a state of non-being, in Lacan's terms, between Thing and object. It also keeps its unbinding energy and libido from being mastered in the subject–other relationship. The painted surface of Cézanne's portraits as the pictorial space where his imaginative insight into the state of subjectivity is ma-terialized, allows us to see how he situates his sitter on the edge of becoming a subject while not becoming an individual.

II The Borderline State of Being on the Painted Surface and the Structure of Melancholia

Hans Sedlmayr's modernist analysis of Cézanne's painting provides us with an insight into this specific connection between psychoanalytic concerns and visual effect. Sedlmayr explains that Cézanne deliberately excluded human feelings in his portraits of people in order to attain "pure

vision." He writes: "the essential aim of Cézanne then is to represent what 'pure' vision can discover in the visible world, vision, that is to say, that has been cleansed of all intellectual and emotional adulteration."[20] This attitude of "pure seeing" in Cézanne's perception enables him to capture "the world of everyday things in a manner, in which they seem more significant, more 'real' than they ordinarily appear." Sedlmayr adds, however, that his pure vision has a side effect: "but precisely because he confines us wholly to the experience of the eye, he also to some extent shuts off from us the very world that the eye beholds, and makes it impossible for us really to feel our way into it."[21]

Developing Novotny's interpretation of aloofness in Cézanne's art as "extra-human" and "divorced from life," Sedlmayr asserts that the uniqueness of Cézanne's attitude in portraying objects exists in his attainment of their "ultimate origins" through retiring from the world of common things.[22] Sedlmayr suggests that where he withdraws from ordinary emotional attachment to objects, Cézanne "attains his essential sphere" and "discovers the realm of colour *per se*." Sedlmayr captures the moment when the artist's perception out of the "peculiar [psychic] state"[23] could provoke the intensity of his color as follows:

> The magic that pertains to this way of looking at things is that even the most ordinary scene acquires a strange and original freshness, and above all, that colour released from its task of indicating and identifying objects, gains an intensity that it never previously possessed.[24]

The viewer cannot ignore the exhilarating color effects in *Madame Cézanne in a Red Armchair* (1877; V. 292; Museum of Fine Arts, Boston), for example. In this canvas, the texture of color looks firm, covering the entire pictorial surface. It seems that Cézanne's concern in this painting is to build up colors on the level of the picture plane, from which they expand and reflect. This amazing celebration of color is composed of a condensed combination of the green, olive, jade, and violet of the blouse with a ribbon, the intensity of the orange-red of the armchair, and the brilliance of the yellowish green of the shirt. Looking at her shirt, our vision strays to the point of transgressing to the tactile and even auditory sensations; it is as if we touch its texture and hear its pleasurable sound as she moves. All these multiple sensations are condensed into the sheer colors that stay on the picture plane.

In *Madame Cézanne in a Red Armchair*, we are led to see her at a distance and to seize her being, but only through our visual reception.

By giving up a physiognomic description and an elaboration of the personal and emotional state of Hortense Fiquet, what Cézanne gains instead in this painting, is the essential quality of her existence beyond her limited individuality – reminding us of Lawrence's notions of *appleyness*, which is extracted and retained in an archaic sensation created by Cézanne's color. This painting allows us to grasp Gasquet's point that Cézanne attained the very substance of his feelings by "disengaging" the object "from anything other than the joy of pure colour."[25]

The tightly textualized surface of color in *Madame Cézanne in a Red Armchair* does not allow the viewer's look to penetrate. More precisely, we do not desire to look through this luxurious color texture, which already gives us enough visual satisfaction through tonal plenitude. In other words, it is obviously not "the transparent window of Renaissance optics"[26] that we look for in viewing this painting. The flatness of the chromatic structure is well compensated for by the spacious effect that the color scheme of this portrait produces, even before our vision realizes that it is placed on a flat surface. The quality of flatness in *Madame Cézanne in a Red Armchair* is not conspicuous in our vision because of this dazzling celebration of color.

The viewer's look goes no further than this tight chromatic texture of representation, which blocks its desire from illusion and phantasy, depriving it of its willingness to move forward and backward in the pictorial space, and of its optical mastery. What Cézanne's Boston representation of Hortense Fiquet offers instead, is the eye's indulgence in the spacious resonance of color, emerging from a deeper site than the façade of representation. It appears evident here that the forms of objects and their conventional meanings are secondary to color. The luxurious red armchair functions more like a fence. The figure's upright upper body appears disconnected from her receding hips and projecting lap, which are radically foreshortened under the glittering flat texture of her skirt.

In *Madame Cézanne in a Red Armchair*, the viewing subject's optical desire is restrained at the level of colored surface. The flatness functions as a "barrier," making the viewer unable to explore the space inside the painting in conventional terms or to invest it with the meanings associated with the forms figured in the painting. Our habitual attempt to explore pictorial space is checked by color, through which the unconscious remnants of meaning irrupts onto the semiotic sphere of the painting.

A range of green, ochre, vermillion, peach, and pale red holds *Madame Cézanne in a Red Armchair* tightly together. This corresponds to Hortense

Fiquet's solid and determined look and her firmly interlocking hands. Cézanne maximizes tonal resonance in the canvas, leaving no uncovered space underneath the colors. In this painting the plenitude of his color reaches the highest degree on which the subject's desire is largely fed. It is a sense of excess or surplus that the chromatic interplay evokes in this painting.

In his reading of Cézanne's still life, Gasquet argues that Cézanne attempted to attain the very substance of his feelings by "disengaging" the object "from anything other than the joy of pure colour."[27] Dorival similarly emphasizes Cézanne's lively color when he analyzes the process of Cézanne's work: "detecting the main volumes of a model's build, simplifying them geometrically, then endowing them with colour and life."[28] It seems that the force of rejection or denial of the traits of *cliché* has a significant alignment to the unusual color effect of Cézanne's portraits. To put this in another way, the depth of Cézanne's color seems greater in proportion to his evacuation of the sitter's emotional expressions, personality, and even the artist's own attachment to him (or her).

This analysis begs a number of questions: why did Cézanne have to render his object (his sitter) as *alien* as possible? What can explain this paradox of the excess of affect conveyed through Cézanne's intense color, which seems to be premised on an ultimate withdrawal from any emotional investment in the object? What is the psychical mechanism involved in this conversion of void to excess in his representation, showing an ardent desire for life through the color constituting his representation, which apparently takes a form "divorced from life"?

I suggest that this paradoxical aspect of Cézanne's painting has a structural similarity to Kristeva's elaboration of a relation between sign system and melancholia or "incomplete mourning." Kristeva highlights the mechanism of melancholia working on signs; that is, driving out the *negation of the loss* (I shall explain this more fully shortly) on which signs are premised and then loading the signs with affects in melancholia as follows:

> The negation of that fundamental loss opens up the realm of signs for us, but the mourning is often incomplete. It drives out negation and revives the memory of signs by drawing them out of their signifying neutrality. It loads them with affects, and this results in making them ambiguous, repetitive or simply alliterative, musical or sometimes nonsensical.[29]

In melancholia, Kristeva argues that language (translation) "becomes alien to itself" in order to "capture the unameable." And "the excess of affect" in

melancholia pushes the limit of existing language, producing new ones such as "strange concatenations, idiolects, poetics." By driving out the negation of the loss of the mother, the melancholic subject seeks to capture the maternal Thing through these different ways of conveying significance. If the melancholic subject is, however, "no longer capable of translating or metaphorizing," it "become[s] silent and die[s]," ending up in "asymbolia, in loss of meaning."[30]

Kristeva's theory of melancholia, therefore, proposes a fundamental linkage between the aloof and alien representation of figures and the intensity of Cézanne's color, obtaining what Sedlmayr terms "original freshness." Kristeva reveals that the "excess of affect" has a close link to the apparatus of "becoming alien to itself" in incomplete mourning.[31] Such excess of affect is, in Cézanne's case, conveyed and brought to the fore by color at the level of the semiotic. Kristeva's delineation of the structure of melancholia in relation to signifying process helps us to grasp an unlikely alignment between the evacuation of emotional expression from figures in Cézanne's portraits and the excess of affect contained in his color. Cézanne's color attains unusually spacious resonance in its visual sign, after its signifying neutrality is driven out, as is in the operation of melancholia.

Interestingly, Sedlmayr in fact detects a psychical structure of the "allegedly 'pure' painters" such as Cézanne and other modern painters, which "borders on the pathological."[32] Sedlmayr draws on the forms of the human body in the paintings of these artists, represented as *having no inherent significance* in themselves, and configured as a "wooden doll," "lay figure," or "engineering model." In doing so, he attributes the "bodiless" state of the human body perceived by these artists to the lack of their capability of projection into external objects, which, according to him, also opened up the realm of modern painting.[33]

In Kristeva's perspective, the "diseased condition" which Sedlmayr senses in so-called "allegedly 'pure' painters" can be regarded as the symptom of melancholia. Defined by Sedlmayr as a "borderline affair" and "a narrow ridge between impressionism and expressionism,"[34] Cézanne's painting, especially his configuration of figures, whose unnatural stillness and "psychic void"[35] is overwhelming, is conceived in the realm of the melancholic's "threshold between 'non-meaning and signs' " in Kristeva's words. The enigmatic intensity of Cézanne's color bears the psychic weight, coming from "the borderline experience of the psyche struggling against dark asymbolism," as Kristeva interprets Nerval's metaphor of depression as a "black sun."[36]

Drawing on Cézanne's configuration of borderline states of being in his unfinished application of color, Cézanne seems to allow the figures in his portraits to *breathe through* those cracks between loosely applied colors, ironically confirming a liveliness based on the precarious condition of their beings. On the one hand, the figures in his paintings appear to be in a state of absolute vulnerability in which their solitude, sorrow, and the burden of their lives are exposed. On the other hand, more importantly, the paintings evoke a sense of release breaking through the *shield of sadness*, which would form the façade of melancholia.

The release of tension, accompanying this process of representing a melancholic state, comes from letting the semiotic resonance of color seep through onto the surface level of representation. It corresponds to a release of a certain archaic affect – what I would call the "Thing affect," which features through the thick texture of the melancholic's language; the "dead language" whose alien skin "conceals a Thing buried alive," to use Kristeva's words. She observes:

> [...] the speech of the depressed is to them like an alien skin; melancholy persons are foreigners in their maternal tongue. They have lost the meaning – the value – of their mother tongue for want of losing the mother. The dead language they speak, which foreshadows their suicide, conceals *a Thing buried alive*. The latter, however, *will not be translated in order that it not be betrayed*; it shall remain walled up within the crypt of the inexpressible affect, anally harnessed, with no way out. (added emphasis)[37]

The melancholic's stubborn objection to translation is, as Kristeva stresses, due to his/her desire to keep "a Thing" under the skin of language in pursuit of his/her incorporation with the maternal Thing. Through this structural feature of melancholia, we may reconsider the significance of the slack links and holes in the painted surface of Cézanne's work. In a certain number of Cézanne's final portraits, we are induced to look at them and imagine what would have preceded those holes and slack links in his painting. In the *Peasant in a Blue Smock, Madame Cézanne in a Yellow Chair* (Figure 4.2) and the *Portrait of Joachim Gasquet* (Figure 4.3), they not only indicate the presence of the picture plane where they reside but also imply that it cannot be all that we see. The initial impression, the sense of release, is reinforced by the recognition of the thick façade of melancholic indifference and inertia, which conceals an indelible desire to attach to the Thing in a Kristevan sense.

Through the psychoanalytic concept of melancholia, therefore, I will draw attention to the fissures and crevasses of Cézanne's painting. Designating an exact borderline between the façade of the painted surface and the invisible behind it, they can be regarded as a passageway from the former to the latter. There exists a sense of breathing through these cracks in his painting, thereby allowing us to imagine that the unsymbolizable aspect of melancholia in language obtains a visual means through which it can emerge on the surface of the representation of Cézanne's painting. By letting the semiotic resonance of color come to the fore, Cézanne may confirm the "symbologenic" function of painting that matrixial theory underlines; "it may generate not an image of the trauma but a symbol that allows the foreclosed the *relief of signification, a pathway into language.*"[38]

Kristeva explains that the subject in melancholia comes to "freeze his unpleasant affects" and "preserve them in a psychic inside thus constituted once and for all as distressed and inaccessible."[39] In Cézanne's melancholy portraits, however, how do we explain a source of pleasure or desire tinted in color, emerging on the painted surface as if it appears to be breaking through the psychic inside? Ettinger's term "solace" provides an appropriate notion for such a relatively unknown affect; Cézanne's representation imparts, through its soothing function, a "painful innerness" in the subject by releasing this pain through the web of color. In Cézanne's portraits of the late period, the obstinate quality of melancholia loosens its grip and exposes its "semiotic markings," in Kristeva's terms, through the borders of his flexible colors. When we look at these portraits, a fresh sensation is aroused; the sensation which we may have when we happen to witness the melancholic who is no longer a foreigner in his maternal tongue.

III Melancholia and Cézanne's Construction of a Self-image

Kristeva asserts that "language starts with a *negation (Verneinung)* of loss"; the fundamental psychical structure of the melancholic (or depressed person) is the "disavowal of negation" or "denial of dénégation."[40] The meaning of the negation of the loss of the mother is formed by the fact that the child must agree to lose the mother in order to retrieve her in the sign system of the Symbolic. Thus the subject's negation of the loss is premised on the inevitable link between the loss of the mother and the subject's entry into language.

Melancholia (or depression as its contemporary form) is, however, derived from a psychical structure in which the subject is never reconciled to the structural loss of the mother and disavows the negation necessary for the subject's proper entry into language. Instead, as Kristeva analyses, "depressed persons nostalgically fall back on the real object (the Thing) of their loss, which is just what they do not manage to lose, and to which they remain painfully riveted."[41] In Kristeva's theory of melancholia, sadness, object relations and a lack of the self are closely related. Through the "mechanism of identification" sadness is derived from the psychical relation of the subject to the "loved-hated other." It evokes a fundamental lack of the self, charged with "the most archaic expression of an unsymbolisable, unnameable narcissistic wound."[42] My interest in the study of melancholia lies in the way the loss of the maternal Thing structures subjectivity on its entry into language. As a potential psychic site where such fundamental loss marked in the subject can be traced, the pre-symbolic imaginary, prior to Lacan's mirror phase, is where I set the issue revolving around loss, lack of the self and symbolization in the process of constructing subjectivity. If in this imaginary register before the mirror phase the child is capable of transferring the maternal Thing and its affect into an object as Kelly Oliver notes to be the case in Kristeva's theory,[43] then how can we experience the tacitly signified "Thing-traces" at the level of the visual? Could a painting possibly realize an optical situation where the subject is imagined to be, prior to the mirror phase?

A nodal point for this discussion is found between the apparatus of the mirror phase and the structure of melancholia, in which the subject's reconciliation to loss is elicited and formed. My proposition is that the alienation of the self occurring in the mirror phase may have a significant alignment with the loss of the maternal Thing, which is mourned incompletely in melancholia. In order to trace the loss inscribed in the operation of perceiving the self in a painting, I suggest that a close look at one of Cézanne's self-portraits will be useful. Amongst the more than thirty self-portraits, one cannot find a work that visualizes a self-image more imaginatively perceived before the mirror phase than the *Self-Portrait with Palette* (1885–7; Figure 4.4).

In this painting, Cézanne holds a palette and brushes, striking a very upright and static pose in front of a canvas placed on an easel at which he firmly fixes his stare. Evoking the viewer's curiosity, the palette and canvas function like a fortress protecting the artist from an easy relation with the viewer. The backdrop painted in a bright mist does not imply any space

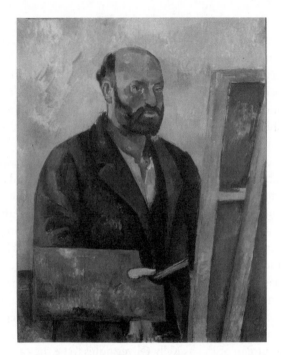

Figure 4.4 Paul Cézanne, *Self-Portrait with Palette*. V.516, 1885–7. 92 × 73 cm. Reproduced courtesy of E.G. Bührle Foundation, Zurich.

into which the figure can recede. The artist in this portrait appears to expose himself to us as if he is captured through our eyes without noticing that he is being looked at. The artist in this portrait wears a suit painted in monotonous gray tones, the same color also depicts his beard and hair. Despite his predominance in this portrait, the figure does not give us the impression that he expects us to recognize his presence and his strong subjectivity as an artist. He has a rather unassertive look and a typical aloofness, as if conforming to the later criticism that he treated people in the same way as "things" like the palette, canvas, and easel. In fact, his body is not distinct from such objects; the line of his arm becomes the extended line of the palette and the lower part of the arm is almost substituted by the palette itself. Schapiro writes: "it is one of the most impersonal self-portraits we know."[44]

The huge and solid body of the artist is framed by the horizontal line of the palette and the slightly tilted vertical one of the easel. The easel, painted in a yellowish brown, the palette painted russet and a part of a

brick-red table in the lower left corner surround the artist's body which itself is composed from the dark grays of his jacket and beard, and the bright brown face that shares a tone with the easel. In this self-portrait, Cézanne himself appears to have realized the completely still pose that he demanded from his models.

The most puzzling thing of all in *Self-Portrait with Palette* is the palette that the artist holds. Ironically, it contains similar tones of color to the painting itself: dark blues, gray, brown in various tones, etc. The gray and dark navy in the palette correspond to the color of the artist's hair, beard, and jacket. The brown in reddish tone, brown in ochre tone, and brown in yellowish tone are the colors of the table, his face and the easel respectively. The ivory and green of the background are also found in the palette.

In this portrait, our attention is drawn to the palette mainly because of its awkward and unlikely angle. The palette is awkwardly positioned; it is not turned toward the artist himself but angled away from him in order to become parallel to the picture plane. Note the figure's unconvincing grip on the palette from which he is to paint. Furthermore, it does not seem as though the finger will be able to hold the palette at such an exact horizontal angle, even for a short while. The precise lines of the horizontal parallels of the palette and its exaggerated sharp edges give us a sense of extreme tension and even discomfort.

The palette in this portrait seems to deflect the act of our viewing as if it is a shield against it. As Schapiro reads it: "the suspended palette in his hand is a significant barrier between the observer and the artist-subject."[45] A question arises: why does Cézanne need a barrier within the relation of looking and being-looked-at (at the two levels, both by us and by himself)? In other words, what sort of viewing does he request from us and from himself? One thing is for certain. The palette allows the viewer to pause and think before the gaze of the Other tries to master the objects in the painting, before the investment of libidinal impulses and the projection of a psychical and emotional charge onto them.

A question arises: what difference could the distance from the mirror make in one's perception of oneself? I suggest that the closer one gets to the mirror, the harder it is to escape from the recurrence of the mechanism of the mirror phase. Thus, we can say that, in terms of distance, Cézanne sets up a remote relationship between the mirror, the canvas, and the artist himself; remote, in as much as he would not give in to the illusion of the mirror, thereby affecting the constitution of the self. Through his oblique stare, which belongs to an intermediate zone between absorption and

indifference, presence and absence, this self-portrait leads to a place from which we can possibly elude the apparatus of the mirror phase.

Let me draw our attention to a paradoxical structure in the mirror phase, as emphasized by Lacan and his commentators. In Lacan's early theory of the mirror phase, the jubilation that he ascribes to the child assuming its mirror image is based on illusion. Malcolm Bowie emphasizes this by saying: "the complex geometry of body, setting and mirror works upon the individual as a ruse, a deception, an inveiglement."[46] The child in front of the mirror knows better than we suppose; in Bowie's words, "the child has a perverse will to remain deluded."[47] Although the child might know (and we now know theoretically owing to Lacan) that the mirror vision is only a trap for the perception of the self, the mirror still provides a solid confirmation of the self with a totalized body in the scopic dimension.

As precarious as it seems, our constitution of the ego through visual (mis)perception is structured on the illusion of the mirror phase. The moment of the mirror phase is, as Jane Gallop underlines, "the first instance of what according to Lacan is the basic function of the ego: misrecognition."[48] Such an illusion in the mirror phase convinces the child in front of the mirror of its validity because there are "firm spatial relationships between its [child's] real body and its [child's] specular body and between body and setting within the specular image."[49] It is, however, worth emphasizing Lacan's point that the illusion in the mirror phase carries with it the alienation of the self. Theoretically the moment when the child comes to perceive the "I" in its unity signals, at the same time, the fact that the subject is in discord with itself. Similarly, as Bice Benvenuto notes: "the formation of the ego commences at the point of alienation and fascination with one's own image."[50]

Such inevitable alienation in the formation of the self leaves unarticulated traces, which emerge from a slight cleavage between the "real body" of the self and the "specular image" reflected in the mirror. We lose a certain part of ourselves in the process of the captation by the mirror image that forms the basis for an "I." We shall need Lacan's revision of his early theory to enable us to reframe the alienation that is delineated in the mirror phase. This contradictory alienation finds a theoretical resolution in his later notion of the gaze as *objet a*, which is encapsulated in Lacan's phrase: "*You* never look at me from the place from which *I* see *you*."[51] In the context of discussing self-portraiture, however, I have to change the "you" and "I" of Lacan's original phrase; "you" becomes "*I in the specular body*" and "I" becomes "*I in the real body.*"

Lacan locates his notion of the *objet a* of the gaze in the scene in which the splitting of the subject causes the subject to recognize its dependence on desire through the unapprehendable state of lack. According to Lacan, the *objet a*, emerging from the primary separation from a corporeal zone, is elided in the subject's illusion of the consciousness of "seeing oneself see oneself (*se voir se voir*)."[52] Realizing this setting of "observation of observation"[53] as a visual dimension, self-portraiture offers an occasion through which to explore the relation between the primary separation from the (m)other and the formation of the self at the very scene of the split of the self in visual perception. By putting oneself into a rare optical situation where "one sees oneself being seen in the Other(A)," self-portraiture can enlighten "the path toward seeing one's Desire in relation to the Other(A)" from the one's (the subject's) position[54] (here, I am suggesting that the one is the artist and the Other(A) is the viewer).

Despite the apparently firm spatial relationships between one's real body and one's specular body in the mirror, the splitting of the "I" due to the two separate positions of oneself misses out a part of the self in the perception of "I," which pertains to the gaze as the *objet a*, as Lacan offers later. Since this *remnant* of the "I" bears the trace of the Thing within the self, we imagine that it would be identified as something other than the sheer verisimilitude of the self-image that the mirror reflects back. What is at stake, however, is the possibility that the Thing in the self could be endowed with a meaning. To be more specific, in relation to this project, the issue is whether we can grasp the trace of the *remnant* of the "I"[55] in Cézanne's representation of himself before it elides itself.

The process of producing self-portraiture may be linked, therefore, to the apparatus of Lacan's mirror phase. Firstly, at a literal level, this occurs because an artist would use a mirror in order to paint himself or herself. Secondly, self-portraiture suggests another image at the level of representation, adding to the specular image reflected in the mirror; the represented image transferred from the mirror image to the canvas by the artist. Portraying oneself thus means that the artist goes through the transference of self-recognition at the scopic level *twice* instead of once.

In other words, the artist re-experiences the mirror phase retrospectively by observing the self-image in a mirror, and then transfers what s/he perceives as his or her self-image onto a canvas. If we call the psychical force involved in the former *introjection* and the latter *projection*, self-portraiture is indeed a privileged space in which we can review the process that has taken place at the mirror phase.

In his article "Cézanne's Mirror Phase,"[56] Hugh J. Silverman suggests that there is another domain that needs to be taken into account in Cézanne's self-portraiture, which extends the apparatus of the mirror phase by revealing the visibility of the represented image. Referring to Merleau-Ponty's aesthetics and his apprehension of Cézanne's work, significantly expanded in the essay "Eye and Mind," Silverman highlights Merleau-Ponty's notion of visibility, which is established in the field of painting. He then adopts this visibility of painting in his analysis of the process of producing self-portraiture. Silverman elaborates the self-displaying visibility of self-portraiture:

> In self-portraiture, there are two moments of self-displaying visibility: that of the specular image and that of the painting. The painter lends his body to the mirror which provides a self-displaying visibility. The painter reiterates that self-displaying visibility by tracing it in paint and thereby providing another self-displaying visibility.[57]

Pointing to Lacan's suggestion that "the specular image seems to be the threshold onto the visible world,"[58] Silverman, however, asserts that in Cézanne's self-portraiture "the specular image is a threshold onto the visible world of the painting and not the world from which the painting arises."[59] By claiming that Cézanne in self-portraiture undertakes to make himself other, "to paint a portrait of himself as other than himself,"[60] Silverman underlines the distinctiveness of the represented image of his self-portrait from that of the specular image. Silverman's reading leads us to see self-portraiture in general terms as a potential space in which to encounter the lost self of the mirror phase. He writes:

> [This] specular self-displaying visibility (of the mirror image) is appropriated and reiterated in the self-portrait. Self-portraiture forms an enterprise in which a new self-displaying visibility comes into being by *tracing the ex-appropriated self of the mirror into the texture of painting*. (added emphasis)[61]

Taking account of the way in which the self is embodied as a representation of the self-portrait, Silverman takes up the point that "the self leaves traces of itself in the painting of the self-portrait."[62] Being constituted with traces of the self, the self-portrait "fulfils its task" in the sense that the "trace or extract or image is complete."[63] Silverman asserts that a complete

image in the self-portrait is, however, structured on the fact that "the self constitutes itself as other."[64] Thus we are led to a proposition that this "other-self" or "other-I" comes to obtain a "new visibility" in the space of self-portraiture. In Silverman's words:

> Self-portraiture appropriates what is appropriate to the visibility of the painter, *makes visible what is invisible in the specular image,* and appropriates the canvas producing a new visibility. The mirror phase makes the new visibility of the self-portrait possible. (added emphasis)[65]

Silverman's argument suggests a crucial point for apprehending the optical mechanism involved in the production of self-portraiture, by tracing the necessary procedures prior to it. In this process, Lacan's mirror phase offers a significant logical explanation for what has preceded the painting of a self-portrait. Silverman's discussion, however, does not specify the way in which Cézanne's self-portrait renders visible "what is invisible in the specular image." This suggests to me that he has failed in taking up the particularity of Cézanne's self-portrait as different from those of other painters. I propose that we take a close look at a self-portrait by Cézanne, which exemplifies what I would call, the "double process" that Silverman implies as necessary for reading his self-portraiture – the self-displaying visibility of the mirror on the one hand, and that of the painting on the other.

I want to focus on "a new visibility" of the painting in Silverman's term, which is distinct from the specular image, reflected in the mirror. I propose that Cézanne's *Self-Portrait with Palette* is one that manages to visualize the gap between the specular image and the represented image. Through such a gap, this self-portrait allows us to glimpse the way in which the artist makes visible what is left unseen in the specular image. It seems that this self-portrait affirms Silverman's comment that "the self-displaying visibility of mirror is not duplicated in the self-displaying visibility of self-portrait."[66] I am suggesting that we can see the melancholic mood of indifference and aloofness of the *Self-Portrait with Palette* as contributing to the perpetuation of the gap between the two images, which then paves the way to the anticipation of the gaze as *objet a* in Lacan's later theory.

Standing in front of the *Self-Portrait with Palette,* we can imagine that the specular image in the mirror that the artist used at the time of painting must have been quite different from this representation – a petrified and

aloof image of Cézanne. Perhaps it was Cézanne's aim to keep as much distance as possible between the two self-images: between the specular image in the mirror and the represented image in his painting. It is important to note that the artist must have had to decide how much he would take from the mirror image registered in the artist's perception in order to configure another self-image(-to-be) produced in the painting during the moments of transfering one to another. It is in these moments of transfering from the specular image to the represented image that I want to bring up the particular, if not unique, representation of Cézanne's self-portrait in terms of the structure of melancholia and its relation to the formation of subjectivity. Premised on the distinction between the object and the Thing, Kristeva's formulation of melancholia lets us see an archaic desire for the attachment to the Thing *through* a detachment from the object. Appropriating Lawrence's reading of Cézanne's painting in this frame, the artist's representation of the *appleyness* of himself, perceived in relation to the trait of the Thing, is possible in *Self-Portrait with a Palette* due to the maximized distance between the two self-images – the specular image and the represented image. If Cézanne had attempted to reach the "other-I" in this portrait, what Cézanne could offer is an extremely foreign and unfamiliar (him)self.

It seems possible thus to hypothesize that the remnant of the "I" or the alienated self in the mirror phase has not completely escaped our view in Cézanne's *Self-Portrait with a Palette*. Cézanne's painting captures it in the form of aloofness and detachment. It seems as though this Cézanne painting brings back a trace of what is an invisible part of the self, which was missed out from the mirror image in the self's attempt to obtain its unified form. This portrait thus suggests a different way of perceiving the self, slightly eluding the logic of Lacan's mirror phase. Cézanne's representation of himself intervenes and shifts. Anticipating in practice Lacan's theoretical formulation of the mirror phase, Cézanne's self-representation intervenes in the debate Lacan theoretically proposed. Cézanne's painting opens another optical dimension in which the other-self or the remnant of the self, lost at the mirror phase, comes into the halflight of visibility via painting.

With regards to Cézanne's self-portraiture, Silverman's discussion serves to trace what emerges in the realm of the visible through the painting's function of self-displaying visibility, what he proposes as another process following the apparatus of the mirror phase. Starting from Silverman's point as such, I am focusing on this process in trying to characterize the

enigmatic aspects of Cézanne's self-portrait through a particular work, the *Self-Portrait with a Palette*. Nonetheless, my argument differs from Silverman's. I suggest that Cézanne's *Self-Portrait with a Palette* sheds light on the way in which Lacan had to revise the earlier study of the mirror phase as he headed toward his theory of gaze as the *objet a*. Alienation in the mirror phase, conditioning the imaginary identification with another self outside, remains present in the frozen image of the *Self-Portrait with a Palette*. That allows us to face a moment of the captation of the mirror phase through a suspension of its mechanism, and visualizes an internalized form of alienation. This is staged in the wide gap between the specular image and the represented image. There is a structural similarity between this gap in Cézanne's painting and the cleft between the eye and the gaze, which is conceptualized in what Lacan names the *objet a*, that is, loss *per se*. Ettinger explains: "in the scopic sphere of vision, the *objet a* is the gaze, lacking and split forever from the passion of the eye, and dwelling in the Other."[67]

In Cézanne's attempt to paint a portrait of himself as *other than* himself, the other-self in his *Self-Portrait with Palette* brings forward a state of subjectivity based on lack and loss. Against the mythic function of the mirror in the constitution of the linguistic I, his painting functions in disillusioning "the unified form" of the self, on which one believes one's identity is premised and upon which one builds up a confidence for a situation and mastery in language. Through Cézanne's self-portrait, we are called into reversing the process of the mirror phase and tracing retrospectively from the illusory unity of the cultural "I" to its archaic state of fragmentation and insufficiency.

By a "deliberate repression of a part of himself," to use Schapiro's phrase,[68] and through extreme objectivity, this portrait by Cézanne produces an archaic affect through which we can imagine earliest sensations of looking at what we later can call "the self." These sensations bring about an uncanny sense of a self on the side of the imaginary in excess of what we are given as the self. The specular "I" creates a hole in the *après-coup* (deferred action) of a hallucinated Real, to which no localization, imago, or signification is designated. Nonetheless, in Cézanne's self-portrait, one is induced to track the remnants of "I" through this hole, which is possibly taken over by the represented image of the self. Perhaps, this uncanny sense of a "self" in excess of what we are given as the self could be the novelty that the *Self-Portrait with Palette* unexpectedly reveals.

Instead of jubilation following the discovery of the self due to the seemingly masterful gaze, Cézanne's alien representation of the self allows

us to look at ourselves more truly with a sense of loss and melancholia. Hardly identifying with the specular image of the self, this distant and unfamiliar form of the "I" carries the forgotten face of the unknowable pre-self, its missing part at the imaginary moment when it first saw itself. I would like to argue that Cézanne's *Self-Portrait with Palette* allows us to see the theoretical demand for Lacan's revision of his early conception of the mirror phase in order to reframe this alienation in his later theory of the gaze as the *objet a.*

Perceiving oneself as other, however, must be painful because it demands that we look at the dark scene of the mirror phase; in other words, to confront the loss of the maternal Thing and the left-out elements of the "yet-to-be-self," which come from the transference of inchoate memories of the real body onto the specular body by projecting oneself into the mirror. Amongst the many things happening during the mirror phase such as aggressivity, narcissism, a sense of alienation, and misrecognition, I want here to highlight delusion. In the child's perverse will to remain deluded for the perception of a "totalized" body, as Bowie points out, this loss and the excess of "not-yet-I" is left behind, belonging to a realm of the unknown. It must be extremely hard, therefore, to imagine a split self because one has been accustomed to looking at oneself as a deluded unified image ever since the mirror phase and the entry into language.[69]

On the subject's entry into language, therefore, the subject loses not only the maternal Thing but also what comes to be imagined retrospectively as a part of the self, which was bound to it. The loss, as loss, feels like a loss of part of the self and as such is already present at the very moment in the formation of the self. This is the way I understand Jane Gallop's reading of "contradiction" in the mirror phase: "the unity is not first, but at the same time it must have preceded the vision of the body in bits and pieces."[70] In the "intrication of anticipation and retroaction" in the mirror phase,[71] the loss is not missed out from the being; on the contrary, it is structured in being itself. In this sense, Cézanne's self-portrait shows a way of tracing an aspect of this "yet-to-be-self," which was lost in the mirror phase by engaging its mechanism of transferring the self-image. This also proves that the texture of painting is an independent and significant space through which one can glimpse or sense this structure of the loss and possibly seek to sublimate it.[72]

Difficult as it is to have a sense of possibly perceiving the "I" at the scene of the paradox ("contradiction" according to Gallop) of the mirror phase; perceiving the "I" before reaching the assumption of an image, which is

always shaped retrospectively by the very event, where I glimpse my being as "not-yet-I." Through the schism between the "I" in the specular image and "not-yet-I," the *Thing affect* is perceived, which is a passageway to the maternal Thing onto which the melancholic is still locked.

The main point of this argument, therefore, is that the desire to attach to the Thing in melancholia entails a counter-force against the function of illusion in the mirror phase. Melancholia works by disillusioning the totalized form of the self of the mirror phase and revealing its apparatus of delusion and alienation. I am suggesting that the obstinate operation of melancholia does not allow the self to be easily subject to such an illusion. Not being inveigled into a unified and totalized image of the self in the mirror phase, melancholia induces its (the self's) eyes to rivet on the underside of this imaginary identification – the relation between the yet-to-be-self and the maternal Thing. The trace of the loss of the corporeal and sensory zone that could be identified with the (m)other lingers over Cézanne's *Self-Portrait with Palette*.

In this sense, then, melancholia signals what is Real. Cézanne's "other-I" featured in his self-portrait leads *Zeuxis* to face the truth of his vision – that is, what he is led to see by *Parrhasios* is in fact a wall painted with a lifelike veil with nothing behind it.[73] Looking at Cézanne's painting via the structure of melancholia allows us to see that representation can go beyond the role of "deceiving the eye (*tromper l'œil*)." As for a reason why the detached and non-expressive faces of the people in Cézanne's portraits look shockingly unfamiliar to us, it is simply that we have never seen our faces *without a mirror* – without the illusion of unification which is premised upon the alienation of subjectivity.

Notes

1 Meyer Schapiro, *Paul Cézanne*, third edition (New York: Harry N. Abrams, 1965), p. 56.

2 Ibid., p. 50.

3 Joachim Gasquet, *Joachim Gasquet's Cézanne: A Memoir with Conversations*, trans. Christopher Pemberton (London: Thames and Hudson, 1991), p. 113.

4 Ibid., pp. 113–14.

5 On the climax of muted coloring in this work see Theodore Reff, "Painting and Theory in the Final Decade," in *Cézanne: the Late Work*, ed. William Rubin (New York: the Museum of Modern Art, 1977, p. 20).

6 Ibid., p. 21.

7 See Badt on " 'impersonal and general' portrayals" (Kurt Badt, *The Art of Cézanne*, trans. Sheila Ann Ogilvie [London: Faber and Faber, 1965], p. 186).

8 Ibid., p. 189.

9 Schapiro, *Paul Cézanne*, p. 56.

10 Julia Kristeva, *Black Sun: Depression and Melancholia*, trans. Leon S. Roudiez (New York: Columbia University Press, 1989), pp. 41–2.

11 John Lechte, "Art, Love, and Melancholy," in John Fletcher and Andew Benjamin (eds), *Abjection, Melancholia and Love: the Work of Julia Kristeva* (London: Routledge and University of Warwick Centre for Research in Philosophy and Literature, 1990), p. 34. "Consequently, while Freud sees melancholia as a particular kind of object relation, Kristeva argues that the problem is located in the failure of the relation as such to materialize. There is no object for the melancholic, only a sadness as an ersatz of an object; or, as Kristeva goes on say, there is only a 'Thing' ('*Chose*'), a vague, indeterminate 'something', a 'light without representation' which Nerval captures in his metaphor of a 'black sun' ('*soleil noir*')." (Kristeva's *Soleil Noir* [Paris: Galli-mard, 1987], p. 22).]

12 Kristeva, *Black Sun*, p. 12.

13 Fritz Novotny, *Paul Cézanne* (London: Phaidon Press, 1947), p. 7: "'Stim-mung'... in its widest sense, a term for which there is no equivalent in English, but which can best be rendered by the English word 'mood' or 'atmosphere.' The element of mood, which is found in some form or other in all European landscape paintings from the beginnings until the end of impressionism and which before the appearance of Cézanne seems to be an indispensable part of the interpretation of landscape, is completely excluded from his landscapes. In them there is no mood, whether in the form of expression of temperament or for the purpose of interpreting definite land-scape situations or phenomena, and it is lacking because Cézanne's art is the very antithesis of expressive art."

14 Ibid.

15 D.H. Lawrence, "Introduction to These Paintings" (1929), in *Phoenix: The Posthumous Papers of D.H. Lawrence*, ed. Edward D. McDonald (London: Heinemann, 1936), p. 579.

16 Ibid., p. 577. Lawrence's description as such originally refers to Cézanne's still life. Lawrence notes: "in [Cézanne's] very best pictures, the best of the still life compositions, which seem to me Cézanne's greatest achievement, the fight with the cliché is still going on. But it was in the still-life pictures he learned *his final method of avoiding the cliché: just leaving gaps through which it fell into nothingness.* So he makes his landscape succeed" (added emphasis).

17 Ambroise Vollard, *Cézanne*, trans. Harold L. Van Doren (New York: Dover Publications, 1984), p. 83.

18 Gasquet, *Joachim Gasquet's Cézanne*, p. 113. "it seems that during a number of sittings Cézanne barely touched the canvas with his brush but never stopped devouring his model with his eyes" (ibid., p. 114).

19 Ibid., p. 113.

20 Hans Sedlmayr, *Art in Crisis: The Lost Centre* (London: Hollis and Carter, 1957), p. 131.

21 Ibid., pp. 131–2.

22 Ibid., pp. 133–4.

23 Sedlmayr hints at this "peculiar state" on which Cézanne's aim of "pure vision" was possible, verging on psychoanalytic sphere: "it is that peculiar state between waking and being completely awake in which, so to speak, only the eye is awake, while the mind is still asleep. Then the world that we ordinarily know appears as a pattern of patches and shapes of various kinds, colour, sizes and 'textures'; the things with which habit has acquainted us are still behind this coloured web or tissue, waiting to come forth" (Sedlmayr, *Art in Crisis*, p. 131).

24 Ibid.

25 Gasquet, *Joachim Gasquet's Cézanne*, p. 102. Gasquet states this in his reading of Cézanne's still life.

26 Griselda Pollock, "The Gaze and The Look: Women with Binoculars – A Question of Difference," in *Dealing with Degas: Representations of Women and the Politics of Vision*, eds. Richard Kendall and Griselda Pollock (London: Pandora Press, 1991), p. 117.

27 Gasquet, *Joachim Gasquet's Cézanne*, p. 102.

28 Bernard Dorival, *Cézanne*, trans. H.H.A. Thackthwaite (London: House of Beric, 1948), p. 59.

29 Kristeva, *Black Sun*, p. 42.

30 Ibid.

31 Ibid.

32 Sedlmayr refers to modern painters as "the allegedly pure painters"; Sedlmayr, *Art in* Crisis, p. 134.

33 Sedlmayr writes: "[...] they [these allegedly 'pure' painters] begin to suffer from that *diseased condition whose essence is the mind's inability to project itself into the minds of others or into the world outside*. When that condition obtains, everything seems dead and *alien*, men can then only see the outside of things, they are no longer conscious of human life in others. It is also at this point that the whole world begins to become unstable, for when things are mere phenomena that have *no meaning inherent in them*, then they begin to be experienced as things without stability, things fleeting, wavering, bodiless and indetermined. They are solid things no longer. This may explain why those who wish to see a world in flux are automatically driven towards absolute painting, the painting that is innocent of any meaning whatsoever" (added emphasis); ibid.

I think the psychical structure of the painters that Sedlmayr takes up is understood by Freud's analysis of melancholia, especially "regression of libido into the ego" and the process of introjection that characterize melancholia in his theory. (Sigmund Freud, "Mourning and Melancholia" (1917 [1915]), *The Standard Edition of the Complete Psychological Works of Sigmund Freud* [London: The Hogarth Press, 1957], p. 258).

34 Sedlmayr, *Art in Crisis*.
35 Kristeva, *Black Sun*, p. 266: Kristeva emphasizes "psychic void" in depressed persons referring to André Green.
36 Ibid., p. 151.
37 Ibid., p. 53.
38 Griselda Pollock, "Inscriptions in the Feminine," in *Inside the Visible: an Elliptical Traverse of 20th Century Art*, ed. M. Catherine de Zegher (Cambridge, MA and London: The MIT Press, 1996), p. 78.
39 Kristeva, *Black Sun*, p. 63.
40 Ibid., p. 43.
41 Ibid., pp. 43–4.
42 Ibid., pp. 11–12.
43 Kelly Oliver, *Reading Kristeva: Unravelling the Double-bind* (Bloomington and Indianapolis: Indiana University Press, 1993), p. 63.
44 Meyer Schapiro, *Paul Cézanne*, p. 64. Schapiro emphasizes the artist's assimilation into the objects surrounding him by using the term "impersonal."
45 Ibid., p. 15.
46 Malcolm Bowie, *Lacan* (London: Fontana Press, 1991), p. 23.
47 Ibid.
48 Jane Gallop, *Reading Lacan* (Ithaca and London: Cornell University Press, 1985), p. 81.
49 Bowie, *Lacan*, p. 23.
50 Bice Benvenuto and Roger Kennedy, *The Works of Jacques Lacan: An Introduction* (London: Free Association Books, 1986), p. 55.
51 Jacques Lacan, *The Four Fundamental Concepts of Psycho-Analysis*, ed. Jacques-Alan Miller, trans. Alan Sheridan (London: Penguin Books, 1979), p. 103.
52 Lacan notes: "[It is here that] I propose that the interest the subject takes in his own split is bound up with that which determines it – namely, a privileged object, which has emerged from some primal separation, from some self-mutilation induced by the very approach of the real, whose name, in our algebra, is the *objet a*. [...] Furthermore, of all the objects in which the subject may recognize his dependence in the register of desire, the gaze is specified as unapprehensible. [...] it is perhaps for this reason, [too], that the subject manages, fortunately, to symbolize his own vanishing and

punctiform bar (*trait*) in the illusion of the consciousness of *seeing oneself see oneself*, in which the gaze is elided" (Jacques Lacan, *The Four Fundamental Concepts of Psycho-Analysis*, p. 83).

53 Jacques Lacan, *Seminaire II*, p. 312, in Ellie Ragland-Sullivan, *Jacques Lacan and the Philosophy of Psychoanalysis* (Urbana and Chicago: University of Illinois Press, 1986), p. 94.

54 Ragland-Sullivan, *Jacques Lacan*, pp. 93–4.

55 The status of the "I" here is difficult to designate since it denotes the presignified "being" that can only be sensed as almost non-human because it is technically pre-human, yet it is the trace of the Real.

56 Hugh J. Silverman, "Cézanne's Mirror Phase," in *The Merleau-Ponty Aesthetics Reader: Philosophy and Painting*, ed. Galen A. Johnson (Evanston, IL: Northwestern University Press, 1993).

57 Ibid., p. 276.

58 Silverman quotes Lacan in *Ecrits* (Paris, 1966), p. 95; Silverman, "Cézanne's Mirror Phase," p. 272.

59 Ibid., p. 273.

60 Ibid.

61 Ibid., p. 277.

62 Ibid., p. 264. Silverman defines traces of the self here as "bodily shapes, expressions, and glances."

63 Ibid.

64 Ibid, p. 263: "Often rectifying the self to look like the pose of another, self-portraiture offers a pictorial account of the self. In self-portraiture, the self constitutes itself as other – slightly modifying Rimbaud's dictum: *le je est un autre.*"

65 Ibid.

66 Ibid., p. 273.

67 Bracha Lichtenberg Ettinger, "Trans-Subjective Transferential Borderspace," *Canadian Review of Comparative Literature*, vol. 24, no. 3 (September 1997), p. 629; reprinted in *A Shock to Thought*, ed. Brian Massumi (London: Routledge, 2002).

68 Schapiro, *Paul Cézanne*, p. 28.

69 Gallop, *Reading Lacan*, p. 79: "the subject's relation to himself is always mediated through a totalizing image that has come from outside."

70 Ibid., p. 80.

71 Ibid., p. 81.

72 Silverman, "Cézanne's Mirror Phase," p. 273, highlights that in Cézanne's self-portrait, his "mirror phase" reversed the transformation that Lacan delineates. He asserts that by "undertaking to make himself other, to paint a portrait of himself as other than himself," "the specular image [in Cézanne's

self-portrait] is a threshold onto the visible world of the painting and not the world from which the painting arises."

73 Jacques Lacan, *The Four Fundamental Concepts of Psycho-Analysis*, p. 103: In order to explain the different functions of the eye and the gaze, Lacan takes up the classical tale of Zeuxis and Parrhasios: whereas Zeuxis made grapes perfect enough to attract the birds Parrhasios painted on the wall a veil which deceived Zeuxis' eye. The veil was so lifelike that Zeuxis said to Parrhasios, "Well, and now show us what you have painted behind it." Lacan takes this tale as signifying "a triumph of the gaze over the eye."

Yayoi Kusama between Abstraction and Pathology

Izumi Nakajima

"Marriage," thought Saki, "is an effort to colour with illusions, the barren screen, that has always prevailed within myself." "Illusions sometimes deceive the sterility of the composition." Sitting down in the middle of the piles of sketches, Saki was in haste to colour in the sketches without completing the composition, and hoped that life will spring forth from within, like the fire that bursts aflame from the lens under the sun.

Oba Minako, *Kozu no Nai E*[1]

Oba Minako (b. 1930), a Japanese woman novelist, started her literary career in the United States. *Kozu no Nai E* (Painting without Composition) was her first work, written while she was studying art at the State University of Wisconsin. It is a story about an art school in a small town in the postwar United States where the author presents three painters. Saki, a Japanese woman and the protagonist, Daniel, a white American, and Ed, an African-American man. Like many literary works that emerged during the period, Oba's *Kozu no Nai E* is outspokenly colored with racial conflicts that emerge from this multinational, multicultural, and multiracial circle. The story revolves around the paintings by these characters. Ed wins a degree award with his speciality abstract painting, but loses an job oppotunity at the university to Daniel whose sketch is "academic" with proper composition. In this story the "painting without composition"– abstract painting – embodies an ultimate symbol of their racialized and tangled relationships, which the woman protagonist experienced through

the axes of gender and sexuality that are represented by the troubling notion of "marriage."

While Oba was writing the story in Wisconsin, another Japanese woman, Yayoi Kusama[2] (b. 1929), was producing paintings in New York. After holding several exhibitions in her native city and in Tokyo, Kusama had decided to move to the United States for the purpose of becoming an "international avant-garde artist." New York was the chosen destination for this ambitious young Japanese woman artist where she involved herself in the postwar painting paradigm generally regarded as abstract.

I shall start here with a series of Kusama's paintings known as "Net painting" that she produced at the beginning of her stay in New York. They formed the recognised starting point of her professional career as an artist. Yet this start was not a simple success story. Griselda Pollock has argued that Kusama's experience of being a painter then and there must have been "lived differentially across the wounds of class, race, gender and sexuality."[3] Net painting has been considered as the most prototypical product of Kusama's "obsessional art." In fact, despite the drastic change in styles and medium through fifty-odd years, the Net paintings were "always there." The paintings have accompanied the artist throughout her life. They exist in profound correspondence with the psychic formation of her subjectivity as an artist. The aim of this chapter is to present a reading of the Net painting as a visual signification that has been produced by a specific individual who is sexually and racially "different."

I aim to develop a matrixially "feminine" reading of Net painting, one through which the viewer can situate Net painting as a symbolic signification that allows some room outside and beyond the dominant, phallocentric Symbolic realm of two cultures between which her work is stretched. Admittedly Kusama is now one of the most widely and internationally recognized Japanese women artists. Notwithstanding this fame, it is still a difficult task to interpret her art without being trapped in the pervasive dynamics of the modernistic paradigm with its power structure still so charged with sexual, racial, and cultural politics. The Matrixial theory of a feminine sex-difference developed by artist-theorist Bracha Ettinger opens up several interpretative possibilities and suggests an urgent necessity for a different way of thinking through art works by women that is fully aware of cultural specificity. Through her model, we may be able to see Net painting also as an aspect of a culturally specific, historically

Figure 5.1 Yayoi Kusama with *Infinity Net*, 10 metres, Stephan Radich Gallery, 1961. Reproduced courtesy of the Kusama Studio.

situated "feminine" subjectivity accessed through the specificity of a painting without image.

Net Painting: A Critical Gap

In 1959, 18 months after arriving in New York, Kusama held an exhibition at Brata Gallery in 10th Street in an area renowned for having produced young artists. For this first solo show in New York, Kusama produced five paintings. Each piece was covered with meticulously inscribed patterns suggestive of a white net, over a slightly darker grayish white background. They were almost as large as the wall on which they were exhibited (Figure 5.1). The show attracted the attention of well-known art critics in New York. Donald Judd wrote for *Art News*:

> Yayoi Kusama is an original painter. The five white, very large paintings in this show are strong, advanced in concept and realized. The space is shallow,

close to the surface and achieved by innumerable small arcs superimposed on a black ground overlain with a wash of white. The effect is both complex and simple. Essentially it is produced by the interaction of the two close, somewhat parallel, vertical planes, at points merging at the surface plane and at others diverging slightly but powerfully... The expression trancends [*sic*] the question of whatever it is Oriental or American. Although it is something of both, certainly of such Americans as Rothko, Still and Newman, it is not at all a synthesis and is thoroughly independent.[4]

The show took place only a year after Greenberg's most influential pronouncements on "American-Type painting." For Greenberg, the abstract painting that appeared after the war in the United States, which he called "American-Type painting," could be distinguished from other modern paintings in respect of their radical attempt at a "self-purification" of medium, and because they showed certain stylistic characters such as: the emphatic flat surface of the canvas, shallow space without representational illusion, a monochrome at the extreme end of chiaroscuro, and "all over" design as a "single synoptic image."[5] Judd's review of Kusama's Net painting owes its vocabulary and theoretical framework to Greenberg. Judd recognizes the Net paintings within formalistic terms and conditions: shallow space, monochrome color, and plane pattern of the net. To the young Kusama, Judd's words were like a letter of welcome to the American art world, as this article practically offers almost everything that one needs to be approved as a painter there and then.

Another critic, Sydney Tillim, compared Kusama's paintings to Jackson Pollock's work, referring to the criterion for the postwar painting that he calls "Western abstract expressionism."

> Hers is an "Impressionism" true to the abstract aesthetic in which there is no centre of interest... Having laboured for ten years over many "tests" to arrive at this moment, Miss Kusama would seem to possess the required patience and, ultimately, the flexibility to extend one of the most promising new talents to appear on the New York scene in years.[6]

The "test" mentioned in Tillim's article implies the norms of the abstract expressionism formulated and practiced in New York. Despite this first exalted mode of criticism, however, Kusama did not quite reach the center of the New York art scene. She was indeed "good enough" to be compared with prominent American painters, but she was never made one of them. Following this debut on the New York art scene, Kusama's artistic style

showed dramatic change in the following decades, ranging between three-dimensional works, environmental installation, clothes production, film-making, and happenings. Despite the variety of the work she engaged in, she never completely abandoned painting. Yet, another few decades would have to pass before these Net paintings again attracted critical attention.

In the 1970s and 1980s, Kusama had an intermission and disappeared from the public eye. Yet in the 1990s, Kusama's work achieved sudden acclaim. By this time, however, the terms of criticism had changed. A retrospective exhibition held in New York in 1989 contributed consider-ably to Kusama's comeback to the New York art world. It was, however, the first occasion to introduce another issue to the interpretation of Kusama's art. Alexandra Munroe, who was the curator of the exhibition, stressed:

> The formalist critic would ignore an artist's emotional and psychological biography. The traditionalist might discredit a madwoman's art as naïve, unschooled and ultimately isolated from art-historical discourse...I believe that Kusama's condition as she explains in interviews and writings relates fundamentally to the imagery and method of her art.[7]

The literature on Kusama since is characterized by a strong interest in the biography of the artist, especially the history of her mental problems. While criticism in the 1950s was largely based on stylistic observations in terms of the paintings' currency, recent criticism has tended to regard Kusama's art as a pure and personal expression of the mental illness that "coincidently" showed a formal resemblance to the artistic trends of its time. This view is a contradiction of the interpretation of Net paintings and the dominant views of the 1950s. For instance, one critic has remarked: "Kusama remained true to her own vision. Her monochromatic, non-objective *Infinity Net*, are not aesthetic comments on the state of late abstract painting but depiction of the psychological state of boredom."[8]

In fact, the artist herself has claimed that her work is a psychological remedy as well as a symptomatic act caused by mental illness. In 1975 she wrote a biographical essay, titled "Waga Tamashii no Henreki to Tatakai" ("Odyssey of My Struggling Soul"), published in a Japanese art journal. In it she recalls the early days in New York:

> I had a desire to foretell and estimate the infinity of our vast universe with the accumulation of units of net, a negative of dots. How profound is the mystery of the infinity that is infinite across the cosmos. By perceiving this

I want to see my own life. My life, a dot, namely, one among millions of particles. It was in 1959 that I gave my manifesto that [my art] obliterates myself and others with the void of a net woven with an astronomical accumulation of dots.[9]

This "self-obliteration" narrative is a too frequently cited psycho-biographical story that presents the repetitive act seen in her works as an attempt to fragment the self and finally eliminate it in the flood of nets or dots. Here the Net painting turns out to be the representation of a hallucination transmuted into an art form that happened to intersect with the key development of the avant-garde art of the late 1950s. The overnight celebrity of Kusama's "psychosomatic art" admittedly lifted the artist up from invisibility in the art world. Yet, at the same time, it established the artist as an enigmatic figure detached from social, cultural, political, and (art-)historical context. The obvious critical gap and contradiction between the discourses of the two periods has brought about an ambivalent reaction accompanied by certain distrust. Lynn Zelevansky's comments on Kusama's recent larger retrospective in 1999 precisely underscore such questionable aspects of the reception of this artist.

As an artist with a history of mental illness, is she conscious or unconscious of the meaning of what she produces? Is she, in fact, mentally ill, or is she a shrewd media manipulator? Has she been exploitative of artistic trends or genuinely responsive to the cultural moment?... Was Kusama doubly dis-advantaged in New York as a woman and an Asian, or did she use sexual provocation and a contemporary fascination with the East to her own advantage?[10]

To these questions, Zelevansky answers by indicating that this is the wrong binarism for the interpretation of Kusama's art that "inclusively incorp-orates the dualities." She continues: "Since her works strive to be nothing less than all-encompassing, no contradiction exists for her between aes-thetic engagement and publicity, or psychic disorder and emotional con-trol, and there is no consistent discernible boundary between herself and art."[11] Zelevansky left the contradictions of these points unquestioned. Instead she returns the problematic position of the artist to the funda-mentally natural and thus special ability of "the artist."

Such a viewpoint mythifies the artist as a supernatural figure, a ten-dency demonstrated by the frequent use of words such as "phoenix,"

"shaman," "polka dot queen," which are too easily linked with Kusama's apparently "abnormal" state of mind. Yet the artist is also a "socialized presence"[12] who cannot simply transcend exterior and interior pressures socially, culturally, and politically inscribed on her. What the critical gap and contradiction indicate are the obstacles that prevent Kusama from being consistent with the lineage of modern art discourse – that is to say, the "differences" that Kusama reified: Japanese-ness, femininity, and mental illness. Whereas formalist criticism had to ignore differences in order to place the Net painting within the frame of current American painting, the discourse of psychosomatic art over-intensifies such differences to the point of complete exclusion from any art-historical frame. Multiple registers of difference provide Kusama a paradoxical (no) place in modern art history as she puts it: "I don't consider myself an artist; I am pursuing art in order to correct the disability which began in my childhood."[13]

A painter as well as a feminist psychoanalytical theorist, Bracha Ettinger, has argued that "art-work-as-symptom" that results from mental disorders is "in fact very sane." She shows how such art making, using known art vocabularies, finds itself in the "already culturally accepted" form of signification What constitutes art is precisely what breaches such known forms to seek out new ways to say that which changes signification.

> Thus the meaningful work-as-symptom of the mentally ill, unlike this kind of crazy artwork-as-sinthôme, is in fact very sane contrary to any intuitive qualification of such a product. A work as a neurotic or psychotic symptom is not at all "neurotic" or "psychotic" in its structure, because it is an articulation of suffering *already in the language of the Other*...a message aimed towards and communicated to a symbolic Other...this work has no potentiality to transform the Symbolic. The work of art as a sinthôme on the other hand, is a unique response, that contains the enigma it corresponds to and, that brings it about, an enigma that resonates a lacuna of quite different status in the Symbolic; it does not correspond to lacks defined by the phallic mechanism of castration but to whatever is not there, to what is yet to come, to what resists the Symbolic and to the mysterious and fascinating territory of that which is *not yet even unconscious* or to what is impossible for cognition.[14]

The structures of psychologically disturbed art are historically familiar rather than creative. There is, however, another discourse at play that Ettinger seeks also to dislodge by linking art making "beyond the phallus," i.e. in the feminine, with such creativity. In dominant narratives, mental

disability is coupled with the conventional image of the female figure, the hysteric and emotional woman just like the *Femme-Enfant* in Surrealist terms. According to Ettinger, such an art-historical frame is a discourse of the "Other," where the differences are interpreted and represented in order to make them decipherable for those who try to "make sense" of them. Abstract expressionism and mentally disturbed art are the discursive performances, sometime developing in conspiracy, which have defined the meaning of contemporary cultural phenomena. In that uneasy parley, they prepared a place for the art of the other woman – Kusama – in their story. What cannot be articulated, however, in this overdetermined conjoining of femininity, alterity, hysteria, and (non) art, are the racial, cultural, and sexual differences that may be operative in producing the art and its subject positions. Between formalism and a psycho-biography, such differences are either eliminated or confined to the image of the exotic and the negative.

It will be necessary, therefore, to reframe Kusama's art theoretically to acknowledge its complex engagement and confrontation with the historical and political environment of Western art without relegating Kusama to a position of "other." Clearly, what is lacking is historical (and not biographical) speculation to specify (and not to generalize) differences of the artist that are otherwise unrecognizable in the existing frames of viewing, thinking, and meaning.

Generation and Geography

In 1956, when Kusama wanted to go to the United States, she searched for Georgia O'Keeffe's address in *Who's Who* at the American Embassy and wrote to the older woman in New Mexico to ask for her advice at this juncture.

> I am a Japanese female painter and have been working on painting for thirteen years since [I was] thirteen years old...though I feel so I am very far away from where you are and only on the first step of long difficult life of painter. I should [*sic*] like to ask you would kindly show me the way to approach this life.[15]

O'Keeffe wrote back to Kusama, and the pair exchange several letters. The following are the first and second replies from O'Keeffe:

In this country the Artist has a hard time to make a living. I wonder if it is that way in Japan. I have been very interested in the Art of your country and sometimes think of going there but it is very far away. It has been pleasant to hear from you.

You seem to be having a hard time to get here. If you do get here I hope it will seem to be worth your trouble.

When you get to New York take your pictures under your arm and show them to anyone you think may be interested ... You will just have to find your way ... as best you can ... It seems to me very odd that you are so ambitious to show your painting here, but I wish the best for you.[16]

O'Keeffe's warm, yet not necessarily encouraging response did not hide her perplexity toward the "ambition" of this young Japanese woman artist. O'Keeffe was already sufficiently well known as an American painter for her name to reach a little suburban town in this country in the "Far East." Kusama's decision to write to O'Keeffe may or may not imply her awareness of being "female" and trying to be an artist in the United States. Yet the distance between the two artists is the geographical and generational gap altering entire conditions in forming one's subjectivity. What did it mean to a Japanese woman artist going to the United States to be an artist at the end of 1950s? What would it mean to paint there?

Japanese Painters and the Internationalism of Abstract Painting

In 1945, the Pacific War ended with Japan's formal surrender to the Allied Powers. The American-operated Occupation from 1945 to 1952 demilitarized and reconstructed the Japanese government and "rehabilitated" people in democratic terms. Japan's defeat was not solely military; its surrender was not simply political. The next decade brought dramatic changes and transformations in the lives of Japanese people, which also affected artists and their activities. People enjoyed formerly restricted international loan exhibitions that brought notable Euro-American artists into view. Newly distributed art magazines introduced art from overseas and provided a forum for discussions on the art suitable for the new age. Many artistic organizations and groups were formed to respond to this contemporary movement. These events gave the postwar generation an impetus for entry into the international trends of modern art. For

the artists who went through the period of wartime national isolation, the word "international" represented a new value that seemed to liberate Japanese contemporary art from estrangement, drawing it toward a world-wide movement. It is important to note that this "international" phenomenon was more a global tendency than a trend observed solely in Japan. It unfolded around the practice and critical argument on postwar painting, especially so-called abstract painting, which was discussed under different names and concepts, such as "Art Informel" in France, "Abstract Expressionism" or "'American-Type'Painting" in the US, and "Chusho-ga" in Japan.

One of the artistic organizations that typified such an international movement in postwar Japan was called Gutai. This group was known for its various experimental art productions, among which painting stood out as the focal point. Gutai's painting activities involved the practical and theoretical study of traditional Japanese art, especially Zen Calligraphy. For Gutai, whose declared aim was to "unite human spirit and the material," calligraphic techniques appeared to realize their ideal act of painting to emancipate the energy of the self through temporal and concrete encounters between humans and materials. Munroe described Gutai's painting as "direct, violent physical gesture, a passionate thrashing of body against matter,"[17] which can be seen in the expressive gesture painting of Shiraga Kazuo and Shimamoto Shuzo. Such paintings bore a certain formal resemblance to their contemporary European and American paintings. They drew the attention of some Euro-American artists and critics and were the subject of many international art exhibitions held in Europe, Japan, and the United States.[18] The relationship between the Japanese art movements and those of Euro-America, however, was not a simple stylistic or methodological exchange. For Japanese artists, the re-evaluation of the Asian tradition through the acquisition of abstract art language was closely linked to their imperative rediscovery of their cultural identity in the postwar reconstruction. The "inter-national-ness" that bridged two aesthetic trends from the East and the West was perceived as an idea of the universality of artistic language. Manifested as "international art of a new era," Gutai's gestural painting aimed to attain a transcendental state of human spirit, which was presumed to be shared universally and therefore was free from political, cultural, and social matters by its nature, just as American critic Harold Rosenberg remarked on American painting as the artists' "gesture of liberation, from Value."[19] It is suggestive that Yoshihara Jiro, the leader of Gutai, identified with Pollock's "action painting" where he found "the

scream of the material itself, cries of the paint and enamel."[20] In the Gutai Manifesto, Yoshihara goes on:

> In Gutai Art, the human spirit and the material shake hands with each other, but keep distance. When the material remains intact and exposes its characteristics, it starts telling a story, end even cries out . . . We have always thought – and still do – that the greatest legacy of abstract art is the opening of an opportunity to create, from naturalistic and illusionistic art, a new autonomous space, a space that truly deserves the name of art.[21]

Here abstract art functioned as a converter to neutralize their vernacular art language by rendering them into purely materialistic and methodological matters. Contrary to the movements of Surrealism or Social Realism that emerged between the wars, Gutai assertively avoided social and political content with emphasis on the materialistic process of creation, just as American Abstract Expressionism maintained its apolitical attitude. Yet, as Eva Cockroft clarifies, American Abstract Expressionism was certainly a "political weapon" that was enabled by the very apolitical posturing of the group to ensure their cultural hegemony in the world of capitalism in the age of the Cold War, by means of celebrating personal liberty and free expression of the self dissociated from political burdens.[22] That paradigm of abstract painting connotes the postwar idealism that incited the Japanese people's dream of world citizenship. This enterprise respectively lays bare their complex search for an anti-regionalist cultural identity where nationalism and universalism paradoxically coexisted. There the "international avant-garde artist" was to personify the new identity perceived as the liberated individual. The Japanese abstract painting exemplified by Gutai was allied with the American paintings by this treaty of aesthetic rules, such as a removal of symbolism and ideological contents, and an emphasis on concrete materiality of medium and the individual act of painting.

The alliance brought the Japanese artists, men and women alike, to feel that it was easier to cross the Pacific Ocean. Yet the professedly ideal mutual relationship between them did not operate in the same way on the "mainland." In Greenberg's argument, the conditions of American painting were always articulated by the comparisons between what he regarded as the "American-Type" and others, such as "American quality" and "French taste," or "Western pictorial art" and "Oriental art."[23] Greenberg's diplomatic logic made the "American-Type" seem applicable to any

work that met the formal conditions of painting, which is, as he stated, naturally shared among those who work in a "given time, place and tradition," namely the artistic milieu of postwar New York.[24] Yet, Japanese artists' participation in the abstract painting movement was never equated with that of white-male Americans in their territory. The title of "American-Type" painter was, after all, given to the artist who was neutral – that is, the western-white-male artist.[25]

The artistic manifesto of Gutai was, in fact, quite different from Greenberg's intellectual, stringent, and disciplined discourse on abstract painting. The unworldly tone narrating imagined fusion of human and material spirit recalls a more romantic and credulous stance towards abstract art. Indeed, such ingenuousness was what the Eastern aesthetic stood for in the global project of abstract art. The discourse of Abstract painting that engrossed Japanese painters was insistently an ideological diplomacy under a spurious universalism, where its "indifference" in political activism served itself as a political exercise. Japanese art represented a tamed and harmless naïveté with its political position, which was deprived of the relevant citizenship to be a subjective creator in the "international" art world.

International Japanese Female Artist?

Then how did the discourse of abstract painting perform itself to Japanese artists who happened to be women? Griselda Pollock has indicated that (white) women artists also shared in the imaginative promises of modernist discourse that poses the rareified sphere of art for a liberated self.[26] Yayoi Kusama, as one among many ambitious women artists, also desired to be such an artist, and, at the end of the 1950s, the Japanese art world was filled with optimistic expectations about participating in a worldwide modern art project. Like the painters in Gutai, Kusama was involved in the "international" current of modern painting during the 1950s.[27] At first, Kusama tried to take advantage of her cultural background. At an exhibition she had before going to New York at the Zoe Dusanne Gallery in Seattle, Kusama wrote to O'Keeffe saying that the theme of her painting was "oriental mystic symbolism." Nonetheless, in later interviews and writings she strongly rejected the attempt to associate her paintings with her homeland. This sudden change of stance toward her native culture was evidently induced by her actual association with the American art world.

It shows conspicuous contrasts to the other aforementioned Japanese (men) artists, who went to New York around the same period and actively tried to bridge Asian expression and American painting. Kusama's attitude can be distinguished in relation to the terms of gendered subjective formation within the kinship structure of a specific cultural field. Trinh T. Minh-ha addresses Asian women's resistance to and negotiation of both foreign and dominant cultural realms, which she calls "a double game." There an Asian woman thinks:

> [O]n the one hand, I shall loudly asset my right, as a woman, and an exemplary one, to have access to equal opportunity; on the other hand, I shall quietly maintain my privileges by helping the master perpetuate his cycle of oppression.[28]

The specificity of an Asian woman's position in the dual cultural relation could be further clarified with racial terms inserted in this sentence to observe the relationship between "I" and "the master" in the psychoanalytical comprehension of kinship structure:

> [O]n the one hand, I shall loudly asset my right, as (an Asian) woman, and an exemplary one, to have access to equal opportunity (with the western-white-male); on the other hand, I shall quietly maintain my privileges by helping the (western-white-male) master perpetuate his cycle of oppression.

What is missing in this relationship is the figure of the Japanese man (or master or Father). After her self-exile to the United States, Kusama was relentlessly critical toward the Japanese art world, which she considers "fifty years behind" the international art scene. Kusama's intense identification with the Euro-American-centered discourse of painting was her affiliation to the different Symbolic order represented as "Abstract Expressionism," which consequently dislocated her from the patriarchal order of her native community – the Japanese art world. The cultural exchange of abstract painting should be read within the complicated re-structuring of social and symbolic hierarchy and its politics. Such connectivity between one's psychic formation and cultural dislocation can be learned from the psychoanalytical studies on the identities of African-Americans.

In "Race, Class and Psychoanalysis: Opening Question," Elizabeth Abel reads Hortense J. Spiller's "Mama's Baby, Papa's Maybe" with stress on the differentiated structure of subjectivity under slavery. Spiller's application

of Lacanian analysis to subject (de)formations under slavery and after suggests the nullification of sustaining kinship structures – the premise of psychoanalytical theory – and the corresponding disintegration of subject under slavery where the power relations change due to the encounter between different symbolic orders.[29] The predominance of the white Father's law prevents symbolic power of the domestic Father in the slave family. Yet the complicated relationship of the plural laws formulates what Spiller calls "dual fatherhood" which, according to her, consists of "the African father's *banished* name and body and the captor father's mocking presence."[30] The conflict of the two kinds of laws brings structural confusion to normal kinship and consequently troubles the gendering process of subjects formed through this nexus. These insights are suggestive for reading the cultural situation of the postwar period where the immigration of Asian people to the United States also initiated the complex power politics of reconstructing their cultural subjectivity. The cultural colonization of Japanese art(ist) by the American abstract art paradigm has lessened, if not banished, the authoritative power of the domestic paternal figure over the Japanese woman.

A work by the novelist Oba can help us to probe further into Japanese women's social and symbolic position in the postwar culture. Her prize-winning work *Sanbiki no Kani* (The Three Crabs) was written in the United States in 1967. The story concerns a Japanese housewife called Yuri who lives in the United States with her husband and daughter Rie. The family embraces a precarious balance because of the husband's infidelity and the daughter's resistance to her mother. During her aimless wandering about, Yuri meets a man of ambiguous ethnicity, and has a relationship with him.

Oba won many prestigious Japanese literary prizes, including the Akutagawa Prize, for works that she produced in the United States. Male members of the prize committee read the story in respect to the problems for each gender in the postwar generation. For instance, Eto Jun commented:

> In order to gloss over the humiliation of "national defeat", men have built up elaborate bluffing self-deception, but women on the contrary have tried to throw themselves bodily into the fissure between reality and the fabrication created by these ruined men. This of course wraps and tears these women.[31]

After the war people had a consciousness of the difference in men's and women's responses to the change in the postwar period brought out from

a newly opened encounter with the *Gaikoku* (foreign countries). The change was acknowledged symbolically through dysfunctional sexual and gender order. As Sharalyn Orbaugh, a scholar of Japanese literature, pointed out, the characters in Oba's work (and also Oba herself) were often regarded as advanced. At the same time, they are considered terrifying or pathetic figures severed from familial and cultural bonds in the "too-free society" of the United States and they menace the domestic order. Implicit hostility to these women is not unlike the Japanese media's unfavorable view of Kusama during her stay in the United States, where she was habitually featured as being scandalous and morbid. The international and cultural exchange set out within the prevalent modernist painting assuredly performed as a site in which one's gender identity should also be varied. Many Japanese women artists have aspired to go to the United States to treat with a "superior" symbolic order rather than a secondary one, but not only because the artists were ambitious to attain a higher status, but also because of the now twisted relationship with their domestic paternal figure.

The heart of Spiller's analysis of symbolism in terms of cultural domination is in the suggestion of differentiated paths for sexual subject formation in the collapsed kinship structure, which creates the "gap between the social and symbolic fields."[32] Most importantly, however, in both Spiller's and Oba's text, the maternal figure is situated in an important role in such fissured cultural, social, and domestic contexts. The disintegrated configuration of social orders prevents the domestic male's symbolic power operation, and, consequently, the customarily oppressed figure of the mother rises to the surface.[33] Spiller's enslaved mother functions centrally in the formation of her children's subjectivity, which also maintains its trace of the African-American male throughout under the "master culture's attack."[34] Oba's mother, Yuri, represents the cause and effect of the disintegrated familial composition. Yet she also holds the central position within the story. In the case of the Japanese woman in Oba's work, however, the position is an incessantly unstable one. As Orbaugh points out, Yuri does not run from the family, but remains in the role of the "ambiguous" female, the "entrapped" maternal figure,[35] despite her evident resistance to the conventional integrity of the family. Orbaugh calls such mother/wife subjectivity "unsought (and unsatisfactory) personal subjectivity."[36]

Although, on one hand, the modernization of postwar Japan indeed fractured its own paternal authority and yielded its power to the

"higher-modernized" country – America, on the other hand, in the process of postwar Westernization/democratization, Japan imported a more articulated, extensive and modernized version of familial structure with the notion of the nuclear family. There the domestic father/husband figure is more or less emptied under the "superior" Name of the Father, but the framework itself is kept in form. These circumstances deprive the Japanese wife of a place to settle or belong. Now her identity is secured (only) by her children, especially her daughter. Nevertheless, from the side of the daughter, her mother's "unsatisfactory" subjectivity is something she has to avoid identifying with (Rie's resistance to her mother is addressed as identification with her mother). Yet, on the other hand, when the daughter equates herself with her mother both as "women" who similarly share that "dual-fatherhood," the mother is the one with whom she sympathizes most and partly identifies. It is "partly" because the daughter can see the "new" external world, where she can be released from the traditional patriarchal restriction with the help of stronger, Symbolic, paternal figures, with whom she wishes to identify herself most. But the identification cannot be processed without a strong residue of the connection with her mother, from which she has to persistently sever herself. In these stories, the mother figures do not erase themselves away in the malfunctioning Oedipal structures; they provide their daughters with the potential site of different subjectivities.

Not working with the Oedipal model of symbolic Fathers and Mothers, Bracha Ettinger's thesis of a supplementary register of human subjectivity that she names the "Matrixial" is formulated to allow into psychoanalytical theory a challenge to the exclusive dominance of a phallic version of the Symbolic which privileges imaginary and symbolic identifications of meaning with the Father. Ettinger's theory, allowing us to think about a feminine contribution to the formations of subjectivity that do not require the abjection of the mother and alignment with the Father's law, reconfigures the ways in which we can think about the role of the m/Other, as she calls the archaic other, in the formations of the feminine subject's psyche. This shift can also be applied to the historically discontinuous, yet commonly shared, male-centered-ness, or phallocentrism of painting discourse. Ettinger challenges the existing psychoanalytical interpretation of subject formation where the "Phallus" determines all of the relationships and the processes of the symbolic on the principle of castration – separation and lack. Instead, she proposes a supplementary signifier, the Matrix that allows for a differentiated plan for the feminine subject, as "the

mother cannot remain as the other for a feminine subject as she can remain to a male subject,"[37] The matrix proposes an expanded Symbolic where the feminine can take part in the operation instead of signifying only the phallic Symbolic's lack.[38] "Abstract painting" is an ideological frame that symbolically represents and forges one's gendered and racialized subjectivity. Ettinger's theory of the Matrix arises in and out of art; she is herself a painter. But she also asserts that art and sexuality have a particular psychic intimacy for "we enter the function of art by way of the libido and through extensions of the psyche close to the edge of corpo-*reality*."[39] Art "in, of and from the feminine," in other words, the art that had been in *excess* or *lack* in the masculine discourse, will indicate the plane for a different, differencing mode if we have the theoretical tools to read for it. If Kusama's art and her subjectivity as an artist have not been articulated and have actually been lost in existing artistic discourses, her art may designate that different "feminine" trajectory.

Reading of Net Painting

Painting a "Net"

Since the end of the 1950s, under different titles, and using differing sizes and color schemes, Kusama has produced a body of work generally titled "Net Painting": *Pacific Ocean* (Figure 5.2), *Yellow Net* (Figure 5.3), *No. F.C.H.*, *Interminable Net*... At first sight, they appear to be simple monotonous patterns of a net. Yet the monotonous look may prompt various associations – from veins of a leaf, the foamy surface of water, the scales of a fish, human skin, a piece of cloth, a flower, wallpaper, lace – anything, but again nothing, other than the supernatural "obsessiveness" of the artist's act. Yet a painter cannot produce works of art merely from an obsessive drive. Each stage always entails technical decisions and procedures.

Let us imagine how the painter addresses herself to the painting.

There is a blank canvas in front of you – normally taller and wider than your body. It is either leaning against the wall or placed on a table. You have to apply paint thinly throughout the length and breadth of the vast expanse of empty white space. When the whole screen is skimmed with monotint, you finally get around to starting painting the "net." You might start from a corner with the very first segment of the net. That first part

Figure 5.2 Yayoi Kusama, *Pacific Ocean*, 1960, oil on canvas, 183 × 183 cm. Reproduced courtesy of the Kusama Studio.

would then expand afterwards. Your brush loaded with thick paint continues making uninterrupted spiral movements without lifting itself from the canvas.[40] The small arc-like curve stimulates the next move to produce another arc. The move involves a constant rhythm and certain unavoidable rules, like bees making a beehive. With a rhythmical impulse, your brush forms larger arcs and circular patterns with each smaller unit. They overlap each other. You have to, or you feel like you must pursue this project until the last brushstroke reaches the last crevice of the lightly painted surface. When you finish covering the whole area with the net, what do you see there?

Figure 5.3 Yayoi Kusama, *Yellow Net*, 1960, oil on canvas, 240 × 294.6 cm. Reproduced courtesy of the Kusama Studio.

The Net painting did not emerge out of the blue from her New York studio.[41] A similar repetitive pattern can be seen in other works produced before she came to the United States. Kusama drew on this familiar form to deploy her painting for an informed and evident art-historical attempt that was primarily addressed toward American painting legacies. She says:

> Although having settled in the Mecca of Action Painting, the highlight of the Tenth Street, I did not ride on the wave of their action painting. Standing in the thick of it, immediately I did the quite the opposite, the negation of action painting. The whole surface was of a mesh of net. There was neither composition, nor focus, nor even a splash of paint.[42]

"Action painting" is an interpretative frame, however prevalent it maybe, of particular paintings where the "action" projected on canvas should be understood in terms of a materialized signifier of the acquisition of

essential human freedom, which can be tracked by violent mastering of pictorial space.[43] In psychic dimensional terms, this process is echoed in the castration stage where a male infant strives to obtain a sexed subjectivity by splitting himself from the "mother" by objectifying "her." What is left in this process as the "object" is the body of the mother (in psychoanalytical terms, "*objet a*"). Thus the gesture of freedom is a symbolic disposition of the psychic process of subjectivization, where its trace is recognized as "the Other/object a." The feminist reading of this master narrative of psychoanalysis has stressed that this process is a model perceived only from the male point of view to formulate the masculine self. As Ettinger puts it: "its subjectivization is characterized by cuts from bodily events (Real) by means of the signifier (Symbolic), in order to leave the *inhuman* behind and enter the specifically *human*" (my emphasis).[44] The aggressive "gesture" of "action" painting should be interpreted as a significantly masculine act on the feminine (maternal) body of the work; the feminine subject cannot participate in this process.[45] This communally held idea of the self envisioned in art factually and canonically did not quite include the woman artist in either country. Here is a woman's reaction to this masculinism of abstract painting. Kusama wrote in one of her novels:

> For the sake of the starving penis, when Ben Shahn rides/rode on the logic of Realism on a canvas with a Social Realist picture putting a hamburger on the red flag of chisel and hammer, he gets told off with one blow that the technique is old, scratches his head, and gets a word in edgewise, "paint like this". Drench the penis brush with a juice of paint, stand in front of the canvas, give a swing, and achieve worldwide fame. Action painting, but actually it is because butt-headed art historians made a major upset to the penis methodology by searching for the trace of pattern on the earth drawn down by the action of Jackson Pollock pissing on the white snow or on the concrete. For the sake of the penis, the sun shines. The earth spins for the penis.[46]

The mocking and rather hostile tone in this prose poem is determinedly addressed to the sexual connotations of the act of painting. There emerges a question that is crucial to Kusama's cultural and sexual position in the art world: Can the practice of "Net" production be a feminine alternative to the masculine staging of "action" as she appeared to produce the "opposite" of Pollock-type painting?

In fact, Kusama's "self-obliteration" narrative seems to relate the extreme opposite of the self-obtaining passage of "action" painting. During painting, her brush does not leave the canvas: her painting gesture keeps her body in close contact to the body of the work. The "net" pattern makes the artist act differently from Pollock's free-hand "action." Dore Ashton favorably reviewed Net paintings in the early years, but has commented: "disturbing none the less is its tightly held austerity."[47] The "disturbing austerity" sensed by this woman critic implies traits that conflict with what Greenberg referred to as the "boldness and breadth" of Pollock's painting. Contrary to the audacious moves of "action" painters, the small arcs or dots are the traces of the least and smallest possible moves to mark the canvas with paint; in Net painting, the "act" of painting is "austerely" restrained in the minimal action. If "action" painting is a trace of a progressive "cutting off" of the body of the painting, "net" painting might suggest a "touching" without harming it. Pollock's "action" is oriented to detach the artist from the body of the painting; Kusama's continuous painting aspires to produce a contiguity with her object – the body of the mother. At the level of production, Kusama's brushstrokes do not "finish" the relationship: it was once called an "Interminable Net"; the brush creates a contacting network from edge to edge, and over, followed by the next Net painting. In this process, to follow the "self-obliteration" narrative, the self is not articulated but is continuous in connection with the "body" of the painting.

This is not to say, however, that Kusama's personal body and mind are always entangled in the net and inseparable from the body of the painting. Such an idea certainly falls back to the traditional idea of pre-human fusion with the maternal body. I agree with Tatehata Akira's opinion that "her unceasing restatement of the *Infinity Net* is also a re-affirming of her persona, a defiant 'I exist.'"[48] The repeated assertion of "self-obliteration" is, it now seems, a means of putting herself in the "right" position within the existing paradigm, which is the feminine, the ill and the pre-human. Further, if the "self-obliteration" is realized, it must be paradoxically processed through the marking of herself on the canvas.[49]

The paint is a part of her body and the brushstrokes left behind are a trace of her presence and thus her self. Kusama's brush was very thick. In this way, one can clearly see the movement and intensity of her "mark." Under the rules of the art world, the gestures left in the work unfailingly represent the artist's signature. Oil paint is quite different from the soaking effect of other materials such as gouache, pastel or watercolor paint that

were her usual materials in Japan. The oil paint leaves a clearer trace of the brushstroke and is the "Western tool" with which she had to mark her presence in the Western art world. Net painting is certainly the proclamation of her existence as a creative subject, and Kusama's body of the painter is on and off the discourse of Abstract Expressionist painting.

It is important to note that Lacan also distinguished "gesture" from "act." According to him, a brushstroke that is marked and "terminated" in the viewing phase signifies that "the relation to the other is situated as distinct ... that of the terminal moment." On the other hand, the "action" suggested by brushstroke appears to the viewer as an *ongoing* "battle scene, that is to say, as something theatrical, necessarily created for the gesture."[50] Yet modernist painting discourses, especially that of Greenberg, do not accept the temporal dimension of the gesture. The process of dishonorable "battle" was disavowed to secure the stable subjective position of the artist hero. For Greenberg, the mark stained on canvas should be perceived strictly as an optical effect rather than, despite the inevitable illusion caused by the first stain applied on the canvas, as an experience of the space where the viewer ought to be physically involved.[51] The emphasis on "pure opticality" is a means of grasping the painting field by mastering the space with a privileged status of painting/seeing subject. Judd's review of Kusama's paintings also contributes to this modernist paradigm. His entirely formalist stance visually subjugates the "net" paint. Judd's words function to rule and eliminate the possible differences of Kusama's painting under the concept of abstract formalism.

Ettinger places such a modernist discourse within the "phallic scope," where "conscious illusion of ownership and mastery over the phallic gaze, which is a classical battle position plunged inside the modernist struggle, distances the visual from primary repartition of energies or from the *nonverbal intensities*."[52] The modernist critics needed to establish *their* subjective standpoint by means of sublimating the "battle" to transparent visual form, where the "free" action of gesture actually reveals itself as a necessary response played by the challenged subject. In "Sexuality in the Field of Vision," Jacqueline Rose emphasized that "psychoanalysis describes the psychic law to which we are subject, but only in terms of its *failing*."[53] Like Ettinger, Rose presents art as an ambiguous site of the unconscious where the sexuality is always imperfectly structured and experienced only through fantasy. It is thus the site that disturbs and perplexes one's sexual identity. Through the experience of a painting, the presence of self has to emerge in contact with the maternal body, not

through detachment from it.[54] Thus the act of painting provides the painting subject with a double-edged process *as well as* a bilateral effect. It is a process to sever oneself from the mother through approaching her by threatening one's subjective position. Painting, conceived as its process is a trace of the self, as well as a given form of the relation to the *objet a* of the mother's body.[55]

Kusama's "Net" painting potentially shows a passage differentiated from the master narrative of modernist painting – that is to say, a visual form of another fantasy where the subject is still in touch with the mother's body as it narrates an example of the paradoxical relation between the body of the artist and art work. The production of "Net" painting is a story of weaving the contacting phase onto the screen of canvas whereas "action" painting is a strategic narrative of a fantasy of the disconnecting stage. Net painting practice can be called "feminine" in the respect that it leaves what the "masculine" subject cannot endure but the "feminine" embraces.

Encountering Net Painting

When we encounter Net painting, we are overwhelmed by the immensity of the canvas and intricate nets over-crowdedly depicted on that huge canvas. The impression can be strong in proportion to the size of the canvas. Mignon Nixon viewed Kusama's enormous paintings as the "trump of Jackson Pollock." "Parodying the excess of Pollock's achievement, Kusama unveils a bigger painting, and announces an equally capacious ambition."[56] The issue of scale is particular to Kusama's painting: the extremity of the repetition and its excessive scale – "obsession." As Nixon pointed out, the largeness of the painting may reflect the artist's enthusiasm and sense of rivalry. People have generally deemed the extensity of the "net" to be an indication of the artist's obsessive desire to cover everything up with *her* net and thus her self. This idea, and Nixon's comments on "capacious ambition," have recourse to the masculine painting modality with which a woman has to play a masculinized role with the female body. In the context of Abstract Expressionist painting, the size of a painting could act as a measure of the "freedom" of the artist in which the painter's magnificent gesture is unfurled. Yet, the Net paintings are sometimes unnecessarily huge. They even risk losing their own identity as paintings.

The scale of a painting is a topic that had not really been discussed in the American painting disciplines. Greenberg once raised the issue of size, and not scale, of canvas as one of the fundamental elements self-critically assigned to the medium. Michael Fried later argued about the issue of "scale" by following Greenberg to suggest what he called "objecthood," which is bestowed on an art work that has a "certain largeness of scale, rather than through size alone."[57] According to Fried, the "objecthood" is found when the viewer has to keep a distance "physically and psychically" to look at a large work.[58] The "scale" implied here indicates the human-centered perception of the size that assures the viewer's subjective position. Fried suggests that when the scale exceeds a certain point, "objecthood" would be lost.[59]

Kusama's Net paintings, especially the ones presented in her first show, certainly overstep such bounds, being at least big enough to trouble the viewer's eye. Lucy Lippard commented on this show, "in which, her paintings approximated the size of the gallery's walls; the initial impression was one of no-show." Nevertheless, contrary to Fried's theory, the work did not require distance. Lippard states: "but on close scrutiny, a fine mesh of circular patterns was revealed."[60] The Net paintings do not let the viewer get a full view in one sweep, but tempt them to look closer. There we find that the apparently unitary patterns of the net of the painting do not produce a *completely* even surface. For instance, two 1960 works – called *Yellow Net* (Figure 5.3) and *No. P.Z* – each show horizontal and vertical stripes that imply also the corresponding longitudinal and lateral movement of the painter. Our eye would be divided into each section where the "net" creates recognizable masses, which are yet still connected to each other. Also, the distinguishable circular forms consisting of the smallest "net" units can be found in the accumulation of mesh in works such as *Pacific Ocean* (Figure 5.2). The experience of the Net painting involves a relationship of intimacy that can also be implied from the literal nearness of the painter's body to the canvas during the production. The act of inscribing net on the canvas requires the artist's sectional, and not overall contact with the canvas. When we encounter a Net painting, it will allocate us partial views of nearness rather than the distanced and integrated sight to "over view" the total (or all-over) field of painting.

Fried has compared the experience of the distance from the work to the experience of encountering someone – "the silent presence of another person – which is 'disquieting.'" In Fried's concept of "objecthood," the "silent presence" of the distanced work of art is rather the absence – the

silenced presence of the absent mother physically and psychically detached from the subject through the symbolic "castration." The Net painting may perform as the symbolic lost object of the mother's body, which is, however, persistently present. It optically seduces and does not reject the viewer: the net comes into sight only when the spectators allow themselves to be involved in the reduced distance. Then the relationship in this nearness is always partial. From the viewpoint of the self-formulating theoretic model, the partially divided relationship with the screen might cause fracture of the self. At the same time, it produces an ongoing and undecided experience of viewing. There the relationship is not subject-centered but partly object-centered where the art work is not completely "objectified." The dimensions of the Net painting are not the large size of the canvas itself but of a scale that pluralizes the potential points of encounter between the spectator and the work, shattering the familiar subject/object binary relationship between viewer and work.

Untitled (1939; Figure 5.4) is a picture drawn when Kusama was ten years old. The artist presented this work in public as an origin of Net/Dot

Figure 5.4 Yayoi Kusama, *Untitled*, 1939, pencil on paper, 25 × 22 cm. Photograph by Tesushi Namura. Reproduced courtesy of OTA Fine Arts.

painting. She says this is a portrait of her mother who had treated her violently and had thereby incurably traumatized her for the rest of her life. We obviously cannot draw the immediate conclusion that her art has always been structured literally from this traumatic experience. It could, none the less, be said that we can learn about her painting from this drawing which she presents as the prototype of her art. True, this drawing has "polka dots" all over the picture. They look like raindrops or snowfall surrounding the woman, which suggests space and depth where the woman is in this picture, which dissociates the figure of the woman from the surface of the screen. What the drawing uncovers is its double structure, with which the maker produced a drawing *and* nets/ dots. The same could be said of the Net paintings. When the artist paints, she meets the picture three times: firstly, the blank space of the canvas or paper, secondly, the mono-colored surface, and finally, the net-covered painting.

We, as the viewer, can participate in the last stage. In the finished work, we see the net hovering. The net comes to the fore, between the background painting and our eyes. As the net does not completely cover the backcloth, it leaves room between each mesh section where we can catch a glimpse of the thing behind. This view of Net painting creates space between the viewed object and viewing subject – in other words, space between the absent maternal body and the present "us."

In fact, a sense of depth and spacious effect is something Kusama's paintings might have lost when she changed her main painting method to oil on canvas. In paintings produced before she went to the United States, or before she was trying so hard to assimilate to the Western contemporary style of painting, space was created with watercolor stained into the paper (Figure 5.5). In the procedure of Western oil painting, the painter customarily puts an undercoating on the canvas. This first layer of paint can be considered as a kind of rite of passage to cover up the empty surface of the screen – the maternal body. The Net paintings made in the USA have imported this stage. In the case of this Japanese woman artist, who wished to identify herself with Western society and to build her new subjectivity there, this technical change can be read as a psychic transference, in which she tried to detach herself from the domestic mother through acquiring the language of American painting, the symbolic order of her outer new world. The oil paint coats the canvas and paints the maternal figure underneath the surface. Yet Net painting does not finish there. The very "net" stage allows the replay of that non-covered

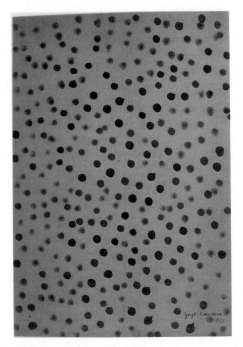

Figure 5.5 Yayoi Kusama, *Infinity Polka Dots (Red)*, 1951, watercolour/ink, 40 ×
30 cm. Photograph by Tesushi Namura. Reproduced courtesy of OTA Fine Arts.

space. The netted surface seems as if it has something behind it, which
is not formed but suggested by the movement of the net that comes to
the surface. It gives form to the things behind by the very act of cover-
ing it. The body of the mother once painted *in* reappears *out* of the
surface and draws *us*. On the other hand, our eyes are also covered by
net that is encroaching the sight/site once experienced as a gap between
the painted surface and us. Thus, the space is an interrelating site that
does not belong to either side but both; therefore it potentially reverses
their place and the "meaning" of the encounter is interchangeable
throughout.

Ettinger indicates that the lost mother figure appears "with-in and
with-out, by the transgression of borderlinks manifested in the contact
within/-out an artwork by a transcendence of the subject-object interval
which is not a fusion, since it is based on an a-priori *share-ability in
difference*."[61] The "net" of the Net painting allows us to "share" the space
with which our experience of subjectivities are also changed. Ettinger

defines the matrixial as the experience of "*subjectivity-as-encounter*."[62] The Net paintings serve as a "screen" between the eye and the faded but not obliterated sense of shared space with the maternal body. The maternal body both functions as a partition between the subject who desires the plenitude of unification with the archaic mother (therefore without the self-annihilation) and as a possibility of meeting and contact (therefore without killing her). Ettinger's key contribution to psychoanalysis and psychoanalytical esthetics concerns not the inversion of mother-mode for father-mode; rather, it is the displacement of the phallic concept of a self cut away from its maternal other by the positing of a non-gendered sharing of borderspace and a non-gendered functioning of borderlinks between several partial subjectivities that remain unknown and unknowable but not unaffecting and not unaffected by the co-emergence and co-fading that is never presence and thus does not become absence. The matrixial theorizes a partiality that resists the binaries of pure presence and pure absence, absolute unity and absolute loss. This is the matrixial definition of the matrixial feminine that is a stratum of subjectivity not a fantasy of a mother.

Unlike the narrative of castration structured around the privileged Phallus, the matrixial stage is a passage that every human entity who was born to a woman has been through. I am suggesting that Net painting may be read as an artistic figuration and thus a different psychic economy that gives an un-form to this matrixial fantasy that does not belong to the phallic Symbolic but clearly emerges only through the model of encounter.

Yayoi Kusama's Story of Net Painting and Postwar Japanese Women: By Way of a Conclusion...

Finally, I have to address what I have been avoiding in this chapter: the biography of the artist. Yet I would like to introduce Kusama's life-story not as an individualized monograph, but as one example of biographical stories, probably, or at least partly, common to the women who share the same generation and geography, namely the milieu of postwar Japan. Kusama was born into a wealthy and traditional family that ran a large farm in a provincial city. The family had a traditional, but peculiar Japanese structure: her father was adopted into the family to save the name of Kusama, a family that has been a member of the ruling class in the area for long time. After the war, the family immediately worked out a

countermeasure to keep their property from the newly established governmental policy, and survived as a capitalist-based enterprise. In that family-based company, however, the authoritative figure was not her (adopted) father, but the mother who succeeded to the name of the family. Yet the family strictly maintained the patriarchal system in which the mother officially had a lower position than her husband who, notwithstanding, caused her much distress with his infidelity. The "hysterical" mother's violence toward the young Yayoi was a sign of this disintegrating family, where the "father" did not have symbolic centripetal force and the "mother" embraced decentralized subjectivity. This "personal" story should be mapped onto the larger view of postwar Japanese society that I have discussed above. After the national defeat in the war, the function of the kinship structure of the Japanese family, as well as its society, was symbolically fractured but socially sustained. That symbolic formation was threatened by "Gaikoku."

Kusama desired the outer world. Postwar society showed her external paternal figures, such as her psychiatrist or the art critics who introduced her to the now-opened outside world: outside of Japan. Her domestic story and encounter with the "outside" was in a sense typical of Japanese postwar women. But it was an extreme case. Her challenge after she left her family and her native country was extremely audacious but not uncommon. Released from the strong pressures of Confucian male domination, the Japanese daughters aspired to go to a freer world. That dream was often represented by going beyond Japan and finding a new subjectivity out there. Kusama's move to the United States and her attempted assimilation to the language of American painting is an example of these postwar Japanese women's experiences. Net painting signifies something of this artist's symbolic and social trajectory. Oba Minako, who was born one year later than Kusama, is also a daughter of postwar Japan. They both seem to pursue the Japanese postwar daughter's desire.

That process, however, inevitably involved them in leaving their mothers, who were after all still trapped in the patriarchal structure of the Japanese family. Such a mother can be observed in works by Oba, who herself became a Japanese mother. On the other hand, in a literal sense also, Kusama has remained a daughter throughout. She has secured her subjectivity without the identification with the Japanese mother. Yet, this is not without cost, as Ettinger tells us: "The absence of the mother is painful by what she leaves behind when she is no longer there, that is a repetition wherein even play is impossible because the *I* finds itself

subjected to the active mother's absence."[63] Kusama continues to paint Net paintings, no matter how strongly her subjectivity as an artist has been established both inside and outside of her native Japan.

Notes

1 Oba Minako, *Kozu no Nai E* (Painting without Composition), *Sanbiki no Kani* (The Three Crabs) (Tokyo: Koudan-sha, 1968), pp. 7–138 (p. 133).
2 In Japanese, the first name comes after the family name. I follow this original order of Japanese names except for Yayoi Kusama in the respect that she *has been* "Yayoi Kusama" in the international art field where she desired to establish her name. For the sake of regularity of Western language, her name and signature was converted to "Yayoi Kusama" from Kusama Yayoi.
3 Griselda Pollock, "Painting, Feminism, History," in *Looking Back to the Future: Essays on Art, Life and Death* (London: Routledge, 2001), pp. 73–111 (p. 79).
4 Donald Judd, "Reviews and Previews: New Name This Month," *Art News*, vol. 58, no. 6 (October 1959), 17.
5 Clement Greenberg, "'American-Type' Painting," in *The New Art: A Critical Anthology*, ed. by Gregory Battcock (New York: E.P. Dutton, 1966), pp. 208–29.
6 Sydney Tillim, "In the Galleries: Yayoi Kusama," *Arts Magazine*, vol. 34, no. 1 (October 1958), 56.
7 Alexandra Munroe, "Obsession, Fantasy and Outrage: The Art of Yayoi Kusama," in *Yayoi Kusama: Retrospective* (New York: Center for International Contemporary Art, 1989), pp. 11–32.
8 Lois Nesbitt, "Special Report: Japanese Art – Yayoi Kusama's First Retrospective at New CICA Blends Brilliance and Madness," *The Journal of Art*, vol. 2, no. 3 (December 1989), 17.
9 Kusama Yayoi, "Waga Tamashii no Henreki to Tatakai," *Geijutsu Seikatsu*, vol. 28, no. 11 (November 1974), 96–113 (p. 110). My translation.
10 Lynn Zelevansky, "Driving Image: Yayoi Kusama in New York," in *Yayoi Kusama, 1958–1968* (Los Angeles: Los Angeles County Museum of Art, 1999), pp. 11–41 (p. 11).
11 Ibid., pp. 11–12.
12 G. Pollock, "Three Thoughts on Femininity, Creativity and Elapsed Time," *Parkett*, vol. 59 (2000), 107–13 (108).
13 Kusama as quoted in Munroe, "Obsession, Fantasy, and Outrage," p. 12.
14 Bracha L. Ettinger, "Some-Thing, Some-Event and Some-Encounter between Sinthome and Symptom," in *The Prinzhorn Collection: Trace upon the Wunderblock* (Los Angeles: UCLA Museum, 2000), pp. 61–75 (p. 61).

15 Kusama, as quoted in Bhupendra Karia, "Biographical Notes," in *Yayoi Kusama: Retrospective*, pp. 66–105 (p. 72).

16 Georgia O'Keeffe as quoted in Karia, "Biographical Notes," p. 74.

17 Alexandra Munroe, "With the Sudden of Creation: Trends of Abstract Painting in Japan and China, 1945–1970," in *Asian Traditions, Modern Expressions: Asian American Artists and Abstraction 1945–1970*, ed. J. Wechsler (New York: Harry N. Abrams, 1997), pp. 30–41.

18 For instance, a French art critic Michel Tapié, the leader of the Art Informel, sympathized with Gutai's activities and contributed to the international exposure of their works. In 1958, he organized an exhibition in Osaka, which was an emblematic exhibition in this period organized by him, which included Gutai artists' works along with paintings by Western painters such as Jackson Pollock, Franz Klein, and Robert Motherwell from the US, and Georges Mathieu, Antoni Tapies, and Karel Appel from Europe.

19 Harold Rosenberg, "American Action Painters," *Art News* (December 1952), 22–3.

20 Originally published as "Gutai bijutsu sengen" in *Geijutsu Shincho*, vol. 7, no. 12 (December 1956), 202–4. Reprinted and translated in Munroe, 1994, p. 370.

21 Ibid., p. 370.

22 Eva Cockroft, "Abstract Expressionism, Weapon of the Cold War," in *Pollock and After: Critical Debate*, ed. Francis Frascina (London and New York: Routledge, 2000), pp. 147–180 (p. 151).

23 Greenberg, "'American-Type' Painting," pp. 213–21.

24 Bert Winther, "Japanese Thematics in Post-war American Art: From Soi-Disant Zen to the Assertion of Asian American Identity," in Munroe, 1994, pp. 155–67 (p. 158).

25 For instance, a young Japanese-American, Abe Satoru, who moved from Hawaii to New York after the war, later states, "New York critics would basically never give full credit to Asian American artists." Jeffery Wechsler, "From Asian Traditions to Modern Expressions: Abstract Art by Asian Americans, 1945–1970," in Wechsler, *Asian Traditions, Modern Expressions*, pp. 58–145 (p. 75).

26 Pollock, "Painting, Feminism, History," p. 79.

27 In 1956, before she wrote to O'Keeffe, Kusama had her first opportunity to expose her work abroad in an exhibition called *The International Water Color Exhibition: Eighteenth Biennial* held at the Brooklyn Museum in New York. The participation in the first group show in the US probably gave impetus to her decision to move to the US. Yet unlike the group orientation of artists such as Gutai or Fluxus, Kusama searched for her own way to New York. Fluxus was another important art group/set of activities of the Japanese avant-garde that exposed itself in various sites around the world. Although

their concepts and methodologies were by no means the same, both groups were similarly interested in traditional Japanese art and fascinated with the Euro-American art scene.

28 Trinh T. Minh-ha, *Women, Native, Other: Writing Postcoloniality and Feminism* (Bloomington and Indianapolis: Indiana University Press, 1989), p. 86.

29 Elizabeth Abel, "Race, Class, and Psychoanalysis? Open Questions," in *Conflicts in Feminism* (London and New York: Routledge, 1990), pp. 184–204 (p. 188).

30 Hortense J. Spiller, "Mama's Baby, Papa's Maybe: An American Grammar Book," *diacritics*, vol. 17, no. 2 (Summer 1987), 72.

31 Eto Jun, 'Michisu no Sugomi' (Immeasurable Ghastliness), trans. by and quoted in Saralyn Orbaugh, "Oba Minako and the Paternity of Maternalism," in *The Father–Daughter Plot: Japanese Literary Women and the Law of the Father*, ed. Rebecca L. Copeland et al. (Honolulu: University of Hawaii Press, 2001), pp. 265–291 (p. 271).

32 Abel, "Race, Class, and Psychoanalysis," p. 188.

33 Ibid., p. 188.

34 Ibid., p. 189.

35 Orbaugh, "Oba Minako," p. 285.

36 Ibid., p. 285.

37 Ettinger, "Some-Thing, Some-Event and Some-Encounter between Sinthome and Symptom," p. 66.

38 Bracha Ettinger, "Matrix and Metramorphosis," *Differences*, vol. 4, no. 3 (1992), 176–208 (177–83).

39 Bracha Ettinger, "The With-In-Visible Screen," in *Inside the Visible: an Elliptical Traverse of 20th Century Art in, of, and from the Feminine*, ed. M. Cathérine de Zegher (Cambridge, MA: The MIT Press, 1996), pp. 89–113 (p. 92).

40 See especially Figure 5.2.

41 Seki Naoko has articulated the relevance and continuity between Kusama's painting produced in Japan and the US as it had been missed out in the former interpretation of Net painting which was formed centrally in the US. Seki Naoko, "In Full Bloom: Yayoi Kusama, Years in Japan," in *In Full Bloom: Yayoi Kusama, Years in Japan* (Tokyo: Museum of Contemporary Art Tokyo, 1999), pp. 6–18.

42 Kusama as quoted in Tanikawa Atsushi, "Zousyoku no Genma" (Phantom of Multiplication – How She Flies Through the Eras), *Bijutsu Techo* (Featuring Yayoi Kusama: The Origin and Development of Obsessional Art), vol. 45, no. 671 (June 1993), 65–77 (69).

43 The importance of the artist's gesture and its aesthetically theorized politics is discussed in Mary Kelley's "Reviewing Modernist Criticism," *Screen*, vol. 22, no. 3 (1981), 41–62.

44 Ettinger, "The With-In-Visible Screen," p. 95.

45 Gutai's artists also looked upon "action" as important. The performative paintings of Shimamoto Shuzo or the unmediated contact between the artist and medium staged in Shiraga's work in effect looks much more aggressive. It may be understood to follow the psychic facet of "action" in painting, as their urgent reclamation of the masculine self by the relentless collision between "human spirit" (self) and "material" (body of a work) in the age of "ruined men."

46 Yayoi Kusama as quoted in Uno Kuniichi, "Kyosei to Uchu" (the Castration and the Cosmos), *Bijutsu Techo*, vol. 40, no. 599 (September 1988), 118–27 (126). Yayoi Kusama, *Woodstock Inkei giri* (Woodstock Phallus Cutting) (Peyotoru-koubo, 1988).

47 Dore Ashton, "Art: Tenth Street Views – Bustling Gallery Area Called a Mecca for the Bargain Hunters," *New York Times* (October 23, 1959), 58.

48 Quoted in Laura Hoptman, "Tatehata Akira 'Magnificent Obsession'," Japan Pavilion (catalog), XLV Biennnale, *Yayoi Kusama* (Tokyo: Japan Foundation, 1993).

49 Laura Hoptman, "Yayoi Kusama: A Reckoning," in *Yayoi Kusama*, ed. Laura Hoptman, Akira Tatehata, Udo Kultermann (London: Phaidon, 2000), pp. 34–82 (p. 34).

50 Jacques Lacan, *The Four Fundamental Concepts of Psycho-analysis*, ed. by Jacques-Alain Miller, trans by Alan Sheridan, introduction by David Macey (London: Vintage, 1998). p. 115.

51 Clement Greenberg, "Modernist Painting," *The New Art: A Critical Anthology*, ed. Gregory Battcock (London: E.P. Dutton, 1973).

52 Ettinger, 1992, p. 11.

53 Jacqueline Rose, *Sexuality in the Field of Vision* (London: Verso, 1986), pp. 225–8.

54 Griselda Pollock also says: "Any painting that results from such a staging of the encounter of artist and canvas as a field, as a territory of the (m)Other is the *product of the risk*" (my emphasis). Griselda Pollock, "Killing Men and Dying Women," in *Avant-Gardes and Partisans Reviewed* (Manchester: Manchester University, 1996), pp. 221–94 (p. 257).

55 Thus it is important to mention that it happens rather at the level of discourse that the subjectivizing process is represented complete without trouble. Therefore, not only works produced by the "feminine" painters, but also male artists' paintings cannot be necessarily comprehended as achievements of subject assertions.

56 Mignon Nixon, "Posing the Phallus," *October*, vol. 92 (Spring 2000), 99–127 (111–12).

57 Michael Fried, *Art and Objecthood: Essays and Reviews* (Chicago: The University of Chicago Press, 1998), p. 152.

58 Ibid., p. 153.
59 Fried puts it: "the beholder knows himself to stand in an indeterminate, open-ended – and unexacting – relation *as subject* to the impassive object on the wall or floor"; ibid., p. 154.
60 Lucy Lippard, "Silent Art," in *Art in America*, vol. 55 no. 1 (January–February, 1967), 58–63 (61).
61 Ettinger, "Some-Thing, Some-Event and Some-Encounter between Sinthome and Symptom," p. 43.
62 Ibid., p. 30.
63 Bracha Ettinger, *The Matrixial Gaze* (Leeds: University of Leeds Feminist Arts and Histories Network Press, 1995), p. 41; see also on repetition and the archaic mother in "Traumatic Wit(h)ness-Thing and Matrixial Co/inhabit(u)ating," *parallax*, vol. 5, no. 1 (1999), 89–98.

Diaspora without Resistance? Theresa Hak Kyung Cha's *DICTEE* and the Law of Genre

Karyn Ball

> [...]*They ask you identity. They comment*
> *upon your inability or ability to speak. Whether you*
> *are telling the truth or not about your nationality.*
> *They say you look other than you say. As if*
> *you didn't know who you were.*[1]

Theresa Hak Kyung Cha's biography perfectly situated her to become an avant-garde darling of poststructuralist and multiculturalist literary criticism in the 1990s devoted to "other voices" and to the poetics of divided language, memory, and identity in immigrant and minority literature. Cha was already a refugee before her birth on March 4, 1951, in Pusan, at the extreme southern tip of Korea, where her family was seeking refuge from the advancing North Korean and Chinese armies. To escape the repressive military rule imposed after the 1961 anti-government demonstrations, the eleven-year-old Cha and her family emigrated to the United States in 1962, finally settling in San Francisco. After receiving her Bachelor of Arts from the University of California in Berkeley, she traveled to Paris in 1976 where she worked with Christian Metz, Raymond Bellour, and Thierry Kuntzel at the Centre d'Études Américaine du Cinéma. After returning to Berkeley, she finished a Master of Arts in 1977, the same year she was naturalized as a United States citizen.[2]

This background animates Cha's poetic montage *DICTEE* (1982), which bears witness to the loss and absence of Korea as the idealized origin of an expatriated cultural memory. *DICTEE* dwells on the tensions and divisions affected by an immigrant's assimilation into another culture as an expropriation and obsolescence of a national imaginary, as a perpetual anxiety feeding an unsure linguistic competence, and as a wound to cultural ease in all countries, including the original.[3] For the shifting speakers of *DICTEE*, living in diaspora means that the attempt to assimilate is asymptotal – moving toward, but never reaching the ideal of social and cultural mastery in the new land. Insofar as assimilation involves identification with and imitation of the "natives," the exile's relations with others are marked by apprehensive imitation, a tentative process of taking dictation that is not merely linguistic and mental, but also, and necessarily, disciplinary and corporeal. The immigrant's tongue simultaneously submits and fails to submit to the intonations of another language while her body becomes a cipher for those who assess performance by ferreting out residues of foreignness. *DICTEE* meditates on the collapse of memory into forgetting, on the temporal and spatial fluctuations of a multilingual identity lived between blanks and cuts: the puncture wounds of colonial occupations and of mourned losses scarring into melancholic absences. This meditation converts the speaker's memories into models it would emulate if only it could fix them and keep them pure. Its compulsive circles around these ideals dissolve their contours; caesuras displace details while time and distance soften their effect.

On a structural level, the struggles of the Korean exile portrayed in *DICTEE* – to recreate her national past while internalizing new cultural conventions – parallel the efforts of critics to reproduce their literary values through reference to generic models. This is to say that diasporic memory and literary reproduction obey the "law of genre" as a dynamic principle of sedimentation, attenuation, and *degenerescence*, to borrow from Derrida. Their repeated attempts to animate their origins successively alter their significance and dim down their force. In "The Law of Genre," Derrida writes ". . . at the very moment that a genre or a literature is broached, at that very moment, degenerescence has begun, the end begins."[4] For Derrida, the law of genre refers to the paradoxical tenuousness of the normative logic that guides the delineation of conventions from canonical models. Even in their status as specimens, these models necessarily exceed generic categorizations by operating always inside and outside, before and after, the principle of their selection. In relation to its

descriptive label, the specimen remains singular by virtue of its particular contiguities with previous, current, and future genres as well as its negative inscription of those it excludes. The retroactive succession of "uses and mentions" constitutes and confirms its generic identity in apparent exclusion of other possible categorizations.

Derrida, moreover, suggests that the work of consolidating the relationship between the specimen and the category is a modality of commitment, of *responsibility* to the literary institution and its values as embodied in its models. Recent approaches to immigrant and multilingual literature have defined this responsibility as an injunction to recognize "cultural specificity" as a locus of resistance (to dominant cultural values that disenfranchise ethnic, minority, and postcolonial subjects). This politicized commitment requires "us" to read an ethnic or postnational "I" of the text as an unthematizable singularity that derails categorization, but nevertheless requires contextualization. In fulfilling my obligation to "locate resistance," I reinscribe a critical protocol that confirms my membership in a professional community, shores up the implicit "we" of literary valuation, and advances identity capitalism. From a skeptical perspective, when I display a proper recognition for the complexity of the circumstances that fence in the persecuted and marginalized or spur them to resist and go beyond them, when I repeat the magic words, I affirm my moral and leftist credentials, and, by extension, my institutionally mediated critical capital. I accrue such capital by sympathizing with suffering and resistance, by identifying with them as a compassionate soul, or by declaring my personal-experiential property rights as a woman/minority subject (speaking "as" in order to speak authoritatively and authentically "for").

Here is my requisite caveat: It is unlikely that this essay will forsake the lure of critical capital, and it might merely succeed in staging this performative contradiction. Before turning to the poem, I will therefore visit the institutional milieu and reception of Cha's *DICTEE* during the last decade to historicize prevailing definitions of critical rigor in academic responses to minority and multilingual literature that link cultural specificity and resistance. To problematize the logical necessity of this linkage, my reading of *DICTEE* will identify the ways in which Cha does not "subvert" genre, but instead faithfully obeys its law in self-consciously enunciating the obstacles confronted by an immigrant in her struggle to preserve an idealized past.

The recent institutional commitment to develop a growing canon of diasporic literature should not be taken for granted as a "spontaneous emergence" on the North American literary scene. The cross-pollination

of discourses that assumed prominence in the literary institution of the 1980s and 1990s spurred a trend to write about diaspora as a venue for the sociopolitical and moral agendas associated with multicultural, postcolonial, and, more recently, globalization studies. It is no coincidence that this critical confluence recently found its witness and critical fetish in the figure of the diasporic or exiled subject. As Homi K. Bhabha recoded it in his 1994 introduction to *The Location of Culture*,[5] geographic homelessness should not be reductively (i.e., ontologically) spatialized, but might also be read as a modality of *différance* in its linguistic and spatio-temporal dispersal of national boundaries and identities linked to the "missing" and "irrecoverable" origin. Diaspora thus becomes a poetic figure that rejuvenates institutionally dominant theoretical concepts with the substance of an "authentic" historical predicament. In mediating the global turn in cultural criticism, it is a geo-trope that re-navigates what Wendy Brown has called the "wounded" liberal attachments of identity politics.[6]

In the period immediately preceding and following the publication of *DICTEE* in 1982, academic identity politics still relied on notions of authenticity as a means of validating the silenced voices of historical oppression. This reliance capitalized on a perceived intimacy between the object of inquiry and its real experiential origin. Throughout this period, the attachment to authentic voices also became increasingly attenuated by a mélange of received ideas: the detritus of the poststructuralist critique of metaphysics that reiterated the contingent and partial disposition of intentionality and identity.

Though it was often disavowed or taken for granted, the poststructuralist turn in literary studies ultimately generated a sense among cultural critics that identity politics needed a new vocabulary if the project of canon reformation and its liberatory agenda were to retain their power. This poststructurally corrected vocabulary overdetermined the selection and treatment of writing by women, minority, and/or postcolonial authors in the 1980s and 1990s, which sparked belated attention to Cha's poetic montage *DICTEE* published posthumously by Tanam Press in 1982. The reception of Cha in the 1990s is instructive in this connection to the extent that it enacts the confluence of political and literary values in criticism, which facilitated the extension of diaspora studies (beyond Jewish history) as a "cutting edge" field of inquiry. What becomes clear from reading *DICTEE*'s reception is that critics in the 1990s typically considered it "crucial" to foreground it as a subversion of dominant cultural ideologies

and conventions that is, at the same time, manifestly determined by them.[7] This dogmatism shows signs of softening in some recent criticism,[8] which also begins to position *DICTEE* for a more traditional mode of canonization. Such criticism attests to an incipient movement away from identity politics in favor of an emphasis on avant-garde experimentation as a modality of subjective transcendence not limited to political transformation. This turn indicates the degenerescence of overtly politicized models of criticism. The law of genre is likewise manifest in *DICTEE* itself as a deconstructive text conspicuously informed by the linguistic turn.

In accentuating the pastiche formation of historical consciousness and hybrid cultural identity, Cha's *DICTEE* appears to offer a quintessentially poststructuralist model for the artistic transformation of identity politics. From this point of view, Cha's *DICTEE* reads as a self-consciously textual meditation on the *différance* affecting a Korean immigrant's attempt to revive the traces of her dispossessed cultural heritage while working through the alienations of assimilation. The montage format of the poem is conspicuously informed by Cha's studies in Paris with Metz, Bellour, and Kuntzel and a nexus of psychoanalytic, structuralist, and film theories. As Shelley Sunn Wong notes, these influences made it unassimilable in the context of Asian-American identity politics when it first appeared in 1982, but all too germane for the postmodernist sensibilities of the 1990s.[9]

This serendipity was celebrated by Third Woman Press's reprinting of *DICTEE* to coincide with its publication of *Writing Self/Writing Nation* edited by Elaine H. Kim and Norma Alarcón in 1994. This volume of elegant and densely informed readings by Kim, Lisa Lowe, Laura Hyun Yi Kang, and Wong is interlaced with work by the visual artist Yong Soon Min and followed by a "Chronology" of Cha's life and works by Moira Roth. The volume remains valuable for Cha's contemporary readers because of the nuance and research each essay assiduously brings to its interpretation of *DICTEE*. It is also a mirror of its moment. Even as the preface marks the volume's urgency in the wake of the harm inflicted upon the Korean community during the Los Angeles riots of 1992, the essays comprising it are symptomatic to differing degrees of the critical trends of the early 1990s. They largely presuppose poststructuralist theories of reference, identity, and textuality while sustaining a multiculturalist commitment to representing the "specific histories" of the disenfranchised as a means of liberating them. The 1994 volume thus instaurates *DICTEE* as an object of desire which could reconcile the tensions between

poststructuralism and multiculturalism that were splintering the critical praxis of a literary institution working through the political legacy of the Civil Rights and liberation movements of the 1960s and 1970s.

In her introduction, Kim observes that Korea and Korean America were "largely ignored or sidelined" in previous discussions of Cha. She voices her desire on behalf of the other contributors to employ the collection as an occasion to "address the absence of interpretations of [Cha's] text both in terms of the *specific histories* it represents and the material histories out of which it emerges: Japanese colonialism in Korea, Korean nationalist movements (official and unofficial), Korean feminism, the Korean War, and Korean immigration to the United States." She adds, "we felt that a materialist reading of this sort, sensitive to the issues of colonialism, nationalism, race, ethnicity, gender, and class, was especially urgent."[10]

Kim's preoccupation with redeeming *DICTEE* as an exploration of a "specifically" Korean identity is slightly at odds with the critical distance evinced in Wong's observations concerning Asian-American identity politics in her historicization of *DICTEE*'s reception. Wong notes that as Asian-American identity politics "was steadily gaining ground, the two leading criteria for determining political and literary value were representativeness and authenticity" (103). In consonance with Wong's assessment, Kang marks the danger that Cha confronts in writing "out of and within a collective history." For Kang, such a writing "risks being read, metaphorized as the 'representative voice', and thus reifying the individual, omniscient author – especially if that history continues to be suppressed for others." Kang consequently disclaims the logic of representativeness because it "*dilutes* the immediacies and specificities of both the personal and the communal."[11] Kang's fear of "dilution" presumes that "immediacies and specificities" enjoy a "personal and communal" presence that could be lost or diffused. Kang is, in effect, ontologizing cultural specificity while failing to account for how she might safeguard it in practice without stooping to the logic of representativeness.

In *Writing Self/Writing Nation*, the normative move to canonize Cha's poetics of displacement within and against a poststructuralist milieu is reconciled with an institutional investment in "locating" her resistance. This compromise is tenuous in its reliance on a poststructuralist vocabulary to articulate a putatively materialist concern with cultural specificity. The effect of the essays as a whole is consequently paradoxical as they variably risk repatriating and expatriating Cha anew in the course of demonstrating *DICTEE*'s "Koreanness" (as a historical "specificity" rather

than an ontological "essence") while surreptitiously affirming the poem's deconstructive and liberatory potential within an emerging canon of immigrant and minority literatures.

Lowe exemplifies this tendency in her references to the damaged and dislocated subject of colonialism and imperialism as a "possible *site* for active cultural and ideological struggle."[12] This definition of the subject conspicuously distances her from prior valuations of authenticity and unified agency and invites a reading of Cha's *DICTEE* as a critique of identity "that engages feminist, psychoanalytic, and Marxist discussions of subjectivity and ideology." In this vein, Lowe contends that "in the multiplication of perspectives, and refusal of inference, deduction, and causality, *DICTEE* unsettles the authority of any single theory to totalize or subsume it as its object" (37), yet her own authoritative vocabulary and anti-identitarian aesthetics overtakes her object. Hence Cha's performance of "unmimetic irresolution" merely reinvents poststructuralism's patented Nietzschean gestures: the repudiation of narratives of progress that affirm stable, unified, homogeneous subjectivity and an attendant celebration of becoming, fragmentation, heterogeneity, indeterminacy, and incommensurability. In this respect, I find Lowe's interpretation of the motif of "failed mimesis" in *DICTEE* convincing, but also potentially tautological in its deployment of poststructuralist principles. My concern is whether any celebration of Cha's aesthetics of irresolution and disruption (including my own) might fall prey to what Rey Chow in *The Protestant Ethnic and the Spirit of Capitalism* calls "compulsory mimeticism," which entraps the ethnic or minority subject in the self-hatred and impotence of attempts to resemble and authenticate herself that "continue to come across as inferior imitations, copies that are permanently out of focus."[13]

Writing Self/Writing Nation was still in press when Chow's *Writing Diaspora: Tactics of Intervention in Contemporary Cultural Studies* appeared in 1993.[14] This overlap is not coincidental when viewed from the standpoint of their interpretative milieu. *Writing Diaspora* was a poststructuralist intervention during an intense period of multiculturalist and postcolonialist canon reformations that aimed to "give the other a voice" with which to express suffering. The authenticity of this voice vouchsafed the moral authority of the critical aim to promote social equality through cultural representation and to sensitize members of dominant groups.

Chow investigates the analytical practices that undermine the political aims of anti-imperialist discourses in the study of Chinese literature in particular and in the larger field of Cultural Studies as a whole. She targets

an institutional preoccupation with the image of the "native" as a "synonym for the oppressed, the marginalized, the wronged," and as an anti-imperialist occupation zone "where battles are fought and strategies of resistance negotiated."[15] She understands this contestation as a by-product of uncritical mimetic assumptions that construct the native's image as a degraded copy, a weak imitation of real victimization. Critics adhering to these mimetic assumptions subsequently seek to redeem the defiled image of the native by replenishing its originary substance, to rediscover and to purify the subjectivity of "the other-as-oppressed-victim" (29).

Chow observes that this search becomes a way of repossessing, stripping, and cleansing the image in order to reveal its naked "truth." Unfortunately, in practice, such an image-politics is governed by a fallacious hermeneutics "of depths, hidden truths, and inner voices" (29). It consequently expropriates the mixed or degraded dimensions of the native that comprise part of her image. In this connection, Chow asks how we might represent the native without recolonizing her by "substituting a 'correct' image . . . for an 'incorrect' one," and by supplying her with a " 'true voice' that will make up for her false image?" (30).

Because Chow tends to focus on the rhetoric of diaspora rather than on its specific realities, the varied conditions of expatriation do not figure prominently in this book. Instead, the trope of diaspora navigates her through an array of critical and acritical practices and an economy of literary institutional values. Though her discussions of Chinese intellectuals and sinologists remain attuned to the influence of class on institutional investments, her analysis does not disavow the class position of the postcolonial theorist which, from Revathi Krishnaswamy's perspective, exacerbates a tendency to romanticize migration.

In "Mythologies of Migrancy" Krishnaswamy registers his annoyance with a myopic and class-unconscious appropriation of diaspora as "the privileged paradigmatic trope of postcolonialism in the metropolis."[16] The "romance" with migrancy, exile, and diaspora commodifies and, as Krishnaswamy observes, neutralizes the sorrows and exigencies that mark such circumstances.[17] In fetishizing homelessness, multiplicity, and hybridity, it is not surprising that this romance overlaps "with poststructuralism and postmodernism and the literary traditions of modernism" as well as a concomitant mythology of the intellectual as "an embattled figure of exile"(137). Krishnaswamy takes the "itinerant postcolonial intellectual" trained in the West to task for a luxurious melancholy that converts homelessness into an existential condition as well as a politico-aesthetic.

Such a standpoint regards "the experience of multiple dislocation – temporal, spatial, and linguistic – to be crucial, even necessary, for artistic development" (135). It is, moreover, naïve in attributing an enhanced self-consciousness about the constructedness of reality to the experience of dislocation as a "privileged locus of imaginative experience" (137); it consequently occults the "grim realities of migrant labour," which, for Krishnaswamy, "inflect the notion of migrancy in ways that make it difficult to link consistently freedom and liberation with movement and displacement" (132).

For Krishnaswamy, then, it is the "excessive figurative flexibility" of a poststructuralized discourse of migrancy that "robs the oppressed of the vocabulary of protest, and blunts the edges of much-needed oppositional discourse" (129–30). By virtue of this expropriation, difference is reduced "to equivalence, interchangeability, syncretism, and diversity, while a leveling subversive subalternity is indiscriminately attributed to any and all" (129). He seeks to intervene by militating for increased attention to the heterogeneity of the historical and social situations determining post-colonial texts over and against their collapse into a generalized migrant "sensibility," or their treatment as "localized embellishments of a univer-salist narrative, an object of knowledge that may be known through a postmodern critical discourse" (128–9).

Krishnaswamy's incisive polemic against the excesses of poststructural-ism reflects a milieu distinguished by an urgent desire among literary critics of a Marxist bent to redeem the "specificities" of class, gender, sexuality, race, culture, and the "materiality" of historical suffering from a quagmire of post-humanist skepticism. The differences between Chow's and Krishnaswamy's perspectives are, in this respect, illustrative of the contradictions in the discourse that institutionalized the political aim of sociocultural revolution. Hence while Krishnaswamy in 1995 emphasizes the need to recognize "material conditions" and "grim realities" as reproof against the promiscuity of a poeticized rhetoric of displacement, it was only two years earlier that Chow criticized the excesses of a multicultural-ist and postcolonial image politics, which installed the testimonies of oppressed and disenfranchised natives as a strategically affective venue for consciousness-raising, resistance, and social transformation.

Chow's *Writing Diaspora* bears witness to the imbedding of the post-structuralist critique of essentialism and authentic experience in both feminist and postcolonial discussions of the early 1990s. These sometimes clashing critical interests fostered protocols that mediated each other in

ways that were not always explicitly acknowledged. On the one hand, there remains the commitment, voiced by Krishnaswamy and echoed in the reception of Cha, to locate resistance in postcolonial and minority texts. On the other hand, there has also been a less conscious requirement to display an appropriate degree of obeisance to poststructuralist conventions of critical rigor including the anti-essentialist stance with its attendant rejection of the ontology of authentic experience. Such obeisance not only spurred the romance of hybridity, multiplicity, and border crossings that Krishnaswamy rightly repudiates; it also factored into the injunction to localize oppression and disenfranchisement, ostensibly to "retain a space for effective resistance" and less ostensibly to affirm the other's "multiplicity" (the other is *also* a complex individual).

The term *specificity* comes into play at this juncture as a materialist recoding of authenticity and representativeness in response to a dogmatic anti-essentialist perspective and to redeem the moral animus of politicized critique from the postmodernist dung heap. Unfortunately, the move to safeguard cultural specificity as a site of resistance is further vexed by a historicist nostalgia for the facticity of local context. This nostalgia leaves the critic vulnerable to the fear of dilution that I already remarked on in Kang's essay, which ontologizes personal and communal presence in the name of "specificities and immediacies."

Krishnaswamy's image politics does not acknowledge the possibility that myths of migrancy are forms of high cultural discourse and ideology that might be politically empowering. In addition, his injunction to localize the differences affecting migrants might be viewed as a symptom of what Victor Li criticizes under the rubric of protectionism in postcolonial studies.[18] Li notes that such protectionism betrays the anxiety that a peripheral and/or indigenous population will be swallowed up by a dominant metropolitan culture, including the culture of theory and critique. This anxiety betrays a performative contradiction among certain critics to argue both within and against the language of critique to defend the potential for culturally pure acts of resistance among subaltern and/or illiterate disenfranchised groups. According to Li, the myth of "demotic resistance" so defined presupposes the liberal ideal of "negative freedom" as "the belief in absolute self-determination free from all external constraints, interferences, or influences." This belief "activates a hermeneutics of suspicion that rigorously tracks down and uncovers any form of external influence or pressure that may compromise the autonomy of an individual or group." It consequently risks reifying a "distinctive, resistant

cultural identity" as a locus of authenticity.[19] To avoid this risk, Li asks us to heed Bhabha's call for an articulation of the "place and time of enunciative agency" whereby processes of transculturation render acts of subversion and resistance at once hybrid and relational (175). This emphasis may offer a way of eluding the logical fallacy of claiming a necessary link between cultural specificity and resistance in minority and immigrant literatures.

Li's analysis invites critics to read Cha's *DICTEE* as an enunciation of diasporic experience that is conspicuously *nondemotic* in that it attests to the influence of high theory and specifically French theories of textuality and the cinematic apparatus. More recent readings of *DICTEE* acknowledge Cha's avant-garde status as a conceptual artist informed by her commitments to semiotics and film theory that affirm her place in an intellectual tradition which she helped to shape and disseminate.[20] In her 1996 analysis of *DICTEE*'s postmodernist textual concerns, Juliana M. Spahr broaches the prospect of analyzing multilingual texts' formal and aesthetic dimensions as a way of complicating "theories of resistance in the context of reading." She prefers, instead, to "locate the cultural necessity of postmodern linguistic practices in the way they challenge reading's potential hegemonies by provoking and engendering the reader."[21] She derives *DICTEE*'s "emancipatory possibility" from its ability to "decolonize" reading as a "foundational force for shaping social vision."[22] Despite her insistence on attending to *DICTEE*'s formal aspects, literary moralism surfaces in Spahr's invocation of the two critical commonplaces of her day: a recognition of the work's "cultural specificity" in conjunction with the "political necessity" of determining its liberatory potential.

Cha's representative "Koreanness" is seemingly reinforced, but in effect deracinated, in a 1998 volume of essays entitled *Other Sisterhoods: Literary Theory and U.S. Women of Color* edited by Sandra Kumamoto Stanley. While the volume's title rather sentimentally officiates the smorgasbord "taste the minority" logic that typically vexes multicultural collections,[23] the essay that represents Cha and thus "Koreanness" for the volume is not particularly preoccupied with *DICTEE*'s cultural specificity. Instead, Eun Kyung Min's "Reading the Figure of Dictation in Theresa Hak Kyung Cha's *DICTEE*" (2000) is attuned to.the ways in which the poem disconnects the textuality of the written sign or image from its visuality as well as its aural or oral referent while reinforcing the dissonance between the model and dictation as a venue of assimilation.[24] For Min, the aim "is not to simply trace and limit *DICTEE*'s meaning to a biographical one, but to

recognize in the mediated representation of the immigrant experience a commentary on the representation of identity."[25]

Stella Oh's "The Enunciation of the Tenth Muse in Theresa Hak Kyung Cha's *DICTEE*" (2002) avoids the performative contradiction cited by Li in his critique of demotic resistance.[26] Oh focuses on Cha's use of post-structuralist theories for a postcolonial critique of the political and cultural structures that create linguistic and gendered subjectivities in "the languages and discourses of the various cultures" (French, Japanese, and English) that occupied Korea. The diseuse, or speaker, of *DICTEE*, is the "tenth muse" who, according to Oh, exorcises the oppression imposed by these languages and ideologies that have "stifled the Korean American female voice" (4). From this perspective, the diseuse is a feminist refiguration and activation of the female voice that has been fragmented and suppressed by Korean patriarchy, Japanese colonization, civil war, and United States imperialism. Though Oh will characterize the diseuse as a "contingent and liminal subject," she nevertheless privileges her cumulative agency as "the author and creator of a new history" over her role as a passive vehicle of dictation – the *dictée* who, throughout the book, is spoken rather than speaking (17 and 3). Nevertheless, the image purification politics that Chow decries is still at play here in the interests of revealing the minority subject's resistant overcoming of history over and against her abject victimization within it.[27]

Caroline Bergvall's "Writing at the Crossroads of Language" furthers a formalist reversion of identity politics in favor of genericization while also testifying to the dynamic of degenerescence in *DICTEE* and its reception.[28] In keeping with the ethos of literary criticism in the 1980s and 1990s, Bergvall recapitulates the postmodernist and multiculturalist celebration of difference, hybridity, and dislocation as markers of avant-garde precocity. *DICTEE* is, thus, a model of "plurilingual poetics" which is "at odds with the traffic of monolingual identity, the Same speaking off the accent of any Other." Despite *DICTEE*'s status as a model, it nevertheless manages to break out of "some of the regulatory conditions that national identity and monolingual environments apply to issues of linguistic belonging and of cultural translatability" (207). Like Lowe and Min, Bergvall is committed to a poststructuralist reading of *DICTEE* as a performative stylization of the experience of mimetic inadequacy among immigrants seeking to master the language and conventions of a foreign culture. In addition, by linking her with the names of Gertrude Stein and Mallarmé, Bergvall folds Cha into the modernist tradition. While her

discussion does not quite relinquish the romanticization of diasporic displacement and intercultural double consciousness, Bergvall's interpretation partially sidesteps the moral unconscious of these motifs in her attention to *DICTEE*'s poetic devices. In this respect, her reading seems to honor Li's caution against the false binary between theory and cultural resistance that would sacralize *DICTEE* as an autonomous and pure expression of Korean-American experience.

Bergvall identifies a "utopian longing for an unalterable Language" (208) in *DICTEE*, which is consonant with its enactment of degenerescence. An "unalterable Language" (with *language* capitalized) is, in Derrida's sense, an ontotheological ideal: it evokes the Word of God and with it the prospect of immediate presence in communication "transubstantiated" against unconscious splitting, cultural differentiation, and historical perspectivalism. As a foundational figure, the ideal of immediate presence reinscribes the *topos* of eternal substance, harkening back to metaphysical concepts of a divine that transcends space, time, and history, and is not, therefore, subject to change. It signals an Augustinian longing for continuity and the prospect of nonalienated existence (lost after the Fall) that eludes all humans, not only immigrants.[29] What is of crucial significance to my reading of Cha is her self-conscious performance of the sense of lack generated by a mistaken identification with the immediacy and fullness of an idealized past that is and always was beyond reach.

I want to look briefly to Lacanian psychoanalysis to highlight the narcissism that underlies this lack. In the psychoanalytic context, the ideal of an "unalterable Language" might be read as a figure for a non-alienated and continuous identity, an extension of the infantile *imago* formed during the mirror stage. In Jacques Lacan's formulation, the mirror stage transpires between the ages of six and 18 months, before the fracturing onset of language and the social order.[30] Lacan insists on viewing this process as a matrix of identification: "the transformation that takes place in the subject when he assumes an image" (2). This image, or *imago*, is the primary narcissistic precipitate of the infant's initial satisfaction with self-discovery – the so-called "*Aha Erlebnis*" whereby the apparent *Gestalt* of his mirror image is misrecognized because it seems to absolve the baby from his actual awkwardness. The sense of satisfaction that results from this misrecognition spurs its introjection as an idealized image of self, the "Ideal-I" that subsequently becomes the impossible model and anchor of identity "proper." According to Lacan, lack is the fruit of this internalized ideal self and, concurrently, of the failure to fulfill

the composite expectations of others, the secondary narcissistic "I-ideal," that can never be completely replicated to reconvene a triumphal sense of completion and fit.

Lack so defined develops in the interplay between primary narcissistic self-love and a secondary narcissistic desire for acceptance, between the Ideal-I and the I-Ideal. To the extent that critical and literary models are also idealized, they might serve as the locus of an imaginary identification. The law of genre can therefore be understood in light of a secondary narcissistic investment in reproducing the contours of an idealized image mediated by critical protocols and literary values as well as the sense of lack that arises from their provisionality. This lack mobilizes institutional attempts to protect critical and canonical paradigms. Such protectionism is self-contradictory, as Derrida suggests, in that these attempts actually differentiate, sediment, and attenuate their models in the process of reproducing them. Criticism's relation to its generic models thus repeats the mirror stage to the extent that the critical or literary model is misrecognized as the origin, orientation, and fulfillment of the ideal of immediate presence and self-mastery. Lack follows this misrecognition as the critic's models reflect a nexus of values and expectations that must be reiterated to retain their power, yet are nevertheless subject to *différance*: the differentiation and deferral of meaning as signifiers move through time and space (what Derrida has also linked to the unconscious and to history).

Disciplinary mimesis is the process of striving for an elusive moment of certainty (when the signifieds might seem to come to a rest under their signifiers) as the basis of professional self-recognition and interpretative closure.[31] It cannot avoid circular reasoning as a mode of the truth drive: The critic confirms institutional values through her "proper" reproduction of the object of inquiry as a locus of transference and a secondary narcissistic investment in the gaze of a professional community whose expectations must be fulfilled to ensure the conditions of meaning for the Other. This secondary narcissistic object of desire is impossible to replicate because it emerges and survives through a sociogenetic process, which enacts the law of genre as a modality of death-driven repetition. Mimetic investments as such are destructive insofar as they successively drain models and values of their "life force" in compulsively neutralizing "contaminating" encroachments. The dissipation of models is thus the metabolic effect of the law's annihilating, repetitive, and reifying enforcement of its generic ideals.

The law of genre provides a formal link between an institutional impetus to prioritize the value of resistant cultural specificity and the writing of an idealized memory. The repetition of these values in literary and cultural criticism assures their continuing life while emptying them of their historicity as a contingent emergence within a particular context of interpretation. Likewise, the exile seeks to fix and protect her memory through successive reactivations of the promise of return, which maintain its active status, while increasingly altering and attenuating it in different contexts. The gaze of outsiders cuts across affectively charged memories, thereby alienating them from within.

Cha's *DICTEE* submits remembrance to the law of genre, which is to say, to a dynamic of destructive mimesis, staged as an impossible desire to reconvene the full presence of an idealized cultural heritage. From the standpoint of the law of genre, Cha's *DICTEE* disarticulates its Korean *imago* under the conditions of a transferential relationship with new cultural models. While her self-referential metaphors attest to the wounds to language and cultural identity precipitated by her forced emigration from Korea, "Korean specificity" as such is formalized as a mode of melancholic degenerescence, a memory that circles around the regulative fiction of a unified community that can never be regained because it never existed. The past thereby assumes a utopic aura in the immigrant's desire to suture memory with the present. Nostalgia is the yearning for this wound binding, a longing to fulfill a promise that must be remembered in order to be reproduced and written in order to subsist. A writing that cannot reconvene the fullness and immediacy of any ideal mirrors the immigrant's vexed emulation of her generic cultural models and assimilate fully by speaking properly.

DICTEE dramatizes degenerescence by adopting unsuccessful dictation and the degraded copy as the pivotal tropes of the book. Cha's figuration of dictation attests to the fraught process of becoming a national and cultural subject by copying a grammar – to assimilate one's models through the ritual of imitating them. As Oh observes, Cha's incorporation of these models ironically evokes the various occupying powers that displaced Korean cultural heritage: the French missionaries who imported Catholicism and its patriarchal values; the Japanese who made speaking the native language a crime punishable by death; and the Americans who faced off with China during the Korean War and continue to occupy South Korea. If *DICTEE* is to be read as a product of dictation and, potentially, as evidence of a sufficient linguistic assimilation, then its manifest imperfections belie the shoddy discipline of its producer. Lowe has suggested that

the subject of dictation remains refractory to the tasks of rote learning as tools of domination.[32] Yet in keeping with the law of genre, the speaker's failures may ironically affirm rather than idealistically challenge the assumption that models remain transcendent in relation to their disciples. Her clumsy repetitions of the catechism open a distance between the mundane and the sacred that confirms the inaccessibility of divine grace toward which a fallen but still faithful exile of paradise strains.[33]

The shifting speakers and points of view constantly reorient the poem – like establishing shots in a film. These shifts make it difficult to speak of a single consciousness in *DICTEE* for whom a proper cultural memory might then be recovered. The "diseuse" or speaker takes dictation for shifting perspectives and multiple characters, thereby configuring a fragmented historical and cultural consciousness. In this respect, the diseuse is herself a "dictée" – the bearer and result of the process of dictation whose power of speech stems from her paradoxical role as a vehicle constituted in the event of being spoken.

The alternation between first-, second-, and third-person narration, between soliloquy and dialog, reflects this split between activity and passivity, memory and forgetting in response to cultural immersion, but also to a superegoic demand for adherence to both past and present models. The diseuse sometimes speaks as herself, but then shifts to an objectified "herself" through the memories of someone else. The first-person "I" gives way to a third-person "she" who subsequently fades out as sentences alternately refer and fail to refer to "her." Split between "she," "her," and "you," the speaker watches herself and then addresses herself as a spectator. If the tasks of cultural assimilation involve self-surveillance in light of one's models, then "she" is the spectator of their degenerescence.

> ...It is you seeing her suspended, in a white mist, in white layers
> of memory. In layers of forgetting, increasing the den-
> sity of mist, the opaque light fading it to absence, the
> object of memory. You look through the window and
> the music fills and breaks the entire screen from
> somewhere. Else. From else where. (*DICTEE*, 108)

The diseuse addresses herself in the second person, but is also in intimate conversation with a mother's memory of a lost motherland, an elsewhere transpiring in an opaquely illuminated cinematic space. There is a female figure in this theater, but she is suspended in a white mist that is

paradoxically associated with both memory and forgetting. Folding memory into its layers, forgetting not only increases, but also hyphenates and thus divides the "den-sity" of mist while opaque light fades memory to absence. Music breaks the screen where memories are played and "Else" splinters twice from its "where." The isolation of the word *Else* suggests a utopic outside, which I have linked to the timeless ideal of an unalterable language cited by Bergvall. It might also be read as a leftover of transpired events that remain anterior to the memories that stand in for them. The *Else* as outside and other is severed from its anterior "where" through an accretion of varying external standpoints both real and imagined that infiltrate memories over time as they travel from Korea to the United States and from the immigrant's mind to the page. In this respect, *Else* may additionally reinscribe the reader/critic as a potentially exoticizing, judgmental, and/or uncomprehending gaze. This gaze already inhabits this writing in the form of an anxious anticipation, alienating the speaker in advance from her own affective investment in the presence and future of her text.

The blank pages between and within the nine chapters reinforce the text's montage effect while disrupting the reader/spectator's identification with the diseuse as a vehicle of memory. The chapters are named Clio/ History, Calliope/Epic, Urania/Astronomy, Melpomene/Tragedy, Erato/Love Poetry, Thalia/Comedy, Terpsichore/Choral Dance, and Polymnia/Sacred Poetry after the muses, the daughters of Zeus, the father of the gods, and Mnemosyne, the goddess of memory. But there is one exception. Elitere, a created muse of Lyric Poetry, substitutes for Euterpe, whom Hesiod's *Theogony* associates with music. Wong understands this substitution as an "oppositional gesture" that disorganizes common constructions which "make possible totalizing identifications on the basis of definitive categories such as 'woman,' 'American,' or 'writer.' " She also views it as a critique of "the privileged place of epic as high literature" (Wong 115). Yet this critique also keeps faith with the law of genre by reinventing the classical tradition that personifies memory as the immortal mother of the literary arts.[34] This personification immortalizes memory whereas the exile fails to fix fragile memories of her motherland. The myth's relative constancy through tradition both compensates for and contrasts with the diseuse's sense of lack in relation to the lost presence of her past. As a compensatory figure, the myth of the muses therefore realizes the power of the law of genre to spur repetitions that are not necessarily opposed to "totalizing identifications," as Wong argues, since

they are fomented by a mimetic drive to borrow the permanence of a classical model.

Caught in the dehiscence of memories affected by division, expatriation, and distance, the immigrant's identity is never proper to itself as it oscillates among the languages of occupation, birth, and assimilation, each undermining her fluency in the other: among the Koreas between various occupations and before the partition on August 15, 1945, along the 38th Parallel; between the ideologies of North and South and East and West; between fading memories of her homeland that are not always her own and her all-present life in the United States. "If words are to be uttered," Cha writes, "they would be from be-/hind the partition. Unaccountable is distance, time to/transport from this present minute" (132). Kim notes that the "North and South Korean governments prevent Koreans from viewing each other except through the filtering haze of political doubletalk and deceit, according to which 'martyred patriot' becomes strangely synonymous with 'traitor.'" Hence Cha's references to veiled language might refer to "the peculiarly Korean 'veil of secrecy' used to silence dissent about the political polarization of the nation into 'inside' and 'outside' " (Kim 12).

From her mother, the speaker inherits an idealized image of Korea supplemented by a reading of Korean histories, and later two visits to contemporary Korea. The text, in Kim's reading, "brings into view a Korea that Korean-Americans like me thought might be our parents' illusion. Cha's insistence on this visibility creates a basis for Korean American presence in opposition to its absence in Western historical consciousness" (9). Kim cites a personal letter from Kang who points out that "Cha places Korea in a broader field of vision than can most Korean immigrants to the U.S., whose feelings of dislocation and whose 'inability *and* refusal to be acculturated' lead them to paint an idealized picture of Korea for their Korean American children" (25). The mother's memory is, thus, a borrowed model that exerts its influence from behind the scenes. *DICTEE* also alludes to Saint Theresa, a Carmelite nun who died at age 24 and whose *Story of a Soul* provided the model of "a simple and beautiful life" for young Catholic girls.[35] This melancholic identification with a Catholic paradigm is transformed into a proto-feminist lineage through a canon of young girl martyrs – Joan of Arc and Yu Guan Soon who, in dying for France and Korea respectively, embody both the promise of national resistance and its vainglorious collapse. Nonetheless, the work of honoring their sacrifice cannot escape the metaphoric martyrdom of memories to writing, which "decapitates" their forms:

> The decapitated forms. Worn. Marred, recording a
> past, of previous forms. The present form face to face
> reveals the missing, the absent. Would-be-said
> remnant, memory. But the remnant is the whole.
>
> The memory is the entire. The longing in the face of
> the lost. Maintains the missing. Fixed between the
> wax and the wane indefinite not a sign of progress.
> All else age, in time. Except. Some are without. (38)

The diseuse surrenders to a nostalgia for an expropriated homeland oxymoronically "Fixed between the wax and the wane." She thereby enunciates the impossibility of re-presencing a marred remnant memory of her Korean heritage whose referent was always constituted at a loss. The idealized Korea hovers "outside" a history of colonization and subsequent partition, but also before the upheavals of emigration and assimilation, when the exile's memory became divided within and against itself. This corrected Korea-ideal orients a paranoid self-consciousness for which writing and repetition pose a threat of depletion: the successive re-writings of the past that alter its anchoring details bear witness to the exile's powerlessness to secure memories of her homeland against objectification and change, against gradual erosion and eventual disappearance:

> You read you mouth the transformed object across
> from you in its new state, other than what it had been.
> The screen absorbs and filters the light dimming dimming
> all the while *without resistance* at the ob-
> vious transformation before the very sight. (131–2; my emphasis)

The diseuse's conversations with herself acknowledge that the splitting of memory between objective and subjective viewpoints alienates and transforms it into a new object. She "mouths" rather than rebels against memory's mediations, which are structural and therefore ineluctable. Kang elaborates this insight, but insists on the "necessity" of seeing defiance in the work of remembrance despite a "sober awareness" of its partiality.[36]

The exile's melancholic preoccupation with protecting her cultural *imago* from dilution, contamination, and displacement is enunciated through a literal evacuation of writing. *DICTEE*'s frequent reliance on white-outs – its blanks, spaces, and intervals – signal a mindset invested

in the transcendence of a pure memory in relation to its representations. The blank pages between the muses produce the effect of empty screens connecting and dividing shots, marking absences, subtending the prospect of plot as well as the reader's identification with the apparatus. The text also brims with internal blanks, half-pages and caesuras at every turn; it is a cut-up that cuts out.

The motif of remembrance as a mode of degenerescence is reinforced through these determinate absences, which foreground *DICTEE*'s status as a gap-ridden expression of a "specifically" Korean consciousness. These voids in memory suggest the traces of repression, the tracks of a wounded historical consciousness that stalks those who have fled Japanese and French Catholic colonization, civil war, partition, dislocation, and dispossession. The blanks also reinforce a characterization of writing as a stain and an occupation on a "formless sheet" that implies a nostalgic longing for a timeless time before the necessity arose to remember or to write to stave off a consuming present.

> The memory stain attaches itself
> and darkens on the pale formless sheet, a hole in-
> creasing its size larger and larger until it assimilates
> the boundaries and becomes itself formless. All mem-
> ory. Occupies the entire. (131)

Before the speaker's expatriation, there was no lost past to retain, and therefore no necessity for the contamination of writing, which is presumed to dispossess what it would make present. The blanks in *DICTEE* stage a desire to retrieve the purified presence of an idealized Korea before as an impetus of annihilation, a compulsion to void out a memory fractured by occupation, civil war, and emigration and "tainted" through writing. The blanks thus attest to the work of a death drive that would return consciousness to an inkless state of *tabula rasa*. The proliferation of references to *white* throughout *DICTEE* also "speak" for a compulsion to purify memory.

What Vijay Mishra refers to as the "half lives" of the diasporic self[37] are rendered here through spatial entropy: as the Korean cultural *imago* that orients the exile's memory work gives up its affective charge in desensitizing repetitions over time, it is absorbed into space. The whiteness that surrounds the lines of text foregrounds writing as occupation, staining, and spacing – a confession that profanes as it purifies. Its erasure fulfills a

death-driven impulse to protect memory by returning to an empty time, a degree zero.

In "Plato's Pharmacy," Derrida enumerates the chain of linguistic and mythological associations that link pure memory with the immediate, yet finite presence of spirit and speech, with *Logos* and the divine substance of the Word of God. From an ontotheological standpoint, writing is, in contrast, *Pharmakon*, which poisons, degrades, and displaces memory as an "essence" and a "spirit." Other philological associations suggest that if writing is administered homeopathically in small doses, it retains the potential to act as a remedy against forgetting. Writing is, thus, that "dangerous supplement" upon which memory in its vicissitudes ultimately depends.[38]

Cha's representation of diasporic consciousness resonates with Derrida's reading of the paradoxical figure of the *Pharmakon* as a "dangerous supplement" that reflects the ontotheological assumptions underpinning the opposition between pure spirit/memory and the "taint" of writing. Writing in *DICTEE* is connected with ink, blood, and blood poisoning; it is a necessary and potentially curative contamination that dislodges the memory it forms.

DICTEE also enacts the ontotheological writing of memory as a secular recapitulation of the Fall, a mark of the mundane or stain of impurity, a degraded substitute for divine immediacy. The diseuse longs for a memory replete with the presence of a former life, but recognizes that she cannot recreate it from the remnant that takes the place of the whole. Something or someone is always missing; hence the very act of writing about it as though it were a whole capitulates to a false confession that at the same time leads to a ritual absolution:

> I am making up the sins. For the guarantee of ab-
> solution. In the beginning again, at zero. Before
> Heaven even. Before the Fall. All previous
> wrongs erased. Reduced to spotless. Pure. (16–17)

Speaking on behalf of the exile, the diseuse yearns to achieve purity by washing away wrongs, to erase the spots of inadequate expression, and leave a clean surface for the remaking of history. The reader is hereby assigned the status of a confessor with the power to grant the diseuse absolution for her sins. This confession reciprocally "infiltrates" the reader in dissembling its own ostensible foreignness through an array of startling

intertextual insertions. These insertions affect an appearance of documentation, but ultimately disallow easy verification. If a recognition of cultural specificity depends on the critic's ability to identify a cultural content from a corresponding representation, then such a recognition is derailed by these images that dislocate rather than reveal their referents.

Cha rebuffs the prospects of cultural specification and repatriation at the very outset, in the photographic negative that serves as a frontispiece for *DICTEE* (Figure 6.1). To an untrained eye, the image appears to be an ink spill flecked with white splotches and marked with white letters, or perhaps a woodcut. The letters fan out in vertically composed lines to the right and to the left, but end suddenly at the extreme left margin. The five lines of writing are not upright, but slant toward the margins, as if drifting from the ideal of spatial regularity. The frontispiece illustration is, furthermore, a negative whose contents are obscured and abstracted by its poor mimeographic quality. Quite literally, one cannot "figure out" the image and read the message inscribed therein.

Cha's use of this nearly illegible reproduction of a negative removes the image from its source, thereby undermining, as Wong suggests, notions of authenticity that call for a direct intimacy between the origin and the vehicle of its transmission. Significantly, Cha does not name the author and source of this anonymous image nor offer any explanation of its contents. The reader is thereby confronted with her own ignorance about

Figure 6.1 Theresa Hak Kyung Cha, *DICTEE*. Reproduced courtesy of the Berkeley Art Museum.

how to read an unlabeled historical document as an indication of a specifically Korean cultural identity. Wong emphasizes the evasiveness of this image in reminding her readers that a frontispiece illustration traditionally serves as an entry-point into the text. The image that precedes the title page of *DICTEE* effectively disables that traditional function. Instead of leading the reader into the work, its vertical slanting movement begins, as Wong puts it, "to usher her back out of the text." In this manner, Cha's frontispiece functions "not to forward the narrative, but rather, to forestall it" (107).

Wong also notes that this image is a negative of some Han-gul phrases (Cha's mother tongue) etched in stone that was taken from the wall of a coal mine in Japan. She goes on to observe that the inscription has been attributed to a Korean exile, "one of thousands who were pressed into various kinds of labor by the Japanese early in this century" (107). The inscription translates as "Mother/I miss you/I am hungry/I want to go home." It augurs one of *DICTEE*'s significant motifs: the exile's longing for a lost "motherland," a fraught emblem of homesickness for the missing origin.

Kang's reading of *DICTEE* intensifies the complexity of the frontispiece image in offering the following subtext from her conversation with Naoki Mizuno, a professor of Korean history at Kyoto University. She reiterates Mizuno's observation that there is some speculation surrounding the inscription's authenticity. The message was inscribed in a tunnel in the Nagano Prefecture, Matsushiro City and not on the walls of a mine, as was previously believed. Kang goes on to note that Korean laborers were imported during the war for the purpose of constructing a new palace for Japan's emperor. In addition, Mizuno has confirmed that the style of this inscription is in keeping with the grammatical rules of Han-gul. Since these rules were instituted by Korean linguists and scholars *after* Korea's liberation from Japanese rule, this discovery has propeled some scholars to revise their views about the dating of the message.[39]

The referential difficulty of the frontispiece image thus goes beyond the effect of poor reproduction since its historical context is itself in question. The culturally specific referent could not find itself in a worse state of disarray as the testimony to the Korean collective memory of the Japanese Occupation implied by the etching is dislodged from its supposed historical moment and then mediated through a series of mechanical reproductions. In enunciating its status as a copy of an original that cannot be properly categorized, the image serves as a *mise-en-abyme* for Cha's depiction of an ebbing national consciousness that relies on historical anchors which are themselves mediated and displaced.

The problematic status of the frontispiece image anticipates other moments of withdrawal before certain gazes – the ethnocentric English speaker's as well as the "non-literary" gaze that cannot gauge the significance of various photographic inserts and figures. The effect is to interrupt reading and/or lengthen it into a potentially dead-end project of research. There is, for example, the pair of figures opening and/or guarding the Astronomy/Urania chapter (Figure 6.2). These body-shaped constellations on a black background are dotted with white words that simulate stars in a dark sky (Cha 63). The text that follows speaks of drawing blood, the prerequisite of immigration. Yet the blood-specimen cannot resolve the question of an immigrant's identity; the sample of these "Contents housed in her membranes" (64) confirms her blood-type, but cannot authenticate her origins. Her nationality remains as "inscrutable" to the immigration bureaucracy as the blood flowing through the guards of Astronomy with their capillaries written in tiny word-stars.

Figure 6.2 Theresa Hak Kyung Cha, *DICTEE.* Reproduced courtesy of the Berkeley Art Museum.

Korean "specificity" cannot be located in Cha's oblique insertions of voice-box diagrams along with blurry portions of the handwritten draft of *DICTEE* as if to indicate the source or "grain" of the authorial voice (echoing Roland Barthes).[40] The standardized textbook diagrams of the vocal apparatus at the end of the *Astronomy* section (Figure 6.3) generically indicate the origin and flow of the voice (Cha 74). The voice remains, nonetheless, invisible in these diagrams of the voice-box and related parts – the pharynx, larynx, trachea, esophagus, and lungs (just as Korea eludes the rudimentary textbook map of its division from the Melpone/Tragedy section) (78). A reader might expect the adjacent text to supply the missing voice; however, this voice is rendered as faltering from a "cracked" and "broken" tongue that speaks pidgin, a "semblance of speech," a poor imitation that stops and starts where "proper pauses were expected" (75).

The History/Clio chapter is paradoxically "finished" with a fragment of the handwritten draft of *DICTEE*. Such an insertion attests to a writer's submission to a perpetually vacillating vision of her ideal text whose fruition in the imminent future she cannot completely anticipate. The portion of draft that closes the History chapter also deflects the actual voice of the diasporic subject to a piece of handwriting in English. The silence of reading frustrates the desire to hear Cha's voice as a vehicle of her style.

This copy of handwriting is the mark of the pot-maker's hand, a bodily trace that would seem to guarantee the integrity of the typeset result. Writing history is evinced here as a physical and dynamic activity, the concerted formation of phenomenal flux behind the glossy commodity. The crossed-out words and phrases bear witness to voice in revision, the ephemeral process belied by the stasis of a printed and mass-produced end-product. In this respect, its gritty materiality is also a red herring that occults more than it indicates the cultural specificity of its production.[41] Readers must accept on faith that it is what it purports itself to be: an "authentic specimen" from the author's "Korean-American" hand.

Multiculturalist critics are hard put to locate cultural resistance in this copy of handwriting which is indexical of the ways in which revision "must answer to time" and has necessarily already *submitted* to its "dictatorship" that "misses nothing." The portion of draft memorializes its writer's sense of lack in relation to her own idealized aims and to any logic of causality that could domesticate them (*because* is crossed out twice) (Cha 40–1).

Figure 6.3 Theresa Hak Kyung Cha, *DICTEE*. Reproduced courtesy of the Berkeley Art Museum.

As evidence of the sacrifice of a dynamic and fragile whole to its static part, it is significant that this mimeographed portion of handwriting appears as one "document" among others. It follows the unlabeled photograph of blindfolded men in white prior to their execution and a 1912 petition from exiled Koreans living in Hawaii to "His Excellency," the president of the United States. The book's assemblage of photographs and film stills cites, in Min's words, the very capacity (and failure) of photography "to fix the essentially transitory, vanishing moment," to make of time "an infinitely quotable though simultaneously absent text...".[42] The unlabeled photograph of the blindfolded men thus evokes, but nevertheless "misses" the heroic beauty of the sacrifice in expropriating the inevitability of their imminent deaths, which, as Min notes, the image implies but does not show (319).

> Some will not know age. Some not age. Time stops.
> Time will stop for some. For them especially. Eternal
> time. No age. Time fixes for some. Their image, the
> memory of them is not given to deterioration, unlike
> the captured image that extracts from the soul pre-
> cisely by reproducing, multiplying itself. Their coun-
> tenance evokes not the hallowed beauty, beauty from
> seasonal decay, evokes not the inevitable, not death,
> but the dy-ing.[43]

"Time fixes for some" but ultimately evokes "the dy-ing" of the martyred captured in the photographs, who stop time because they have been memorialized and idealized. The broken words fracture the immigrant's reconstruction of Korea's history. The hyphenation of "dy-ing" plays on the motifs of death and staining in *DICTEE* that reiterate the impossibility of approximating the ideal of a pure, eternal cultural memory. The text's preoccupation with the *topos* of temporal transcendence is also reflected in the line breaks and juxtapositions. "Time stops" the first line of the passage and is, in the same instance, counterpoised above *Eternal* at the end of the second line. This positioning evokes the ideal of an "unalterable Language" previously cited by Bergvall and with it the ontotheological desire for a stable and present cultural heritage. The hyphenation of *precisely* and *countenance* following the line that breaks at *unlike* emphasizes the imprecision of writing and remembering that mediate the faces they would "capture," thus rendering them dissimilar. The passage thereby

portrays the stuttering of Clio, the muse of history, and of the diseuse who would be her vehicle, but who cannot resurrect the beauty of her models. Such stuttering enunciates the structural degeneration of faltering ideals.

The photograph of the to-be-executed visually echoes the motif of martyrdom connected to the story of Guan Soon, the Korean girl who is arrested "as the leader of the revolution, with punishment deserving of such a rank." Stabbed in the chest, subjected to questioning, she refuses to reveal names. Her act is characterized as an "eternity," and, in a subsequent fragment, "Is the completion of one existence." The contradiction between the grammatical fragment and the ideal of completed existence (a beautiful death) reasserts the paradoxical function of photographs and documents that should open the past to memory, but cannot reproduce the fullness of an affectively invested *imago*. The time of heroism is static, eternal: it "Does not move. Remains there" (*DICTEE* 37). The evidence of it misses the timelessness of sacrifice.

> "*DICTEE goes on living its mysterious 'afterlife'... though the author herself, as divinized in the text, is sacrificed.*" – Walter Lew[44]

Lowe observes, "The subject of *DICTEE* recites poorly, stutters, stops, leaves verbs unconjugated. She fails to imitate the example, is unfaithful to the original."[45] But who is this poor subject of dictation? The well-trained critic is also a "subject" to the dictates of an institutional context that determines the terms of her analysis. In seeking to offer a rigorous interpretation of *DICTEE*, the critic confirms her responsibility to the institution, to the "we" of valuation and professionalism, and to a canon of critical models. The generic protocols of a recent tradition of politicized cultural critique demand that my reading of Cha reproduces such values by bearing witness to *DICTEE*'s cultural specificity as a text authored by a Korean immigrant to the United States. It is in this intercultural specificity that I *must* then locate her resistance against repatriation by dominant cultural ideologies and narratives and/or against any attempt to force it to coincide with a particular set of aims. This disciplinary demand betrays a ritualized circular reasoning behind it, driven to realize its moral premises in its objects. The question that institutional identity capitalism raises is whether critics might become more critical still by relinquishing their fetishes: To declare a moratorium on resistance in the name of saving it from certain death and to take the risk of

deracinating cultural specificity in the interests of staving off yet another reification of the role of the native informant.

Chow echoes Derrida when she argues, "There is no return to any origin which is not already a construction and therefore a kind of writing."[46] Her observations on diaspora reflect the impact of poststructuralist terminology upon the discourse of cultural criticism and the literary institution as a whole. It is by means of this intersection that those forced into exile become the historical models of an ineluctable search for lost origins, a suitable theme for a poetic reflection on the "wanderings" of the arbitrary signifier through various semantic fields.

The recoding of diaspora as a literary and theoretical sign indicates the institutional reproduction of critical standards and concepts that professionalize and naturalize what Henry Louis Gates has called the "sentimental romance of alterity."[47] It also officiates a romance of resistance as a rehumanizing antidote to post-humanist critiques of voluntaristic notions of agency and essential identity. It is in this manner, then, that the posthumanist and anti-essentialist ethos of poststructuralism not only exacerbates the will to shore up the historical and moral legitimacy of cultural criticism that would "locate resistance" or "redeem cultural specificity," but also overdetermines the reaction against it that converts the "alterities" of diasporic experience into "historical materialities." In *The Protestant Ethnic and The Spirit of Capitalism*, Chow has observed that this conversion commodifies the labor power of cultural liminals by compelling them to assume the role of witnesses or informants whose varied performances of difference authenticate the critical materialism of cultural studies. She critiques a sentimental conflation between critical thinking and political activism that idealizes ethnic specificity in the same way that the Marxian perspective idealized the worker's dignity and labor. The ironic result is that the objects of our analysis can no longer resist the romance of resistance and, by extension, the critical savvy of their analysts who "locate" it. I have been arguing against this alternate romance because I am concerned that it goes too far in forcing writers to embody their minority specificity "for us" by speaking only "as" and thereby stripping them of the freedom to claim a potentially universal status in their representations of identity, experience, and history.

Cultural critique becomes a genre of discourse in its own right when it appropriates diaspora as a means of mobilizing resistance to "colonizing reading practices," including what Spahr has referred to as the "hegemony" of genre. Yet to the extent that *DICTEE* self-consciously foregrounds

the degenerescence of an idealized cultural memory, Cha's poetic montage might be read as a metacommentary on the ways that interpretative strategies operate generically in reiterating institutionalized critical and theoretical trends. *DICTEE*'s stylized dispossession of Korean memory preempts a redundant compulsion (including my own) to render diaspora identity at once culturally determinate and poststructurally indeterminate by repatriating it as a textual exemplar of current critical categories and preoccupations. As Cha's employment of unreadable images suggests, the "specificity" of diaspora may evince itself precisely in the ways in which the writing of memory is distressed by its reception as a representation that is never "in itself," but always "for oneself and others," whose gaze objectifies and stylizes its sociological and political particularities. A cloying self-consciousness, a perpetual uneasiness, a poisonous anxiety about the contamination of writing troubles *DICTEE*'s speakers; however, the competent language of the expert overshadows such moments of obliqueness and ironic abjection before a penetrating, humanizing, and idealizing heuristic. The critic's stutterings may, therefore, be most rigorously faithful to Cha's example only in the degree to which they weakly refract and betray it.

Notes

I am grateful to Maria Damon and Keya Ganguly for their feedback at various stages of revision in my preparation of this essay for publication.

1 Theresa Hak Kyung Cha, *DICTEE* (Berkeley: Third Woman Press, 1995; originally published by Tanam Press in 1982), pp. 56–7.
2 For the details of Cha's personal history, I relied on Moira Roth's "Chronology," in *Writing Self/Writing Nation: Essays on Theresa Hak Kyung Cha's DICTEE*, ed. Elaine H. Kim and Norma Alarcón (Berkeley: Third Woman Press, 1994), pp. 151–61.
3 See L. Hyun Yi Kang's "The 'Liberatory Voice' of Theresa Hak Kyung Cha's *DICTEE*," in Kim and Alarcón, *Writing Self/Writing Nation*, pp. 73–99.
4 Derrida, "The Law of Genre," *Acts of Literature*, ed. Derek Attridge (New York: Routledge, 1992), pp. 221–52 (231).
5 Homi K. Bhabha, *The Location of Culture* (New York: Routledge, 1994).
6 Wendy Brown, *States of Injury: Power and Freedom in Late Modernity* (Princeton: Princeton University Press, 1995).
7 One partial exception is John Cho's "Tracing the Vampire," in *Hitting Critical Mass: A Journal of Asian American Cultural Criticism*, vol. 3, no. 2 (Spring 1996), 87–113.

8 Elaine H. Kim, in *Holding Their Own: Perspectives on the Multi-Ethnic Literatures of the United States*, eds. Dorothea Fischer-Hornung and Heike Raphael-Hernandez (Tübingen: Stauffenberg Verlag, 2000) and Caroline Bergvall, "Writing at the Crossroads of Language," *Writing it Slant: Avant-Garde Poetics of the 1990s*, eds. Mark Wallace and Steven Marks (Tuscaloosa: University of Alabama Press, 2002).

9 Shelley Sunn Wong, "Unnaming the Same: Theresa Hak Kyung Cha's *DICTEE*," in Kim and Alarcón, *Writing Self/Writing Nation*, pp. 103–40.

10 Kim, "Preface," p. ix. My emphasis.

11 Kang, "The 'Liberatory Voice' of Theresa Hak Kyung Cha's *DICTEE*," p. 77. My emphasis.

12 Lowe, "Unfaithful to the Original: The Subject of *DICTEE*," in Kim and Alarcón, *Writing Self/Writing Nation*, pp. 35–69 (38; my emphasis).

13 Rey Chow, *The Protestant Ethnic and the Spirit of Capitalism* (New York: Columbia University Press, 2002), pp. 108 and 137.

14 Rey Chow, *Writing Diaspora: Tactics of Intervention in Contemporary Cultural Studies* (Bloomington: Indiana University Press, 1993).

15 Ibid., p. 29.

16 Revathi Krishnaswamy, "Mythologies of Migrancy: Postcolonialism, Post-modernism and the Politics of (Dis)location," *ARIEL: A Review of International English Literature*, vol. 26, no. 1, 125–46 (130).

17 Ibid., 133.

18 Victor Li, "Towards Articulation: Postcolonial Theory and Demotic Resistance," *ARIEL: A Review of International English Literature*, vol. 26, no. 1 (January 1995), 167–89.

19 Ibid., 172–3.

20 See Theresa Hak Kyung Cha (ed.), *Apparatus, Cinematographic Apparatus: Selected Writings* (New York: Tanam Press, 1980).

21 Juliana M. Spahr, "Postmodernism, Readers, and Theresa Hak Kyung Cha's *DICTEE*," *College Literature Special Focus Issue: (De)Colonizing Reading/ (Dis)Covering the Other* (1996), 23–43 (25).

22 Ibid., 27.

23 The protocol of "giving voice" to ethnic diversity is not limited to American scholarship as a 2000 collection published in Germany featuring an essay by Elaine H. Kim and edited by Dorothea Fischer-Hornung and Heike Raphael-Hernandez shows. See *Holding Their Own: Perspectives on the Multi-Ethnic Literatures of the United States* (Tübingen: Stauffenberg Verlag, 2000) and particularly Fischer-Hornung's and Raphael-Hernandez's "Introduction," pp. xi–xvi.

24 Eun Kyung Min, "Reading the Figure of Dictation in Theresa Hak Kyung Cha's *DICTEE*," *Other Sisterhoods: Literary Theory and U.S. Women of Color*, ed. Sandra Kumamoto Stanley (Urbana and Chicago: University of Illinois

Press, 1998), pp. 307–24. Despite her focus on dictation, Min follows previous critics who reintroduce an accent to *DICTEE* (capitalized on the title page).

25 Ibid., p. 133.

26 Stella Oh, "The Enunciation of the Tenth Muse in Theresa Hak Kyung Cha's *DICTEE*," *Literature Interpretation Theory*, vol. 13 (2002), 1–20 (4).

27 Chow observes that the entrapment of the ethnic in her hybridity reproduces a kind of existential abjection through autobiographical accounts of stigmatization. See "The Secrets of Ethnic Abjection," in *The Protestant Ethnic*.

28 Caroline Bergvall, "Writing at the Crossroads of Language," *Writing it Slant: Avant-Garde Poetics of the 1990s*, eds. Wallace and Marks, pp. 207–23.

29 See Paul Ricoeur's "The Aporias of the Experience of Time: Book 11 of Augustine's *Confessions*," in *Time and Narrative, Volume 1*, trans. Kathleen McLaughlin and David Pellauer (Chicago: University of Chicago Press, 1984), pp. 5–30.

30 Jacques Lacan, "The mirror stage as formative of the function of the I as revealed in psychoanalytic experience," *Écrits: A Selection*, trans. Alan Sheridan (New York: Tavistock Publications Limited, 1977), pp. 1–7.

31 See my theorization of disciplinary mimesis in "Disciplining Traumatic History: Goldhagen's Impropriety," *Cultural Critique*, vol. 46 (Fall 2000), 124–52.

32 Here, I am drawing on Lowe's discussion of dictation; Lowe, "Unfaithful to the Original," 38–42.

33 Rob Wilson reacts to Cha's recourse to Catholic imagery and ritual language as "a foreign language throughout the book, disturbing the self into a quest for sacred otherness." However, Wilson's analysis of *DICTEE* as an alternately uncanny and sublime "feminist experiment" tends to estheticize the sensibility of *being* foreign which *DICTEE* ironically performs. See Rob Wilson, "Falling into the Korean Uncanny," *Korean Culture* (Fall 1991), 33–7. Lowe suggests that Cha's incorporation of French dictation exercises alludes to nineteenth-century French Catholic missionary activity in Korea. In general, she reads the trope of poor dictation as a "more specific," "dynamic," and "resistant" corrective of the static binary between the imaginary and the material in Althusser's concept of interpellation (Lowe 60). Lowe's characterization of Althusser is debatable since he insists on the inextricability of interpellation and ritual in his allusion to Pascal's "scandalous inversion" to the effect that praying precedes religious belief (Louis Althusser, "Ideology and Ideological State Apparatuses," *Lenin and Philosophy* [New York: Monthly Review Press, 1971], pp. 127–86 (168)]. In Althusser's words, "where only a single subject (such and such an individual) is concerned, the existence of the ideas of his belief is material in that *his ideas are his material actions inserted into material practices governed by the material rituals which are themselves defined by the*

material ideological apparatus from which derive the ideas of that subject" (169; his emphasis). In conversation, Maria Damon has pointed out that the reading of dictation as subjectification expropriates the potentially genuine spiritual dimension of Cha's citation of the catechism, which resonates with her references to the French Catholic Joan of Arc.

34 For a fuller reading of the significance of the muses, see Oh "The Enunciation of the Tenth Muse in Theresa Hak Kyung Cha's *DICTEE*" (1997) cited above.

35 Ibid., 7.

36 Kang, "The 'Liberatory Voice' of Theresa Hak Kyung Cha's *DICTEE*," pp. 96–7.

37 Vijay Mishra, "Lives in Halves: A Homage to Vidiadhar Naipaul," *Meanjin*, vol. 61, no. 1 (2002), 123–6.

38 Jacques Derrida, *Dissemination*, trans. Barbara Johnson (Chicago: University of Chicago Press, 1981).

39 Kang, "The 'Liberatory Voice' of Theresa Hak Kyung Cha's *DICTEE*," p. 99.

40 Roland Barthes, "The Grain of the Voice," *Image, Music, Text*, trans. Stephen Heath (New York: Hill and Wang, 1977), pp. 179–89.

41 Cha, *DICTEE*, pp. 39–40.

42 Min, "Reading the Figure of Dictation in Theresa Hak Kyung Cha's *DICTEE*," 319.

43 Cha, *DICTEE*, p. 37.

44 Walter K. Lew, *Excerpts from: AIKTH/DIKTE for DICTEE* (1982). Lew's "critical collage" honors *DICTEE* by serving as a supplement that might also stand alone as a work of art.

45 Lowe, p. 39.

46 Chow, *Writing Diaspora*, p. 39.

47 I am borrowing from Victor Li (173) who cites Gates' "Critical Fanonism," *Critical Inquiry*, vol. 17, no. 3 (1991), 457–70 (466).

Fragment(s) of an Analysis: Chantal Akerman's *News from Home* (or a Mother–Daughter Tale of Two Cities)

Adriana Cerne

> *Re-vision – the act of looking back, of seeing with fresh eyes, of entering an old text from a new critical direction – is for women far more than a chapter in cultural history: it is an act of survival.*
>
> Adrienne Rich[1]

> *No doubt about it: looking is power, but so also is the ability to make somebody look.*
>
> Michael Ann Holly[2]

Endings – Departures/Returns

The concluding section of *Visual and Other Pleasures* finds Laura Mulvey in retrospective mood. There, in her penultimate essay, she opens upon the problematic of closure. Her specific subject is the sense of historical closure set upon the struggles that she and others in the Women's Movement had worked through during the heyday of political

and cultural interventions of the late 1960s, and through the 1970s. Mulvey writes: "it was tempting to accept a kind of natural entropy: that eras just did come to an end."[3] Her musing on endings, however, poignantly returns her thinking back to what she calls the "distrust of *narrative* closure that had always been a point of principle for the feminist avant-garde."[4]

By re-visioning feminist filmmaking's now foreclosed practices, here at the turn of the century, three decades on from its initial interventions, I find myself in effect negotiating what may be thought of as a generational gap that maps itself out as a space between an arrival and a return. In light of this dual move that distinctly refuses closure, and the so-called distrust of narrative endings to which Mulvey alludes, I am led toward an image that arrives from within an oeuvre born out of this avant-garde feminist moment. Somewhat ironically, it is the closing shot of a film with which I wish to begin this journey.

News from Home was made in 1976 by the Belgian filmmaker Chantal Akerman (b. 1950). The last ten minutes of the film was taken from aboard the Staten Island ferry leaving Manhattan; the prior location of the film. Of this long, uncut continuous shot Akerman says: "I found it so beautiful there was no reason to stop it, except at the end of the reel."[5] The filmmaker's statement points toward an image marked by desire, departure, and separation. This statement also leads us toward a sight where Akerman, as (pre)-viewer/filmmaker, appears captured at the site of seeing – and held in thrall by the image.

Described as "voluptuous" by the filmmaker, *News from Home*, Akerman's tenth film, is ninety minutes long (feature length). The film consists of a kaleidoscopic array of shots of New York on the image track, over which a series of letters (previously sent to the filmmaker from her mother *back home* in Belgium, during an earlier trip to New York to learn about avant-garde and underground film) are periodically read by Akerman in voice-over. She shoots day and night scenes of the city populated by passing strangers whose looks range from bemusement to indignation (and mostly indifference between). There are also subway scenes, shot both onboard and from platforms. These are intercut with slow panning shots of both stationary and moving vehicles. The list can go on. Each of the shots appears to bear no narrative relation to the preceding shot. Yet with each, a type of narrative begins to surface – building itself through a combination of abstracted forms: of line, shape, and color that mark the physicality of the city; and, conversely, through the interweaving of its

human inhabitants. One of the most important factors, however, for granting us the potential for narrative, appears to be time itself. We are given time to watch, to observe each scene as it unfolds – most often from the viewpoint of a static camera – but without any apparent *point of view*.

Fragment 1: A descriptive interlude

> *The past can be seized only as an image which flashes up at the instant when it can be recognized and is never seen again.*
>
> Walter Benjamin[6]

Emerging from a dark cavernous inlet, an eerie backward glance glimpses several sparkling lights that appear as the limit of an upper space (Figure 7.1). There is a deep groaning noise in this darkness. Perhaps it is mechanical. The voice (over) of the young woman – the filmmaker who had been reading her mother's letters – hushed abruptly as we entered into this shot. I try to remember the first time I was here. I cannot.

Figure 7.1 Still from *News from Home*, Chantal Akerman, 1976. Reproduced courtesy of the artist.

Then I hear... the splash of a wave that eventually wanders into view – a definite "glug" hits the vessel we appear to be travelling on. I am emerging into light – a sea-fronted wall of wooden timbers faces me. The journey continues with a sideways motion. It becomes clearer the further we go. The light from the sky reflects on the water in shimmering waves, drifting sideways, whilst I get further from the harbour mouth that expelled us. Then buildings appear: square and oblong blocks; smoking mist from their tips. This oceanic symphony in blue and gray summons Whistler to mind.

Gulls, like those I drew as a child, appear in the sky quietly gathering, proceeding to fly forward – pushing toward our own gentle, yet persistent backward move. Every so often they drop out of the currents that carry them, their bodies fall heavily toward a sea of waves whose fluidity keeps the whole scene moving and rhymes with the very flow of air made visible by the birds. Their weightless flight disappears beneath their sudden mass. A smoky sky hovers around the architectural density (marked in my memory as both landscape and mythscape): a backdrop for the intermittent cawing of the gulls. The solidity of this huddled island city stands in a *moving* relationship to distance and proximity – where the camera *and* "I" join the movements of the waves – pushing the sharp silhouette of the Manhattan skyline into an impressing view.

In an orchestration of sound and vision this dark, dark land deeply cutting into the distance finally appears shrouded in mist. In a growing discordant harmony the grinding cylinders of the boat appear to join forces with the heightened shrieks of the seabirds in an unknowing struggle with the lapping of the waves and the scratched surface of the imprinted celluloid that seems po(i)sed as "The true picture of the past." Walter Benjamin's own "Theses on the Philosophy of History" *appears momentarily* to co-respond in relation to my seizure of this image as it flits by.

This interlude, my own foray into what the theorist Mieke Bal has termed the "shipwreck" of description,[7] functions as a method, or perhaps a wilful practice of pleasure, in which film theory's perceived problematic of distinguishing between the filmmaker, the camera, and the spectator's viewing position is re-appropriated as a re-engagement with the film at the point of its own resistance to closure. It is also in effect a return to the serious consideration of pleasure, and its counterpart, unpleasure – a charge both levied at much feminist filmmaking and, at times, proposed.

Pleasure and the Image

I think it's a voluptuous film, because of the noise, because of the images, because of the colours. Sensual delight – there are a lot of people who don't know anymore what that is.

Chantal Akerman[8]

It is said that analysing pleasure, or beauty, destroys it. That is the intention of this article.

Laura Mulvey[9]

please, please, give me back my pleasure

Sally Potter[10]

Pleasure is a serious matter. The collectively discursive moment of feminist filmmaking and critical theory from the early 1970s to the mid-1980s attests to it as a central concern for women.

Laura Mulvey, as a feminist filmmaker who loved the movies, was all too aware of the gravity of the terms of pleasure in 1973 when she declared theoretical war on phallocentric codes of visual pleasure in her "Visual Pleasure and Narrative Cinema" paper. The essay, published in 1975, spoke of the need for the "destruction of pleasure as a radical weapon" in the cinema in order to "conceive a new language of desire."[11]

In an elliptical move, I have returned via my own viewing experience in 2005, to what may now be considered as a *closed moment* of feminist film-making in 1976, by way of an engagement with a *not-yet-closed, but infinitely closing moment* of a film from within the imaginary of a sealed temporal frame. Whilst considering what Akerman claimed as the "sensual delights" that arise out of this encounter, I aim to explore these sensory pleasures as they are traced through a phenomenological methodology, whilst also traversing what for feminism has always been, the highly disputed and yet fruitful ground of psychoanalysis. I take my lead from Akerman herself who said:

> For my cinema... the most suitable word is phenomenological: it is always a succession of events, of little actions which are described in a precise manner. And what interests me is this relation to the look, with how you look at these little actions going on. And it is also a relation to strangeness.[12]

Like Mulvey, Akerman here talks about our "relation to the look," and "how you look." However, if we allow ourselves to move through and beyond the

parameters of film theory (which as a discipline leans emphatically on the problematic of the spectator position) other possible frames for conceptualizing the image as a theoretical event may emerge. Akerman's *additional* and somewhat ambiguous idea of a "relation to strangeness" will be considered in due course, in a discursive return to Freud's notion of "The Uncanny" (*Unheimlich*), with its related sense of *home-sickness*.[13]

Feminist claims

It is clear from contemporaneous journals such as *Camera Obscura* just how central to early feminist film theory Akerman's filmmaking was perceived to be. Her seminal film *Jeanne Dielman 23 Quai du Commerce, 1080 Bruxelles* is 200 minutes long. It looks with detached precision at the everyday domestic activities carried out during three consecutive days in the life of the eponymous "Jeanne," a fictional Belgian housewife and part-time prostitute. The film was presented for the first time in the UK (without subtitles) on August 29, 1975, at the Edinburgh Film Festival – the same year as Mulvey's "Visual Pleasure" article was published in *Screen*. The following year *Jeanne Dielman* returned in a screening at the "Psychoanalysis and Film" event at Edinburgh. In the accompanying *Edinburgh '76* magazine, the feminist film theorist Claire Johnston not only highlights the importance of this film, and by implication its filmmaker, by allowing it to frame the closing section of her essay called "Towards a Feminist Film Practice: Some Theses"; the section of which is headed "Feminist Film Practice: '*Jeanne Dielman* . . . ,'" but does so in relation to Julia Kristeva's own groundbreaking work on the semiotic and symbolic in *Revolution in Poetic Language*. Johnston goes on in her final statement to claim that:

> Akerman's film is important for feminism because it resolutely refuses to present us with the security of the reverse shot of classic representation and instead foregrounds the "thetic" aspect of the field of vision, the Symbolic Order . . . In so doing it reveals the fragility of such a Symbolic Order by the over inscription of absence and by the inscription of the drives as "elsewhere". The film's inscription of this asymmetry opens up the possibility of a different Symbolic Order, a different mode of articulation between the Imaginary and the Symbolic . . . [14]

By bringing *Jeanne Dielman* and Kristeva's *Revolution in Poetic Language* into a discursive relation, Johnston effectively sets up a theoretical starting

point for my own *late* enquiry into the feminist moment of counter-cinema, which she herself inscribed; coining the term feminist counter-cinema, within which she, and to some extent Mulvey, are later entombed. My own encounter with *Jeanne Dielman* and *News from Home* – far beyond the restrictive dimensions of feminist film theory's claims (yet *enabled by* that very intensive and revolutionary moment of enquiry) – raised a new set of questions that were pressing back upon this moment whilst *moving with the image* (like the "inscription of the drives") – *elsewhere*. My reading of this moment of film, however, provokes questions that cannot be answered solely in either the annals of feminist film theory or the archives of feminist film, as the first has, in moving to the academy, left the second in a state of dereliction.

So, what if we were to consider Akerman as a filmmaker whose work signals, whilst opening up, "the possibility of a different symbolic order"; *not-yet-spoken*, yet (somehow) made represent-able; visible in a medium that is embraced by the feminist movement in its challenge toward patriarchal systems that constructed Woman as a signifier of both pleasure and absence.

Although *Jeanne Dielman* has in some sense stood at the forefront of not only Akerman's, but also feminist filmmaking *per se* – it is her next film, *News from Home*, that would seem to re-address what Johnston refers to as *Jeanne Dielman*'s "over inscription of absence" in a complex interplay of re-inscriptions in, and in/difference of the feminine. The pressing issue of Woman-as-absence for feminist theory, so sublimely referenced in *Jeanne Dielman*'s elliptical play of presence and absence, is re-configured in the avant-garde and abstracted forms of *News from Home*. The narrative structure of the film also, and importantly, however, conveys an engagement with the epistolary, which is rooted at the nascent site of the literary novel.

The fragility of *the* symbolic to which, as Johnston claims, *Jeanne Dielman* points, via its "over-inscription" of absence, is further explored in the inter-relational (mother's) writing, which is *put to work* in *News from Home*. As this writing becomes re-invested with(in) the symbolic sphere of the daughter's social, political, and artistic practice of filmmaking it circulates differently in a poetics of feminism, which expands the modernist poetic crisis of signification into other strands of theoretical thinking that flows to and from questions of the feminine.

As we now know, the feminist revolutionary impulse for change raced headlong toward a series of dilemmas, crystallized in the unyielding intersection between the rhetoric of realist representation and Lacan's

psychoanalytical re-vision of Freud, where, as Christine Gledhill commented, the feminist predominance of locating femininity "in difference... raises its own problems. First, within the Lacanian framework, difference is *sexual* difference founded in castration..."[15] In order to move beyond this equation that rests upon a binary trap one would it seems have to create a shift *with-in* an otherwise immovable phallocentric paradigm.

Shifting the parameters of the phallic: a "matrixial" intervention

> At the symbolic level, the *matrix* is no more feminine than the *phallus* is masculine: it is a mark of difference. It concerns the symbolic network that is culturally shared by men and women. The vicious circle in the Lacanian paradigm by which the phallic is defined as the *symbolic* and the *symbolic* is defined as the phallic, and by which sexual difference has only one signifier – the phallus (either you have it or you don't) – needs to be rotated. The *matrix* is not the opposite of the *phallus*, it is just a slight shift aside the *phallus*, a shift inside the *symbolic*.
>
> Bracha Ettinger[16]

In its rhythmic asymmetry, *News from Home* points toward a flow of "co-emergence" and "co-fading." These are terms which arrive from elsewhere, namely from the work of the theorist, psychoanalyst, and artist Bracha Ettinger. Neither Oedipal, nor anti-Oedipal, Ettinger intervenes in the disciplines of psychoanalysis and philosophy. Her conceptual expansion of the symbolic arises out of a close engagement with the work of Freud – particularly, in the first instance, with his essay on the notion of the uncanny, and his exposition of an unconscious infantile complex "of intra-uterine existence" or "*womb*-fantasies,"[17] which Ettinger goes on to theorize as "matrixial."[18] Ettinger writes:

> The Matrix is not the opposite of the Phallus; it is, rather, a supplementary perspective. It grants a different meaning. It draws a different field of desire. The intra-uterine feminine/pre-natal encounter represents, and can serve as a model for, the *matrixial stratum of subjectivization* in which *partial subjects* composed of co-emerging *I(s)* and *non I(s)* simultaneously inhabit a shared borderspace, discerning one another, yet in mutual ignorance.[19]

In the course of her work, Ettinger importantly proposes a way of considering the symbolization of the connections between the question of

femininity and those of creation, procreation, and sublimation, beyond the "perpetual failure" in the symbolic to which they are famously condemned by Jacques Lacan in his 1975 publication of his 1972–3 seminars where he writes: "*the* woman ... doesn't exist and doesn't signify anything."[20] Ettinger meticulously maneuvers amongst the remnants of Lacan's otherwise "impossible" feminine and the *object petit a*: a terrain that yields theoretical seeds, which are sown elsewhere.[21] Upon a ground that combines her psychoanalytic perspective with the "emergent model" of "becoming" that is philosophically developed by Gilles Deleuze and Felix Guattari. As Brian Massumi states of Ettinger's work: "This hybridization of psychoanalysis with schizoanalysis involves a significant revision of the former...This approach has major consequences."[22] Not least of which is Ettinger's theoretical proposition of a "matrixial encounter," which enables interconnectivity of the above questions of femininity and creation to, as she puts it, "...rise [...] to the symbolic surface by *metramorphosis*."[23]

Unlike metaphor and metonymy (as condensation and displacement they operate within the Oedipal sphere as either passive fusion, *or* aggressive separation), "metramorphosis has no focus, it is a recognition which cannot fix its 'gaze', and if it has a momentary centre then it always slides away towards the peripheries."[24] Metramorphosis as a process of "out-of-focus *passages* from non-definite compositions to others"[25] enables me to re-view *News From Home* through a repositioned aesthetic and psychoanalytic lens – a matrixial one – that deals with giving recognition to "invisible differences recorded in psychological space."[26]

The "feminine" (the) sex difference

> The difference of the feminine is inaugural of its own space and is originary; it
> is not deduced from the masculine or the male.
>
> Bracha Ettinger[27]

The concept of the "Matrix" as an "originary," "feminine" intra-subjective encounter experienced by subjects regardless of phallically organized realms of gender enables us to re-think both subjectivity, and femininity, *-as-encounter*. The theoretical complexity of this terrain echoes (differently) Mulvey's polemical call to appropriate psychoanalytical theory as a discursive tool. Ettinger, like Mulvey, moves within a Freudian and Lacanian frame, but Ettinger's dialog – by engaging the phallic with(in) a discourse of the matrixial – heads toward a point where we can *reconsider*

the idea of pleasure and loss in terms of jointness-in-separation. We are, as a result, able to move in a different way through Laura Mulvey's now famous, polemical argument in which she called for the "destruction of pleasure as a radical weapon" in the cinema in order to "conceive a new language of desire." As a symbolic concept the "Matrix" allows us to consider an idea of pleasure, which can accompany "variable levels of intimacy through separation, or separation in intimacy."[28]

The analytical confrontation that Mulvey now appears to have heralded for feminist film theory was, however, as Johnston suggests, already at serious work in the *filmmaking processes* of Chantal Akerman, and by situating this chapter within the dual frame of the contemporaneous and theoretical work carried out by the film *News from Home*, and an engagement with the psychoanalytic theory of Bracha Ettinger, we may now track a way of thinking-through the possibility for inclusion of the feminine in symbolic terms. Ettinger's concept of the "Matrix," as a "sub-symbolic" signifier, importantly offers the possibility of *a shift with/in* a phallocentric paradigm.

The apparent blasphemy of Ettinger's theory of "Matrixiality" offers us an analytical model that reconsiders the terrain of the inter-subjective, whilst developing the site of object relations, at the point at which the aesthetic is in*formed*. This field of matrixial theory enables a perceived borderspace simultaneously to exist as a threshold – conceptually allowing for an encounter with/in the stranger, the foreigner, the Other that Ettinger significantly figures as the "m/Other."

"My Mother wrote me Love Letters" – Chantal Akerman

In the essay "Love Letters to the Mother: the Films of Chantal Akerman,"[29] Brenda Longfellow enables an analogous connection between films and letter-writing to surface through an analysis of four of Akerman's films that deal with the mother–daughter relationship.[30] In gathering these films under a collective title: "Love-letters *to* the mother...," an enquiry into a type of correspondence "in/of and from the feminine"[31] emerges out of the site of a film practice. However, only one of the four films under discussion deals directly with the mother's writing: *her* "love letters" *to her daughter*. *News from Home* can be considered, at one level, as the filmic response to those maternal letters. In corresponding, it allows a culturally negated and *differenced* maternal "voice" to emerge at the cultural level.

Speaking of her mother's letters to her, Akerman says:

My mother wrote me love letters, and that was marvellous. With her own words...my mother didn't learn to write, she quit school at 11...She writes as she can, she formulates her feelings in an unsophisticated way, they really reflect her. If she were more sophisticated, she wouldn't have dared to ask me all the time "When are you coming back? You know very well that we love you, you know that we miss you". She wouldn't have dared, she would've said it by way of a thousand "detours". But she's not sophisticated, she used the words that she had.[32]

My dearest little girl, I'm very surprised not to have had any news from you – your last letter was ten days ago. I'm wondering what's happening especially since I replied immediately...write to me immediately, you know I wait impatiently. I live to the rhythm of your letters. Don't leave me without news... We only ask one thing – that you don't forget us.

Mother's letter, *News from Home*

This mother's circular pleading of love and loss re-sounds like an echo in the daughter's mouth: "that primary cavity of emptiness and *jouissance*."[33] Her *nagging kisses*, sometimes fueled with anger, seem to pull at the edges of these missives. Yet, they also seem to join them together – one letter to the next – each one saying the same thing – differently. Repetition and difference are intensely played out within the disembodied voice as it rhythmically plays with an otherwise culturally neglected syntax.[34] Both the image and overlaid soundtrack of the city, and the voice-over reading the mother's letters, exist interdependently. Neither clearly lending nor borrowing from the other. Yet in *coexisting* they enable other meanings to slip across the semantic and prosaic ground from which both appear to have sprung.

The "fragmentary" letters from the mother can be heard as pre-textual signifiers of displacement. Memories are dis-jointed in the intimate words that surface upon the image of an outer world that seems to "*suffer* from reminiscences."

"I content myself with what can be written and I dream whatever should be dreamed" – Marie de Sévigné in a letter to her daughter[35]

As if waking from a dream the opening shot of *News from Home* provides us with a languorous and hazy light, which suggests an early morning

scene. The silence, in conjunction, is like an uncanny reminder of a dream space. In our uncertainty we enter into a film that slowly unravels. As sounds surface, and are again lost in the film, our own auditory pleasure is gradually awakened.

The history of cinema has, in its development of sound, increasingly aimed at creating a unity in the relation of sound and image; sound becoming the "articulating" support of a scopophilic field of subjective recognition. When Stephen Heath looks at the relative positions of sound and image in the cinema and considers the idea of pleasure in hearing, he importantly (for my purposes) draws upon an analogy that rests the "other scene" of psychoanalysis, together with silence(s) in film, as "acute moment[s] of sound."[36] Listening to the gaps and hesitations allows one to hear an ill-fitting flow that begins to *speak* – with and across the body (and also the body of cinema as a critical practice) – of another space of presence.

In *News From Home* the idea of a "controling gaze" is disarmed as we can no longer treat the onscreen subject as our object – its (non-)presence is marked continually by its own absence, which, through the treatment of the soundtrack, is paradoxically periodic. Although the perceived loss of the subject links us in some way to a phallic desire for fusion, we are, through the film's complex image/sound structures, guided toward desires that interrupt/rupture the phallocentric paradigms that govern "visual pleasure" in classic narrative cinema. But this is not "classic narrative cinema." As Maria Walsh reminds us in her recent reframing of the film *News from Home*, it is "a classic of feminist cinema," yet, it is one that Walsh wishes to be liberated from "classic feminist film theory."[37] In her article, Walsh creates a re-staging of the duality between Lacanian and Deleuzian territory, which polarizes their distinctions, between what she refers to as a "psychoanalytic depth model," with its "passivity/activity binary that characterizes the subject/object dialectic,"[38] and a Deleuze and Guattari "subject [who] is always in a state of process being fractured by pre-personal differences that exceed identity."[39] Walsh also re-frames what she refers to as Stephen Heath's "Lacanian indebted" reading of *News from Home*.[40] She "rework[s] aspects of Deleuze's philosophy in order to re-view the negativity of Heath's unresolved question [on the impossibility of a woman's desire] and the equation of passivity and absence with femininity."[41]

Walsh's reading of *News from Home* focuses on the closing shot of the film as "the locus for unleashing a tracery of sensations,"[42] she suggests that "The continuous accumulating movement of this tracery of

sensations goes against the melancholia of being fixed on an absence (of the mother, the daughter, the lost object of psychoanalytic parlance)."[43] In her desire to move beyond "predictable interpretations of loss and separation [which] inhibit [...] the possibility that *News from Home* may be generative of positionalities of subjective engagement that are not bound by such familial tropes," and in her wish to read beyond the psychoanalytic referents of a "passivity/activity binary that characterizes the subject/object dialectic,"[44] Walsh interestingly poses *News from Home* as a theoretical object. She says it is "generative of subjectivity as an affective moment of sensations prior to or beyond identity"[45] – which is, as she states of interest to feminist theory.

In her reading of the "intensities" of the film image, however, Walsh replaces Heath's (read Lacan's) so-called "impossible question of a woman's desire" with a strangely situated and responsive "I." She writes: "If 'I' identify with anything, it is with the flight of the seagulls as their sway carries me away on the surface skin of a duration which reconfigures 'me.'"[46] Her understandable "problematic" with a Deleuzian perspective of an "absolute divorce from a perceiving body," leaves her as an "I" "travers[... ing] the unbound sensations" of what she calls "pure affect" on an "impersonal body of surface intensities."[47] By reconsidering these *intensities* of affect and sensation within the aesthetic encounter, beyond the restrictive *Oedipal/anti-Oedipal* framework that has been set up, we may be able to "suspend [...] the exilic condition of the feminine"[48] long enough to rethink *the* "feminine"; beyond the terms of "archaic" psychic processes – *retroactively defined in terms of an oedipal presence/absence.* I suggest that Walsh's sense of an affectively moving "reconfiguration" need not dispose – so quickly – of Heath's *crucial* question of a woman's desire; its "impossibility" as a question is perhaps more a question of where, and within what symbolic spectrum the question is posed.

By returning – with this moment of film as a "theoretical object" – across the foreclosure of a political and temporal framework of feminism, we might *now* see its difference, e-merging *with us* from/with-in, its own nascent moment of closure. This (impossibly situated) "question of a woman's desire," designated within the Oedipal/anti-Oedipal dialectic that nevertheless still upholds a phallocentric sex difference, may be relocated in relation to matrixiality, where difference itself is conceptually reconfigured. The crucial question which bypasses both Deleuze and Lacan, and as a result Walsh, is Ettinger's re-posed question of a *non-phallic sex difference.* To borrow Deleuze's own words, "it is difference which is differentiated."[49]

This expansive theoretical moment of film is *not* an image of the horizon *leaving us* (somehow traversing (or stranded) upon the surface of an impossibly situated foreground). This image that *intimates* closure immeasurably expands and contracts perceived boundaries. Relations to distance and proximity (dis-appear) upon the waves, and subjectivity-as-encounter, *is moved and moving* in this image of relations-without-relating.

In "classic feminist" style, and whilst talking about the rhythm of film, in an interview for the journal *Camera Obscura* in 1977, Chantal Akerman said: "It's a really hard problem to try and say what differentiates a woman's rhythm in a film...I don't know if we have the words, if they exist yet."[50] Perhaps the words did not exist. However, in Akerman's attempt to *voice* her *vision* as filmmaker, she points beyond the eradication of the feminine as unspeakable, toward an altogether differently nuanced direction – that of an intuited *not-yet*-spoken.

It is here, at the site of the not-yet-spoken – where Akerman's work draws upon processes of erasure and inscription – that her work most successfully, and complexly, marks out new cinematic territory. In doing so, her films expand the cinematic far beyond the disciplined boundaries of film history and theory. It is at the very point of that which might be "inconceivably" (over)heard, and thus spoken, made visible, with-in difference that I encounter the film/image. As I return to the film through a radically expansive moment of closure, this image of a landscape – at the threshold of an erasure – points me toward contemplation of annihilation, just as it unfurls into *other potentially re/mark/able inscriptions*.

As the "external" histoire (story, via the mother's letters) touches us, it slips away into pictures: just like postcards of a foreign place that arrive to meet us – our own foreignness is sealed within the meeting. The final closing shot of *News from Home*, which has been referred to as the only subjective view in the whole film, announces this meeting of/with the foreigner/stranger, the m/Other – in a prolonged moment of what appears to be a departure.

Richard Kwietnowski suggests that this closing shot is both a response to the narrative of the film – hence can be read as a return "to the mother" – and yet, in its protracted backward gaze, is a type of "giving in to the film's place – the city."[51] However, although this bordering "departure" hovers over the narrative sense of closure necessary to think the *return home to Europe and "the mother"* – it is in actuality a *roundtrip*, a ferry journey that will soon return to the Manhattan shore, just as Akerman herself was to do.

I too, am traveling now, as I am both tempted and impelled by this image of an ever-widening yet never fully (dis)closing gap to swerve into the path of another story: one that famously problematizes endings and narrative closure. I am referring to the renowned "story" and Freudian psychoanalytic case history of "Dora" (real name Ida Bauer). "Dora's" story underwent something of a re-naissance at the hands of many feminist filmmakers, artists, and theorists from the mid-1970s on, who clearly saw (through) a site of patriarchal vulnerability in this most famous of psychoanalytic case histories – this was after all, if not the only, then conceivably the "greatest," quantifiable failure Freud ever had.[52]

At the vulnerable site of my own desire to traverse the territory of the "feminine," in a matrixially expanded symbolic sphere that moves through and beyond the dialectical modes of phallic pleasure, and displeasure – which are violently grafted out of loss, separation, and the Other – I find myself entering into a "productive confusion,"[53] which wends its way across another journey. Because it is here, where the "hysteric" girl ("Dora"), in a re-visitation of a dream (which she re-calls to Freud that opens with her wandering around a "strange" town, where she finds a letter from her mother), intersects with Akerman's dream-like inscription of her own mother's letters, across images of a "foreign" city. Somewhat ironically though, what really draws me toward these sites of traversals is *a moment of prolonged stillness and utter captivation* (which I shall shortly discuss) which resonates so compellingly in the closing shot of *News from Home*; as re-called by Akerman when she says it was so beautiful there seemed to be no reason to stop (looking) until the film ran out.

Re-reading a (Dream) Letter ("Dora"/Käthe[54])

I was walking about in a town which I did not know. I saw streets and squares which were strange to me. Then...I found a letter from Mother lying there. She wrote saying that as I had left home without my parent's knowledge she had not wished to write to me to say that Father was ill. "Now he is dead and if you like (?) you can come."[55]

Fragment of 'Dora's'/Ida Bauer's second dream
transcribed by Sigmund Freud

My mother loved it, but my father was angry...[56]

Chantal Akerman talking about her parents' reaction
after having seen *News from Home*

As in "Dora's" "second" dream, Chantal Akerman "had left home without her parents' knowledge."[57] She spent seven months in New York before returning to her parents in Belgium; she later returned to New York and made *News from Home*. It was midway, whilst still on the plane, between the "home" of Europe and parents, and her newly chosen "artistic" home of the United States (with its filmmakers whose films, she said, gave her a "lesson in freedom"),[58] that she decided to make *News from Home* (the title, it seems, turns upon a mutually determined axis as the "news" can be read as travelling in opposite directions simultaneously: that is, depending on where you situate "home"). Akerman said: "I was in the plane and I thought – my mother is going to send me those letters again... That's how I got the idea of the film."[59] In anticipating a new batch of letters from her mother the idea flew into her mind just as she herself flew toward the city that would provide her with the imaginary space of enunciation.

As Akerman travels the streets of New York *alone*[60] she, like Dora, looks at the city in terms of its "pictures" (Freud insisted that pictures were a "nodal point" to Dora's dream). Akerman *takes/makes* pictures that the living city offers her: as if staring into her own dream – whilst invoking other dreams. Akerman does not only dream, however; she creates films, which in their working, act partially like a dream.[61] By this I mean they re-route our viewing, bypassing the well-trodden pathways traveled by the "manipulated" and "alienated subjects" caught within the unconscious of a patriarchal society – thereby allowing psychical traces to be felt, as we are touched by the "dream"/film in a "dimension that is beyond appearance."[62] The result is that we "strangely" find ourselves awakened. Whatever has been repressed is allowed temporary release in the dream. As Freud explains, in the introduction to "Dora's" analysis:

> ... the dream is one of the roads along which consciousness can be reached
> by the psychical material which, on account of the opposition aroused by its
> content, has been cut off from consciousness and repressed,... The dream
> in short, is one of the *detours by which repression can be evaded*...[63]

This (*regressing*) image of the "foreign" city of New York brings with it the re-inscription of other journeys, *at least one* of which had occurred in Dresden (Dresden is the city "Dora" had previously visited, where she had gone alone to the "picture gallery" and sat before Raphael's *Sistine Madonna* for "two hours"). Freud connects this experience to the later dream because of reappearing elements.[64] This journey is – according to Freud's

analysis – transposed into her second dream, which opens in a foreign town where she goes on to find, and read, a letter from her mother.

In paying close attention to Dora's second, and final, dream in her analysis, which Freud attempted to unveil, but was, according to himself, unable to fully clear up because of the nature of the (premature) ending of the analysis,[65] we may explore traces of dis-placement *already inscribed*, as another layer that may be re-routed through Freud's own emerging concepts of "transference" and "counter transference," analytical terms that *make their entrance* through the unconscious dream/desire of the Other. As Mary Jacobus succinctly puts it in her essay, "Dora and the Pregnant Madonna": "Freud himself has always been anticipated in what he discloses to Dora."[66] This idea of always having been anticipated, momentarily directs my thoughts toward Michael Ann Holly, who in her essay "Past Looking" reflects the perspectival form of Renaissance painting back toward the representational practices of art-historical writing that positions it in history. Holly writes:

> Perhaps it has never been true that historians of art or culture can easily escape the lure of casting their own histories in the shape of those objects they have set out to investigate . . . the historian, as a special kind of spectator, is herself or himself always already anticipated or implicated in the formal logic of the works he or she describes.[67]

Traveling across discursive and interdisciplinary boundaries with an *already implicated* desire in "the shape" of /for the Other, be it, painting/art history, or psychoanalysis, takes us to the shores of yet another land – back (home) one might say, to the site of the originary Other, the m/Other – who, as Jacobus reveals, was concealed in "Dora's" (counter) transferential relation to Freud. Behind Freud's inquiry, Jacobus suggests that another set of questions slide into view – Dora's own question of what it means to be a woman, and, above all:

> what . . . it mean[s] to be a mother, when mothers are the waste product of a sexual system based on the exchange of women among men? Freud's question concerns hysteria: Dora's question, aimed at the blind spot of Freud's enquiry, concerns femininity; but it also implicates the mother who is strikingly absent from Freud's account.[68]

Akerman, three quarters of a century after "Dora" had dismissed Freud, creates a space for acknowledging, and responding to *the* Mother via her

letter(s). By valuing the maternal and her own mother's real letters, she inadvertently enables value to be unlocked from an otherwise repressed letter – that is, repressed by Freud in his analysis of "Dora's" second dream. His disavowal of the dream-letter's significance – *as a correspondence between mother and daughter* – is tied within his repression of the pre-Oedipal Mother herself.[69] "Dora's" unconscious, *it appears*, had to kill the father before mother and daughter could be united (even though this was a missed encounter). But all of this could only ever appear for the "sick" "Dora" in a dream – a dream whose structure, like language, was deciphered – or *spelt out* – within a patriarchal paradigm: thus resurrecting the "dead father."[70]

In embarking upon the analysis of this dream Freud appears to leave us (those who follow) a distinct theoretical gap through which to proceed (elsewhere). In light of the fact that Dora broke off the analysis before he could complete his work with her – Freud says that "the whole of it [the second dream] was not cleared up."[71] Indeed, as a fragmentary analysis in a fragmentary case history any attempt to follow Freud in his own analytical scenes of wandering is somewhat revealing.

Fragment 2: The invisible scene of reading, or " 'Dora's' a-Dora-tion"

> *It's 9.45; I am wandering about the town, hope I won't lose my way.*
> Sigmund Freud[72]

The above is a postscript, written by Freud in a love-letter sent to (his then fiancée) Martha Bernays on December 16, 1883 from Leipzig. *The day before travelling to Dresden*, where he visits the *Alte Meister* gallery at the Zwinger Museum. This magnificent Dresden building, home to the "old masters," houses the *Sistine Madonna* by Raphael – an image that is (*yet*) to become central to "Dora's" analysis, at the very point where she dreams of receiving a letter from her mother.

Seventeen years after his own visit to Dresden, Freud, in his own reminiscence-suffering way, re-writes "Dora's" dream, he says:

> The wandering about in a strange town was overdetermined.... [it] reminded her of her own first brief visit to Dresden. On that occasion she had been a stranger and had wandered about, not failing, of course, to visit the famous picture gallery... [she] stopped in front of the pictures that appealed to her. She remained *two hours* in front of the Sistine Madonna,

rapt in silent admiration. When I asked her what had pleased her so much about the picture she could find no clear answer to make. At last she said: "The Madonna."[73]

"Dora," sitting in front of the Madonna is a scene of reading. It was of course a culturally invisible scene of reading regarding the complexities of maternal/ filial relations: for "Dora" it constituted an as-yet-unspeakable reading of/ for the feminine. As a scene of reading, it drastically re-appears, *re-written* in Freud's story of the hysterical girl. But there the Mother disappears once more. But, if we look more closely we might notice that it is Sigmund who is concerned to tie Dresden and the *Sistine Madonna* to the case history (Figure 7.2). By insisting on Dresden as central to the dream, he sets up a dual city setting between Vienna and Dresden, *his* free-association from *her* Dresden to *his* Dresden re-creates anOther moment of correspondence that silently inscribes itself as an effaced/ dis-placed image of love that is finally able to surface – *via Dora.*

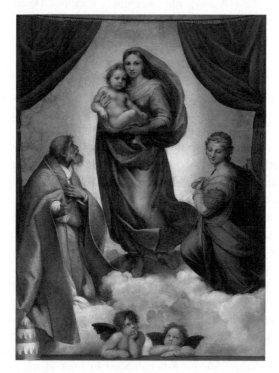

Figure 7.2 Raphael, *Madonna and Child.* Dresden Gemäldegalerie.

On December 17, 1883[74] (seventeen years [a lifetime] before "Dora")
Sigmund writes in his own love-letter to Martha:

> at last we found the picture gallery where we spent about an hour, ... [where
> I] myself began to admire ... Raphael's [Sistine] Madonna ... is a girl, say 16
> years old; she gazes out on the world with such a fresh and innocent
> expression, *half against my will she suggested to me a charming, sympathetic
> nursemaid, not from the celestial world but from ours.* (emphasis mine)[75]

This all-too-human nursemaid re-appears, it would seem, not only as
another character in "Dora's" story, and indeed is the root of Freud's
choice of a name for his patient Ida Bauer (who must remain incognito),
but as a synecdoche for the maternal may also be said to negate *mother-
hood* as a subject of enquiry. As in a palimpsest Other tales and traces of
love appear to find satisfaction in this dream.

By opening upon the captivating closing shot of *News from Home*, I am
led to an *unfinished fragment* of Freud's case history. Here at the site of
"Dora's" second dream, where both the mother and the Madonna reside,
the spellbinding image of the Madonna remains central to an *unspeakable*
moment of reading for the girl. This is a reading that cannot be fully
translated into the language of the doctor, who demands an answer to his
own strangely posed question of what had "pleased her so much about
the picture" at Dresden. "Dora's" "two-hour" experience in front of the
painting (an actual event) is woven as a material source for the dream, and
re-emerges as the site of an unspeakable imagined "pleasure" for the girl.
A pleasure that she cannot (give) voice (to) but only enact in her "hys-
tericized" muteness. Freud's question assumes a displaced "pleasure" that
he then goes on through the rest of the analysis to attempt to uncover.

How Far Have We Traveled With This Image of a Departure?

*For both the man and the woman, the maternal body lines the seductive surface of
the image, but the body he sees is not the same one she is looking at.*[76]

Mary Kelly

In her essay "Desiring Images/ Imaging Desires," Mary Kelly suggests that
"it *is* possible to produce a different form of pleasure for the woman by
representing a specific loss – that is the loss of her imagined closeness to

the mother's body."[77] Kelly claims this possibility by working with Roland Barthes's concept of pleasure as "a loss of preconceived identity." I would suggest that the concept of a "different form of pleasure" and the "specificity" of this "imagined" "loss" not only fits the aesthetic profile of *News from Home*, but is, moreover, theoretically deployed in the closing shot of the film as an extended phenomenological moment of *being* (moved), as such there is a correspondence with/ in Dora – who found *herself* (*immovably*) *moved* in front of the *Sistine Madonna*.

Although he remained blind to it, what Freud enables us to see is a difference, invested in the relations between the image (as the sight/ site of a shifting femininity) and "Man, as bearer of the look."[78] This difference points us toward the over-looked figure of the "engineer" abroad, the "adorer" who, as Freud tellingly says, "was concealed behind the figure of Dora herself."[79] Lurking in the shadows of the feminine, his significance relates directly to the occasion of Dora's "admiration" of the Madonna, and the way in which *she-as-he* is positioned at the gallery – facing the image from "the male's side." This interpretation strikes me as being closely related to that of Laura Mulvey's analysis of the "voyeuristic gaze" within the cinema, in which "pleasure" in looking derives from "the neurotic needs of the male ego"[80] and where female spectators are "caught" looking at the "eroticized" object.

For "Dora" the image of the Madonna offered itself as a site of desire for/ of the woman-m/Other that did not, as Kelly suggests, transgress the social boundaries to which Dora herself was bound. This was a moment of correspondence – but a moment of (desiring) – love without love-letters – in a life and case history littered with them. But there was only one letter from the mother for Dora – "writing" that *had to be dreamt, in order that* the real experience in front of the painting at Dresden *might finally (re)appear*. Let us then return – like Freud – once more to Dresden.

Although Freud clearly speaks of the *pictures* that Dora chose to view at Dresden, he goes on in the analysis to mention *only one* painting from that city; this one painting is of course the *Sistine Madonna*. In her re-reading of the "Dora" case, Mary Jacobus turns her analytic gaze momentarily from the *Sistine Madonna* to another painting, which she introduces as a "fantasy of my own." This "fantasy" arrives in the shape of Piero della Francesca's fresco, *The Pregnant Madonna*.[81]

Armed with Jacobus' idea of introducing a phantasy of *my* own, I wish to imagine both Freud's and "Dora's" visit to the gallery. By consulting the Dresden gallery catalog of 1880 we are provided with a gallery map that

Figure 7.3 Floorplan of the Dresden Gemäldegalerie in 1882.

suggests an imaginary journey detailing the suggested route to be taken by visitors (Figure 7.3). We are also able, from Freud's love-letter to Martha, to re-trace part of his journey around the gallery. The letter provides us with the knowledge that he spent some considerable time "admiring" *The Sistine Madonna* in room A. Freud, however, also writes about several other paintings which were located in other rooms – H, J, K, and N. With the aid of the catalog map we can move across a topographical surface, whilst delving into the imaginary spaces of the (indexed) rooms.

So it is here, at the intersectional space of delving into the imaginary, and the actual (rooms), that I too, like Jacobus, wish to slide another "picture" into view. I, however, imagine "Dora" and Freud encountering not only the *Sistine Madonna*, but a painting that dwelt nearby. Johannes Vermeer's *Girl Reading a Letter by an Open Window* (c. 1657) permanently resided in room L (Figure 7.4). The Vermeer and the Raphael paintings were on display at the time of both visits. The Vermeer, appropriately enough referred to as *The Dresden Letter Reader*, appears to enter into a tale beyond its telling. As we observe it (as I imagine Freud and Dora did, even momentarily in passing) we are clearly drawn toward a contemplative scene of yet another girl's reading – Vermeer's first solitary figure of

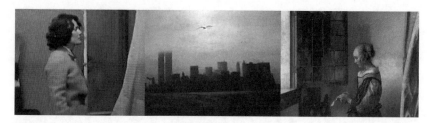

Figure 7.4 Adriana Cerne, collage 2005. © Adriana Cerne.

a girl reading – what is assumed (in the writing of art's histories) to be a "love-letter."

Fragment 3: Girl at window – reading (love?) letter

Vermeer (the "Sphinx of Delft," as Théophile Thoré called the artist he championed in his 1866 writings for the *Gazette des Beaux Arts*) may very well have provided "Dora" and Chantal with a riddle of baroque proportions – a way perhaps, to re-address imaginary scene(s) of wandering and reading in an inwardly reflecting moment of stillness that re-calls by way of the epistolary what is not-yet-spoken. This other picture, as Jean-François Lyotard suggested of Vermeer's work, provides us (as does the hysteric) with a sublime moment of anamnesis.[82] The not-yet-famous Sigmund in his own wandering around the gallery – perhaps contemplating in a pre-emptive way his next love-letter to Martha – may have seen a pre-view – not only of "Dora" the "nursemaid" that day – but of a girl who reads an as-yet-untold letter, in the dream-like presence of anOther reflected image. The stillness of the Vermeer is disturbed by a series of uncanny doublings, brought to life in the voluptuous fictions of Freud's "Dora" as they intersect with a cinematic moment of feminist poetics. Strangely enough, however, it is Gilles Deleuze – a theoretical stranger for my own work who provides me with an itinerary for my journey back toward this Other painted scene/ seen, when in writing about Akerman's film *Rendezvous d'Anna* (1978) (the film that follows *News from Home*) he says:

> ... the chain of states of the female body is *not* closed: descending from the mother or going back to the mother [and] makes itself seen or heard only through the window of a room ... which makes it cross ages.[83]

Deleuze obliquely points us toward the simultaneously conceptual and physical site of an opening (another theoretical gap through which thoughts might slip) – a window-space (a traditional site of framing for woman in the cinema), where he suggests an Other Scene/seen. This Other is the site of a potential/temporal shift, where narratives might re-emerge – shifting the terms of (their own) closure.

This painting by Vermeer, whose *absence* from the text of Freud's love-letter to Martha (sent on December 20, 1883), (re-)emerges on the horizon of another story. Whilst corresponding to the *News* one receives *from Home*, it appears to come into view the further away we go. Framed once more by the billowing green curtain (echoing both Raphael and Piero della Francesca's paintings) – the prosaic pleasure of Vermeer's "Girl Reading a Letter by an Open Window" ("pre-posterously," as Mieke Bal would say) *re-calls News from Home* – and the color palette of the film. Whilst *reflecting* upon the (in-)visibility of the m/Other woman, the girl here is central to the image – this double image – and yet is obliquely also caught in the reflective figure *in* the "window." This is, I suggest, a *visibly active* moment of reading which, in shifting the Madonna into the site of the secular, transcends the religious into a different dream of communicating – with the m/Other.[84]

Perhaps it is only by finally returning to Akerman's earlier film *Jeanne Dielman* that we are able to see how re-viewing, from a different direction, sets in motion not only survival, as Adrienne Rich puts it – but pleasure of a different order – where the possibility of other as-yet-unasked questions of the feminine might reside.

It is, of course, at the site of newly-posited politically interventionist questions that feminism made its most considerable marks upon culture. As Mary Kelly saw it in her enquiry into desire and images – the idea of woman as the locus of the look and the body, circuitously returns (her) to the point of desire – which is "embodied in the image." To break out of this "dangerous and circuitous logic" Kelly reminds us of the "progress" made by feminist theory in its move to formulate the problem of the image of women *as a problem* – *as a question* in order to implement change. As Kelly says: "The legacy is not a through-route, but a disentangling of paths that shows more clearly their points of intersection and draws attention to the fact that it is not obligatory to start over again at the beginning."[85] The legacy inherited from the feminist intervention into "images of women" is an inheritance of new ownership – to own in this case is to owe a debt, which is to continue asking questions, from new unthought places.

Departure

The matrixial phantasy complex can't be folded into the "castration" track but should be mounted on a different trail. Through it, another kind of strangeness haunts us from the margins. But to delineate the orbit of a matrixial gaze, we need to elaborate another unconscious sphere, a matrixial stratum of subjectivization, neither Oedipal nor anti-Oedipal, that entices sex difference already in the feminine, since a different gaze is not about criticizing Oedipus or binarity, but about contriving a space for questions on/ from the feminine that the subject orients towards an-Other qua "woman" in search for a difference already in the feminine and for an emerging Other-desire...

Bracha Ettinger[86]

Just as Dora's dream provides Freud with a route back to Dresden and its "pictures," Akerman's film allows us, by means of the *still/ ed moving* image, the potentiality of a matrixial encounter, *beyond and beside the phallic effect* of the screen as a site/ sight of absence and loss. In a series of encounters – weaving through(out) the surface of the "moving" image in *News From Home*, a space for questions appears to form, where the expansiveness of thought inter-connects, and swells up-on the borders of other images; touching *their thinking*, their representations at indefinable moments that are then able to filter back, *differently*, changed, and changing through(out) the encounter.

In this bordering moment of departures and returns – stretched before us desire appears enfolded in a sea of tension, and yet we are strangely liberated by our captivation – both enthralled and detached – we are moved with-in the space of seeing in a temporal and sensorial frame of looking. This may be a moment of feminist cinema – of relations-without relating. Could we call this moment matrixial cinema – or pleasure by a m/ Other name?

Notes

1 Adrienne Rich, *On Lies, Secrets and Silence* (London: Virago Press, 1980), p. 35.
2 Michael Ann Holly, "Past Looking," in *Vision and Textuality*, ed. Stephen Melville and Bill Readings (Basingstoke and London: Macmillan Press, 1995), p. 86.

3 Laura Mulvey, "Myth, Narrative and Historical Experience," in *Visual and Other Pleasures* (Basingstoke and New York: Palgrave, 1989), p. 159.

4 Ibid.

5 Quote from "Chantal Akerman's Films: a Dossier," compiled and introduced by Angela Martin, in *Feminist Review*, vol. 3 (1979), 45.

6 Walter Benjamin, "Thesis on the Philosophy of History," in *Illuminations* (London: Pimlico, 1999), p. 247.

7 Mieke Bal, *Louise Bourgeois' Spider: the Architecture of Art-writing* (Chicago and London: University of Chicago Press, 2001).

8 Quoted in Christina Creveling, "Women Working: Chantal Akerman," *Camera Obscura*, vol. 1, no. 2 (Fall 1977), 138.

9 Mulvey, "Visual Pleasure and Narrative Cinema," in *Visual and Other Pleasures* (Basingstoke and New York: Palgrave, 1989), p. 16.

10 A line from the opening song of the film *The Golddiggers* made by Sally Potter in 1983.

11 Mulvey, "Myth, Narrative and Historical Experience," p. 16.

12 Quoted in Brenda Longfellow, "Love Letters to the Mother: The Work of Chantal Akerman," *Canadian Journal of Political and Social Theory*, vol. 13, nos 1–2 (1989), 82.

13 Sigmund Freud, "The Uncanny," in *Art and Literature*, vol. 14, The Penguin Freud Library (Harmondsworth: Penguin Books, 1990), pp. 339–76.

14 Claire Johnston, "Toward a Feminist Film Practice: Some Thesis," in *Edinburgh '76 Magazine*, ed. Phil Hardy, Claire Johnston, Paul Willemen (London: BFI, 1976), p. 59.

15 Christine Gledhill, "Developments in Feminist Film Criticism," in *Quarterly Review of Film Studies*, vol. 3, no. 4 (Fall 1978), 42.

16 Bracha Ettinger, "The Becoming Threshold of Matrixial Borderlines," in *Travellers' Tales*, ed. by George Robertson et al. (London and New York: Routledge, 1994), p. 49.

17 Freud, "The Uncanny."

18 See Bracha Ettinger, "Matrix and Metramorphosis," in *Differences*, vol. 4, no. 3 (1992), 176–208.

19 Ettinger, "Metramorphic Borderlinks and Matrixial Borderspace," in *Rethinking Borders*, ed. John C. Welchman (Minneapolis: University of Minnesota Press, 1996), pp. 125–6.

20 Quoted in Ettinger, "The Becoming Threshold of Matrixial Borderlines," p. 47.

21 See part one of *The Matrixial Gaze*, called "The 'Uncanny' and the Matrixial Object a/ *objet a*" (pp. 1–30).

22 Brian Massumi, "Painting: The Voice of the Grain," in Bracha Ettinger, *Artworking 1985–1999* (Ghent: Ludion 2000), p. 30.

23 Ettinger, "The Becoming Threshold of Matrixial Borderlines," p. 48.

24 Ettinger, "Woman–Other-Thing: a Matrixial Touch," in the catalogue *Matrix-Borderlines* (Oxford: MOMA, 1993). p. 13.

25 Ettinger, "The Becoming Threshold of Matrixial Borderlines," p. 48.

26 Ettinger, "Woman–Other-Thing: a Matrixial Touch," p. 13.

27 Ettinger, "Trans-subjective Transferential Borderspace," in *A Shock to Thought: Expression After Deleuze and Guattari*, ed. Brian Massumi (London and New York: Routledge, 2002), p. 223.

28 Ettinger, *Matrix-Borderlines*, p. 11.

29 Longfellow, "Love Letters to the Mother."

30 Ibid. The four films are: *Je tu il elle* (1974), *Jeanne Dielman, 23 Quai du Commerce, 1080 Bruxelles* (1975), *News From Home* (1976), and *Rendez-vous d'Anna* (1978).

31 Griselda Pollock, "To Inscribe in the Feminine: A Kristevan Impossibility? Or Femininity, Melancholy and Sublimation," in *parallax*, vol. 4, no. 3 (1998), 111.

32 Creveling, "Women Working: Chantal Akerman," 137–8.

33 Christine Buci-Glucksman, "Bracha Lichtenberg Ettinger: Images of Absence in the Inner Space of Painting," in *Inside the Visible: An Elliptical Traverse of 20th Century Art: in, of, and from the Feminine*, ed. Cathérine De Zegher (Cambridge, MA, and London: MIT Press, 1996), p. 284.

34 Akerman said: "When you see the letters of a mother, like those of my mother, who is not a writer, who is not an intellectual, it is a subculture... there is no place within artistic things for this kind of expression"; quoted in Ivonne Margulies, *Nothing Happens; Chantal Akerman's Hyper-realist Everyday* (Durham and London: Duke University Press, 1996), p. 15.

35 Marie de Sévigné wrote this in a letter to her absent daughter on July 15, 1671, *Madame de Sévigné: Selected Letters*, trans. Leonard Tancock (Harmondsworth: Penguin Books, 1982), p. 105.

36 Stephen Heath, "Body, Voice," in *Questions of Cinema* (Basingstoke and London: Macmillan, 1981), p. 176.

37 Maria Walsh, "Intervals of Inner Flight: Akerman's *News from Home*," *Screen*, vol. 45, no. 3 (autumn 2004), 190–205.

38 Ibid., p. 199.

39 Ibid., pp. 198–9.

40 Walsh refers to Heath's chapter, "On Suture," in *Questions of Cinema*.

41 Ibid., p. 194.

42 Ibid.

43 Ibid.

44 Ibid., p. 199.

45 Ibid.

46 Ibid., p. 205.

47 Ibid., p. 198.

48 Griselda Pollock, "Thinking the Feminine: Aesthetic Practice as Introduction to Bracha Ettinger and the Concepts of Matrix and Metramorphosis," *Theory Culture and Society*, vol. 21, no. 1 (February 2004), 51.

49 Gilles Deleuze, quoted by Ettinger in "Trans-subjective Transferential Border-space," p. 223.

50 "Chantal Akerman on *Jeanne Dielman. Excerpts from an interview with* Camera Obscura *November 1976*," *Camera Obscura* (1977), 121.

51 Richard Kwietnowski, "Separations: Chantal Akerman's 'News from Home' (1976) and 'Toute en Nuit' (1982)," *Movie*, nos 34–5 (winter 1990), 113.

52 See chapter 3 of this volume for further discussion of the "Dora" case study and the significance of the image.

53 The term "productive confusion" is borrowed from the cultural analyst Mieke Bal who spoke about it in relation to research practice and pedagogy at a seminar at the University of Leeds in 2002.

54 Katherina (*née* Gerber) was Ida Bauer's mother's name.

55 Sigmund Freud, "Fragment of an Analysis of a Case of Hysteria ('Dora')" (1905[1901]), in *Case Histories, vol.* VIII (Harmondsworth: Penguin Books, 1990) p. 133.

56 Angela Martin, "Chantal Akerman's Films: A Dossier," *Feminist Review*, no. 3 (1979).

57 Freud, "Fragment of an Analysis...," p. 133.

58 ICA audiotape of the Guardian Lecture, "Talking Art: Chantal Akerman," interviewed by Simon Field, 1990.

59 Martin, "Chantal Akerman's Films: A Dossier," pp. 2–3.

60 Although the "vision" of New York in the film appears as a solo journey, Akerman is not entirely alone. Babette Mangolte accompanies her as her cinematographer.

61 For further discussion of art and the dream see chapter 2 of this volume.

62 Ettinger, *The Matrixial Gaze* (Leeds: Feminist Arts and Histories Network, 1995), p. 9.

63 Freud, "Fragment of an Analysis...," p. 44.

64 Ibid., p. 136.

65 "Dora" had abruptly ended her analysis by telling Freud on her last visit: "Do you know I am here for the last time today... Yes I made up my mind to put up with it till the New Year. But I shall wait no longer than that to be cured." "Fragment of an Analysis... ('Dora')," p. 146.

66 Mary Jacobus, "Dora and the Pregnant Madonna," in *Reading Woman: Essays in Feminist Criticism* (New York: Columbia University Press, 1986), p. 189.

67 Holly, "Past Looking," pp. 78–80.

68 Jacobus, "Dora and the Pregnant Madonna," p. 142.

69 Although The Mother remains present throughout Freud's writings, she is usually submerged in the text as a "resistant voice" – for an analysis of the

maternal read through a close study of Freud's own writing see Madelon Sprengnether, *The Spectral Mother: Freud, Feminism and Psychoanalysis* (Ithaca and London: Cornell University Press, 1990).

70 "Dead father" refers to the content of the dream, the portion upon which Freud first focuses, suggesting this dreamt of death in the letter signifies "Dora's" sadistic tendencies.

71 Freud, "Fragment of an Analysis...," p. 134.

72 Sigmund Freud, Freud's postscript to his letter sent to Martha Bernays on December 16, 1883. Sigmund Freud, *Letters of Sigmund Freud, 1873–1939*, ed. E.L. Freud (London: Hogarth Press, 1961).

73 Freud, "Fragment of an Analysis...," pp. 135–6.

74 Although there is some confusion regarding the exact date of the gallery visit I am assuming it occurred on the 17th as he writes on the 16th: "Tomorrow I will hardly have time to write...I have also to pay a visit...in Dresden"; in any case the visit occurred between December 17 and 20, 1883.

75 The very name Freud chose for "Dora" was the same as that given to his sister's children's nursemaid, see Freud, *Psychopathology of Everyday Life*, trans. Anthea Bell, with an introduction by Paul Keegan (London: Penguin Books, 2002), pp. 230–1.

76 Mary Kelly "Desiring Images/ Imaging Desire," in Amelia Jones, *Feminism and Visual Culture Reader* (London and New York: Routledge, 2003), p. 75.

77 Ibid.

78 Mulvey, "Visual Pleasure and Narrative Cinema," p. 19.

79 Freud, "Fragment of an Analysis...," p. 148, no. 1.

80 Mulvey, "Visual Pleasure and Narrative Cinema," p. 26.

81 Jacobus claims this other image "makes outrageously visible what Raphael's painting represses, the Madonna's corporeal implication in the Virgin Birth." Jacobus, "Dora and the Pregnant Madonna," p. 145.

82 Lyotard says: "Rembrandt, Vermeer, Van Gogh, etc., they are all able to say something that was not known and which had never been marked. So, a work of anamnesis, but one which works on the matter itself." See Richard Beardsworth, "Freud, Energy and Chance: a Conversation with Jean-François Lyotard," *Teknema 5 "Energy and Chance"* (Fall 1999) http://tekhnema.free.fr/5Beardsworth.html (visited March 28, 2005).

83 Gilles Deleuze, *Cinema 2: the Time-Image* (London: Athlone Press, 2000), p. 196.

84 On this point see Griselda Pollock, "To Inscribe in the Feminine: A Kristevan Impossibility? Or Femininity, Melancholy and Sublimation," pp. 93–6.

85 Kelly, "Desiring Images/Imaging Desire," p. 72.

86 www.othervoices.org/1.3/brachale/bracha13.html (visited March 28, 2005).

Bibliography

Compiled by Hester Bloom

Abel, E. (1990) "Race, Class, and Psychoanalysis? Open Questions," *Conflicts in Feminism*, ed. Marianne Hirsch and Evelyn Fox Keller (London and New York: Routledge), pp. 184–204.

Appignanesi, L. and Forrester, J. (1996) *Freud's Women* (London: Weidenfeld and Nicolson).

Armstrong, R. (1999) "The Archaeology of Freud's Archaeology: Recent Work in the History of Psychoanalysis," *The International Review of Modernism*, vol. 3, no. 1, 16–20.

Assmann, J. (1997) *Moses the Egyptian: The Memory of Egypt in Western Monotheism* (Cambridge, MA: Harvard University Press).

Bal, M. (1985) *Narratology: Introduction to the Theory of Narrative* (Toronto: University of Toronto Press; fully revised and expanded edition, 1997).

—— (1991) *Reading Rembrandt: Beyond the Word–Image Opposition* (Cambridge: Cambridge University Press).

—— (1991) *On Story-Telling: Essays in Narratology* (Sonoma, CA: Polebridge Press).

—— (1999) *Quoting Caravaggio: Contemporary Art, Preposterous History* (Chicago: University of Chicago Press).

—— (2001) *Louise Bourgeois' Spider: the Architecture of Art-Writing* (Chicago: University of Chicago).

—— (2002) *Travelling Concepts in the Humanities: A Rough Guide* (Toronto: University of Toronto Press).

—— "Abandoning Authority: Svetlana Alpers and Pictorial Subjectivity," in *Taking Pictures Seriously*, eds. Celeste Brusati, Mark Meadow and Walter Melion (in press).

Barthes, R. (1977) "The Grain of the Voice," *Image, Music, Text*, trans. Stephen Heath (New York: Hill and Wang), pp. 179–189.

Benjamin, W. (1999) "Theses on the Philosophy of History," in *Illuminations*, trans. Harry Zohn (London: Pimlico).

Bergson, H. (1991) *Matter and Memory*, trans. N.M. Paul and W.S. Palmer (New York: Zone Books).

Bergstein, M. (2003) "Gradiva Medica: Freud's Model Female Analyst as Lizard-Slayer," *American Imago*, vol. 60, no. 3, 285–301.

Bergstrom, J. (1999) "Invented Memories," in *Identity and Memory: The Films of Chantal Akerman*, ed. Gwendolyn Audrey Foster (Wiltshire: Flicks Books).

Bergvall, C. (2002) "Writing at the Crossroads of Language," *Writing it Slant: Avant-Garde Poetics of the 1990s*, eds. Mark Wallace and Steven Marks (Tuscaloosa: University of Alabama Press), pp. 207–23.

Bernfeld, S.C. (1951) "Freud and Archaeology," *American Imago*, vol. 8, no. 2, 1107–128.

Bernsheimer, C. and Kahane, C. (ed.) (1990) *In Dora's Case* (New York: Columbia University Press).

Bhabha, H.K. (1994) *The Location of Culture* (New York: Routledge).

—— (1983) "The Other Question: The Stereotype and Colonial Discourse," *Screen*, vol. 24, no. 6, 18–36.

Bollas, C. (1987) *The Shadow of the Object: Psychoanalysis of the Unthought Known.* (New York: Columbia University Press).

Bowdler, S. (1996) "Freud and Archaeology," *Anthropological Forum*, vol. 7, 419–38.

Bowie, M. (1991) *Lacan* (London: Fontana Press).

Brown, W. (1995) *States of Injury: Power and Freedom in Late Modernity* (Princeton: Princeton University Press).

Butt, G. (ed) (2005) *After Criticism: New Responses to Art and Performance* (Malden, MA and Oxford: Blackwell).

Chow, R. (1993) *Writing Diaspora: Tactics of Intervention in Contemporary Cultural Studies* (Bloomington: Indiana University Press).

—— (2002) *The Protestant Ethnic & the Spirit of Capitalism* (New York: Columbia University Press).

Cockroft, E. (2000) "Abstract Expressionism, Weapon of the Cold War," in *Pollock and After: Critical Debate*, ed. Francis Frascina (London and New York: Routledge), pp. 147–180.

D[oolittle], H[ilda] (1974) *Tribute to Freud* (Boston: David Godine).

De Zegher C. (ed.) (1996) *Inside the Visible: An Elliptical Traverse of 20th Century Art in, of, and from the Feminine* (Cambridge, MA: MIT Press).

Deleuze, G. (2000) *Cinema 2: the time-image* (London: Athlone Press).

Derrida, J. (1981) *Dissemination*, trans. Barbara Johnson (Chicago: University of Chicago Press).

—— (1992) "The Law of Genre," *Acts of Literature*, ed. Derek Attridge (New York: Routledge), pp. 221–52.

—— (1996) *Archive Fever: A Freudian Impression*, trans. Eric Prenowitz (Chicago: University of Chicago Press).

Dimock, G. (1994) "The Pictures over Freud's Couch," *The Point of Theory: Practices of Cultural Analysis*, eds. Mieke Bal and Inge Boer (Amsterdam: Amsterdam University Press), pp. 239–50.

Doane, M.A. (1981) "Woman's Stake in Representation: Filming the Female Body," *October*, no. 17, 23–36.

—— (1987) *The Desire to Desire: The Woman's Film of the 1940s* (Basingstoke: Macmillan).

Duras, M. (1996) *The Ravishing of Lol V. Stein*, trans. Richard Seaver (New York: Grove Press)

Eco, U. ([1962]1989) *The Open Work* (Cambridge, MA: Harvard University Press).

Ellenberger, H. (1970) *The Discovery of the Unconscious: The History and Evolution of Dynamic Psychiatry* (New York: Basic Books).

Engleman, E. (1976) *Berggasse 19: Sigmund Freud's Home and Offices, Vienna 1938* (New York: Basic Books).

Ettinger, B.L. (1992) "Matrix and Metramorphosis," *Differences*, vol. 4, no. 3, 176–210.

—— (1994) "The Becoming Threshold of Matrixial Borderlines," in *Travellers' Tales*, eds. G. Robertson et al. (London and New York: Routledge).

—— (1995) *The Matrixial Gaze* (Leeds: University of Leeds: Feminist Network, Fine Art), reprinted in C. de Zegher and B. Massumi (eds.), *Bracha Lichtenberg Ettinger: Eurydice Series. Drawing Papers*, no. 24 (New York: The Drawing Center, 2001); and Bracha Ettinger, *Matrixial Gaze and Borderspace: Essays on the Feminine and the Artwork*, ed. Brian Massumi (Minneapolis: University of Minnesota Press, 2006).

—— (1996) "The With-In-Visible Screen," in *Inside the Visible: an Elliptical Traverse of 20th Century Art in, of, and from the Feminine*, ed. M. Catherine de Zegher (Cambridge, MA: MIT Press), pp. 89–113.

—— (1999) "Traumatic Wit(h)ness-Thing and Matrixial Co/in-habit(u)ating," *parallax*, no. 10, 89–98.

—— (2000) "Art as the Transport-Station of Trauma," in Bracha Lichtenberg Ettinger, *Artworking 1985–1999* (Amsterdam/Ghent: Ludion & Brussels: Palais des Beaux-Arts), pp. 91–116.

—— (2000) "Some-Thing, Some-Event and Some-Encounter between Sinthôme and Symptom," in *The Prinzhorn Collection: Trace upon the Wunderblock* (New York: Drawing Center), pp. 61–75.

—— (2001) "Wit(h)nessing Trauma and the Matrixial Gaze," *parallax*, no. 21, 89–114.

—— (2002) "Trans-subjective Transferential Borderspace," in Brian Massumi (ed.), *A Shock to Thought* (London and New York: Routledge).

—— (2004) "Weaving the Woman Artist with-in-the Matrixial Encounter-Event," *Theory, Culture and Society*, vol. 21, no. 1, 69–94.

Fabien, J. (1983) *Time and the Other: How Anthropology Makes Its Object* (New York: Columbia University Press).

Felman, S. (1977) "To Open the Question," *Yale French Studies: Literature and Psychoanalysis. The Question of Reading: Otherwise* (special issue), no. 55/56, 5–10.

—— (1987) *Jacques Lacan and the Adventure of Insight: Psychoanalysis in Contemporary Culture* (Cambridge, MA: Harvard University Press).

—— (1993) *What Does a Woman Want? Readings in Sexual Difference* (Baltimore: Johns Hopkins University Press).

Fisher, A. (1987) *Let us Now Praise Famous Women: Women Photographers for the US Government 1935–1944* (London: Pandora Press).

Flax, J. (1993) "Can Psychoanalysis Survive in the Post-modern West?," in *Disputed Subjects: Essays on Psychoanalysis, Politics and Philosophy* (New York: Routledge).

Foucault, M. (1972) *The Archaeology of Knowledge*, trans. A.M. Sheridan-Smith (London: Tavistock Books).

Freud, S. ([1893]1924) "Charcot," trans. Joan Riviere, *Sigmund Freud: Collected Papers*, vol. I (London: The Hogarth Press).

—— ([1896] 1924) "Aetiology of Hysteria," *Collected Papers*, vol. I (London: The Hogarth Press).

—— (1900) *The Interpretation of Dreams, Standard Edition of the Complete Works of Sigmund Freud*, ed. James Strachey (London: Hogarth Press) and Penguin Freud Library, vol. 4 (London: Penguin Books).

—— ([1905]1953) "Fragments of an Analysis of a Case of Hysteria," *The Standard Edition of the Complete Psychological Works of Sigmund Freud*, vol. VII (London: Hogarth Press), pp. 15–112.

—— ([1907]1990) "Delusions and Dreams in Jensen's *Gradiva*," Penguin Freud Library, vol. 14, *Art and Literature* (London: Penguin Books).

—— ([1909]1979) "Notes upon a Case of Obsessional Neurosis ['The Rat Man']," Penguin Freud Library, vol. 9, *Case Histories II* (London: Penguin Books), pp. 33–130.

—— ([1915]1957) "Mourning and Melancholia," *The Standard Edition of the Complete Psychological Works of Sigmund Freud* (London: Hogarth Press).

—— ([1918] 1987) "The History of an Infantile Neurosis ['The Wolf Man']," Penguin Freud Library, vol. 9, *Case Histories II* (London: Penguin Books), pp. 227–345.

—— ([1931]1977) "Female Sexuality," Penguin Freud Library, vol. 7, *On Sexuality* (London: Penguin Books), pp. 367–93.

—— (1960) *Briefe 1873–1939*, ed. Ernst and Lucie Freud (Frankfurt am Main: S. Fischer).

—— (1961) *Letters of Sigmund Freud, 1873–1939*, edited by E.L. Freud (London: Hogarth Press).

—— (1985) *The Complete Letters of Sigmund Freud to Wilhelm Fliess 1887–1904*, ed. Jeffrey Masson (Cambridge, MA: The Belknap Press at Harvard University Press).

Freud, S. and Breuer, J. ([1895]1991) "Anna 'O,'" *Studies in Hysteria, 1893–95*, Penguin Freud Library, vol. 3, *Studies in Hysteria* (London: Penguin Books), pp. 73–102.

Fried, M. (1998) *Art and Objecthood: Essays and Reviews* (Chicago: University of Chicago Press).

Fry, R. (1924) *Art and Psychoanalysis* (London: Hogarth Press).

Gallop, J. (1982) *Feminism and Psychoanalysis: The Daughter's Seduction* (London: Macmillan).

—— (1985) *Reading Lacan* (Ithaca and London: Cornell University Press).

Gamwell, L. and Wells, R. (eds.) (1989) *Sigmund Freud and his Art: His Personal Collection of Antiquities* (New York: Harry N. Abrams in conjunction with London: Freud Museum).

Gasquet, J. (1991) *Joachim Gasquet's Cézanne: A Memoir with Conversations*, trans. Christopher Pemberton (London: Thames and Hudson).

Gates, H.L. (1991) "Critical Fanonism," *Critical Inquiry*, vol. 17, no. 3, 457–70.

Gilman, S. et al (1994) *Reading Freud's Reading* (New York; New York University Press).

Ginzburg, C. (1980) "Morelli, Freud, and Sherlock Holmes: Clues and Scientific Method," *History Workshop*, no. 9, pp. 5–36.

Gledhill, C. (1978) "Developments in Feminist Film Criticism," *Quarterly Review of Film Studies*, vol. 3, no. 4, 18–49.

Grigely, J. (1997) "Caravaggio's Musicians," published in conjunction with the exhibition *Recovering Lost Fictions: Caravaggio's Musicians*, a collaboration between Kathleen Gilje and Joseph Grigely (Cambridge, MA: MIT List Visual Arts Center).

Grosz, E. (1990) *Jacques Lacan: A Feminist Introduction* (London: Routledge).

Hak Kyung Cha, T. (ed.) (1980) *Apparatus, Cinematographic Apparatus: Selected Writings* (New York: Tanam Press).

Hak Kyung Cha, T. (1995) *Dictée* (Berkeley: Third Woman Press).

Handler Spitz, E. (1989) "Psychoanalysis and the Legacies of Antiquity," in Gamwell and Wells, *Sigmund Freud and his Art*.

Heath, S. (1978) "Difference," *Screen*, vol. 19, no. 3, 51–112.

—— (1981) *Questions of Cinema*, (Basingstoke & London: MacMillan).

Holly, M.A. (1984) *Panofsky and the Foundations of Art History* (Ithaca and London: Cornell University Press).

—— (1999) *Past Looking: Historical Imagination and the Rhetoric of the Image* (Chicago: University of Chicago Press).

Hoptman, L., Tatehata, A., and Kultermann, U. (eds.) (2000) *Yayoi Kusama* (London: Phaidon).

Iser, W. (1978) *The Act of Reading: A Theory of Aesthetic Response* (Baltimore: Johns Hopkins University Press).

Jacobus, M. (1986) *Reading Woman: Essays in Feminist Criticism* (New York: Columbia University Press).

Johnston, C. (1976) "Toward a Feminist Film Practice: Some Thesis," in *Edinburgh '76 Magazine*, eds. Phil Hardy, Claire Johnston, and Paul Willemen (London: BFI).

Jun, E. (2001) "Michisu no Sugomi" (Immeasurable Ghastliness), trans. by and quoted in Saralyn Orbaugh, "Oba Minako and the Paternity of Maternalism," in *The Father–Daughter Plot: Japanese Literary Women and the Law of the Father*, eds. Rebecca L. Copeland et al. (Honolulu: University of Hawaii Press), pp. 265–91.

Kelly, M. (1981) "Reviewing Modernist Criticism," *Screen*, vol. 22, no. 3, 41–62.

—— (1998) "Desiring Images/Imaging Desire," *Imaging Desire (Writing Art)* (Cambridge, MA: MIT Press).

Klein, M. (1998) "Infantile Anxiety-Situations Reflected in a Work of Art and in the Creative Impulse," *Love, Guilt and Reparation and Other Works 1921–45* (London: Vintage Books).

Kofman, S. (1988) *The Childhood of Art: An Interpretation of Freud's Aesthetics*, trans. Winifred Woodhull (New York: Columbia University Press).

Krishnaswamy, R. (1995) "Mythologies of Migrancy: Postcolonialism, Postmodernism and the Politics of (Dis)location," *ARIEL: A Review of International English Literature*, vol. 26, no. 1, 125–46.

Kristeva, J. (1979) *Desire in Language: A Semiotic Approach to Literature and Art*, ed. Leon Roudiez (Oxford: Basil Blackwell).

—— (1981 and 1987) "Women's Time," *Signs*, vol. 7, no. 1. Reprinted in *The Kristeva Reader*, ed. Toril Moi (Oxford: Basil Blackwell).

—— (1989) *Black Sun: Depression and Melancholia*, trans. Leon S. Roudiez (New York: Columbia University Press).

—— (1998) "Experiencing the Phallus as Extraneous, or Women's Twofold Oedipus Complex," *parallax*, no. 8, 29–39.

Kuspit, D. (1989) "A Mighty Metaphor: The Analogy of Archaeology and Psychoanalysis," in *Sigmund Freud and his Art: His Personal Collection of Antiquities*, eds. Lynn Gamwell and Richard Wells (New York: Harry N. Abrams), pp. 133–53.

Lacan, J. (1949) "The Mirror Stage as Formative of the Function of the I as Revealed in Psychoanalytical Experience," in *Ecrits: A Selection*, trans. Alan Sheridan (London: Tavistock Books), pp. 1–7.

—— (1963) *The Four Fundamental Concepts of Psychoanalysis*, ed. Jacques Alain Miller, trans. Alan Sheridan (Harmondsworth: Penguin Books).

—— (1966–67) *La logique du fantasme*. Unpublished seminar.

Laplanche, J. and Pontalis, J.B. (1988) *The Language of Psychoanalysis* (London: Karnac Books).

Lawrence, D.H. (1936) *Phoenix: The Posthumous Papers of D.H. Lawrence*, ed. Edward D. McDonald (London: Heinemann).

Lechte, J. (1990) "Art, Love, and Melancholy," in *Abjection, Melancholia and Love: the Work of Julia Kristeva*, eds. John Fletcher and Andrew Benjamin (London: Routledge University of Warwick Centre for Research in Philosophy and Literature).

Leupold-Löwenthal, H. et al. (1994) *Wien IX, Berggasse 19: Sigmund Freud Museum* (Vienna: Verlag Christian Brandstätter).

Li, V. (1995) "Towards Articulation: Postcolonial Theory and Demotic Resistance," *ARIEL: A Review of International English Literature*, vol. 26, no. 1, 167–89.

Longfellow, B. (1989) "Love Letters to the Mother: The Work of Chantal Akerman," *Canadian Journal of Political and Social Theory*, vol. 13, nos 1–2.

Lyotard, J.F. (1984) "Adrift," *Driftworks*, ed. Roger McKeon (New York: Semiotext(e)).

Margulies, I. (1996) *Nothing Happens: Chantal Akerman's Hyperrealist Everyday* (Durham, NC and London: Duke University Press).

Martin, A. (1979) "Chantal Akerman's Films: a Dossier," *Feminist Review*, vol. 3.

Metz, C. (1983) *Psychoanalysis and Cinema: the Imaginary Signifier* (Basingstoke: MacMillan).

Mitchell, J. (1974) *Psychoanalysis and Feminism* (Harmondsworth: Penguin Books).

Mitchell W.J.T. (1986) *Iconology: Image, Text, Ideology* (Chicago: University of Chicago Press).

Mulvey, L. (1975) "Visual Pleasure in the Narrative Cinema," *Screen*, vol. 16, no. 3, 6–18 and *Visual and Other Pleasures* (Basingstoke and New York: Palgrave), pp. 14–26.

—— (1989) "Myth, Narrative and Historical Experience," in *Visual and Other Pleasures* (Basingstoke and New York: Palgrave.)

Munroe, A. (1989) "Obsession, Fantasy and Outrage: The Art of Yayoi Kusama," in *Yayoi Kusama: Retrospective* (New York: Center for International Contemporary Art), pp. 11–32.

—— (1997) "With the Sudden of Creation: Trends of Abstract Painting in Japan and China, 1945–1970," in *Asian Traditions Modern Expressions: Asian American Artists and Abstraction 1945–1970*, ed. J. Wechsler (New York: Harry N. Abrams), pp. 30–41.

Nixon, M. (2000) "Posing the Phallus," *October*, vol. 92, 99–127.

Obeyesekere, G. (1990) *The Work of Culture: Symbolic Transformation in Psychoanalysis and Anthropology* (Chicago: University of Chicago Press).

Ogden, T.H. (1989) *The Primitive Edge of Experience* (Northvale, NJ: Jason Aronson).

Oliver, K. (1993) *Reading Kristeva: Unraveling the Double-Bind* (Bloomington and Indianapolis: Indiana University Press).

Panofsky, E. (1955) *Meaning in the Visual Arts* (Harmondsworth: Penguin).

Parker, R. and Pollock, G. ([1981]1995) *Old Mistresses: Women, Art and Ideology* (revised edition) (London: Pandora Press).

Pollock, G. (1991) "The Gaze and the Look: Women with Binoculars – a Question of Difference," in *Dealing with Degas: Representations of Women and the Politics of Vision*, eds. Richard Kendall and Griselda Pollock (London: Pandora Press).

—— (1996) "Inscriptions in the Feminine," in *Inside the Visible: an Elliptical Traverse of 20th Century Art*, ed. M. Catherine de Zegher (Cambridge, MA and London: MIT Press).

—— (1996) "Killing Men and Dying Women," in *Avant-Gardes and Partisans Reviewed* (Manchester: Manchester University), pp. 221–94.

—— (2000) "Three Thoughts on Femininity, Creativity and Elapsed Time," *Parkett*, vol. 59, 107–13.

—— (2001) "Painting, Feminism, History," in *Looking Back to the Future: Essays on Art, Life and Death* (London: Routledge).

—— (2003) "Does Art Think?," in *Art and Thought*, eds. D. Arnold and M. Iverson (Malden and Oxford: Blackwell). pp. 129–56.

—— (2004) "Thinking the Feminine: Aesthetic Practice as an introduction to Bracha Ettinger and the Concepts of the Matrix and Metamorphosis," *Theory, Culture and Society*, vol. 21, no. 1, 5–69.

—— (ed.) (1996) *Generations and Geographies in the Visual Arts: Feminist Readings* (London: Routledge).

Ragland-Sullivan, E. (1986) *Jacques Lacan and the Philosophy of Psychoanalysis* (Urbana and Chicago: University of Illinois Press).

Raphael-Leff, J. (1990) "If Oedipus was an Egyptian: Freud and Egyptology," *International Review of Psychoanalysis*, vol. 17, 309–35.

Ricoeur, P. (1970) *Freud and Philosophy: An Essay on Interpretation* (New Haven and London: Yale University Press).

—— (1984) "The Aporias of the Experience of Time: Book 11 of Augustine's Confessions," in *Time and Narrative, Volume 1*, trans. Kathleen McLaughlin and David Pellauer (Chicago: University of Chicago Press), pp. 5–30.

Rogoff, I. (1992) "Tiny Anguishes: Reflections on Nagging, Scholastic Embarrassment, and Feminist Art History," in *Differences: A Journal of Feminist Cultural Studies*, vol. 4, no. 3.

Rose, J. (1986) *Sexuality in the Field of Vision* (London: Verso).

Roth, M. (1994) "Chronology," in *Writing Self/Writing Nation:Essays on Theresa Hak Kyung Cha's Dictée*, ed. Elaine H. Kim and Norma Alarcón (Berkeley: Third Woman Press), pp. 151–61.

Rubin, G. (1975) "The Traffic in Women: Notes on the Political Economy of Sex," in *Towards an Anthropology of Women*, ed. Rayna R. Reiter (New York: Monthly Review Press), pp. 157–210.

Schapiro, M. (1965) *Paul Cézanne*, third edition (New York: Harry N. Abrams).

Sedlmayr, H. (1957) *Art in Crisis: The Lost Centre* (London: Hollis and Carter).

Silverman, H.J. (1993) "Cézanne's Mirror Phase," in *The Merleau-Ponty Aesthetics Reader: Philosophy and Painting*, ed. Galen A. Johnson (Evanston, IL: Northwestern University Press).

Silverman, K. (1996) *The Threshold of the Visible World* (New York: Routledge).

Spahr, J.M. (1996) "Postmodernism, Readers, and Theresa Hak Kyung Cha's *Dictée*," *College Literature Special Focus Issue: (De)Colonizing Reading/(Dis) Covering the Other*, 23–43.

Spence, D. (1987) *The Freudian Metaphor: Towards Paradigm Change in Psychoanalysis* (New York: Norton).

Spiller, H.J. (1987) "Mama's Baby, Papa's Maybe: An American Grammar Book," *diacritics*, vol. 17, no. 2.

Sprengnether, M. (1990) *The Spectral Mother: Freud, Feminism and Psychoanalysis* (Ithaca, London: Cornell University Press).

Tate, C. (1998) *Psychoanalysis and Black Novels: Desire and the Protocols of Race* (New York and Oxford: Oxford University Press).

Torgovnick, M. (1990) *Gone Primitive: Savage Intellectuals, Modern Lives* (Chicago: University of Chicago Press).

Trinh, M.T. (1986) *Women, Native, Other: Writing Postcoloniality and Feminism* (Bloomington and Indianapolis: Indiana University Press).

Walsh, M. (2004) "Intervals of Inner Flight: Akerman's *News From Home*," *Screen*, vol. 45, no. 3, 190–205.

Wilson, R. (1991) "Falling into the Korean Uncanny," *Korean Culture*, (Fall), 33–7.

Zelevansky, L. (1999) *Yayoi Kusama, 1958–1968* (Los Angeles: Los Angeles County Museum of Art).

Index

Note: Figures in *italics* refer to illustrations.

Oh, Stella: on *DICTEE* 172, 175
oil paint 147–8
oil painting 152
O'Keeffe, Georgia 134–5, 138
Oliver, Kelly 111
opticality 148
Orbaugh, Sharalyn 141
originary repetition 6, 24–5
other
 inside dreams of 31–9
 gender and 39–47
 interplay with self
 in dreams 38–9
 in *Musicians, restored* 44, 45–6,
 47, 54–5, 56
 language of 133–4
 see also matrixial; subjectivity

pagan cultures: Freud 6–7
painters: pure 108
painting *see* specific types eg abstract
palette: in *Self-Portrait with Palette* 113
Paris: Cha in 161
parody: *Musicians, restored* as 40, 43,
 44, 45–6, 49, 54
patriarchal order: Japan 139, 140–2,
 155
performance: visual dream images
 as 32
phallic: shifting parameters of 201–2
phallic law 81
Pharmakon 181
photographic inserts: in *DICTEE* 184
photographs 187–8
 of Freud's consulting room 1–12
pictures: Akerman 209
Piero della Francesca: *Pregnant
 Madonna, The* 214
plait *see* RSI plait
Plato 25
pleasure
 in Akerman 217

Dora case study 213
 in feminist filmmaking 197,
 198–203
 in hearing 205
 Kelly on 213–14
 Matrix and 202–3
 phallocentric codes of 198
politics: art and 137, 138
Pollack, Max: portrait of Freud 1
Pollaiuolo, Antonio: *Hercules Slaying
 the Hydra* 19
Pollock, Griselda *19*, 128, 138
Pollock, Jackson 130, 146, 149
 action painting 136–7, 147
Pompeii
 as archaeological metaphor 13, 16
 Jensen 20, 22
 preservation of 10
Popper, Karl 48
postcolonialism: romanticization of
 migration 168–9
post-natal: female relations 70–1
poststructuralism
 Cha and 172
 identity politics and 164–70, 189–90
practice: theory and 47
prehistory
 Freud 5, 11–12
 sedimentation and
 stratification 13–14
pre-natal: female relations 70–1
preposterous history 55
preservation: Freud 10–11
primal scene 89
 compared with Oedipus
 complex 76–9
 Freud 4, 14
 Lacan 75–6
 in *Ravishing of Lol V. Stein* 64–6,
 69–70, 74, 86–7, 91–2
 subjects 75–7
primitivism 11